CÉZANNE by himself

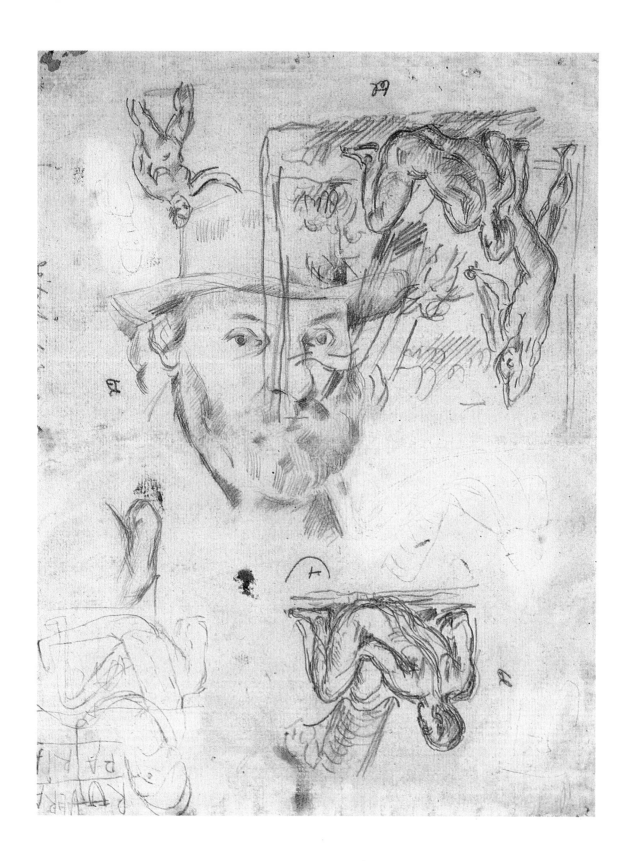

Edited by Richard Kendall

Drawings, paintings, writings

CÉZANNE by himself

LITTLE, BROWN AND COMPANY

BOSTON NEW YORK LONDON

To Bruce Bernard

A LITTLE, BROWN Book

First published in Great Britain in 1988
by Macdonald & Co (Publishers)
Reprinted 1990 by Macdonald & Co (Publishers)
Reprinted 1994 (paperback) by Little, Brown and Company

This edition published in 2000 by Little, Brown and Company (UK)

A CIP catalogue record for this book is available
from the British Library

ISBN 0-316-85503-0

Editors: Hazel Harrison, Sarah Chapman
Design: Andrew Gossett
Picture Research: Sharon Hutton
Production by Omnipress
Printed in Spain

Little, Brown and Company (UK)
Brettenham House
Lancaster Place
London WC2E 7EN

Contents

Acknowledgements

Any study of the writings and pictures of Cézanne must lean mightily on the patience, the erudition and the labour of many other scholars, and my principal debt of gratitude is to them. The catalogues of Lionello Venturi and Adrien Chappuis, and the researches of Michael Doran, have all been invaluable; but it is to John Rewald, whose definitive publications on the artist and whose personal support made this project possible, that a particular acknowledgement is due.

The list of individuals who have helped, encouraged and advised me in the production of this book is a long one, but I must single out Bruce Bernard, for his astute counsel in the choice of plates; many of the staff of Macdonald Orbis, including Sarah Snape, Lewis Esson, Christopher Fagg, Elizabeth Eyres, Hazel Harrison, Sarah Chapman and Martyn Longly, for their support and guidance; my assiduous picture researcher, Sharon Hutton; Derek Birdsall and the designer of the book, Andrew Gossett, for their willingness to admit the author to the design process and demonstrate again their extraordinary expertise; the curators, collectors and others who have helped me gain access to pictures, amongst them Max Bollag, Douglas Druick, Martha Tedeschi, John Elderfield, Marianne Feilchenfeldt, Lawrence Gowing, Tokushichi Hasegawa, Gary Tinterow, Nicholas Wadley, the Galerie Beyeler, Beverley Carter, and the staff of the drawings collections at the Art Institute of Chicago, the Philadelphia Museum of Art, the Metropolitan Museum of Art and the Museum of Modern Art, New York, the Kunsthaus, Zürich, the Kunstmuseum, Basle, and the Louvre; Peter and Angela Brookes, Joanna Drew, Michael Howard, Arianne Lawson, Robert McGinley, Peter Major, Richard and Belinda Thomson, and the art librarians at Manchester Polytechnic, who have all contributed in a variety of ways to the book and its contents; and my wife, for her patience, and my daughter, Ruth, for a secretarial contribution commensurate with her age.

Paul Cézanne has been described as 'probably the greatest painter of the last hundred years', yet his personality and achievement have remained obscure to many of the lovers of art who have responded so enthusiastically to the art of his contemporaries. Since his death in 1906, Cézanne has been appropriated by a series of different commentators and artistic movements, many of whom have compounded his reputation as a difficult, inaccessible individual. The purpose of this book is to present Cézanne as he presented himself, through his own writings, conversations, drawings, watercolours and paintings, with a minimum of editorial intervention. His letters, while sometimes densely expressed, reveal him as a man of strong emotion and passionately held beliefs; his conversations show Cézanne at his most eloquent and incisive; and in his pictures we find an artist of extraordinary diversity, the virtual mirror-image of the austere theoretician so beloved of twentieth-century critics. It is hoped that this compilation of the words and the work of Paul Cézanne will show the artist in a clear and direct light, as the fallible, original and utterly dedicated sensibility who thought he might become 'the primitive of a new art'.

Richard Kendall

Introduction

Picasso, who was probably more indebted to Cézanne than to any other single artist, once insisted that it was Cézanne's anxiety that impressed him above all. His contemporary Matisse, writing of a small Cézanne canvas he owned, claimed that it had 'sustained me spiritually in the critical moments of my career as an artist', but went on to admire 'the exceptional sobriety of its relationships'. Other artists, and successive generations of admirers and critics, have singled out Cézanne's fine and dramatic use of colour; his legendary concern with geometry, construction and picture-making; his obsessive relationship with certain landscape features, such as Mont Ste-Victoire, and his equally obsessive arrangements of still lifes; and even the obscure eroticism of his late paintings of bathers.

Paul Cézanne has been celebrated as the greatest of the Impressionist generation, as the artist who laid the foundations of Cubism and as the father of abstract art and the modern movement. Since his death in 1906, countless writers have claimed him for themselves, elaborating his work in the language of their own day and crediting him with preoccupations close to their own. Few artists have been subjected to a comparable barrage of erudition, speculation and redefinition, and it is some measure of the complexity and resilience of Cézanne's work that this process continues unabated today. In spite of, or because of, this, Cézanne is still considered by many to be a 'difficult' artist, whose sometimes awkward, often unfinished, and occasionally distressing imagery has never endeared itself to the wide public that has conspicuously adopted contemporary figures such as Claude Monet, Pierre-Auguste Renoir and Vincent Van Gogh. Cézanne's reputation as an 'artist's artist', or as a painter whose very complexity attracts those of a theoretical disposition, is a forbidding one.

Any attempt to extricate Cézanne from these decades of accumulated over-presentation must be directed at two principal and original sources of information: firstly, his own account of his life, his aspirations and his views on art as expressed in his letters and in the records of his friends; and secondly, the formidable resources of his own works of art – oil-paintings, watercolours and pencil, ink and chalk drawings. Neither source is without its problems, but both of them offer rich and unexpected moments of contact with something comprehensible, vigorous and familiar. Without testing our views against these sources, we cannot arrive at a fully realized (to use one of Cézanne's favourite words) picture of the artist.

Cézanne's relationship with words was a paradoxical one. As a young man he delighted in them, reciting poetry to his friends, composing long rhymed sagas both solemn and facetious, and writing vividly descriptive letters to friends and family. Throughout his life he was drawn to men of letters, from the celebrated Emile Zola, with whom he spent his youth, to the young Provençal poets and Parisian critics of his maturity. It is also clear, whatever his protestations to the contrary,

that he loved to talk about art (a letter of 1897 from Cézanne to Emile Solari reads: 'Last Sunday your father came to see me – unfortunate man, I saturated him with theories about paintings.') and both his letters and conversations show how he could, on occasion, crystallize an idea about painting in a few terse, incisive words. But words could also put him on his guard, especially written words, and those concerned with art most of all. His relations with the professional critics were always uneasy ('Don't be an art critic, but paint, there lies salvation', he wrote to Emile Bernard), and the references to painting in his own letters are circumspect, concise and deliberated. Above all, he despised what he called 'literary' painting, that is, the kind of art that took a poem or narrative for its subject-matter and needed another one in order to explain its significance.

Whatever doubts he may have had about the written word, Cézanne's own letters offer a crucial access to the most elusive issues of his art. Certain themes recur throughout his career, and it is possible to establish from these a number of cardinal principles that appear to have dominated his thinking. Firstly, nature was pre-eminent in representing the foundation and the inspiration for his art ('. . . the strong feeling for nature – and certainly I have that vividly – is the necessary basis for all artistic conception. . .'), and his belief in the need for the artist to experience nature at first hand, whether it be a Provençal mountainside, a face or an arrangement of fruit, took on for him an almost mystical significance. Secondly, he repeatedly stresses the artist's need for a personal, independent perception of the world, perhaps informed by a respectful study of the great masters but always aspiring towards the intense and artless vision of a child. Such vision in a painter required doggedness, a resistance to the easy formula and a search for one's own 'temperament' ('. . . as soon as you begin to feel vividly, your own emotion will always emerge and win its place in the sun – gain the upper hand, confidence'). Finally, Cézanne asserts that art must aspire to be an 'equivalent' to nature, a series of marks, colours and tones on a canvas or sheet of paper that is not a copy, but a 'realization of one's sensations'.

Some of Cézanne's written observations, like his remark to Joachim Gasquet that 'Art is a harmony which runs parallel with nature', have become justly famous, and others exaggeratedly so, like the celebrated but widely misrepresented remark about the cylinder, the sphere and the cone. Taken in conjunction with his more reliably recorded conversations, Cézanne's views provide a concrete, plausible and precious link with the ultimate object of our interest – his paintings and drawings. And in combination with the documented events of his life, they offer us the best chance of a fresh and unbiased view of the artist and his art.

The Early Years, 1839–1874

For an artist of such singularity, Cézanne's life was remarkable mainly for its uneventfulness. Much of his career was spent in isolation or obscurity, and he experienced neither the protracted poverty nor the glamorous exposure of many of his contemporaries. As the only son of a rising middle-class family, he enjoyed an untroubled childhood, a privileged education and, ultimately, a financially secure maturity. His contacts with fellow painters were sporadic and he was never more than momentarily associated with any artistic group. Ferociously independent, massively single-minded and tenacious, his life was governed by the imperatives of painting, with which few practical or domestic contingencies were allowed to interfere.

Cézanne was born in Aix-en-Provence, twenty miles north of Marseilles and the Mediterranean, and four hundred miles away from Paris. The majority of his life was spent in and around Aix, which was crucial to him in many ways, not least as the centre of the Provençal countryside he loved and painted so obsessively – though Joachim Gasquet describes how, in later years, the artist would shake his fist at the city and its inhabitants, cursing their intolerance and artistic conservatism. Aix also gave him a sense of himself as a provincial, an outsider excluded from the machinations of the metropolitan world, a position which seems to have dogged his professional career. As a child, however, the town and its surroundings were a paradise for him. The story has often been told of how as a teenager in the 1850s (he was born in 1839) he roamed the countryside in the company of his friends Emile Zola and Baptistin Baille, swimming, shooting ineffectually at whatever moved, reciting verse and developing that kinship with nature that was to dominate his adult life. He was lucky in his friends, several of whom grew up to be artists, poets and distinguished professionals of various kinds, and there can be no doubt that his carefree childhood and his intimacy with the young Emile Zola were formative influences on his life.

It is one of the delightful ironies of Cézanne's early years that his childhood friend Zola, who was to become the most celebrated and controversial literary figure of his age, was always the one who carried off the school drawing prizes, while the young Cézanne poured his energies into poetry, which was admired by Zola. Cézanne's vocation as an artist came slowly and met with little encouragement. As his earliest surviving letters show, he struggled with his studies at the College Bourbon in Aix, finally matriculating in 1858. For a while he joined the life-drawing classes at the Aix Drawing Academy, learning to master the orthodox figure conventions of the day, but family pressures soon obliged him to enrol as a student of law at the University. Cézanne's family, particularly his father, was to have an exaggerated influence on his career, and it was with the greatest reluctance that the only son was allowed to consider becoming an artist. The family fortune had been built on

banking, and Louis-Auguste Cézanne had decided that a legal training for his son would be the best guarantee of their continuing prosperity. There still exist some pages of Cézanne's legal notes, half covered with portraits and caricatures scribbled down by the frustrated, day-dreaming would-be artist.

While Cézanne was dividing his time between the life class and the University, Zola had left Aix for Paris. A long and animated exchange of letters between the two friends gives us our first detailed insight into their daily lives and preoccupations, and introduces an important new factor into Cézanne's early life. The lure of Paris, with its art galleries and salons, the vitality of its literary life and the possibility of a serious training as a painter, seems to have become an obsession with him, and inevitably led to a head-on collision with his father. Eventually Cézanne triumphed, and in 1861, with a modest allowance reluctantly conceded by the family, he established himself in Paris to begin his chosen career.

For at least the next decade he moved restlessly from studio to studio, from discouragement and rejection in Paris to the security of Aix (he even worked briefly in his father's bank), and from Aix back to the artistic rigours of the capital. He endured not only the abuse of the public and the incomprehension of his peers, but also personal difficulties and financial distress. Artistically, he seemed at odds with both his age and with his own achievements in later life. But throughout this period, however great were the obstacles and disillusionments which temporarily deflected him, he continued to demonstrate his most distinctive traits of independence, tenacity and exceptional single-mindedness. In a letter of 1863, Cézanne deplores the fact that a fellow student is training under an artist who 'makes them learn a certain hackneyed style which leads to doing just what he does himself', and adds, 'to think that a young intelligent man had come to Paris to lose himself.' When completing a questionnaire some years later, Cézanne answered the inquiry 'What is your greatest aspiration?' with the word 'certainty'. And it was said later in his life that 'you were as likely to get Cézanne to change his mind as to get Nôtre Dame to dance a quadrille.'

Cézanne's determination to follow his own path is dramatically evident in his earliest surviving pictures, the drawings and paintings from the 1860s which caused such consternation in Paris. An audience accustomed to the work of his maturity can still be shocked by these scenes of nakedness, rape and murder, the awkward groupings of clothed and unclothed figures, the lugubrious portraits and oleaginous still lifes. In technique they are equally disconcerting, often thickly painted (sometimes with a palette knife) and strongly outlined, animated by a muscular and barely controlled energy. Half fantasy and half passionately sensed reality, these pictures seem to represent a direct attempt by Cézanne to transpose his private sensations onto the picture surface. If they are uncouth, intense

and abrasive it is because Cézanne himself could be all of these things. His adulation of the great masters, especially Rubens and Delacroix, is perhaps too openly flaunted, but nowhere is there evidence of the 'hackneyed style' affected by the young artists he despised. Whatever agonies of creation they caused him and whatever derision they attracted from the world, these early pictures are utterly his own, as true to the man as anything he ever made.

It can hardly surprise us that these early paintings were rejected by the official Salon, but each rejection both distressed Cézanne and increased his belief in his own independent vision. His friend Zola, who had established himself as a crusading Parisian journalist and critic, made a number of attempts to defend Cézanne's work in print and Cézanne, in his turn, embarked upon several paintings of the aspiring young writer. Even more significantly, Cézanne had begun to associate with and work with other Parisian painters, such as Armand Guillaumin and Camille Pissarro, and it seems that a number of them (including Edouard Manet) were able to offer him crucial encouragement. Cézanne even appeared, on occasion, at the legendary Café Guerbois, where the future Impressionists like Claude Monet, Alfred Sisley, Pierre-Auguste Renoir and Edgar Degas met and talked, but it seems that Cézanne's habitual distrust of words kept him in the background.

By the early 1870s much of the pattern of Cézanne's life was already established. He worked remorselessly at his art, attracting few admirers and fewer purchasers. Depending still on his allowance from his father, he regularly spent time in Aix and its vicinity, but increasingly found the family atmosphere unsympathetic. Matters became worse when he met a young model, Hortense Fiquet, and began to live secretly with her in Paris. In 1872 Hortense gave birth to a son, christened Paul after his father, and an elaborate system of deception was developed to keep news of the liaison and its offspring from the family at Aix. Regrettably, few letters have survived from the period 1868 to 1872, but other relationships were clearly maturing and we know that Cézanne's friendship with Pissarro was one of them. Cézanne found Pissarro a patient, generous and knowledgeable colleague who was willing to help him towards the mature means of expression that still eluded him. They painted together, their easels side by side in the countryside around Pontoise where Pissarro lived, and it was probably Pissarro above all who fostered Cézanne's belief in the vital, direct contact between painter and nature. From this point onwards, through the years of Impressionism and into his late career, the painting of the landscape was to become the mainstay and the heart of Cézanne's artistic enterprise.

The Years of Impressionism, 1874–1886

On 15 April 1874 the first exhibition of the group of artists referred to by Cézanne as the 'Société Coop', but later known as the Impressionists, opened in Paris. Cézanne showed three paintings, two of which (*The House of the Hanged Man* and *Landscape at Auvers*) were, significantly, landscapes. Both pictures are strong, confident compositions based on the rectilinear forms of trees and cottage walls, and the opposing diagonals of roof-tops and cart tracks. Both pictures have the freshness and authenticity – indeed the slight awkwardness – of paintings carried out on the spot, responsive to the colours, tones and textures of half-tamed nature seen at first hand. They suggest a painter of maturity and conviction, close in spirit and practice to several of the other Impressionist artists but already, in his insistence on crisply defined structure, a separate and idiosyncratic sensibility.

Between 1874 and the final Impressionist exhibition of 1886, Cézanne contributed to only one more, but in spite of this he became closely identified with the Impressionist artists and established important links with individuals like Pierre-August Renoir, Claude Monet and Antoine Guillemet. His own painting continued to advance in consistency and purposefulness, and many of the great themes of his maturity, such as the groups of nude bathers, the studies of Mont Ste-Victoire and the monumental still lifes, made their first appearance. Critics, dealers and collectors began to notice and support him, though it was to be many years before he could count on an appreciative audience and a significant income from his art. Throughout these years he witnessed the rise to fame and fortune of his school friend Emile Zola, which initially resulted in much-needed financial support for the artist, but ultimately caused the breakdown of their friendship. And as the years went by, Cézanne began to develop an increasing intimacy with his son, and to experience the gradual estrangement of his wife and the eventual end of the stranglehold of the family at Aix with the death of his father in 1886.

In his letters from the Impressionist era, Cézanne offers some precious glimpses of the workings of his mind and his artistic ambitions. Writing to his mother in 1874, he notes that Pissarro thinks highly of him and adds, 'I am beginning to consider myself stronger than all those around me, and you know that the good opinion I have of myself has only been reached after serious consideration.' He goes on, in an even more telling phrase: 'I have to work all the time, not to reach that final perfection which earns the admiration of imbeciles. And this thing which is commonly appreciated so much is merely the effect of craftsmanship. . .' Cézanne's abhorrence of mere technique, of a meretricious 'perfection' which is easily learned and as easily admired, remains one of his defining characteristics. This, in conjunction with his preoccupation with nature ('the aim to be attained, that is to say, the rendering of

nature'; 'I began to see nature rather late'; 'Nature presents me with the greatest difficulties' and so on) and his developing interest in colour, offered him the beginnings of a pictorial language that was to become distinctively his own.

Cézanne shared with the Impressionist landscape painters a feeling for the vivid portrayal of ordinary landscape, for the high-toned luxuriance of poplar trees, cottage walls and reflections in water. His own open, fragmented brushwork is also a variant of that used by Claude Monet, Alfred Sisley and Camille Pissarro, though Cézanne increasingly subjects his individual touches of paint to a more ordered principle. For example, the painting of *Hillside Houses* (Boston Museum of Fine Arts), executed about 1880, is a subject that many of his contemporaries might have chosen, but Cézanne has treated it in a highly individual way, marshalling his brushmarks into a taut mosaic of vertical and diagonal blocks, emphasizing the rhythms of the landscape and the structures of the painted composition. A slightly later landscape, *The Gulf of Marseilles* (Philadelphia Museum of Art), carries this principle further: ambitiously tackling a sweeping panorama of houses, sea and distant mountains, Cézanne patiently disentangles the visual complexities of the scene, where Monet might have celebrated the ocean and the brilliance of its light, and Renoir would have discovered an orgy of Mediterranean colour. In Cézanne's painting, the eye moves from foreground trees to distant houses, from factory chimneys to sea and beyond in a series of meticulously defined progressions. Colour intensifies the drama of the encounter, rhythmic brushwork energizes the canvas, and a textured surface reminds us that we are confronting a rough-hewn, artfully constructed work of art.

In later life Cézanne is reported to have said, 'I wanted to make of Impressionism something durable, like the art of the museums.' Despite his close involvement with the Impressionist artists, Cézanne was never at ease with the rapidly painted moment and the fleeting impression. Part of his mind was always with the great artists of the past, with the dense colour harmonies of Veronese and the elaborate, sensual compositions of his declared favourite, Rubens. This tension in Cézanne between the art of the museums and a contemporary art based on nature lies behind many of the decisions of his career: his persistence in returning to the great subjects of past art, such as the still life, the portrait and the nude composition; his slow, painstaking build-up of the finished picture surface; and his curious love-affair with Paris, which coaxed him away from Provence but offered him Michelangelo, Titian, Giorgione and Delacroix in exchange.

Cézanne's restless peregrinations from Aix-en-Provence to Paris, from Paris to the homes of Pissarro, Monet and Zola and back to Aix and Paris, seem to reflect the itineraries of his artistic ambition. In the 1880s his periods of painting the landscape in and around Aix became more protracted, but never a year passed without a long residence in the capital and visits to

exhibitions and friends. Stubborn as ever, he continued to submit to the Paris Salon, noting his rejections at times with anger and at times with something approaching pride. He regularly returned to the Louvre to draw, filling hundreds of sketchbook pages with studies from the paintings and sculptures he revered. And he began to attract admirers to his home in the south, just as he continued to be drawn to the galleries and studios of the city.

An important rendezvous for artists in Paris was the shop owned by 'Père' Tanguy, a dealer in artists' materials who would also accept works of art in payment for debts and display them on his walls. Tanguy, who was memorably portrayed by Van Gogh in a painting of 1887, accepted some of Cézanne's canvases in return for items purchased, and was thus responsible for finding him one of his first patrons. A collector named Victor Chocquet, who had amassed a group of pictures by Delacroix and had already begun to buy from Renoir, bought a Cézanne canvas from Tanguy in 1875, and soon met and befriended the artist. Other purchases followed, and Cézanne returned the compliment by painting his new admirer several times, though one of the portraits was received with almost hysterical derision when it was exhibited at the Impressionist exhibition of 1877. One or two critics, notably Duret and Rivière, had by now rallied to Cézanne's defence and other collectors, such as the wealthy painter Gustave Caillebotte, were soon to acquire pictures. But such encouragement remained exceptional and, embittered by public scorn and as far as ever from earning a living from his painting, Cézanne was obliged to rely on the charity of Zola and the meagre support of his family.

Cézanne's tenacious dedication to his painting was never more acutely tested than during these years, the very years when the definitive repertoire of his subject-matter and the distinctive language of his art were to establish their roots and begin to bear such extraordinary fruit. The compulsion to render nature, or rather to render his sensations of natural and living forms, whether landscape, portrait or still life, still provided the essential momentum for his work. By this stage in his career, the still life had taken on a special significance for him, and he was to become one of the most original and dedicated exponents of the form. Far from being just a pretext for picture-making, the groups of apples, pears, cherries or flowers were for Cézanne as much a part of nature's extravagant beauty as the trees and hillsides of Provence, and as likely to produce his 'vibrating sensations' as the landscape itself. According to Joachim Gasquet, who was admittedly given to rather fanciful recollections, Cézanne once claimed to overhear conversations between the fruit he was painting, and approached each item in a group as he would a human portrait. It is certainly known that he took great pains over the arrangement of his still lifes, propping up objects with hidden piles of coins and assembling an elaborate cast of bottles, jugs and more exotic objects like

skulls and plaster sculptures to provide the necessary visual drama for his tabletop stage.

Several of Cézanne's varied and familiar still-life properties dominate the centre of a finely resolved painting of 1886, the *Vessels, Fruit and Cloth in front of a Chest* (Munich, Neue Pinakothek). The simplicity of the green earthenware jar is juxtaposed against the more refined form of the much-painted ginger jar; the yellowing apples are confirmed in their roundness by the crisp linen cloth and the angularity of Cézanne's studio table. Verticals are set against horizontals, diagonals against circles and ellipses, warmth and softness against the severity of a blue-grey outline. Objects and furnishings seem to be chosen for the disparity of their relationships, for their ability to engage the broadest possible range of visual and tactile sensibilities. There is, in addition, evidence of Cézanne's famous willingness to 'distort', to allow the top and bottom of a jar or the two sides of a plate to follow different systems of perspective, as if the artists's need for the fullest possible truth has led him to integrate information carried over from previous perceptions of the subject.

Cézanne's portraits share with the still lifes an increasing mastery of technical means and a greater density of pictorial expression. His own self-portraits, numbering at least twenty from this period, can suggest both his growing self-confidence and a wariness directed at the prospective viewer. Most of his other models were friends or members of his family who could tolerate the protracted immobility of numerous sittings and the regular outbursts of frustration as the artist felt himself losing his way. The drawings and paintings of his son and of Hortense, which fill dozens of sketchbook pages and canvases of all sizes, remind us how tender an artist Cézanne could be and how finely responsive to nuances of feature, tone and expression. Whoever the model, Cézanne's portraits are uniformly still and generally symmetrical, the casual gesture excluded by the longevity of the pose and the particularity of detail subsumed in the monumentality of a single, undemonstrative human image.

At the end of this phase in his life, a series of events which transformed Cézanne's personal circumstances were to occur within a few months of each other. In March 1886 Zola published his latest novel, *l'Oeuvre* (*The Masterpiece*), which revolves around the figure of Claude Lantier, a painter recognizably based on Cézanne himself. For many years Zola had continued intermittently to forward sums of money to Cézanne and his family, and Cézanne had regularly commented in his letters on Zola's recent publications and achievements. The two friends still met on occasion, though the 1880s had seen a cooling of their relationship and a certain critical distancing of Zola from the painting of Cézanne and his colleagues. Cézanne's brief and poignant note of April 1886, in which he thanks Zola for his copy of *l'Oeuvre*, is one of the most famous from his pen. The book had portrayed Lantier the painter as a

confused failure, an artist of promise who overreaches himself and dies in front of his flawed masterpiece. For Cézanne, it was the final confirmation of Zola's loss of faith in him, and his letter marked the end of their friendship.

Within less than a month of writing his farewell to Zola, though for quite separate reasons, Cézanne resolved another of the ambiguities of his life by agreeing to marry Hortense, publicly and with the approval of his parents. His son Paul was now fourteen years old. And before the year was out his father, the former banker Louis-Auguste Cézanne, had died at the age of eighty-eight, leaving enough of his considerable wealth to the painter to ensure that he would be free from financial cares for the rest of his life.

The Years of Maturity, 1886–1897

For almost a decade after the death of his father, Cézanne's life followed a well-established pattern consisting of painting, occasional visits to Paris and brief contacts with artist friends. Outwardly, it was an uneventful time, untroubled by the money worries of his early career and free from harsh encounters with an uncompromising public and press. Finally at liberty to follow his vocation, Cézanne worked unremittingly, evolving and refining some of the greatest images of his career: the *Card Players*, the *Bathers*, the portraits of Geffroy, Gasquet and Vollard, and the awesome *Mont Ste-Victoire* series. It was a decade in which his preoccupation with colour infused and underscored much of his work and in which that most subtle of media, watercolour, became increasingly central to his procedures. And it was a period crowned by ultimate triumph, with the first exhibition devoted entirely to his work opening at the gallery of Ambroise Vollard in Paris in 1895.

As he approached his sixtieth year, Cézanne wrote to the young Joachim Gasquet of his failing health and vigour, adding: '. . . were it not that I am deeply in love with the landscape of my country, I should not be here.' Cézanne's acknowledgement that his physical survival depended on an immediate contact with nature is everywhere in evidence in his paintings of the landscape, which continued to grow in audacity and vitality with the passing years. His *Hills and Mountains in Provence* of about 1890 (National Museum of Wales), which was once owned by Paul Gauguin, has a tautness of composition, a resonance of colour and an extraordinary palpability in its structure that shows how far Cézanne had moved from the shimmering mirages of Impressionism. Solid blocks of colour, the blue of the water and sky, the ochre of the earth, generate a visual energy within the picture, establishing oppositions and contrasts and galvanizing the spaces and rhythms of the painted hillside. Even the watercolours, though quieter in hue, have this same vibrancy. *Le Grand Pin* (c. 1890, Zürich Kunsthaus) is painted almost aggressively, a superimposition of

jagged patches of colour against the paleness of the paper. The brushmarks, the brittle outlines of the branches and the fragmented hues of the foliage all work to specify and express the identity of the tree. Colour and form, unencumbered by the niceties of detailed description, are left to breathe life into the artist's perception.

The pine trees, the rocks and the earthy colours of Provence are never neutral features in Cézanne's landscapes, but are charged with an ancient Mediterranean potency unknown to the sophisticates of Paris; the clear air and the stable climate of the south were also generous to an artist of such slow and fastidious habits. In an earlier letter from l'Estaque, a coastal village beyond Marseilles, Cézanne had written: '. . . there are motifs which would need three or four months' work, which would be possible, as the vegetation doesn't change here. The olive and pine trees always keep their leaves. The sun here is so tremendous that it seems to me as if the objects were silhouetted not only in black and white, but in blue, red, brown and violet. I may be mistaken, but this seems to me to be the opposite of modelling . . .' The notion that 'the great magician, the sun . . .' itself presents the landscape as a series of brilliant interlocking hues and that the painter may also build up, with colours on canvas or paper, a sequence of interrelated silhouettes, planes and intervals which form a 'harmony parallel to nature' is central to Cézanne's later work. In conversation with friends and admirers, the artist repeatedly stressed his veneration for colour and his dislike of tonal modelling, and in his own pictures colour is invariably used to animate the most prominent and the most insignificant features. Fine hatchings or facets of tonally related tints are laid side by side, a cool green next to a yellow-green, a grey-blue beside an ultramarine and a violet, as if to invigorate each centimetre of the painted surface.

But however much Cézanne insisted upon the centrality of colour, drawing and form were never subservient in his art. The same paintings that are so subtly coloured have often a network of containing, defining lines above and below the surface pigment, and many are descended from a line of considered pencil drawings. Throughout the 1880s and 1890s, he continued to visit the Louvre and make energetic drawings from his favourite artists, characteristically choosing those who used form at its most pronounced and vigorous, such as Rubens and the Provençal sculptor Puget. Such strong formal structures, consciously or unconsciously echoing the formations of past art, also inhabit many of Cézanne's most ambitious figure compositions of this period. The seemingly endless arrangements of male and female nudes in every medium and on every scale from pencil sketch to finished canvas had clearly a private significance for him. As exercises in form in the grand manner, as investigations of the monumental and the Utopian, even as flights of erotic fancy, these pictures are united in their rich compositional inventiveness. But they remain alone as the great exception in Cézanne's mature work, the single group of pictures at a remove from his principal stimulus, the direct perception of nature.

A painting such as *Bathers* (*c*. 1890–94, Musée d'Orsay, Paris), apparently showing four naked males exercising or drying themselves beside a river, has much of the freshness and spontaneity of a landscape sketch, but everything we know about Cézanne at this date suggests that it was contrived in his studio. The people of Aix, with their deep suspicion of artists in general and of Cézanne in particular, seem to have been reluctant to provide nude models for his paintings, and there is some evidence that his own inhibitions may have played a part in the problem. Using life drawings preserved from his youth, studies of sculptures from museums and, according to Cézanne himself, glimpses of soldiers bathing in the local river, the artist pieced together hundreds of variations on this most improbable of subjects. Apart from the echoes of the Old Masters, there are memories of Cézanne's adolescence beside the river Arc, bathing with Zola and Baille; fantastic, Dionysian scenes of orgy and concupiscence; intricate permutations of limbs, gestures and pictorial dynamics; and ambitions to re-invent an epic figure tradition, to 'do Poussin again from Nature'.

Such ambitions and such achievements inevitably made their mark on the few painters and friends who visited Cézanne in Aix, and gradually led to a shift in the critical awareness of his art. In 1890 Cézanne was invited to participate in an exhibition in Brussels, and soon after he attracted the attention of the critic Gustave Geffroy, the writer and painter Emile Bernard, and the Provençal poet Joachim Gasquet. As his letters show, Cézanne embarked on a major portrait of Geffroy, abandoned after many sittings, and was later to portray both Joachim and his father Henri Gasquet. The most telling portrait of the decade, however, and one of the best-documented paintings of Cézanne's entire career, is that of the young art dealer who gave him his first exhibition, Ambroise Vollard.

Vollard's account of the painting of his portrait, like his anecdotes and memories of Renoir and Degas, was written down some years after the event, but his mixture of gossip and fact contrives to be both illuminating and plausible. There are few better descriptions of Cézanne the man, utterly serious, endlessly self-critical, infinitely demanding of his sitters and of his own capacities as an artist. Vollard illustrates how slowly and painstakingly Cézanne worked, how suddenly he could react to some distraction or to his own perceived failure, and how violently he could behave towards his own imperfect creations. The final portrait, now in the Petit Palais in Paris, was abandoned rather than finished, with Cézanne announcing after over a hundred sittings that he was not displeased with the shirt-front. Cracked, dull and over-worked paint bears witness to the protracted struggle. This is one of a number of canvases in which the painter seems to have lost his battle against impossibly complex pictorial ambitions.

The Late Work, 1897–1906

The final years of Cézanne's life were years of relative tranquility, undisturbed by family feuds and financial stress, sweetened by growing recognition and artistic achievement. There were periods of discouragement and characteristic self-censure, but equally a recognition that progress had been made and that he was 'not one of the most miserable on earth.' From at least 1890 Cézanne had suffered from diabetes, and he complained on a number of occasions of declining energy and increased infirmity, but in spite of his health he continued to paint in the open air, walking each day to his chosen subject or, in his last months, hiring a cart to carry him. He even encouraged some younger painters, such as Camoin and Bernard, to paint alongside him, deriving reassurance and perhaps new vigour from their companionship. From these years some of Cézanne's most ample and informative letters survive, letters which were to be published and endlessly quoted by succeeding generations.

In a letter of 1904 Cézanne repeated again the great clarion-call of his career: 'The real and immense study to be undertaken is the manifold picture of nature.' It is an often overlooked curiosity of Cézanne's career that he, who more than all his contemporaries has been associated with the art of the twentieth century, was the one least involved with the imagery of the city, the machine and the modern age. Cézanne's commitment to the landscape was as great in his last years as ever, and was now concentrated almost exclusively in half-a-dozen motifs around Aix, to which he returned again and again. Cézanne would walk two or three miles from his studio to the quarry at Bibémus, with its flaming red rocks; to the dense woodland and mossy boulders around Château Noir; to the trees and cottages at the hamlet of le Tholonet; and to the favoured sites from which the most haunting subject of all, La Ste-Victoire, could be seen.

Cézanne painted more than thirty oil paintings as well as dozens of watercolours of Mont Ste-Victoire, and this curiously asymmetrical rocky abutment became for him an unchanging measure of his artistic enterprise, an emblem of Provence and of nature itself. In his *Mont Ste-Victoire* (Philadelphia Museum of Art), painted between 1904 and 1906, the nature of the artistic challenge is spelt out. The massive, arching form of the mountain dominates the top of the picture, distanced from the foreground and the viewer by a deep, largely featureless space. By means of slabs and patches of colour, Cézanne has animated the entire canvas area, leading the eye from picture surface to spatial arena and back again, balancing pictorial dynamics with the perceived identity of the motif. There is a sense of nature seen and experienced, of colours and forms grasped and transmuted, not of nature frozen by the photographic stare.

Those who watched Cézanne at work describe how he would look fiercely at his subject for minutes on end, then suddenly dart at his canvas or paper and put down a single touch of colour. Each of the marks he made grew out of observation, scrutiny and analysis, an attempt to crystallize his perceptual experience as areas of pigment. In a letter of 1904 to Emile Bernard, he wrote, 'This is true, without any possible doubt – I am quite positive: – an optical sensation is produced in our visual organs which allows us to classify the planes represented by colour sensations as light, half tone or quarter tone. Light, therefore, does not exist for the painter.' Colour alone, interacting with other areas of colour on the surface of the picture, would create light, space, energy and sensation.

Some of Cézanne's most remarkable pictures are the watercolours painted in the last years of his life, and it is possible that these dense, fragile paintings offer us the clearest realization of the artist's lifelong aspirations. Watercolour allowed Cézanne to work rapidly and directly, laying down touch after touch as perception followed perception, the translucent washes of pigment superimposed in a rich, suggestive membrane of colour. A still life such as *Pot bleu et bouteille de vin*, painted between 1902 and 1906, exemplifies his use of the medium. Each contour and each interval between contours has been assessed a dozen times, each assessment leading to a gentle, decisive touch of the brush. As the process advanced, the 'vibrating sensations' described by Cézanne appear to take form, the resonant colours of the bottle and fruit intensifying against the paleness of the paper. The picture might almost have been in Cézanne's mind when he wrote in 1904, 'I remain in the grip of sense-perceptions and, in spite of my age, riveted to painting.'

Cézanne was to elevate watercolour to a status equalled by few other artists, and, like his great predecessor Turner, he particularly valued the medium's versatility and portability. In October 1906, only days before his death, he described a steep hill climb 'with only my bag of watercolours' but he appears to have reluctantly accepted the impracticality of painting in oils on a large scale in the open air. Some of the late paintings, notably the large *Bathers*, portraits and still lifes, were necessarily painted in the studio, though even here there were problems. In 1899 Cézanne had been obliged to leave his studio at the much-loved and much-painted family house, le Jas de Bouffan, when the house was sold to settle his parents' estate, and he had established a studio in the centre of Aix. Dissatisfied with this arrangement, in 1902 he built himself a new studio on a hill overlooking Mont Ste-Victoire and Aix itself, finally achieving the peace and comfort he desired, within sight of some of his most revered motifs.

The artist's domestic arrangements had also changed with the passing years, and by this time his son Paul was acting as intermediary and agent between his father and the Paris picture dealers. Cézanne had long since accepted his own incompatibility with his wife, Hortense, and both mother and child had been obliged to live in Paris for long periods. As his

letters show, however, the artist continued to maintain contact with his family and could be disconcertingly tender with younger relatives. In his later years Cézanne developed a particular sympathy with the young, encouraging artists at the beginning of their careers and mixing with a group of young writers, among them Joachim Gasquet, who were involved in a revival of Provençal culture. Gratified by their attentions and enthused by the promise of an artistic succession, Cézanne encouraged their visits, answered their letters and expounded for them his views on art. To Charles Camoin, a young artist already friendly with Matisse, Cézanne offered encouragement and constructive criticism. With the painter and theorist Maurice Denis, who had already exhibited a painting entitled *Hommage à Cézanne*, the artist discussed his ideas and passed on his aphoristic wisdom. Most important of all for subsequent generations, Cézanne corresponded at some length with a young painter and writer who had also known Gauguin and Van Gogh: Emile Bernard.

The letters from Cézanne to Bernard have been seen as the most complete and authorative statement of Cézanne's ideas in later life. Many of the familiar battle-cries are echoed: 'The Louvre is a good book to consult'; 'Painters must devote themselves entirely to the study of nature'; 'a painter, by means of drawing and colour, gives concrete form to his sensations and perceptions'; 'One must look at the model and feel very exactly'; and, in a much-quoted letter of 1904, 'treat nature by means of the cylinder, the sphere, the cone'. This famous remark, which was seized upon by the Cubists and their apologists when it was published and has been associated with them ever since, is almost certainly more innocent than it seems. In spite of his preoccupation with colour, Cézanne never relented in his struggle to construct forms in his pictures and to study them in nature. At the same time, there is hardly a single cylinder, sphere or cone to be found in his own work and Cézanne was probably referring to the system of drawing, familiar in teaching then as now, by imagining simple structures within complex forms.

Already, in his old age, the process of the assimilation of Cézanne by younger generations was underway, and on occasion the artist was to regret the passing of his isolation. As ill-health and petty irritations slowed him down, Cézanne drew comfort from the 'progress' he perceived in his work and the sense that he might become 'The primitive of a new art'. His diabetes appears to have affected his eyesight, and perhaps even his colour vision, contributing to intermittent depressions and 'cerebral disturbances'. Some of the late pictures, such as the groups of skulls and the gloomier nude compositions and portraits, are partly expressions of his increasingly sensed mortality, though his final works can be as radiant and limpid as anything he made. The magisterial still-life compositions, the intricately inflected watercolours, the studies of Vallier his gardener and the ubiquitous visage of Ste-Victoire,

all continued to find concrete form in the mysterious alchemy of Cézanne's colours.

Only days before his death he wrote to his son Paul, ordering new paintbrushes and reporting on his slow progress. Unwittingly, Cézanne also produced in this, his last important surviving letter, a rounded and honest summary of himself which might almost serve as his own epitaph. He writes of the paramount importance of his sensations and of his confidence beside his contemporaries; he refers affectionately to his family and generously to younger artists; there is news of a thunderstorm, which must have kept him from painting outdoors; above all, he shows a grim determination to keep on painting, sensing that his life's work has value for the future: 'I continue to work with difficulty, but in the end there is something. That is the important thing, I believe.'

The Early Years, 1839–1874

When Cézanne wrote his earliest surviving letters he was nineteen, living in a provincial town a few miles from the Mediterranean and dreaming of poetry, love affairs and long escapades in the country with his former school-friends. He was already prey to the moods which marked his adult life, and often expressed himself in extremes: 'with what infinite joy would I clasp your hand!'; 'I despair, I despair . . .'; or 'I no longer recognize myself, I am heavy, stupid and slow'. His letters sometimes break into verse, filling page after page with obscure rhymed couplets and awkward literary pastiche, as if his imagination were rebelling against the constraints of prose. Everywhere there is evidence of energy, a turbulent and unpredictable engagement with sensation and experience which colours both his youthful writings and his earliest drawings and paintings.

Few pictures survive from the early part of Cézanne's career, many being presumed lost on his fitful travels from Aix to Paris and elsewhere, others perhaps destroyed in bursts of self-criticism. Some of his sketchbook pages are the visual equivalent of his letters, juxtaposing scribbled figures and fantasies with glimpses of his adolescent world. A drawing of a diver plunging into a river recalls his own childhood adventures and almost illustrates his own earlier lines: 'Zola the swimmer strikes fearlessly through the limpid water. His sensitive arms are spread joyously in the soft fluid.' At times his drawings are violent, at others casual to the point of artlessness, but his studies from the life model show how paradoxical his talent could be. While attending the Drawing Academy at Aix, and in the early 1860s at the Académie Suisse in Paris, Cézanne displayed an impressive command of traditional draughtsmanship, a command that heightened his self-esteem just as it increased his suspicion of over-refinement and technical display.

Much of our knowledge of the young Cézanne comes from the series of letters he exchanged with his childhood friend Emile Zola, who had preceded him to Paris and was trying to establish himself as a writer. The intimacy of their relationship is evident in the frank descriptions of passions and disillusionment, though it is noticeable that their later exchanges become more concise and businesslike. As Zola achieved some celebrity, he rallied to the public defence of his artist friends, but his support of Cézanne appears to owe more to loyalty than to a profound sympathy for the painter's achievements. As Cézanne's letters and paintings show, however, other friends were important to him at this time, including a number of artists who encouraged and advised him in his vocation. Achille Emperaire, a fellow painter and resident of Aix, remained penniless and obscure despite Cézanne's efforts to help him, but his single-minded pursuit of an unfashionable mode of painting impressed Cézanne deeply. Emperaire had a deformity of the legs, clearly visible in Cézanne's monumental painting of him, though both painting and portrait drawings suggest his considerable dignity as well as Cézanne's tenderness towards him. Other artist friends from Aix, such as Huot, Solari, Coste and Villevieille, feature in Cézanne's letters, and one or two, including Marion and Valabrègue, also served as models for his earliest exercises in portraiture.

Cézanne's struggles in the 1860s to establish himself as a painter met with little sympathy outside his immediate circle of friends, and his attempts at public exhibition only led to rejection or humiliation. The annual Salon was still the most prestigious opportunity for artists to display their work, as Cézanne's repeated submission of his pictures suggests, though a profound dissatisfaction with the system is reflected in his letter of protest to the exhibition authorities in 1866. An earlier opportunity to circumvent the exhibition monopoly, the Salon des Refusés of 1863, had produced little but critical indifference towards

Cézanne's pictures, but his insistence that alternative and less conservative exhibitions be established served as part of a general movement which led to the first Impressionist exhibitions in the following decade. It is not possible to identify the pictures submitted by Cézanne to the Salon juries, though some of his surviving paintings suggest how baffling and unorthodox they might have appeared. The muscular energy and drama of his earliest works still linger on in the Magdalen *and* The Negro Scipio, *now combined more ambitiously with elements from the artists he admired, such as Delacroix and Veronese. More curious still, the* Pastorale *fuses together a number of Cézanne's early obsessions: the classical nude and the voluptuous fantasy, the romantic landscape and the distant echo of schooldays beside the river.*

A letter of March 1865 to Camille Pissarro reminds us of another formative influence on the young Cézanne's career. Pissarro was eight years his senior and already in touch with painters like Monet, Renoir and Degas who were to form the nucleus of the Impressionist group. In his letter Cézanne identifies himself with Pissarro's struggles against the exhibition system, ending with the phrase: 'I hope that you will have done some fine landscapes . . .' Subsequent letters refer increasingly to Cézanne's own landscape-painting activities, and it is clear that Pissarro's example had both a disciplining and a liberating effect on the younger artist. Despite the rarity of surviving letters from around 1870, there is evidence that the friendship flourished and that the two artists began to paint together in the country in the early 1870s, sharing a delight in nature directly perceived and an appreciation of its fresh colours and unsophisticated subject-matter. In Pissarro's company Cézanne also met Dr Gachet, an amateur artist and collector who introduced him to the process of etching and who later cared for Van Gogh in his last illnesses. It is surely significant that when Cézanne came to choose his entries for the first Impressionist exhibition of 1874, the paintings he selected (such as The House of the Hanged Man *and* Landscape at Auvers) *owed much to Pissarro's example.*

At some unspecified date in the late 1860s, Cézanne was persuaded to fill in an album or questionnaire called 'Mes Confidences', designed to elicit information about an individual's personality. Conventional and simplistic though some of the questions are, Cézanne's replies say much about the artist at the outset of his career. His expressed preferences for nature, for the early morning, for swimming and for the wild scabiosa flower all recall his childhood in Provence as well as anticipating his later preoccupation with landscape. The emphasis on friendship and the dedication to painting identify two of the conditioning factors of his adult life, while his choice of Rubens as his favourite artist reminds us of the strongly sensuous aspect of his personality. Most telling of all, in identifying himself with Napoleon and Frenhoffer (the perpetually dissatisfied artist in a story by Balzac) Cézanne acknowledges his past frustrations and recognizes his future need, as he noted in his final entry, to be 'strong and solitary'.

To Emile Zola

Good morning my dear Zola! I have just seen Baille, this evening I am going to his country house (I'm talking about the older Baille) and so I am writing to you . . .

Since you left Aix, my dear fellow, dark sorrow has oppressed me; I am not lying, believe me. I no longer recognize myself, I am heavy, stupid and slow. By the way, Baille told me that in a fortnight he would have the pleasure of causing a sheet of paper to reach the hands of your most eminent Greatness in which he will express his sorrows and griefs at being far away from you. Really I should love to see you and I think that I, we, shall see you, I and Baille (of course) during the holidays, and then we shall carry out, we shall complete those projects that we have planned, but in the meantime, I bemoan your absence . . .

Do you remember the pine-tree which, planted on the bank of the Arc, bowed its shaggy head above the steep slope extending at its feet? This pine, which protected our bodies with its foliage from the blaze of the sun, ah! may the gods preserve it from the fatal stroke of the woodcutter's axe.

We think that you will come to Aix for the holidays and that then, *nom d'un chien*, then long live joy! We have planned haunts as monstrous and enormous as our fishing trips. Soon, my dear, we shall start to hunt fish again, if the weather holds; it is magnificent today, for I am finishing my letter on the 13th. . . .

PAUL CÉZANNE
Salve, carissime Zola

*

Aix, 3 May, 1858

To Emile Zola

Are you well? I am very busy, *morbleu*, very busy. This will explain the absence of the poem you asked me for. I am, you can be sure, most penitent not to be able to reply with a verve, a warmth, a spirit equal to yours . . .

My dear, I am studying for the matric. Ah! If I had matric, if you had matric, if Baille had matric, if we all had matric. Baille at least will get it, but I: sunk, submerged, done for, petrified, extinguished, annihilated, that is what I shall be.

My dear, today is the 5th of May and it is raining hard. The sluice-gates of heaven are half open . . .

Water two feet high runs through the streets. God, irritated by the crimes of the human species, has no doubt decided to wash away their numerous iniquities by this fresh deluge. For two days this horrible weather has lasted. My thermometer is 5 degrees above zero and my barometer indicates heavy rain, tempest, hurricane for today and all the rest of the quarter. All the inhabitants of the town are plunged in deepest gloom. Consternation can be read on every face. Everyone has drawn features, haggard eyes, a frightened expression and presses his arms against his body as if afraid of being bumped in a crowd. Everyone goes about reciting prayers; at the corner of every street, in spite of the beating rain, groups of young maidens are to be seen who, no longer thinking of their crinolines, cry themselves hoarse hurling litanies to the heavens. The town re-echoes to their indescribable uproar. I am quite deafened by it. I hear nothing but *ora pro nobis* resounding on all sides. I myself have let the impudent doggerels and

the atrocious hallelujahs be followed by some pious *pater noster* or even *mea culpa, mea culpa ter, quater, quinter mea culpa*, thinking, by an auspicious return, to make the very august trio who reign above, forget all our past iniquities.

But I notice that a change, for evermore sincere, has just calmed the anger of the Gods. The clouds are disappearing. The luminous rainbow shines in the celestial vault. Adieu, adieu.

<div style="text-align:right">P. Cézanne</div>

<div style="text-align:center">*</div>

<div style="text-align:right">Aix, 29 [?] 1858</div>

To Emile Zola

My dear, it was not only pleasure that your letter gave me; receiving it brought me a higher sense of well-being. A certain inner sadness fills me, and, dear God, I only dream of the woman I told you about. I don't know who she is, I see her passing sometimes in the street when going to my monotonous college. I am so smitten that I heave sighs, but sighs that do not betray themselves outwardly, they are mental or spiritual sighs.

That poetic piece you sent me has given me great pleasure, I loved to see that you remembered the pine-tree which shades the riverbanks of Palette. How I should like, cursed fate that separates us, how I should like to see you coming. If I did not restrain myself I should hurl long strings of litanies of 'Good God', 'God's brothel'; 'damned whores' etc. to heaven; but what's the use of getting in a rage? That won't get me anywhere, so I resign myself. – Yes, as you say in another piece no less poetic (though I prefer your piece about swimming) you are happy, yes *you* are happy, but I, miserable wretch, I am withering in silence, my love (for it is love that I feel) cannot find an outlet. A certain ennui accompanies me everywhere, and only for a moment do I forget my sorrow: when I have had a drop to drink. But then I have always loved wine, and now I love it even more. I have got drunk; I shall get drunk still more, unless by some unexpected luck, hey ho, I should succeed, *nom d'un Dieu!* But no, I despair, I despair, and so I shall grow a tougher hide . . .

The weather is improving but I am not too sure whether it will go on. What is sure is that I am burning to go:

> As a daring diver
> Ploughing through the liquid waters of the Arc
> And in this limpid stream
> Catch the fish chance offers me.
> Amen! Amen! These verses are stupid
> They are not in good taste
> But they are stupid
> And worth nothing.
> Good-bye, Zola, Good-bye.

I see that after my brush, my pen can say nothing good and today I should attempt in vain:

> To sing to you of some forest nymph
> My voice is not sweet enough
> And the beauties of the countryside
> Whistle at those lines in my song
> That are not humble enough.

I am going to stop at last, for I am doing nothing but heap stupidity on absurdity.

<div style="text-align:right">P. Cézanne</div>

SKETCHBOOK STUDIES

TO EMILE ZOLA

Carissime Zola, Salve . . . Here are some little verses of mine which I find admirable, because they are by me – and the very good reason is that I am the author.

> Zola the swimmer
> Strikes fearlessly
> Through the limpid water.
> His sensitive arms
> Are spread joyously
> In the soft fluid.

It is very misty today. Listen, I have just made up a couplet – here it is:

> Let us celebrate the sweetness
> Of the divine bottle,
> Its incomparable goodness
> Warms my heart.

This must be sung to the tune: *D'une mère chérie célébrons la douceur*, etc.

My dear, I do really believe that you are sweating when you tell me in your letter

> That your brow bathed in sweat
> Was enveloped by the learned vapour
> Which exhales as far as me horrible geometry.
> Do not believe that vilification
> If I qualify
> So does Geometry!
> In studying it I feel my whole body
> Dissolving in water under my only too impotent efforts.

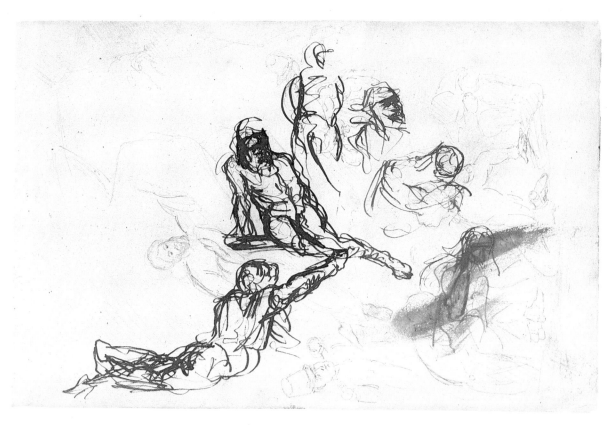

SKETCHBOOK STUDIES

My dear, when you have sent me your *bout-rimé* I shall set about hunting for other rhymes both richer and more distorted; I am preparing, I am elaborating – I am distilling them in my cerebral retort. They will be new rhymes – heum – rhymes such as one seldom sees, *morbleu*, in a word, accomplished rhymes.

My dear, having started this letter on the 9th July, it is right, at least, to finish it today, the 14th, but alas, in my arid mind, I do not find the least little idea, and yet, with you, how many subjects would I have to discuss, hunting, fishing, swimming, what a variety of subjects there, and love (*Infandum*, let us not broach that corrupting subject):

> Our soul still pure,
> Walking with a timid step,
> Has not yet struck
> The edge of the precipice
> Where so often one stumbles
> In this corrupt age.
> I have not yet raised
> To my innocent lips
> The bowl of voluptuousness
> From which souls in love
> Drink to satiety.

Here's a mystical tirade, hum, you know it seems to me that I see you reading these soporofic verses, I see you (although it is rather a long way), shaking your head and saying: 'It doesn't exactly roar with him, the poetry . . .'

Letter finished on the 15th in the evening.

SONG IN YOUR HONOUR!

Here I sing as if we were together surrendering
To all the joys of human life.
It is as it were an elegy,
It is vaporous, you will see.
In the evening seated on the side of the mountain,
My eyes straying over the distant countryside
I murmured to myself,
When, great Gods, will a companion appear
To deliver me from the misery of all the pain
That overwhelms me today?
Yes! she will seem to me
Dainty, pretty, like a shepherdess,
Sweet charm, a fresh round chin,
Rounded arms, shapely legs
With a trim crinoline,
And a shape divine,
And lips of carmine.
Digue, dinguedi, dindigue, dindin
Oh! oh! the pretty chin.

I am going to stop at last, for I see that I am not really in the mood, alas!

Alas oh Muses! Weep, for your foster-child
Cannot even make up a short song.
Oh matric, terrible exam!
Examiners, oh horrible faces!
Were I to pass, oh joy indescribable.

Great Gods, I really don't know what I should do. Goodbye, my dear Zola, I keep rambling.

PAUL CÉZANNE

I have conceived the idea of a drama in 5 acts, which we shall entitle (you and I): 'Henry VIII of England'. We will do it together in the holidays.

*

[*Aix*] Wednesday, 17 November, 1858

TO EMILE ZOLA Excuse, friend, excuse me. Yes, I am guilty. However, for all sins, forgiveness. Our letters must have crossed, tell me when you next write – there is no need to put yourself out for that – if you did not receive a letter dated from my chamber, rhyming with the 14th November? . . .

I passed my matriculation, but you must know that from this same letter of the 14th, always providing that it reached you.

I wrote to Baille to give him the news, and to announce irrevocably and finally that I have passed matric. Heigh-ho!

P. CÉZANNE

*

Aix, 7 December, 1858

TO EMILE ZOLA

My dear, you did not tell me that your illness was serious, very serious. – You should have informed me; Monsieur Leclerc told me instead, but since you are well again, greetings! . . .

> Alas I have chosen the tortuous path of Law.
> – I have chosen, that's not the word, I was forced to
> choose!
> Law, horrible Law of twisted circumlocutions,
> Will render my life miserable for three years.
> Muses of Helicon, of Pindus, of Parnassus,
> Come, I beg you, to soften my disgrace.
> Have pity on me, on an unhappy mortal,
> Torn against his will away from your altar . . .

Did you not say on hearing, no on reading, these insipid verses that the muse of poetry has withdrawn from me for ever? Alas, this is what the accursed law has done.

Find out about the entrance exam for the Académie, because I persist in the intention which we had formed to compete at any price – provided it doesn't cost anything, of course . . .

I wish you a thousand and one good things, joys, pleasures; goodbye, my dear, greetings to Monsieur Aubert, to your parents; goodbye, I salute you.

Your friend, PAUL CÉZANNE

*

[*Aix*] 20 June, 1859

TO EMILE ZOLA

My dear, yes, my dear, it is really true what I said in my previous letter. I tried to deceive myself, by the dime of the pope and the cardinals, I have had a passionate love for a certain Justine who is really 'very fine', but as I have not the honour to be 'of a great beautiful' (sic!), she always turned her head away from me. When I cast my peepers towards her, she dropped her eyes and blushed. Now I thought I noticed that when we were in the same street, she made as it were a half-turn and dodged away without looking back. *Quanto à della donna* I am not happy, and yet I must say that I risk meeting her three or four times a day. And better still, my dear: one fine day a young man accosted me, he is a first-year student like myself, it is in fact Seymard, whom you know. 'My dear', he said, taking my hand, then hanging himself on my arm and continuing to walk towards the rue d'Italie: 'I am' – he continued – 'about to show you a sweet little thing whom I love and who loves me.' I confess that instantly a cloud seemed to pass before my eyes, I had, as it were, a presentiment that I didn't have a chance, and I was not mistaken, for, midday having just struck, Justine emerged from the salon where she works, and upon my word, the moment I caught sight of her in the distance, Seymard gave me a sign: 'There she is', he said. At this point I saw nothing more, my head was spinning, but, Seymard dragging me along with him, I brushed against the little one's frock . . .

Nearly every day since then I have seen her and often Seymard was following in her tracks . . . Ah! what dreams I have built up, and the most foolish ones at that, but you see, it's like this: I said to myself, if she didn't detest me we would go to Paris together, there I would make myself into an artist, we should be together. I said to myself, like that, we should be

happy. I dreamt of pictures, a studio on the fourth floor, you with me, then how we should have laughed! I didn't ask to be rich, you know what I'm like, me, with a few hundred francs I thought we could live contentedly, but by God, that was a great dream, that one, and now I who am so lazy, I am content only when I have had something to drink; I can scarcely go on, I am an inert body, good for nothing.

My word, old man, your cigars are excellent; I am smoking one while writing to you; they have the taste of caramel and barley sugar. Ah! but look, look, here she is, she, how she glides, she sways, yes, it is my little one, how she laughes at me, she floats on the clouds of the smoke, see, see; she rises, she falls, she frolicks, twirls round, but she is laughing at me. Oh, Justine, tell me at least that you do not hate me; she laughs. Cruel one, you enjoy making me suffer. Justine, listen to me, but she is fading away, she climbs, climbs, always climbs until at last she vanishes. The cigar falls from my mouth, and thereupon I fall asleep. For a moment I thought I was going mad, but thanks to your cigar, my mind is reasserting itself, another ten days and I shall think of her no longer, or else I shall see her only on the horizon of the past as a shadow of which I dreamed.

Oh dear! with what infinite joy would I clasp your hand. You see, your mamma told me that you would be coming to Aix towards the end of July. You know, if I had been a good high-jumper, I should have hit the ceiling, I jumped so high. Because really, for one instant I did think I was going mad, it was night, it was evening, and I thought I was going mad, but it was nothing, you understand. Only I had drunk too much and so before my eyes I saw spirits swaying round the tip of my nose, dancing, laughing, jumping about, enough to smash everything.

Goodbye, dear boy, goodbye,

P. CÉZANNE

*

Paris, 4 June, 1861

To JOSEPH HUOT

Oh, my good Joseph, so I am forgetting you *morbleu!* and our friends and *le bastidon* and your brother and the good wine of Provence; you know it is detestable, what you get here. I do not want to write an elegy in these few lines, yet, I must confess, my heart is not very gay. I fritter away my petty existence to right and to left. *Suisse* keeps me busy from six o'clock in the morning until eleven. I have some sort of a meal for 15 sous; it is not a lot; but what can you expect? I am not dying of hunger, anyway.

I thought that when I left Aix I should leave behind the boredom that pursues me. I have only changed place and the boredom has followed me. I have left my parents, my friends, some of my habits, that's all. Yet I admit that I roam about aimlessly nearly all day. I have seen, naive thing to say, the Louvre and the Luxembourg and Versailles. You know them, the pot-boilers which these admirable monuments enclose, it is stunning, shocking, knocks you over. Do not think that I am becoming Parisian . . .

I have also seen the Salon. For a young heart, for a child borne for art, who says what he thinks, I believe that is what is really best, because all tastes, all styles meet there and clash there. I could give you some beautiful descriptions and send you to sleep. Be grateful to me for sparing you.

I saw by Yvon a brilliant battle;
Pils in his drawing of a moving scene
Traces the memory in his stirring picture
And the portraits of those who lead us on a leash;
Large, small, medium, short, beautiful or of a worse kind.
Here there is a river; there the sun burns,
The rising of Phoebus, the setting of the moon,
Sparkling daylight, gloomy twilight.

(Here I am at the end of my rhymes, so I should do well to be silent for it would be a bold enterprise on my part to want to give you an idea, even the most meagre, of the style of this exhibition.) There are also some magnificent Meissoniers. I have seen nearly everything and I intend to go back again. It is worth my while.

As my regrets would be superfluous, I shall not tell you how sorry I am not to have you with me to see all this together, but, the devil, that's how it is . . .

A thousand respects from me to your parents; to you, courage, good vermouth, not too much boredom and *au revoir*.

Good-bye, dear Huot, your friend,

PAUL CÉZANNE

PS. – You have greetings from Combes, with whom I have just had supper. Villevieille has just made the sketch for a picture gigantic in size, four metres high, figures of two metres and more.

The great G. Doré has a magnificent picture at the Salon. Good-bye again, my dear; hoping to empty a heavenly bottle.

P. CÉZANNE
Rue d'Enfer 39

*

Paris, 5 January, 1863

TO NUMA COSTE

My dear, this letter which I address to you is meant for you and M. Villevieille at the same time. And first of all, I could have written to you a long time ago, because it is already two months since I left Aix.

Shall I talk to you about the fine weather? No. Only, the sun, until now hidden by clouds, has today just put its head through the garret window, and wanting to end this last day gloriously, throws us in departing a few pale rays.

I hope that this letter will find you all in good health. Courage and let us try to be together again in a little while.

As in the past (for it is right that I should tell you what I am doing), I go to [the Académie] Suisse in the morning from eight until one-o'clock and in the evening from seven to ten. I work calmly and eat and sleep that way too.

I go fairly often to see M. Chautard who has the kindness to correct my studies. The day after Christmas, I had supper with them and tasted the *vin cuit* that you sent them, oh Monsieur Villevieille, and your little girls, Fanny and Thérèse, are they well, at least I hope so, and all of you too? My respects, I beg you, to Mme Villevieille, to your father, to your sister, to you also. By the way, is the picture, of which I saw you doing the sketches, going well? I spoke to M. Chautard about it, he praised the idea of it and said that you should be able to

SKETCHBOOK STUDY — DRAPERY

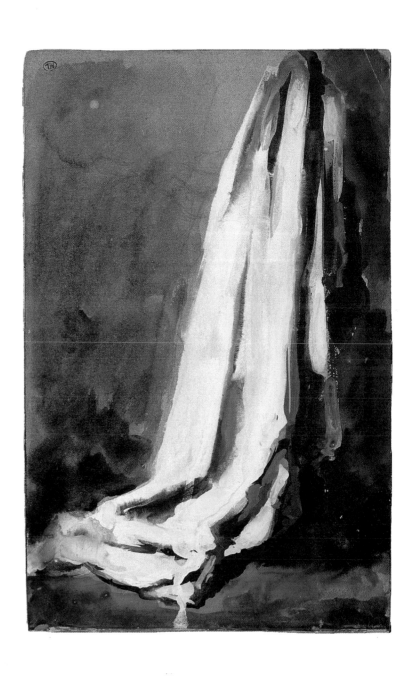

make something good of it . . .

It is now nearly a month since Lombard came back to Paris. I learned, not without sorrow, that he attends the Signol studio. This worthy gentleman makes them learn a certain hackneyed style which leads to doing just what he does himself; that's all very well, but not admirable. To think that a young intelligent man had to come to Paris to lose himself. However, the novice Lombard has made great progress . . .
I yearn for:

> The days when we went to the fields of the Torse
> To eat a good lunch, and palette in hand
> Traced on our canvas the landscape around . . .

I hope that this present letter which I did not finish at once will find you all in the best of health; my respects to your parents, bonjour to our friends; I shake your hand, your friend and colleague in painting,

PAUL CÉZANNE

*

Paris, 15 March, 1865

To Camille Pissarro

Forgive me for not coming to see you, but I am leaving this evening for St Germain and shall only come back on Saturday with Oller to take his pictures to the Salon, for he has painted, so he writes, a biblical battle-scene, I think, and the big picture which you know. The big one is very beautiful, the other I have not yet seen.

I should have liked to know whether, in spite of the misfortune that befell you, you have done your canvas for the Salon. – If sometimes you should wish to see me, I go every morning to Suisse and am at home in the evenings, but give me a rendezvous that suits you and I shall come and shake your hand when I return from Oller's. On Saturday we are going to the barrack of the Champs-Elysées to bring our canvases, which will make the Institute blush with rage and despair. I hope that you will have done some fine landscapes, and shake you warmly by the hand.

Paul Cézanne

*

Paris, 19 April, 1866

To M. de Nieuwerkerke
(Superintendent of the Beaux-Arts)

Sir, Recently I had the honour to write to you about the two pictures that the jury has just turned down.

As you have not yet answered me, I feel I must remain firm about the motives which led me to apply to you. Moreover, as you have certainly received my letter, there is no need for me to repeat the arguments that I thought necessary to submit to you. I content myself with saying again that I cannot accept the unauthorized judgement of colleagues to whom I myself have not given the task of appraising me.

I am therefore writing to you to insist on my petition. I wish to appeal to the public and to be exhibited at all costs. My wish appears to me not at all exorbitant and, if you were to interrogate all the painters who find themselves in my position, they would all reply that they disown the Jury and that they wish to participate in one way or another in an exhibition which would perforce be open to all serious workers.

Therefore let the Salon des Refusés be re-established. Even were I to be there alone, I should still ardently wish that people should at least know that I no more want to be mixed up with those gentlemen of the Jury than they seem to want to be mixed up with me.

I trust, Monsieur, that you will not continue to keep silent. It seems to me that every decent letter deserves a reply.

Please accept, I beg you, the assurance of my most distinguished sentiments.

Paul Cézanne
2, rue Beautreillis

To Emile Zola

I received the two letters you sent me in which were the 60 francs, for which I thank you very much because I am more unhappy than ever when I haven't a sou. So nothing amusing happens of which you do not speak at length in your last letter. Impossible to get rid of the *patron*. I don't know for certain which day I shall be leaving, but it will be Monday or Tuesday. I have done little work, the fête at Gloton was last Sunday the 24th, and the brother-in-law of the *patron* came, a whole heap of idiots. – Dumont will leave with me.

The picture is not going too badly, but a whole day passes very slowly; I ought to buy a box of watercolours to work during the time I do nothing to my picture. I am going to change all the figures in my pictures; I have already given Delphin a different posture – like a hair – he is like that, I think it is better. I am also going to alter the two others. I have added a bit of still life to the side of the stool, a basket with a blue cloth and some green and black bottles. If I could work at it a little longer it would go fairly quickly, but with scarcely two hours a day, it dries too rapidly, it is very annoying.

Really these people should pose for one in the studio. I have begun a portrait out-of-doors of old father Rouvel, which is not turning out too badly, but it must still be worked over, particularly the background and the clothes, on a canvas of 40, a little longer than one of 25.

Tuesday night and last night I went fishing, with Delphin, in the holes, I caught more than twenty at least in a single hole. I took six, one after the other, and once I got three at one go, one in the right and two in the left; they were rather beautiful. It's easier, all this, than painting, but it doesn't lead far.

My dear, *à bientôt*; and my respects to Gabrielle, as well as to you.

Paul Cézanne

*

To Emile Zola

For some days it has been raining in a determined way. Guillemet arrived on Saturday evening, he has spent some days with me and yesterday – Tuesday – he went to a small place, good enough, which costs him 50 francs a month, linen included. In spite of the driving rain the countryside is magnificent and we have done a bit of sketching. When the weather clears up he will start work seriously. For my part, idleness overwhelms me, for the last four or five days I have done nothing. I have just finished a little picture, which is, I believe, the best thing I have yet done; it represents my sister Rose reading to her doll. It is only one metre, if you like I will give it to you; it is the size of the frame of the Valabrègue. I shall send it to the Salon . . .

But you know all pictures painted inside, in the studio, will never be as good as those done outside. When out-of-door scenes are represented, the contrasts between the figures and the ground is astounding and the landscape is magnificent. I see some superb things and I shall have to make up my mind only to do things out-of-doors.

I have already spoken to you about a picture I want to attempt; it will represent Marion and Valabrègue setting out to look for a motif (a landscape motif of course). The sketch, which Guillemet considers good and which I did after nature, makes everything else fall down and appear bad. I feel sure that all the paintings by the old masters representing subjects out-of-

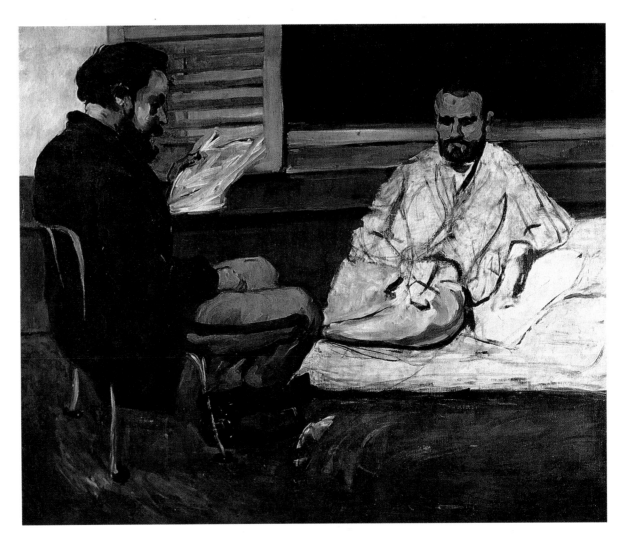

PAUL ALEXIS READING TO EMILE ZOLA

doors have only been done with skill [*chic*] because all that does not seem to me to have the true, and above all original, appearances provided by nature. Père Gibert of the museum invited me to visit the Musée Bourguignon. I went there with Baille, Marion, Valabrègue. I thought everything was bad. It is very consoling. I am fairly bored, work alone occupies me a little, I am less despondent when someone is there. I see no one but Valabrègue, Marion and now Guillemet . . .

But I repeat that I have a little attack of the blues, though for no reason. As you know, I don't know what it comes from, it comes back every evening when the sun sets, and now it is even raining. It makes me feel black . . .

Just imagine that I hardly read any more. I don't know whether you will be of my opinion, and that would not make me change mine, but I am beginning to see that art for art's sake is a mighty humbug; this *entre nous* . . .

P.S. For four days I have had this letter in my pocket and I feel the urge to send it to you; Goodbye, my dear,

PAUL CÉZANNE

*

[*Aix, 23 October, 1866*]

TO CAMILLE PISSARRO My dear friend, here I am with my family, with the most disgusting people in the world, those who compose my family stinking more than any. Let's say no more about it.

29

I see Guillemet every day and his wife, who have found quite good lodgings, Cours Ste-Anne 43. Guillemet has not yet started on big pictures, as a prelude he has begun with some small paintings which are very good. You are perfectly right to speak of grey, for grey alone reigns in nature, but it is terrifyingly hard to catch. The country here is very beautiful, much individual character, and Guillemet did a study yesterday and today in grey weather, which was most beautiful. His studies seem to me much freer than the ones he brought back from Yport last year. I am delighted with them. Anyway you will be able to judge better when you see them. I add nothing except that he is going to start a big picture as soon as possible, the moment the weather improves. In the next letter which we shall write to you there will probably be some good news about it.

I have just posted a letter to Zola.

I work a little all the time, but paints are scarce here and very expensive, misery, misery! Let us hope, let us hope, that we shall sell. We will sacrifice a golden calf then. You don't send anything to Marseille, well, neither shall I. I do not want to send again, all the more because I have no frames, and because it makes me spend money which it is better to devote to painting. I say this for myself, and damn the jury . . .

Give my kind regards to your family please, to Mme Pissarro and your brother.

PAUL CÉZANNE

*

Aix, towards the end of November [*1868*]
It is Monday evening.

TO NUMA COSTE

My dear Numa, I cannot tell you exactly the date of my return. But it will probably be during the first days of December, about the 15th. I shall not fail to see your parents before my departure and bring you whatever you want . . .

You have given me great pleasure by writing to me, for that rouses one from the lethargy into which one finally falls. The lovely expedition we were to have made to Ste-Victoire has fallen into the water this summer because of the excessive heat, and in October because of the rains; you can see from this what softness begins to spread in the willpower of the little comrades. But what can one do, that's how it is, it seems that one is not always fully responsive, in Latin one would say *semper virens*, always vigorous, or better, always strong-willed . . .

M. Paul Alexis, a boy who is, by the way, far superior and, one can safely say, not stuck-up, lives on poetry and other things. I saw him a few times during the fine weather, only quite recently I met him and told him of your letter. He is burning to go to Paris with paternal consent; he wants to borrow some money, mortgaged on the paternal cranium, and escape to other skies, drawn, by the way, by the great Valab[règue], who gives no sign of life. And Alexis thanks you for thinking of him, he does the same for you. I have scolded him for his laziness, he replied that if only you knew his difficulties (a poet must always be pregnant with some Iliad, or rather with a personal Odyssey) you would forgive him. Why don't you give him a prize for diligence or something similar? But I am in favour of forgiving him, for he read me some verses of poetry which give proof of no mean talent. He already possesses in full the skill of the trade. I clasp your hand from rather a long distance, whilst waiting to clasp from nearer, ever your old,

PAUL CÉZANNE

A questionnaire, *Mes Confidences*

1. Q: What is your favourite colour?
 A: *General harmony.*

2. Q: What is your favourite smell?
 A: *The smell of the fields.*

3. Q: What is your favourite flower?
 A: *Scabiosa.*

4. Q: What animal is most appealing to you?
 A: (No reply)

5. Q: What colour eyes and hair do you prefer?
 A: (No reply)

6. Q: What do you consider the most estimable virtue?
 A: *Friendship.*

7. Q: What vice do you detest most?
 A: (No reply)

8. Q: What work do you prefer?
 A: *Painting.*

9. Q: What leisure activity do you enjoy most?
 A: *Swimming.*

10. Q: What seems to you the ideal of earthly happiness?
 A: *To have* une belle formule.

11. Q: What seems the worst fate to you?
 A: *To be destitute.*

12. Q: May we ask how old you are?
 A: (No reply)

13. Q: What Christian name would you have taken if you had the choice?
 A: *My own.*

14. Q: What was the finest moment of your life?
 A: (No reply)

15. Q: What was the most painful?
 A: (No reply)

16. Q: What is your greatest aspiration?
 A: *Certainty*.

17. Q: Do you believe in friendship?
 A: *Yes*.

18. Q: What moment of the day do you find most agreeable?
 A: *The morning*.

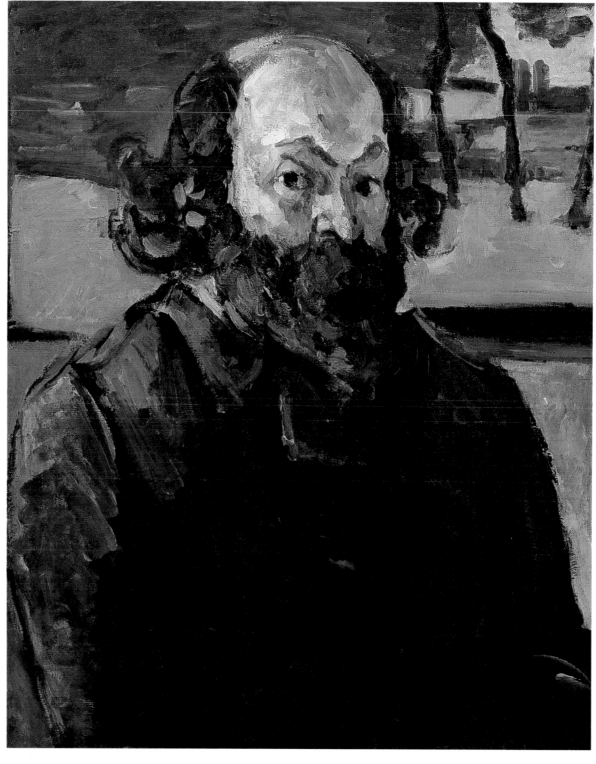

SELF-PORTRAIT

19. Q: What historical personage are you most drawn to?
 A: *Napoleon.*

20. Q: What character from literature or the theatre?
 A: *Frenhoffer* (sic).

21. Q: In what region would you like to live?
 A: *Provence and Paris.*

22. Q: What writer do you admire most?
 A: *Racine.*

23. Q: What painter?
 A: *Rubens.*

24. Q: What musician?
 A: *Weber.*

25. Q: What motto would you take if you had to have one?
 A: (No reply)

26. Q: What do you consider nature's masterpiece?
 A: *Her infinite diversity.*

27. Q: Of what place have you retained the pleasantest memory?
 A: *The hills of St Marc.*

28. Q: What is your favourite dish?
 A: *Les pommes de terre à l'huile.*

29. Q: Do you like a hard bed or a soft one?
 A: *In-between.*

30. Q: To the people of which foreign country are you most drawn?
 A: *To none.*

Autograph: Write one of your own thoughts or a quotation that you agree with.

Lord, you have made me strong and solitary
Let me sleep the sleep of the earth.
– De Vigny

STUDY OF NUDES DIVING

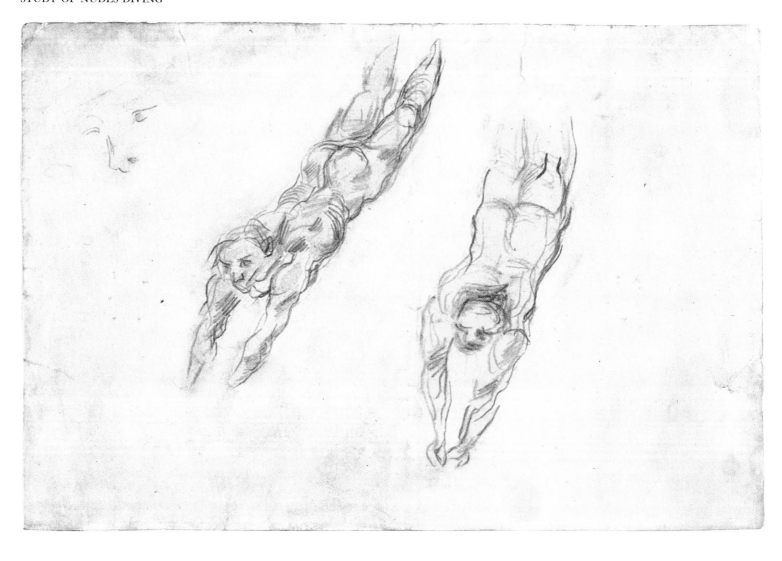

THE DIVER

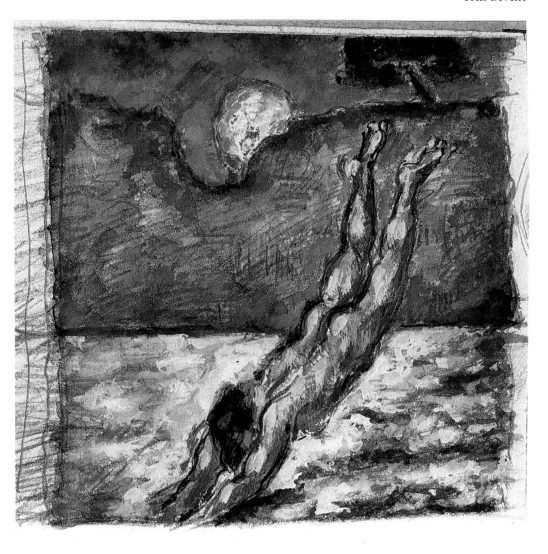

STUDY FOR 'L'AUTOPSIE'

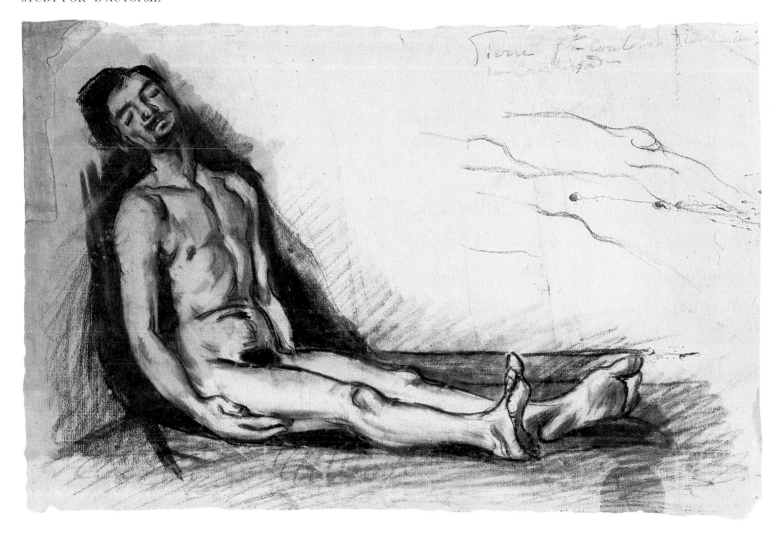

MALE NUDE LEANING ON HIS ELBOW

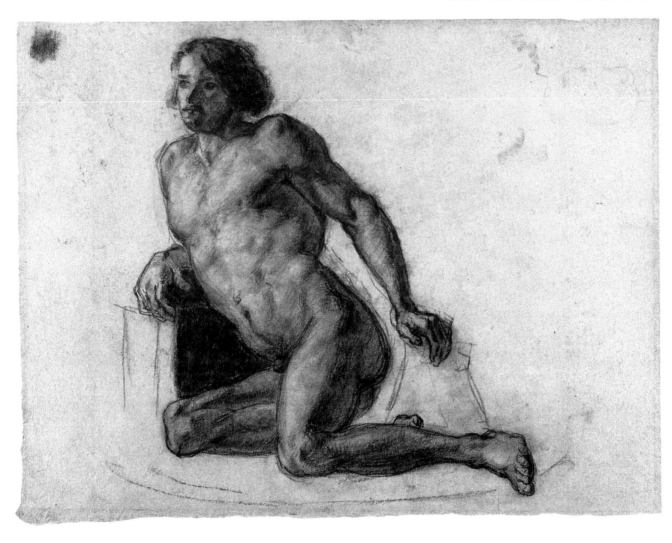

THE NEGRO SCIPIO

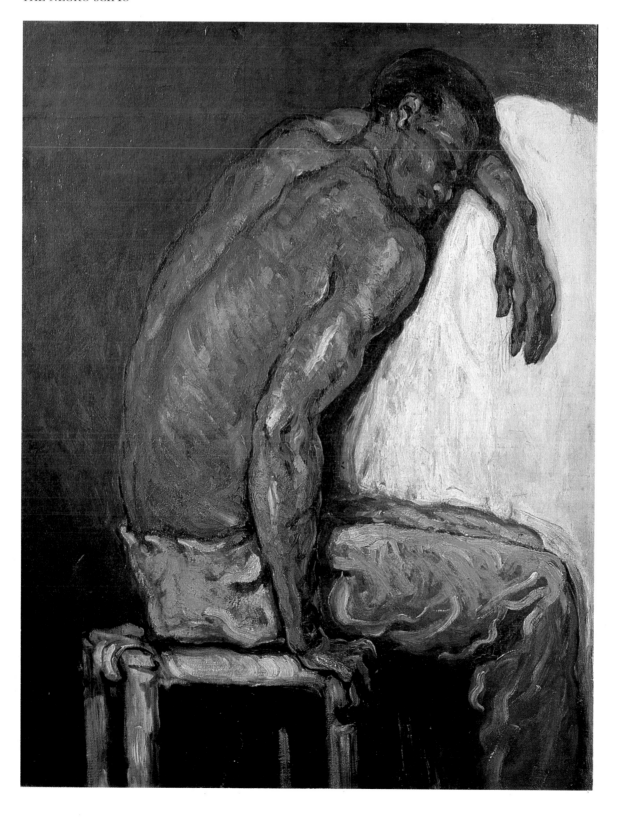

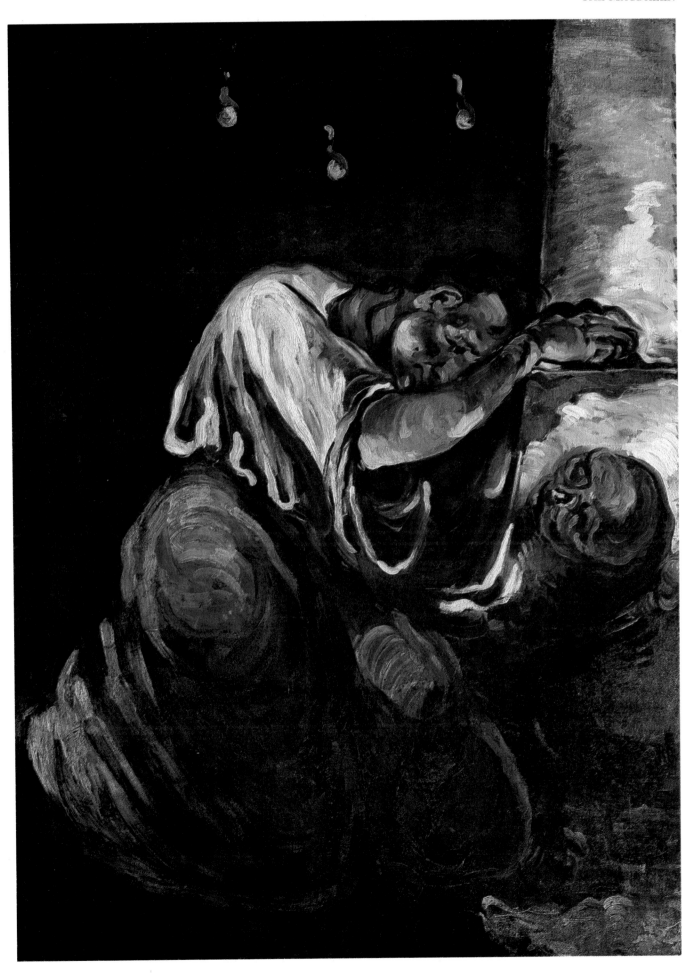

THE ARTIST'S FATHER

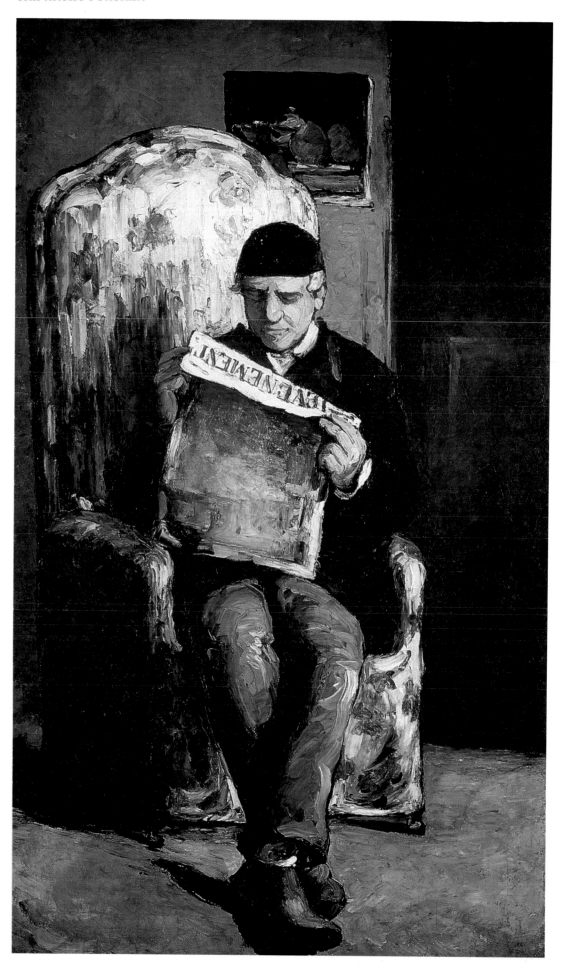

THE ARTIST'S FATHER, LOUIS-AUGUSTE CÉZANNE

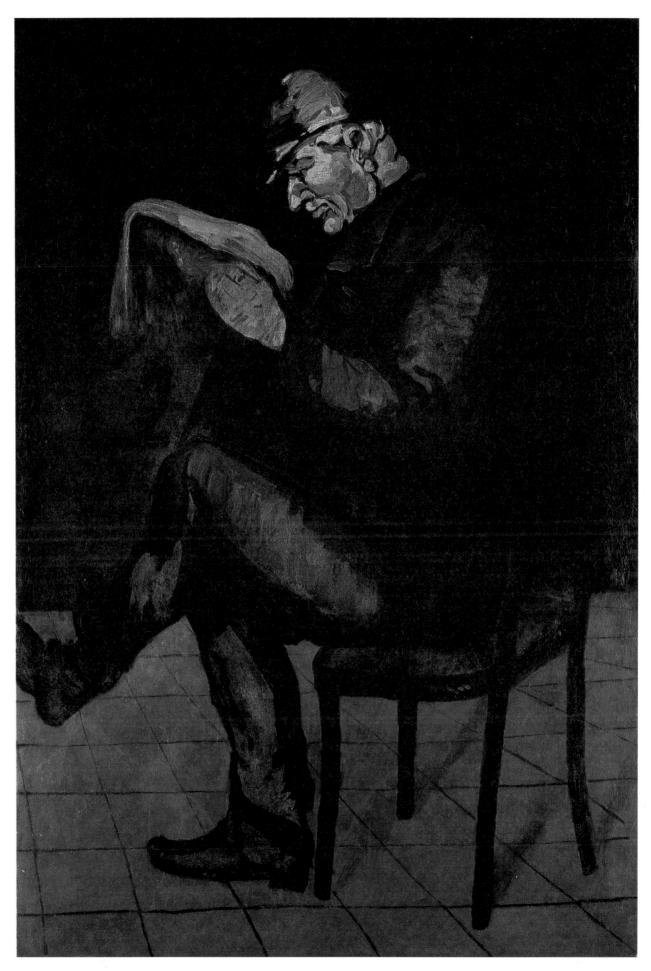

ACHILLE EMPERAIRE

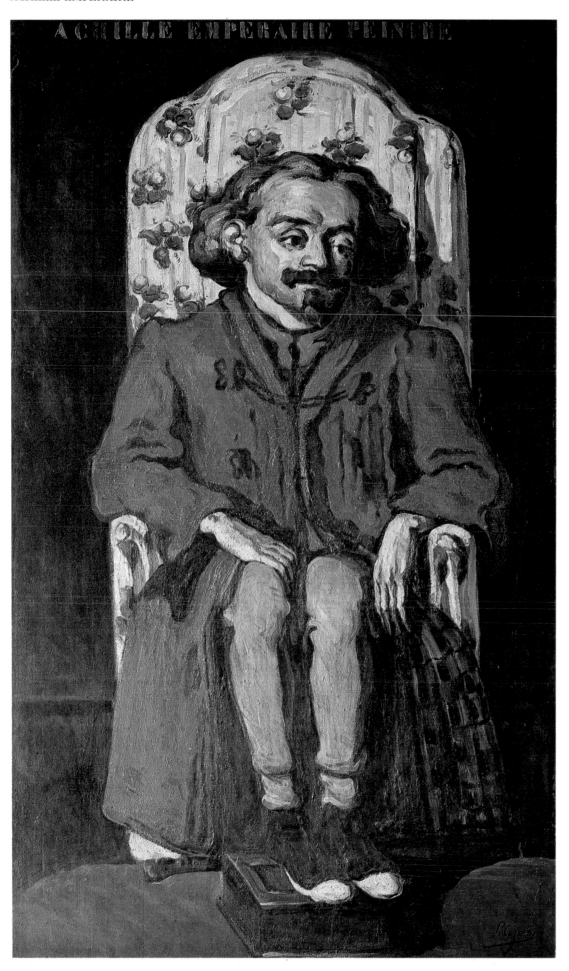

PORTRAIT OF ACHILLE EMPERAIRE

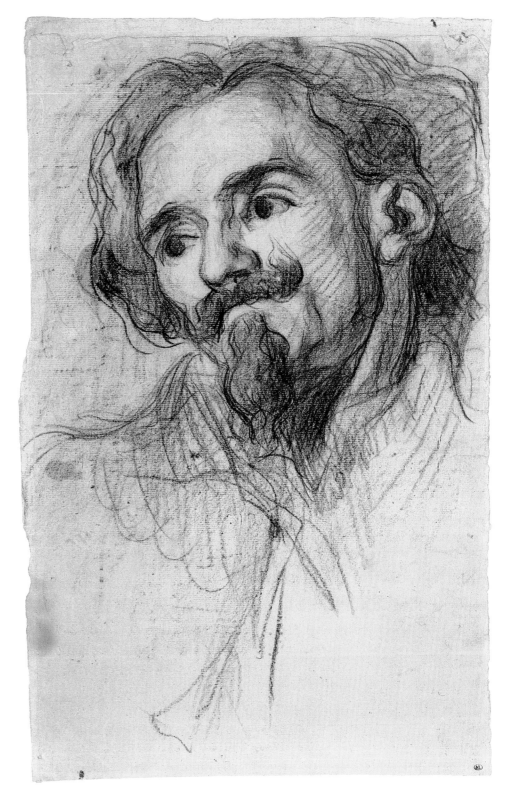

FORTUNÉ MARION

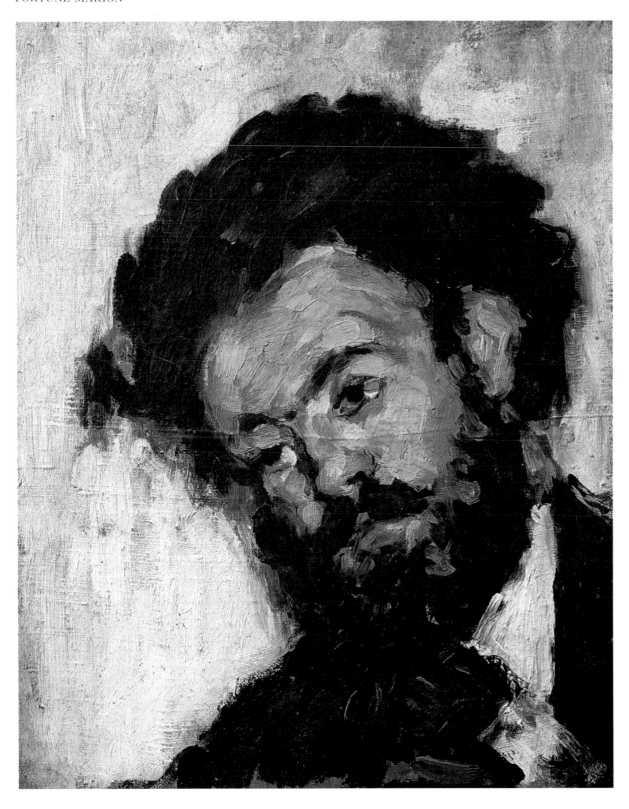

45

ANTHONY VALABRÈGUE

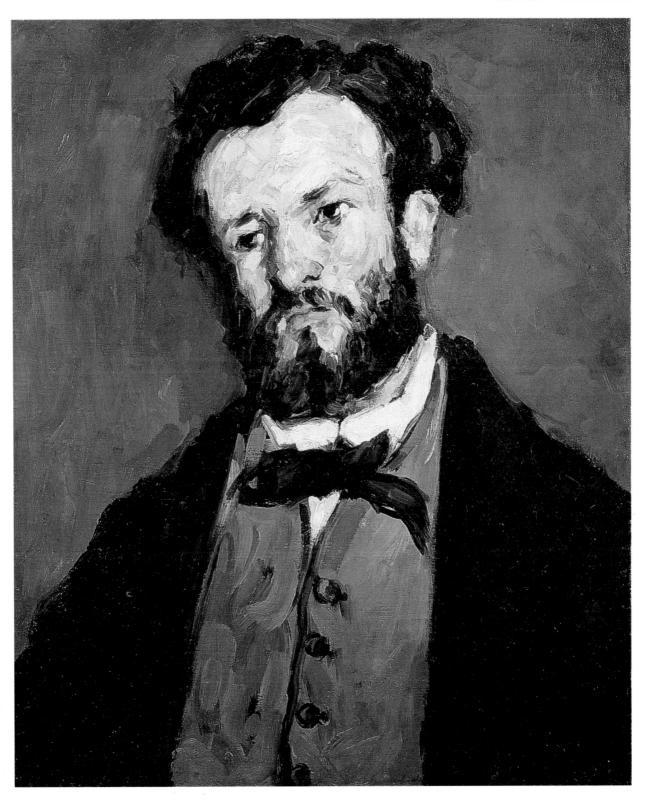

THE DANCE

PASTORALE

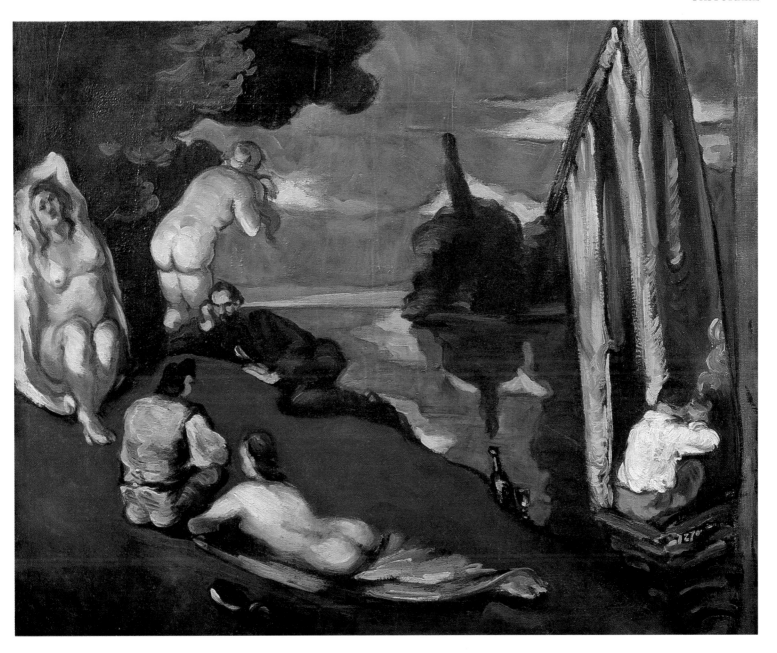

STILL LIFE WITH BOTTLE, FRUIT AND POTTERY

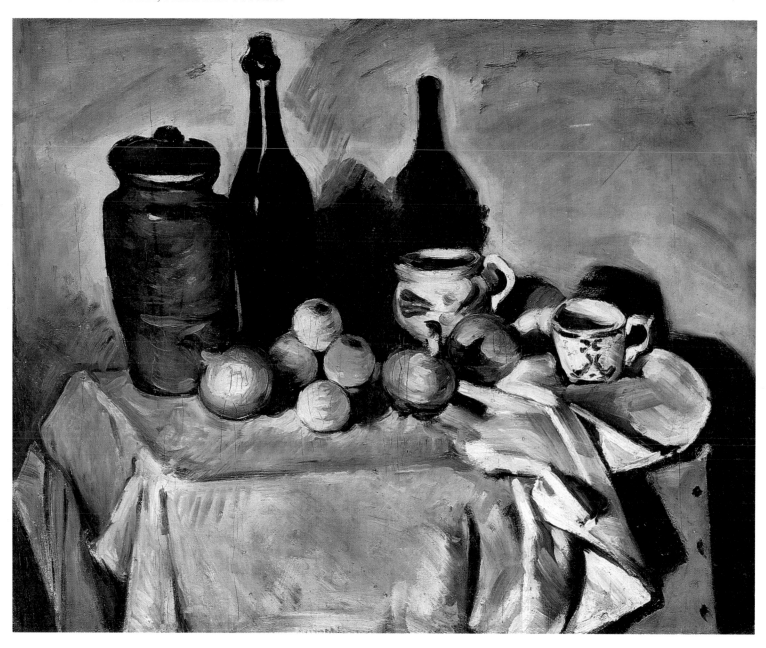

GREEN APPLES

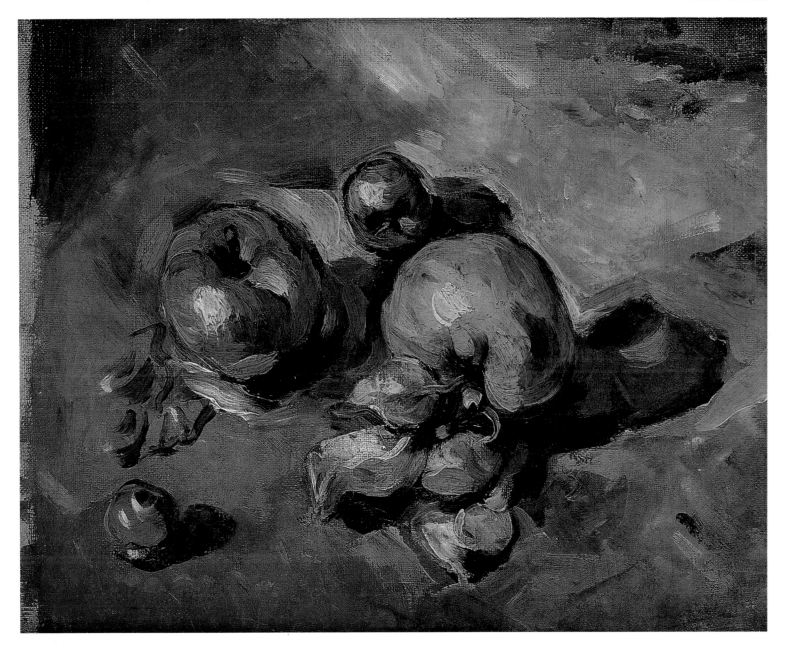

HOUSE IN PROVENCE

L'ESTAQUE UNDER SNOW

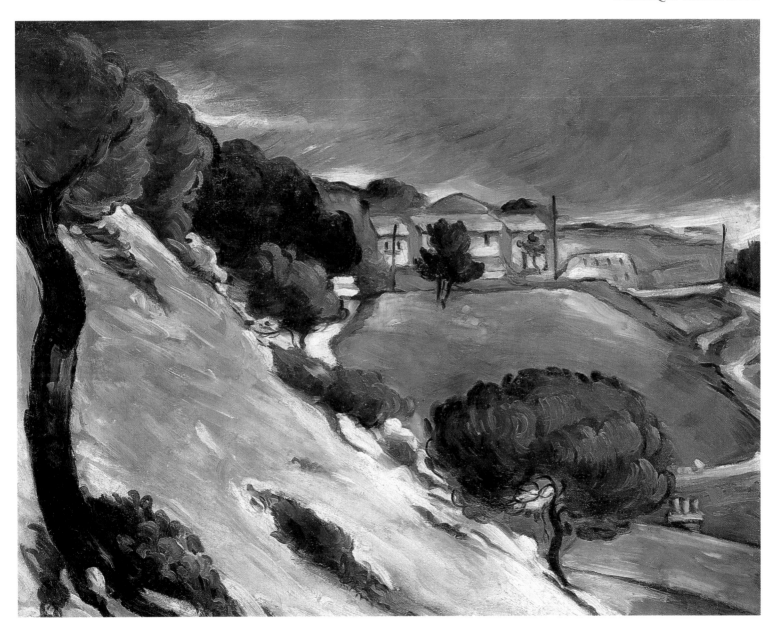

THE HOUSE OF THE HANGED MAN

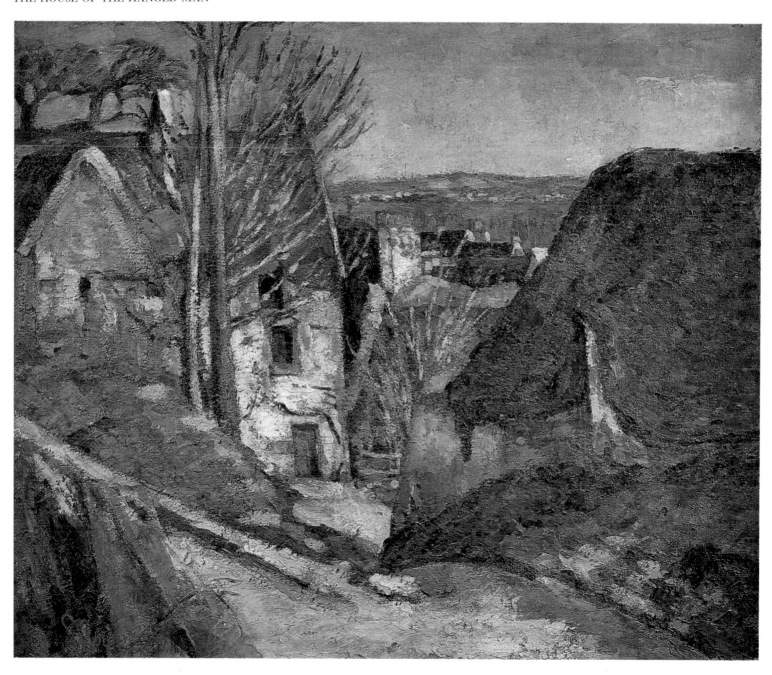

LANDSCAPE, AUVERS

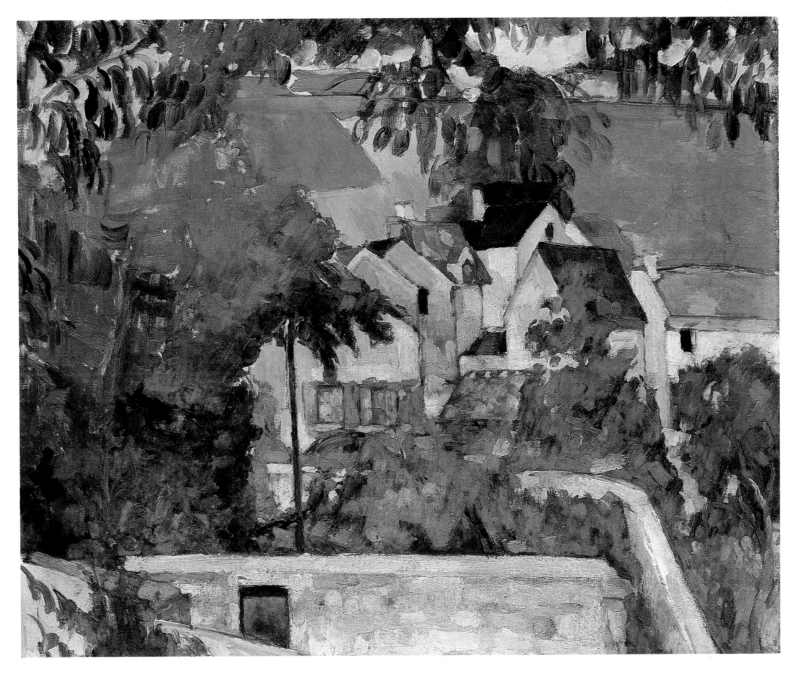

The Years of Impressionism, 1874–1886

Cézanne's association with Impressionism was a brief and unsatisfactory one, a marriage of convenience rather than a true affair of the heart. Initially, he welcomed the opportunity to exhibit his pictures in the company of some of the artists he knew and respected, such as Pissarro, Renoir and Monet. He also shared a number of their views, including their resentment of the government-controlled exhibition system, a preference for contemporary subject-matter and a dislike of the highly polished and drearily coloured traditional 'machine' or exhibition picture. His experience of the Impressionist exhibitions of 1874 and 1877, however, soured some of his personal relationships and brought him little but abuse from critics and public. Always a highly strung individual, given to dark depressions and irrational outbursts of anger with even his most loyal friends, Cézanne declined to contribute to the remaining exhibitions, perhaps more sensitive than ever to the idiosyncrasy of his vocation and about his own independence of mind. No longer associated formally with the Impressionist group, he did, however, continue to visit their exhibitions and maintain contact with some of the artists, writing frank and affectionate letters to Pissarro and even arranging to paint with Renoir in Provence.

Writing to Zola in 1883, Cézanne announced that he had rented a little house at L'Estaque and added: 'I am still busy painting. I have here some beautiful views but they do not quite make motifs.' L'Estaque was a small village overlooking the gulf of Marseilles, where Cézanne found the rocks, the pine trees and the views across the Mediterranean that feature so often in his paintings and drawings. Cézanne's use of the word 'motif' is instructive in this context. A 'beautiful view' might satisfy the need for elegant colour or subtle effects of natural light, but a 'motif' demanded something more taxing, more unified. One of his paintings from this site, Rocks at L'Estaque (Sao Paolo Museum of Art) shows the characteristic articulation of planes from foreground to distance, the balance of horizontals and verticals against complementary diagonals, and the rich variation of density and texture that Cézanne required from a 'motif'. The slightly later View of L'Estaque (Fitzwilliam Museum, Cambridge) is even more ambitiously conceived, adding the entire spectrum of colour from warm terracotta roof-tiles to the distant violet-blue of the sea to an already elaborate structure of trees, houses and foliage. Both pictures are anxiously considered, the 'motif' scrutinized, analysed and reassembled on the canvas in the kind of painstaking way that had already set Cézanne apart from many of his former Impressionist colleagues.

Another attraction of his retreats at L'Estaque was that Cézanne was able to escape from the continuing friction with his family. Some of the letters from this period concern the artist's attempts to reassure his parents about his chosen career or to outwit the manoeuverings of his suspicious father. Extraordinary though it may seem, for more than a decade Cézanne was able to conceal from his father his relationship with Hortense Fiquet and the fact that they had a son, Paul. He did so, perhaps, in the fear that his allowance would be discontinued. Cézanne lived with his own family only sporadically, preferring the solitary life of a Paris studio or his L'Estaque cottage, but he was always ready to use his relations as models when the occasion arose. His numerous portraits of Hortense are some of the most delicate and finely inflected of his career, and the gradually unfolding series of studies of Paul, in which the chubbiness of childhood gives way to the leaner lines of adolescence, is one of the most irresistible of Cézanne's creations.

The domestic tensions and private uncertainties of Cézanne's career are never far from the surface of his art, even in the apparently tranquil landscapes and meticulously constructed still lifes. The sense of 'anxiety'

that Picasso so much admired in Cézanne animates the innocent brushmark as well as the most complex pictorial construction, and in some of the imagery that persists into this period it is expressed in the most explicit form. The sketchbook drawing Boy Beset by Rats *(Art Institute of Chicago) is one of the most uncomfortable subjects in his or any other artist's work, and the* Bather with Raised Arm *(private collection, Switzerland), an image which recurs in drawings, sketchbooks and paintings, appears to have carried some sexual or symbolic significance for the artist. Even the extensive series of* Bathers, *which continued to preoccupy Cézanne until the end of his career, is not without its mysteries. While some of the pictures of bathing males may look back nostalgically to his schooldays, the groups of naked women are evidently more fanciful. Part of Cézanne's mind seems to have been on the great nude subjects of Rubens or Michelangelo, part on the reinvention of classical symbolism within a plausible modern setting, and yet another part on a private erotic Utopia of his own.*

The responses of Cézanne's contemporaries to the paintings of this period are not well documented, though one or two courageous collectors, such as Victor Chocquet, befriended the artist and began to acquire his work. Tales had already begun to circulate about the temperamental Provençal who spent days analysing a plate of apples, breaking down the colours, tones and forms into a series of painted relationships. Cézanne's 'constructive stroke', built up systematically into groups of parallel brushmarks, was later to influence a younger generation of artists (amongst them Gauguin), but at this point it was without precedent. His abhorrence of all kinds of refinement or superficial 'finish' led him to stress the mechanics of the picture, emphasizing texture and the interplay of colours on the surface of the canvas. While a painting like Mountains in Provençe *(National Gallery, London) echoes the rhythms of the perceived landscape in its carefully orchestrated curves and intervals, it frankly declares itself to be 'a harmony parallel with nature'.*

In the early 1880s Cézanne's letters to Zola made few references to his painting, and their relationship appears to be that of increasingly distanced friends. Cézanne regularly acknowledged the receipt of Zola's latest publications and even arranged to visit the stage production of Zola's novel 'L'Assommoir' in Paris, noting without apparent irony that he had managed to stay awake throughout the whole performance. In one of his letters he records the astonishment of an acquaintance who had discovered Cézanne's friendship with the celebrated novelist, but his own persistent obscurity must have strained what little intimacy still remained. The careers of the two boyhood friends had steadily grown apart, and Zola's new affluence and notoriety, as well as his increasingly unsympathetic attitude to contemporary painting, all contributed to their final estrangement in 1886.

HOUSE OF PÈRE LACROIX

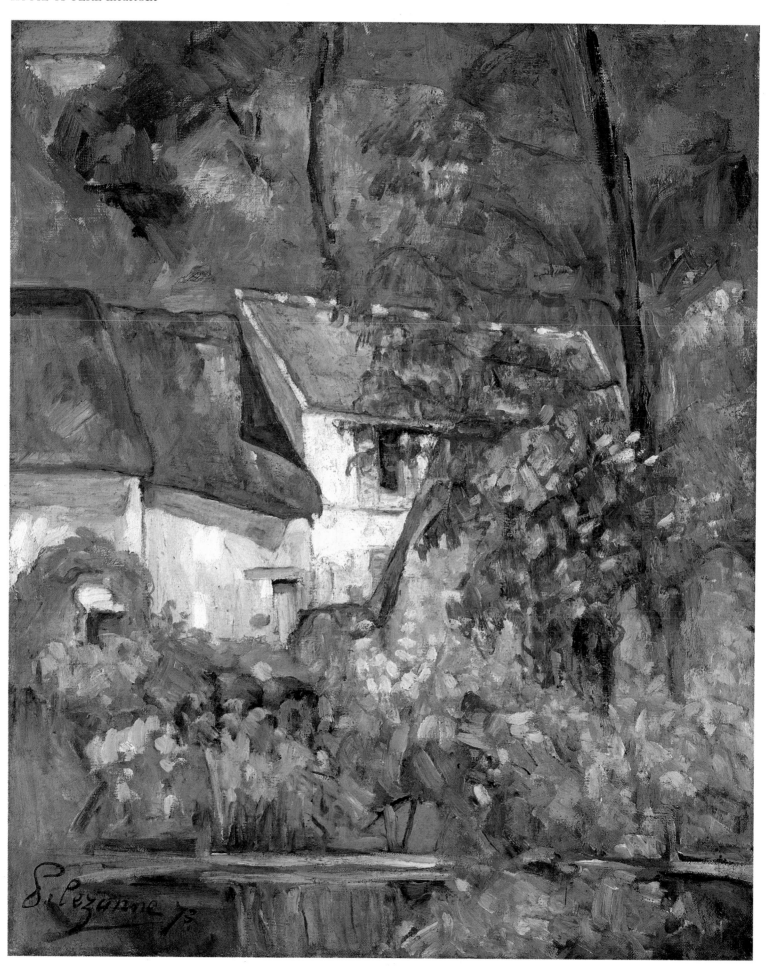

HOUSE OF PÈRE LACROIX

[*Auvers-sur-Oise, beginning of the year 1874*]
[*Draft*]

To a Collector at Pontoise In a few days I shall be leaving Auvers to settle down in Paris. I am therefore taking the liberty of recalling myself to your memory. If you wish me to sign the picture you spoke to me about, please have it sent to M. Pissarro where I shall add my name.

 With kindest regards

<p style="text-align:center">*</p>

[*Probably Paris, about 1874*]
[*Draft*]

To the Artist's Parents You ask me in your last letter why I am not yet returning to Aix. I have already told you in that respect that it is more agreeable for me than you can possibly think to be with you, but that once at Aix I am no longer free and when I want to return to Paris this always means a struggle for me; and although your opposition to my return is not absolute, I am very much troubled by the resistance I can feel on your part. I greatly desire that my liberty of action should not be impeded and I shall then have all the more pleasure in hastening my return.

 I ask Papa to give me 200 francs a month; that will permit me to make a long stay in Aix, and I shall be very happy to work in the South where the views offer so many opportunities for my painting. Believe me, I do really beg Papa to grant me this request and then I shall, I think, be able to continue the studies I wish to make.

 Here are the last two receipts.

<p style="text-align:center">*</p>

[*Aix*] 24 June, 1874

To Camille Pissarro Thank you for having thought of me while I am so far away and for not being angry that I did not keep my promise to come and see you at Pontoise before my departure. I painted at once after my arrival, which took place on a Saturday evening at the end of the month of May. And I can well understand all the misfortunes which you have to go through. You really have no luck – always illness at home; however, I hope that when this letter reaches you, little Georges will be well again. By the way, what do you think of the climate of the country in which you are living? Are you not afraid that it will affect the health of your children? I am sorry that fresh circumstances have arisen to keep you from your work again, for I well know what privation it is for a painter to be unable to paint. – Now that I have seen this country again I really believe that it will satisfy you completely, for it recalls in a most amazing way your study of the railway barrier painted in full sunshine in the middle of summer.

 For some weeks I was without news of my little boy and I was very worried, but Valabrègue has just arrived from Hortense telling me that he is not doing badly.

 From the papers I learned of Guillemet's great success and of the happy event of Groseillez, who has had his picture bought by the administration, after it had been given a medal. Well, this proves that if one follows the path of virtue one is always rewarded by man, but not by art.

I should be happy if you could give me news of Mme Pissarro after the birth, and if you could let me know whether there are fresh recruits at the Société Coop. But naturally you must not let this interfere in any way with your work.

When the time approaches, I shall let you know about my return and what I have been able to get out of my father, but he will let me return to Paris. – That is already a great deal. – Recently I saw the director of the Musée d'Aix who, driven by a curiosity fed by the Paris papers, which mentioned the Cooperative, wished to see for himself how far the menace to painting went. But at my protestations that, after seeing my productions, he would not have a very good idea of the progress of the evil, and that it would be necessary to see the works of the big criminals of Paris, he replied: 'I shall be well able to form an idea of the dangers which painting runs when I see your *attentats*.' – Whereupon he came and when I told him, for instance, that you replaced modelling by the study of tones, and was trying to make him understand this in nature, he closed his eyes and turned his back. – But he said he understood and we parted, each satisfied with the other. But he is a decent fellow who urged me to persevere, because patience is the mother of genius, etc.

I nearly forget to tell you that mother and father send you their affectionate greetings.

A word to Lucien and Georges, kiss them both for me. My best regards and thanks to Mme Pissarro for all your goodness to me during our stay at Auvers. A firm handclasp for you, and if wishes were calculated to make things go well, you may be sure that I would not fail to make them. Ever your

PAUL CÉZANNE

*

[*Paris*] 26 September, 1874

To the Artist's Mother I have first of all to thank you very much for thinking of me. For some days the weather has been beastly and very cold. – But I don't suffer in any way and I make a good fire . . .

Pissarro has not been in Paris for about a month and a half; he is in Brittany, but I know that he has a good opinion of me, who has a very good opinion of myself. I am beginning to consider myself stronger than all those around me, and you know that the good opinion I have of myself has only been reached after serious consideration. I have to work all the time, not to reach that final perfection which earns the admiration of imbeciles. – And this thing which is commonly appreciated so much is merely the effect of craftsmanship and renders all work resulting from it inartistic and common. I must strive after perfection only for the satisfaction of becoming truer and wiser. And believe me, the hour always comes when one breaks through and has admirers far more fervent and convinced than those who are only attracted by an empty surface.

It is a very bad time for selling, all the bourgeois jib at letting go of their sous, but this will end.

My dear Mother, remember me to my sisters . . .

Ever your son,

PAUL CÉZANNE

*

[*Aix*] April, 1876

TO CAMILLE PISSARRO Two days ago I received a large number of catalogues and newspapers dealing with your exhibition at Durand-Ruel. – You must have read them. – Among other things I saw a long slating attack by Sieur Wolff. It is Monsieur Chocquet to whom I owe the pleasure of hearing this news.

I have also learned from him that Monet's *La Japonaise* was sold for 2000 francs. According to the papers it seems that Manet's rejection at the Salon has made a sensation, and that he now exhibits in his own house . . .

We have just had a very watery fortnight. I am much afraid that this weather has been general. Here with us the frost has been so severe that all the fruit and vine harvest is lost. But behold the advantage of art, painting remains.

I almost forgot to tell you that a certain letter of rejection has been sent to me. This is neither new nor astonishing. – I wish you fine weather and, if this is possible, a good sale.

Please give my kindest regards to Mme Pissarro and my love to Lucien and your family. With a warm handclasp,

PAUL CÉZANNE

*

L'Estaque, 2 July, 1876

TO CAMILLE PISSARRO I am forced to reply to the charm of your magic crayon with an iron point (that is, with a metal pen). If I dared I should say that your letter bears the marks of sadness. Pictorial business does not go well; I am much afraid that your morale is coloured slightly grey by this, but I am convinced that it is only a passing thing.

How much I should like not always to talk of impossibilities and yet I always make plans which are most unlikely to come true. I imagine that the country where I am would suit you marvellously. – There are some famous vexations but I think they are purely accidental. This year it rains two days out of seven every week. That's unbelievable in the Midi. – It's unheard of.

I must tell you that your letter surprised me at Estaque on the sea shore. I am no longer at Aix, I left a month ago. I have started two little motifs with the sea, for Monsieur Chocquet, who had spoken to me about them. – It's like a playing-card. Red roofs over the blue sea. If the weather becomes favourable I may perhaps carry them through to the end. Up to now I have done nothing. – But there are motifs which would need three or four months' work, which would be possible, as the vegetation doesn't change here. The olive and pine trees always keep their leaves. The sun here is so tremendous that it seems to me as if the objects were silhouetted not only in black and white, but in blue, red, brown and violet. I may be mistaken, but this seems to me to be the opposite of modelling . . . As soon as I can, I shall spend at least a month in these parts, for one must do canvases of two metres at least, like the one by you sold to Faure.

If we were to exhibit with Monet, I should hope that the exhibition of our cooperative would be a flop – you will think me a beast, perhaps, but one's own affairs first, before everything else. – Meyer, who has not the elements of success in his hands with the cooperative, seems to me to become a bloody stick, who tries, by postponing the date of the Impressionist exhibition, to harm it – he might tire public opinion and bring about confusion.

PISSARRO GOING OFF TO PAINT

PISSARRO GOING OFF TO PAINT

– In the first place, too many successive exhibitions seem to me bad, on the other hand people who may think they are going to see the Impressionists will see nothing but cooperatives . . .

My dear friend, I shall conclude by saying as you that since there is a common aim amongst some of us, let us hope that necessity will force us to act together and that self-interest and success will strengthen the ties that goodwill, as often as not, was unable to consolidate. – Lastly, I am very pleased that Monsieur Piette is on our side. – Remember me to him, my best regards to Madame Piette and to Madame Pissarro, my love to all the family, a firm handclasp for you and fine weather . . .

Ever your,

<div align="right">PAUL CÉZANNE</div>

If the eyes of the people here could flash murder I should have been done for long ago. My head doesn't suit them.

<div align="right">P.C.</div>

<div align="center">*</div>

<div align="right">[Paris] Saturday morning [10] September [1876]</div>

TO THE ARTIST'S PARENTS

My dear Parents, I am writing to you to give you my news and to receive yours in return. I am well and I hope that you can assure me of the same on your part.

I went to Issy (-les-Moulineux) to see my friend Guillaumin. I found him there and dined with him last Wednesday. – I learned from him that the exhibition organized by the painters of our society last April went very well. – The rent of the premises where the exhibition took place, rue Lepeletier and rue Laffite (one enters through a door in the rue Lepeletier and leaves by another in the rue Laffitte), amounted to 3000 francs. Only 1500 francs were paid and the landlord had to raise the other 1500 francs from the entrance fees. Not only were all the 3000 francs paid, but also the 1500 francs advanced by the artists in equal shares were repaid to them, plus a dividend of 3 francs, which, it is true, does not amount to very much. So this a good beginning. And already the artists of the official exhibition, learning about this small success, have turned up to rent the room, but it had been retained for next year by the exhibitors of this year.

According to what Guillaumin had told me, I am one of the three new members who are to take part in it, and I have been very hotly defended by Monet when, at a reunion dinner, which took place after the exhibition, a certain Lepic had spoken against my admission.

I have not yet been able to go and see Pissarro nor the other people I know, as I started painting immediately on the morning after my arrival . . .

<div align="center">*</div>

PORTRAIT OF DR GACHET

Thursday morning, 5 October [*1876*]

To Doctor P. F. Gachet My dear Doctor, I suffer at the moment from a rather
heavy headache, which does not allow me to accept your invitation.

Please allow me to excuse myself. Guillaumin, whom you will see tonight, and with whom I
was yesterday, Wednesday, in Issy, will be able to tell you about my attack.

I would have cut rather a wretched figure at this pleasant party, although I would have
been most happy to take part if only this stupid vexation hadn't prevented me.

I can assure you that I regret this very much indeed.

Always yours,

P. Cézanne

*

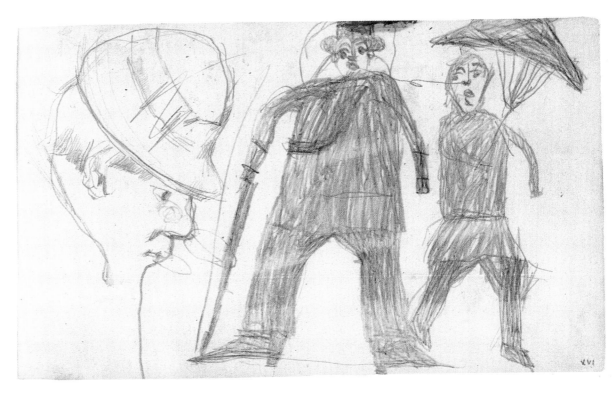

HEAD OF A MAN IN PROFILE AND TWO FIGURES BY THE ARTIST'S SON

<div align="right">

[*Paris*] 24 August, 1877

</div>

TO EMILE ZOLA My warmest thanks for your kindness to me. May I ask
you to tell my mother that I do not need anything, for I am thinking of spending the winter at
Marseille. If, when December comes, she will undertake to find me a tiny apartment of two
rooms in Marseille, not expensive but yet in a district where there are not too many
assassinations, she will give me great pleasure. She could have a bed brought there and what is
necessary for sleeping, two chairs that she can take from her house in l'Estaque to avoid
unnecessary expense. – About the weather here, I must tell you, the temperature is often
refreshed by pleasant showers.

I go every day to the park d'Issy where I do some studies. And I am not too dissatisfied,
but it appears that profound desolation reigns in the Impressionist camp. Gold is not exactly
flowing into their pockets and the pictures dry out where they are. We are living in very
troubled times and I do not know when unhappy painting will regain a little of its lustre . . .

Are the sea baths beneficial to Madame Zola, and you yourself, do you strike out through
the salty waves? I send all of you my respects, and clasp your hand cordially. Au revoir then
after your return from the sunny shores.

Grateful for your kindness, I am your painter,

<div align="right">

PAUL CÉZANNE

</div>

<div align="center">

*

</div>

[*l'Estaque*] 23 March, 1878

To Emile Zola I find myself very near to being forced to obtain for myself the means to live, always provided that I am capable of doing so. The situation between my father and me is becoming very strained and I am threatened with the loss of my whole allowance. A letter that Monsieur Chocquet wrote to me and in which he spoke of Madame Cézanne and of little Paul, has definitely revealed my position to my father, who by the way was already on the watch, full of suspicion and who had nothing more urgent to do than to unseal and be the first to read the letter although it was addressed to: *Mons. Paul Cézanne – artiste peintre.*

I therefore appeal to your goodwill towards me to try in your circle of friends and through your influence to get me in somewhere, if you consider that possible. All is not yet completely broken between my father and myself, but I think that not a fortnight will pass without my situation becoming absolutely clear.

Write to me (addressing your letter to M. Paul Cézanne, poste restante), whatever decision you may take with regard to my request.

Kindest regards to Madame Zola and a firm handclasp for you. I am writing from l'Estaque, but am returning to Aix this evening.

PAUL CÉZANNE

*

[*Aix*] 28 March [*1878*]

To Emile Zola I think as you do that I should not too hastily renounce the paternal allowance. But judging by the traps that are laid for me and which so far I have managed to avoid, I forsee that the great discussion will be the one concerning money and about the uses I must put it to. It is more than probable that I shall not receive more than 100 francs from my father, even though he promised me 200 when I was in Paris. I shall therefore have to recourse to your kindness, all the more so because my little boy has been ill with an attack of paratyphoid fever for the last fortnight. I am taking all precautions to prevent my father from gaining absolute proof.

Forgive me for the following remark: but the paper of your envelope and notepaper must be heavy: at the post I had to pay 25 cent. for insufficient stamping – and your letter contained only one double sheet. When you write to me would you mind only putting in one sheet folded in two?

If therefore, my father does not give me enough, I shall appeal to you in the first week of next month, and I shall give you Hortense's address to whom you will be kind enough to send it.

Remember me to Madame Zola and a handclasp for you.

PAUL CÉZANNE

An exhibition of the Impressionists' will probably take place; if so I shall ask you to send the still life that you have in your dining room. I received a summons in this matter for the 25th of this month, rue Lafitte. – I didn't go, naturally.

Has *Une Page d'Amour* come out yet?

*

[*Aix*] Wednesday evening, 1878

TO EMILE ZOLA

My warmest thanks to you for having sent me your last book and for the dedication. I haven't yet got very far in reading it. – My mother is extremely ill and has been in bed for ten days, her condition is most serious. – I stopped reading at the end of the description of the sun setting over Paris and of the development of the mutual passion between Hélène and Henri.

It is not for me to praise your book, for you could reply, like Courbet, that the conscientious artist addresses to himself praise far more just than that which comes to him from without. So what I am telling you about it, is merely to explain what I have been able to perceive of the work. It seems to me that it is a picture more delicately painted than the preceding one, but the temperament or creative force is always the same. And then – if this is not heresy – the progress of the passion between the heroes is very finely graded. Another observation which seems to me just, is that the places, through their descriptions, are impregnated with the passion that moves the characters, and through this, form more of a unity with the actors and are less dissociated from the whole. They seem to become animated, to participate as it were in the sufferings of the living beings. – Furthermore, according to the notices in the papers, it will be at least a literary success.

A handclasp for you and please give my regards to Mme Zola.

PAUL CÉZANNE

You will no doubt notice that my letters are not actually answers to yours, but this is because I often write before having read yours, as I am unable to go to the post regularly.

P.C.

*

[*Aix*] 4 April, 1878

TO EMILE ZOLA

I beg of you to send 60 francs to Hortense at the following address: Mme Cézanne, rue de Rome 183, Marseille. In spite of the sacredness of treaties I was unable to obtain more than 100 francs from my father, and I even feared that he would give me nothing at all. He has heard from various people that I have a child, and he is trying to surprise me by all possible means. He wants to rid me of it, he says. – I shall add nothing further. – It would take too long to try and explain the good man to you, but with him appearances are deceptive, you can take my word for it. – If you can write to me, as soon as possible, you will give me pleasure. I am going to try to go to Marseille, I escaped on Tuesday, a week ago, to go and see my little boy; he is better, and I was forced to walk back to Aix seeing that the train given in my railway guide was wrong, and I had to be home for dinner. – I was an hour late.

My respects to Mme Zola and a handclasp for you.

PAUL CÉZANNE

*

[*Aix*] May, 1878

TO EMILE ZOLA Since you are kind enough to come to my assistance I shall ask you to send 60 francs to Hortense, at the same address, 183, rue de Rome.

Thank you in advance, I can quite understand that at this moment you must be fully occupied with your new book, but later when you are able, you would be doing me a great favour if you would tell me about the artistic and literary situation. In this way I shall be still further removed from the provinces and nearer to Paris.

With many thanks, please give my regards to Mme Zola.

PAUL CÉZANNE

*

[*Aix*] 8 May, 1878

TO EMILE ZOLA Thank you for sending again. I can assure you that it is a great service to me and frees me from anxiety . . .

Thank you for the news of my little canvas. I quite understand that it could not be accepted because of my starting-point, which is too far removed from the aim to be attained, that is to say, the rendering of nature.

I have just finished *Une Page d'Amour*. You were quite right to tell me that it could not be read in instalments. I had in no way perceived its coherence, it appeared hashed, whereas on the contrary the composition is extremely clever. It shows a strong dramatic sense. – Nor had I seen that the action took place in a restricted frame, intensified. – it is really regrettable that works of art are not more appreciated and that in order to attract the public an exaggeration is necessary which does not entirely belong, without harming it to be sure.

I read your letter to my mother, she joins me in sending you greetings.

Kind regards to all your family.

PAUL CÉZANNE

*

[*Aix*] 1 June, 1878

TO EMILE ZOLA Here is my monthly prayer to you recommencing. I do hope it does not weary you too much and that it does not seem to you too uninhibited. But your offer saves me so much embarrassment that I am having recourse to it again. My good family, otherwise excellent, is, for an unhappy painter who has never been able to achieve anything, perhaps a little bit mean, a slight failing and easily excusable without doubt in the provinces.

Now comes the inevitable result of such an introduction. I am asking you to be kind enough to send 60 francs to Hortense, who, by the way, is feeling no worse.

From Lambert, the democratic bookseller, I bought *L'Assommoir*, illustrated, *L'Egalité* of Marseille publishes it as a serial.

I continue to work a little. Politicians occupy a terrifying position. And how is Alexis?

I clasp your hand and send my regards to Mme Zola.

PAUL CÉZANNE

*

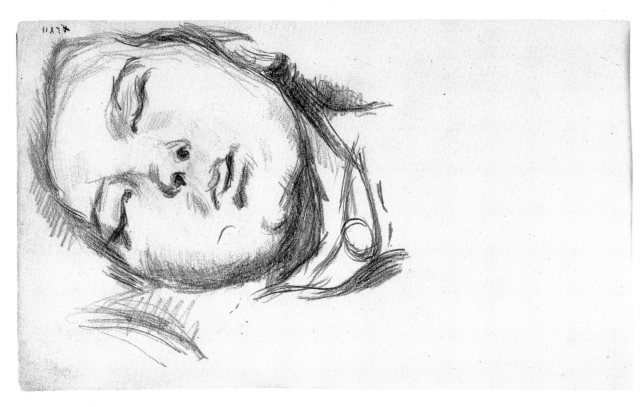

THE ARTIST'S SON ASLEEP

TO EMILE ZOLA Before leaving Paris I left the key of my apartment with a man named Guillaume, a cobbler. This is what must have happened. The fellow must have taken in people from the provinces because of the exhibition and lodged them in my flat. – My landlord, very annoyed at not having been asked beforehand, sends, with the receipt for last quarter, a pretty strongly worded letter telling me that my flat is occupied by strangers. My father, reading this letter, concluded that I conceal women in Paris. The whole thing is beginning to assume the aspect of a *vaudeville à la Clairville*. Apart from that, everything was going very well; I was trying to settle down at Marseille, to spend the winter working there and go back to Paris next spring, say in March. At that time the atmosphere grows heavy and I don't think that I shall be able to make such good use of my time outside, and another point, I should be in Paris at the time of the exhibition of painting . . .

I clasp your hand, greetings to Madame and to your mother, who is no doubt with you. And good trips on the river.

PAUL CÉZANNE

*

[*l'Estaque, Autumn 1878*]

TO EMILE ZOLA

Hortense recently went to Aix and there saw Achille Emperaire. His family is in great want, three children, winter, no money, etc., you can just imagine what it is like. Therefore I beg you: (1) seeing that Achille's brother is on bad terms with his ex-superiors in the tobacco administration, withdraw the file relating to his petition, if there is nothing for him to obtain within a short time; (2) see if you can find or help him to get, a job of any kind, in the docks, for example; (3) Achille also appeals to you for a job, no matter how small it may be.

So if you can do something for him, please do, you know how much he deserves it, being such a decent man, who has been shouldered aside by everybody and abandoned by all the smart ones. There it is!

Moreover, I wanted to write to you apart from this, for it seems to me that I haven't had news from you for a long time. – I understand that nothing new has happened. – You will give me pleasure if you write a few lines, it will lend a little variety to this long series of days that are so monotonous for me. My position continues the same as ever.

My respects to your wife and mother.

Always yours . . .

PAUL CÉZANNE

*

[*l'Estaque*] 14 September, 1878

TO EMILE ZOLA

It is in a quieter frame of mind that I am writing to you at this moment and if I have been able to weather some slight mishaps without too much suffering, then this is thanks to the good solid plank you held out to me. Here is the latest tile which has fallen on my head.

Hortense's father wrote to his daughter at the rue de l'Ouest (in Paris) under the name of Mme Cézanne. My landlord hastened to send this letter to the Jas de Bouffan. My father opens and reads it, you can imagine the result. I deny vehemently and, as very fortunately the name Hortense is not mentioned in the letter, I maintain that it is addressed to some woman or other.

I received your book of plays. So far I have only read five acts, three of *Héretiers Rabourdin* and two of *Bouton de Rose*; it is very interesting, and especially *Bouton de Rose*, I find. The *Héretiers Rabourdin* have some kinship with Molière, whom I re-read last winter. I have no doubt that you will succeed perfectly in the theatre. Having read nothing of this kind by you, I did not expect such lively and good dialogue.

I met an architect called Huot, who highly praised the whole of the *Rougon-Macquart* and told me that the work was greatly appreciated by people who know.

He asked me whether I saw you; I said: 'Sometimes' – whether you wrote to me; I said 'Recently'. Stupefaction, and I rose in his esteem. He gave me his card and an invitation to go and see him . . .

My respects to Mme Zola and my warmest thanks.

PAUL CÉZANNE

Nota-Bene: Father gave me 300 francs this month. Incredible. I think he is making eyes at a charming little maid we have at Aix; I and Mother are at l'Estaque.

What developments.

*

l'Estaque, 13 November, 1878

To Gustave Caillebotte My dear Colleague, when you hear that I am very far from Paris, you will forgive me for having failed in the obvious duty imposed on me in view of the fresh blow that has hit you. It is about nine months since I left Paris and your letter reached me at the other end of France after long detours and a long delay.

Allow me to send you in your affliction the expression of my gratitude for the good services you have rendered our cause and the assurance that I share your sorrow even though I did not know Madame your mother, but I well know the aching void caused by the disappearance of people we love. My dear Caillebotte, I press your hand affectionately and beg you to devote your time and energy to painting, this being the surest means of diverting our sadness.

Remember me to Monsieur your father and be of good courage as far as is possible.

PAUL CÉZANNE

*

l'Estaque, 20 November, 1878

To Emile Zola It is now some time since I received news from Paris telling me that you were kind enough to advance me the 100 francs I asked for. In the meanwhile a week has passed and I have had no more news from Paris. My little one is with me at l'Estaque but the weather has been horrible for some days.

Doubtless you are swamped with work. I am waiting for a break in the weather to take up again my studies in painting.

I bought a very curious book, it is a mass of observations of a subtlety that often escapes me, I feel, but what anecdotes and true facts! And people *comme il faut* call the author paradoxical. It is a book by Stendhal: *Histoire de la Peinture en Italie*, you have no doubt read it, if not, allow me to draw your attention to it. – I had read it in 1869, but had read it badly, I am re-reading it for the third time. – I have just finished buying the illustrated *Assommoir*. But better illustrations would no doubt not have served the editor better. The next time I can talk to you face to face I shall ask you whether your opinion on painting as a means of expressing feeling is the same as mine. – I ask you to remember me, I am still at l'Estaque.

Do not forget to give my kind regards to Mme Zola, a handshake for you and Alexis.

PAUL CÉZANNE

*

<p style="text-align: right">[l'Estaque] 19 December, 1878</p>

TO EMILE ZOLA

Probably I really did forget to tell you that I had moved last September from the rue du vieux Chemin de Rome. At the moment I am living, or at least Hortense is, in the rue Ferrari 32. – As for me, I am still at l'Estaque, where I received your last letter.

Hortense came back from Paris four days ago, which is a relief to me for my little one was with me and my father might have surprised us. It is almost as if there were a conspiracy to reveal my position to my father, my clot of a landlord is interfering too. – It is more than a month since Hortense received the money that I asked you to send her and I thank you very much for it, she needed it very badly. She had a little adventure in Paris. – I am not going to put it down in writing; I shall tell you when I come back, in any case it is nothing very much. – Finally, I think I shall stay here for a few more months and leave for Paris towards the beginning of March. – I had expected to have a taste of the most complete tranquillity here, but a lack of understanding between myself and the paternal authority makes me on the contrary more disturbed than ever.

The author of my days is obsessed by the idea of liberating me. – There is only one good way of doing that, it is to stick on another two or three thousand francs a year, and not to wait until after my death to make me his heir, for I shall surely end my days before he does.

As you say, there are some very beautiful views here. The difficulty is to reproduce them, this isn't exactly my line. I began to see nature rather late, though this does not prevent it being full of interest for me.

<p style="text-align: right">I shake your hand. PAUL CÉZANNE</p>

<p style="text-align: center">*</p>

<p style="text-align: right">l'Estaque, 28 [January] 1879</p>

TO VICTOR CHOCQUET

May I ask you to be kind enough to get some information for me? Here is what it is all about. Always provided, of course, that you can obtain the information required without too much bother and inconvenience, otherwise I could ask the good Tanguy, which I should have done if I had not had good reason to think that I would get more satisfactory and complete information from you. But now to the point: I should like to know how to set about letting a picture reach the administration of the Beaux-Arts with the aim of submitting it to the judgement of the jury, and then if, as I fear, the picture is refused whether the gentle administration will undertake to return the above-mentioned work of art to its author, the author being in the provinces. Unnecessary to add that the artist is not ignorant of the fact that both the sending and the return of his work must be at his own expense.

It is to help one of my compatriots that I am taking the liberty of appealing to you. It is not on my own behalf, for I shall be returning with my little caravan to Paris in the first days of March this year.

The weather is very watery this year, but very mild in our area for the last fortnight.

Please forgive me for troubling you, Monsieur Chocquet, and give my kind regards to Madame; my wife and the little one send you their greetings.

<p style="text-align: right">Your humble servant, PAUL CÉZANNE</p>

<p style="text-align: center">*</p>

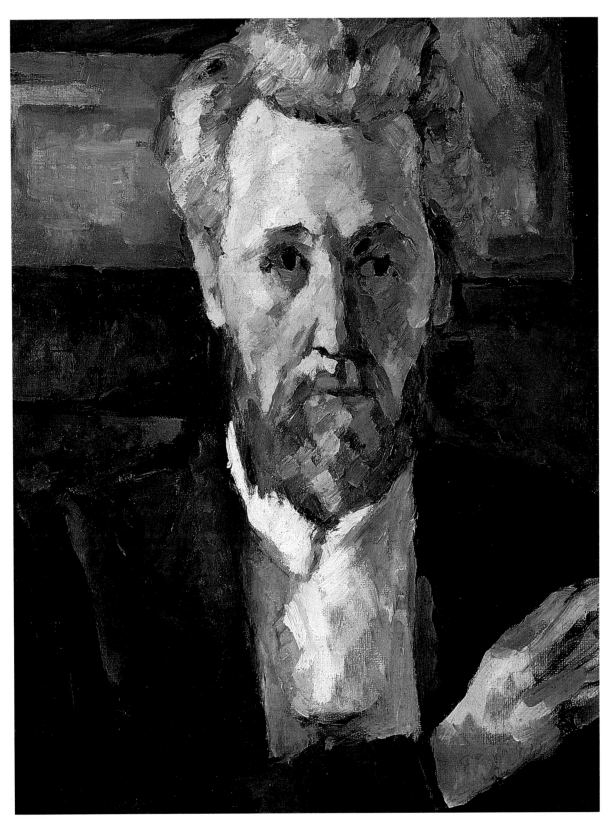

PORTRAIT OF VICTOR CHOCQUET

To CAMILLE PISSARRO I think that, in the middle of the difficulties caused by my sending in to the Salon, it would be more appropriate for me not to take part in the Exhibition of the Impressionists.

Another point, I shall avoid the upset and disturbance caused by the transport of my few canvases. Moreover, I am leaving Paris in a few days.

I send you greetings, waiting for the moment when I can come to shake your hand.

PAUL CÉZANNE

*

[*Melun*] 24 September, 1879

To EMILE ZOLA This is what makes me write, for nothing has happened since I left you last June which could give me reason to write a letter, although you did ask me in your last letter to give you news of myself. Tomorrow was so similar to yesterday that I didn't know what to tell you. But this is what I should like: to go and see *L'Assommoir*. May I ask you for three seats? – But that is not all, there is still another nuisance, and that is the definite date for which I want this, that is the 6th of the month of October. Please see if my request doesn't cause too much trouble. For, to begin with, you are not in Paris. I am not going there either, and I am afraid it will not be easy to fit in the time of my arrival in Paris with the issuing of the ticket. – And so, if it is too much trouble, tell me and do not be afraid to refuse me for I well understand that you must have been overwhelmed with similar requests . . .

I am still striving to discover my way as a painter. Nature presents me with the greatest difficulties. But I am not too bad, after a renewed attack of the bronchitis I had in '77, which racked me for a month. I wish that you may be spared all similar trials. I hope that this letter will find you and your family in good health. My father lost his partner some time ago, but fortunately they themselves are all well.

I shake your hand and ask you to give my sincerest greetings to Mme Zola, your wife and to your mother.

Your devoted PAUL CÉZANNE

*

[*Melun*] 27 September, 1879

To EMILE ZOLA Heartiest thanks. Send me the tickets to Melun. I am not going to Paris until the morning of the 6th.

I gladly accept your invitation for Médan. Particularly at this time when the country is really astonishing. – There seems to be a greater silence. These are feelings that I cannot express, it is better to feel them.

My greetings to your family and my thanks. I shake your hand.

Your devoted PAUL CÉZANNE

*

Melun, 9 October, 1879

TO EMILE ZOLA I went to see *l'Assommoir*, and am very pleased I did. I couldn't have had a better seat and I didn't sleep at all, although I am in the habit of going to bed soon after 8 o'clock. The interest does not slacken at all, but I would dare, after seeing this play, to say that the actors seem so remarkable to me, they could bring success to a mass of works which are plays only by name. Literary form does not appear necessary for them. The end of Coupeau is really extraordinary and the actress who plays Gervaise is most appealing. But as a matter of fact they all act very well . . .

I saw the next appearance of *Nana* announced for the 15th, on a large screen which covers the whole curtain of the theatre.

Heartiest thanks, and when my colleagues with the large brushes have finished, please write to me.

Please give my respects to Mme Zola, to your mother and yourself.

I shake your hand, PAUL CÉZANNE

*

OLYMPIA

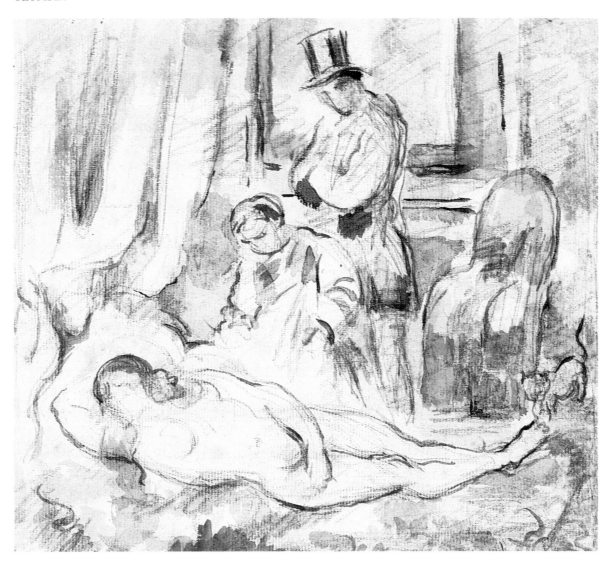

Melun, 25 February, 1880

TO EMILE ZOLA

This morning I received the book that Alexis has just published. I should like to thank him and as I do not know his address I must ask you to be kind enough to let him know how touched I am at this sign of friendship that he is good enough to show me. This volume will be added to the literary collection which you have made for me, and I have for quite some time enough to distract me and to occupy my winter evenings. Moreover, I hope that I shall see Alexis when I am back in Paris, and that I shall be able to thank him myself.

Our friend Antony Valabrègue has published a charming volume, *Petits poèmes parisiens*, with the publisher Lemerre. You must have had a copy. My paper speaks well of it . . .

An affectionate handshake for you and please give my respectful greetings to Mme Zola.

Your devoted friend, PAUL CÉZANNE

*

[*Paris*] 1 April, 1880

TO EMILE ZOLA

Having received your letter this morning, 1 April, enclosing the one from Guillemet, I descend on Paris, I learn from Guillaumin that the 'Impressionists' are open. – I rush there. Alexis falls into my arms, Doctor Gachet invites us to dine, I prevent Alexis from paying his respects to you. May I take the liberty of inviting us to dinner on Saturday evening? Should the opposite be the case, please be good enough to let me know. I am staying at the rue de l'Ouest 32, Plaisance.

I remain in gratitude your ancient college comrade of 1854. I ask you to give my respects to Mme Zola.

PAUL CÉZANNE

*

[*Paris*] 10 May, 1880

TO EMILE ZOLA

I am enclosing a copy of a letter that Renoir and Monet are going to send to the Ministre des Beaux-Arts to protest against the bad hanging of their pictures and to demand an exhibition next year for the group of the pure Impressionists. Now here is what I have been requested to ask you to do:

That is, to publish this letter in *Voltaire*, preceded or followed by a few words on the previous activities of the group. These few words should aim at showing up the importance of the Impressionists and the real interest they have aroused.

I shall not add that whatever solution you consider proper to give to this request must have no influence on your friendly feelings for me nor on the good relations that you have very kindly wanted to exist between us. For I am liable more than once to have to make requests of you that may be disagreeable for you. I fulfil the function of an intermediary and nothing more.

I heard yesterday the very sad news of Flaubert's death. – Also, I fear that this letter will fall upon you at a time of much worry and excitement.

My sincerest respects to Mme Zola and your mother. I shake your hand cordially.

PAUL CÉZANNE

*

[*Paris*] Saturday, 19 June, 1880

To Emile Zola

I ought to have thanked you for the last letter but one that you wrote to me on the subject of what I had asked you to do for Renoir and Monet . . .

– Monet has at the moment a very fine exhibition at M. Charpentier's at the 'Vie Moderne'.

I am not quite sure whether the really hot weather is coming, but as soon as I shall not be in your way please write to me and I shall come to Médan with pleasure. And if you are not alarmed at the length of time that I risk taking, I shall allow myself to bring a small canvas with me and paint a motif, always providing that you see in this nothing disturbing.

I am very grateful to Mme Zola for the large pile of rags she sent me, which are very useful. – I go into the country every day to do a little painting . . .

Please remember me to Mme Zola, also to Mme Zola your mother.

I shake your hand.

PAUL CÉZANNE

*

[*Paris*] 4 July, 1880

To Emile Zola

On 19 June last I sent my reply to your letter of the 16th. I asked you whether I could come to you to paint, it is true, – but please understand that I didn't want to cause embarrassment. Since then I have had no news from you, and as nearly a fortnight has now passed I am taking the liberty of asking you to send me a few lines to explain the position. If you would like me to come and say how do you do, I shall come, or if you tell me the contrary, I shall not come yet. – I have read, beginning with no. 11, the articles that you are publishing in *Voltaire*. And I thank you in my own name and in the name of my other colleagues. – Monet, so I have heard, has sold some of the pictures he exhibited at M. Charpentier's and Renoir is said to have received some good commissions for portraits.

I send my best wishes for your health – and please give my sincere respects to Mme Zola and to your mother.

I remain your grateful and devoted PAUL CÉZANNE

*

[*Aix*] Jas de Bouffan, 27 November [*1882*]

To Emile Zola

I have decided to make my will, because it seems that I can do so as the title-deeds of the stocks that fall to me are made out in my name. So I am asking your advice. Could you tell me how I should word this document? In the event of my death, I should like to leave half my income to my mother and the other half to my little boy. – If you know anything about it, please let me know. For if I were to die in the near future, my sisters would inherit from me, and I think my mother would be cut out, and my little boy (whom I acknowledged when I registered him at the *mairie*) would, I believe, have a right to half my estate, but perhaps not uncontested.

If I can make out a will in my own hand, I should like to ask you, if it is no trouble to you, to keep in custody a duplicate of the same. – Provided this does not inconvenience you, because the paper in question might be purloined from here.

This is what I wanted to explain to you. I salute you and wish you bonjour, not forgetting to send my respects to Mme Zola.

Ever your PAUL CÉZANNE

*

[*Aix*] Saturday, 10 March, 1883

TO EMILE ZOLA

I am rather late in thanking you for sending me your last novel. But here is the attenuating circumstance for this delay. I have just come from l'Estaque, where I had been for a few days. Renoir, who is to have an exhibition of painting following Monet's, which is now taking place, asked me to send him two landscapes which he had left with me last year. I sent them to him on Wednesday; and so here I am at Aix, where snow fell all day on Friday. This morning the countryside presented the very beautiful sight of a study in snow. But it melts.

We are still in the country. My sister Rose and her husband have been at Aix since October and she gave birth to a little girl there. All this is anything but amusing. I think the result of my protestations will be that they won't return to the country this summer. – This is a joy to my mother. – I shall not be able to return to Paris for a long time; I think I shall spend another five or six months here. So I remind you of my existence and ask you to remember me to Alexis.

Please give my respectful greetings to Mme Zola, also from my mother.

Thanking you warmly, I am always your PAUL CÉZANNE

*

[*l'Estaque*] 24 May, 1883

TO EMILE ZOLA

Now that I am quite certain you are at Médan, I am sending you the paper in question, of which my mother has a duplicate. But I am afraid that all this will not be of much use for these wills are very easily disputed and annulled. A formal statement in front of the civil authorities would be better, should the case arise.

I shall not return to Paris before next year; I have rented a little house and garden at l'Estaque just above the station and at the foot of the hill, where behind me rise the rocks and the pines.

I am still busy painting. – I have here some beautiful views but they do not quite make *motifs*. – Nevertheless, climbing the hills as the sun goes down one has a glorious view of Marseille in the background and the islands, all enveloped towards evening to very decorative effect . . .

I press your hand warmly. Ever your PAUL CÉZANNE

*

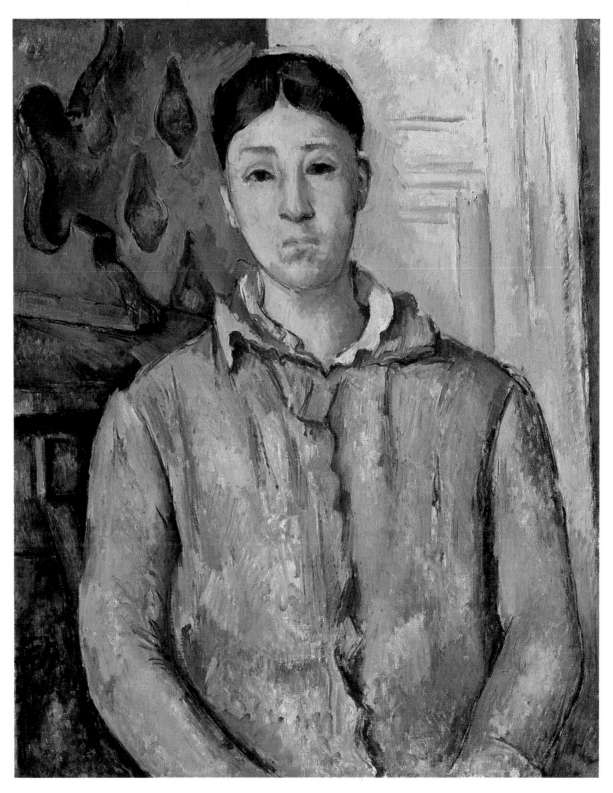

MADAME CÉZANNE IN BLUE

Aix, 23 February, 1884

To Emile Zola

I received the book that you were kind enough to send me recently, the *Joie de Vivre* which appeared in *Gil Blas*, because I saw some extracts in the above paper. Therefore, thank you very much for sending it, and for not forgetting me in the seclusion of my retreat. I should have nothing to tell you were it not that, happening to be at l'Estaque a few days ago, I received there a letter written in his own hand from good old Valabrègue, Antony, telling me of his presence at Aix, where I at once ran to yesterday, and where I had the pleasure of clasping his hand this morning – Saturday. We made a tour of the town together – recalling some of those we had known – but how far apart we are in our feelings! I had my head full of the character of this country, which seems to me quite extraordinary. – On the other hand, I saw Monet and Renoir who went for a holiday to Genoa in Italy towards the end of December.

Don't forget to remember me to my compatriot Alexis, although I have not heard from him for ages.

My best thanks to you and my respects to Mme Zola, hoping you are both in good health.

I salute you sincerely, Paul Cézanne

*

[*Aix*] 27 November, 1884

To Emile Zola

I have just received two new books that you were kind enough to send me. I thank you, and I must tell you that I have not much news to give you about the good old town where I saw the light of day. Only (but this doubtless will not affect you much), art is changing terribly in its outer appearance, putting on too much of a small, very mean form, while at the same time the ignorance of harmony reveals itself more and more through the discord of the colours and, what is even worse, the aphony of the tones.

After groaning, let us cry long live the sun, which gives us such a beautiful light.

I can only repeat, I am yours from my heart, not forgetting to send my respects to Mme Zola,

Paul Cézanne

*

[*Spring 1885*]
[*Draft*]

To an Unknown Lady

I saw you and you allowed me to kiss you; from that moment a profound emotion has not stopped exciting me. You will excuse the liberty that a friend, tortured by anxiety, takes in writing to you. I do not know how to explain to you this liberty that you may find so great, but could I have remained under this burden which oppresses me? Is it not better to give expression to a sentiment rather than to conceal it?

Why, I said to myself, suppress the cause of your agony? Is it not a relief granted to suffering, to be allowed to express itself? And if physical pain seems to find relief in the cries of the afflicted, is it not natural, Madame, that moral sadness seeks some consolation in the confession made to an adored being?

I know well that this letter, the hasty and premature sending of which may appear indiscreet, has nothing to recommend me to you but the goodness of. . . .

*

[*Aix*] Jas de Bouffan, 25 August, 1885

To Emile Zola

This is the beginning of the comedy. I wrote to La Roche-Guyon the very day that I sent you a line to thank you for having thought of me. Since then I haven't received any news; besides, for me, there is complete isolation. The brothel in town, or something like that, but nothing more. I pay, the word is dirty, but I need rest, and at that price I ought to get it.

I beg you therefore not to reply, my letter must have arrived at the proper time.

I thank you and ask you to excuse me.

I am beginning to paint, but [only] because I am very nearly without trouble. I go to Gardanne every day and in the evening I come back to the country at Aix.

If only I had an indifferent family, everything could have been for the best.

I shake your hand cordially.

PAUL CÉZANNE

*

Gardanne, 4 April, 1886

To Emile Zola

I have just received *L'Oeuvre* which you were kind enough to send to me. I thank the author of the *Rougon-Macquart* for this kind token of remembrance and ask him to allow me to press his hand in memory of old times.

Ever yours under the impulse of years gone by.

PAUL CÉZANNE

SELF-PORTRAIT

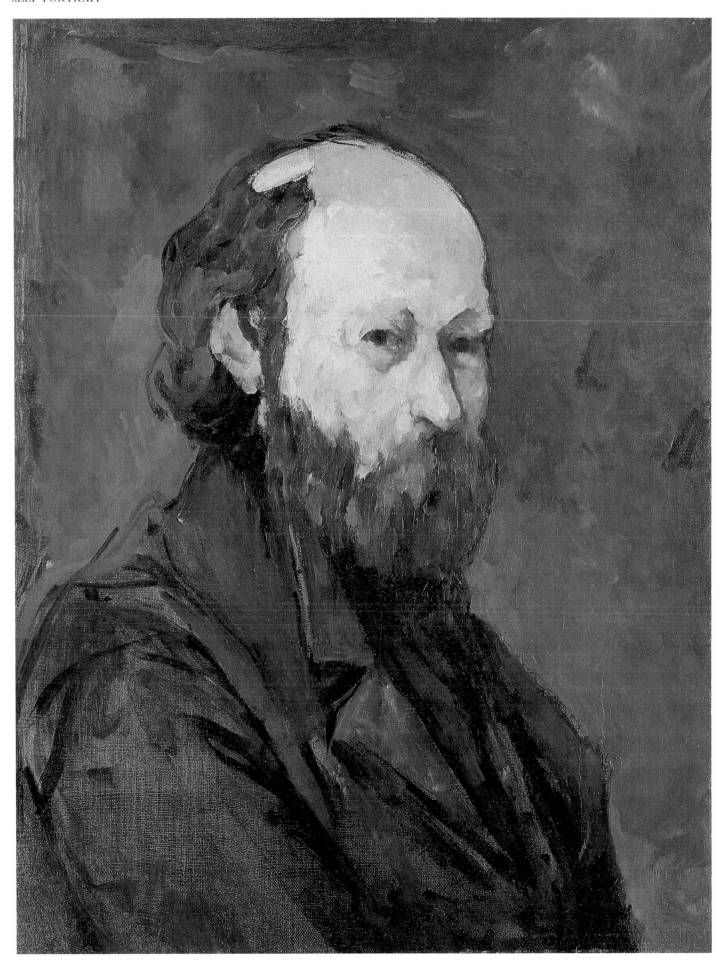

SELF-PORTRAIT

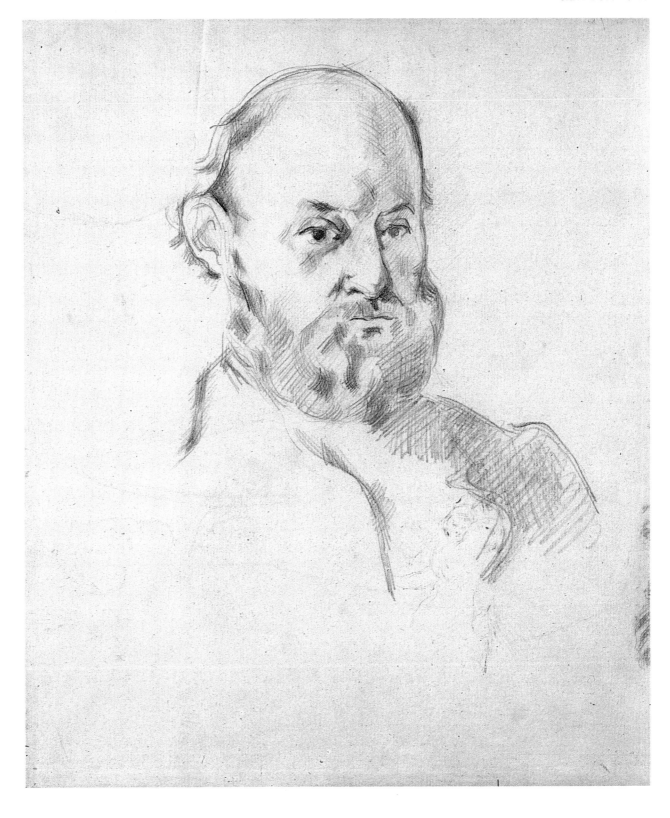

SELF-PORTRAIT AND PORTRAIT OF THE ARTIST'S SON

PORTRAIT OF MADAME CÉZANNE

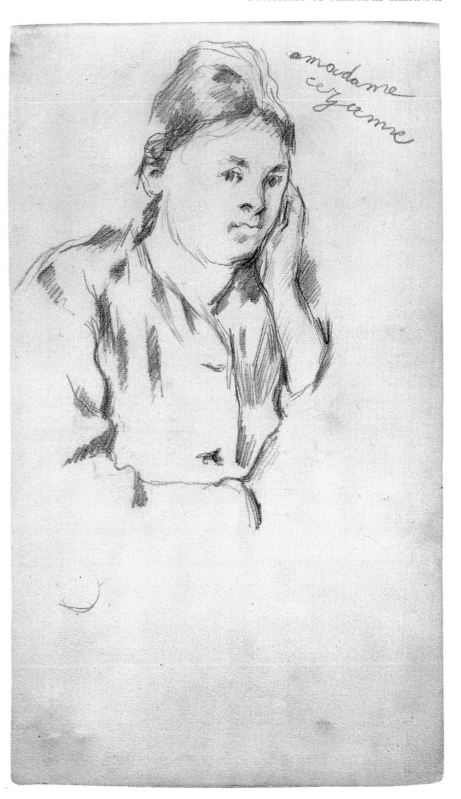

THE ARTIST'S FATHER AND ANOTHER HEAD

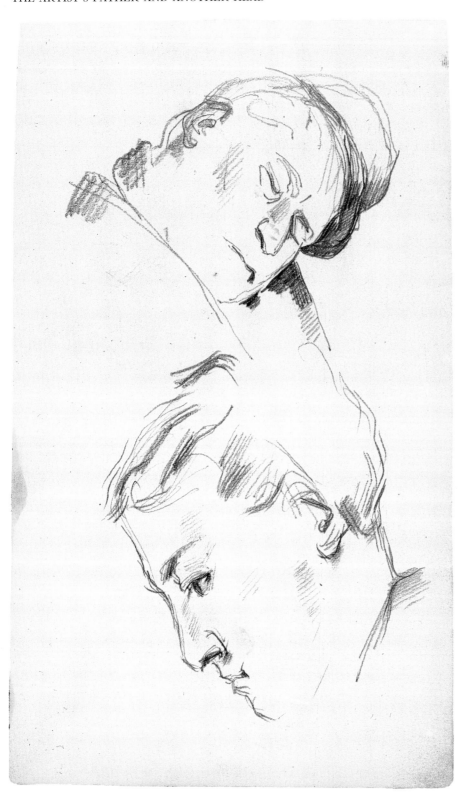

TWO PORTRAITS OF THE ARTIST'S SON

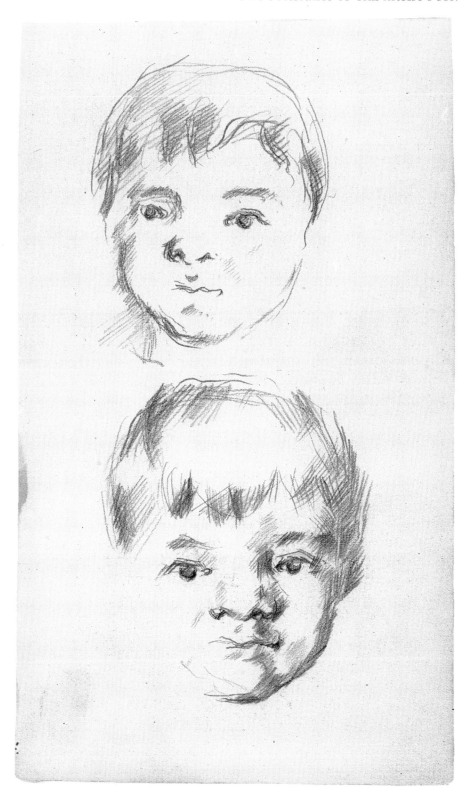

PAGE OF STUDIES, INCLUDING SELF-PORTRAIT

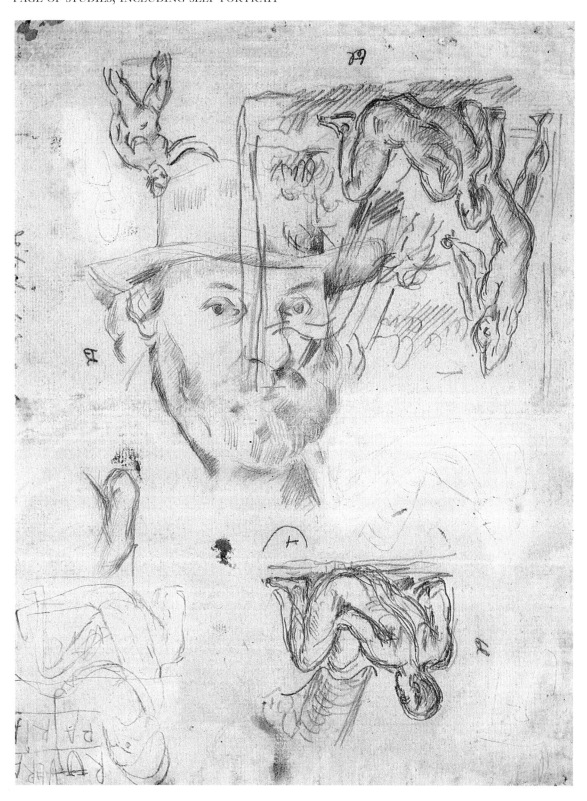

SELF-PORTRAIT

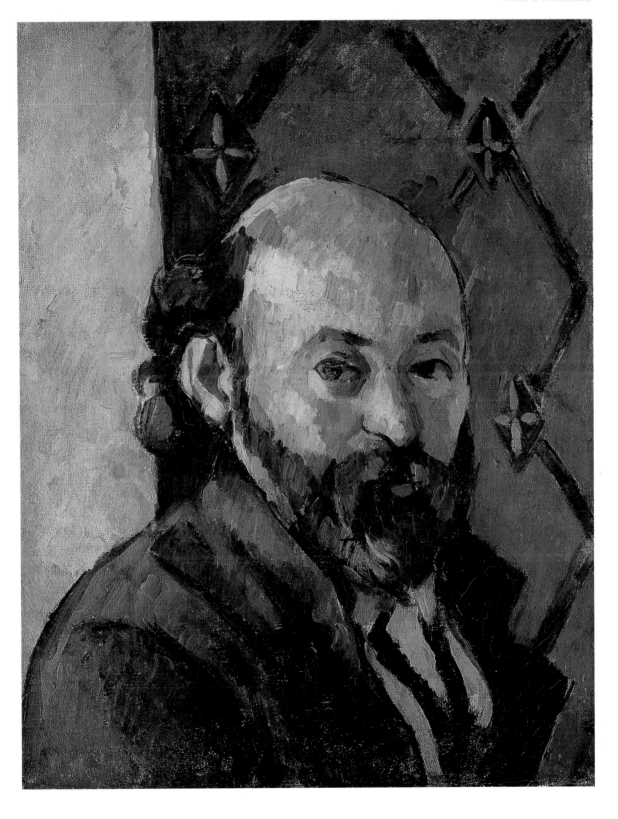

CÉZANNE'S WIFE AND FATHER

PORTRAIT OF THE ARTIST'S SON

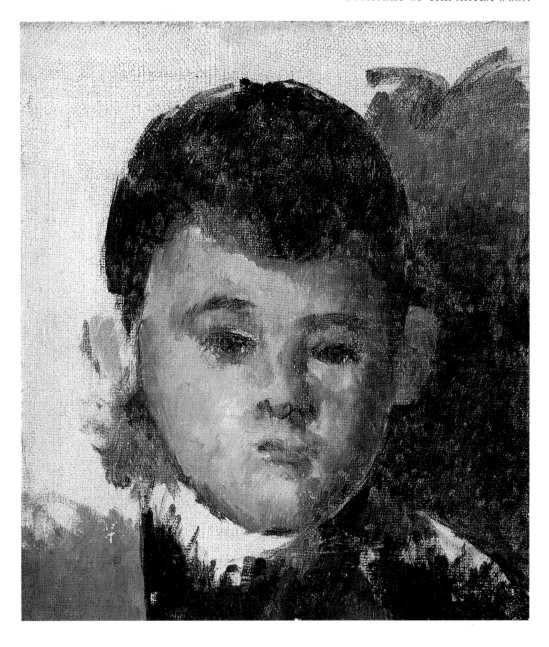

LOUIS GUILLAUME

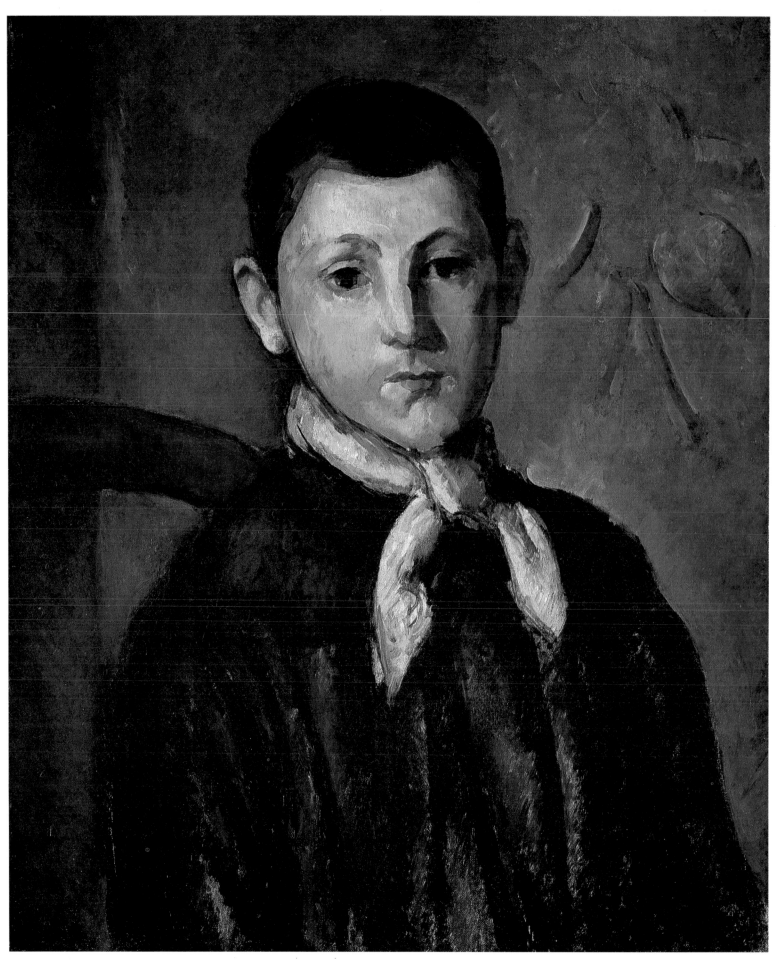

PORTRAIT OF THE ARTIST'S SON

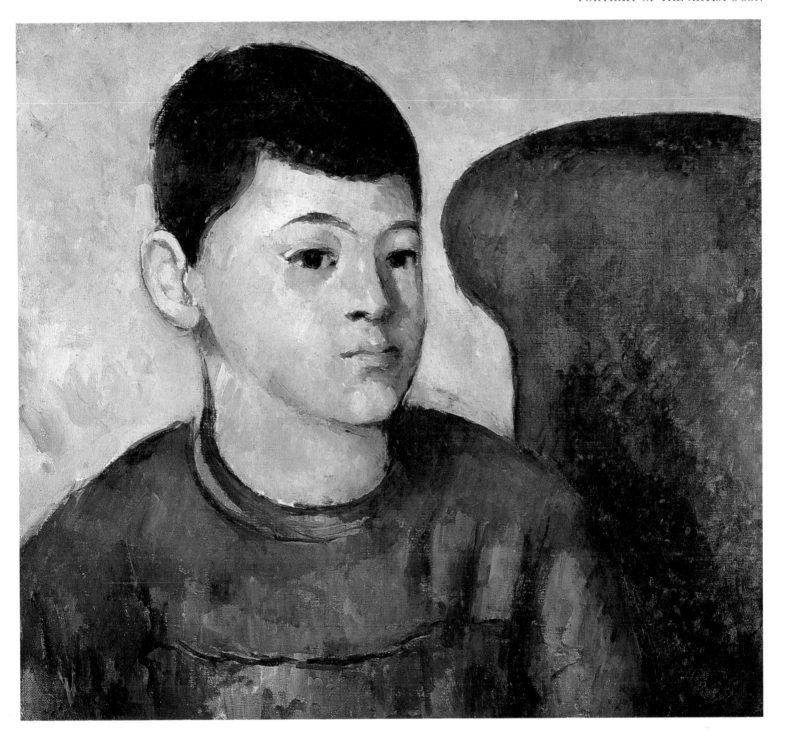

MADAME CÉZANNE IN A RED ARMCHAIR

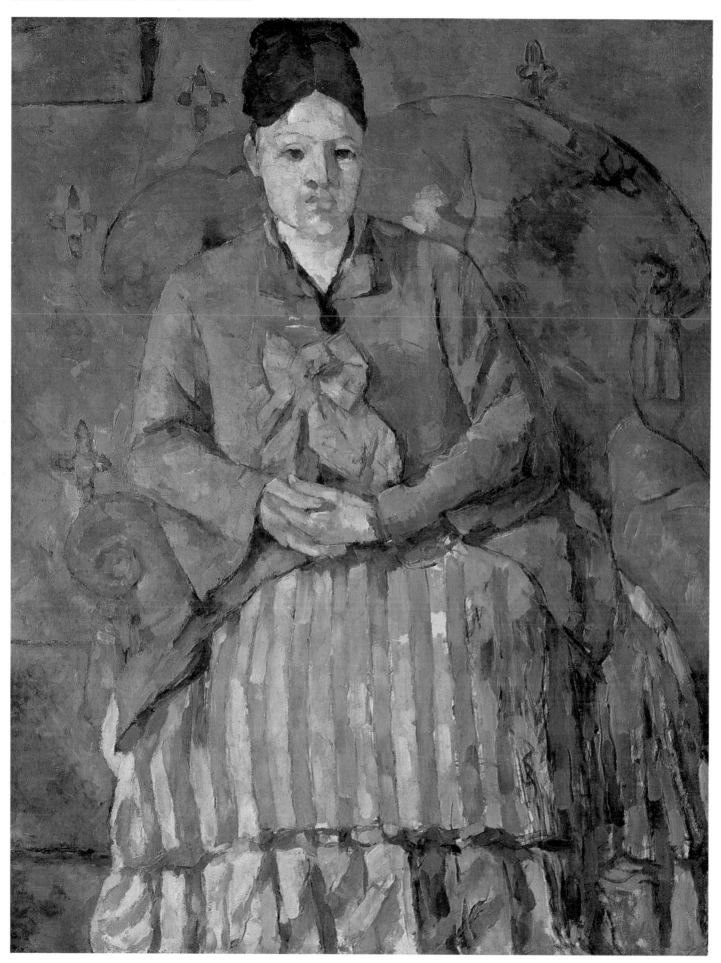

MADAME CÉZANNE IN A RED ARMCHAIR

MADAME CÉZANNE

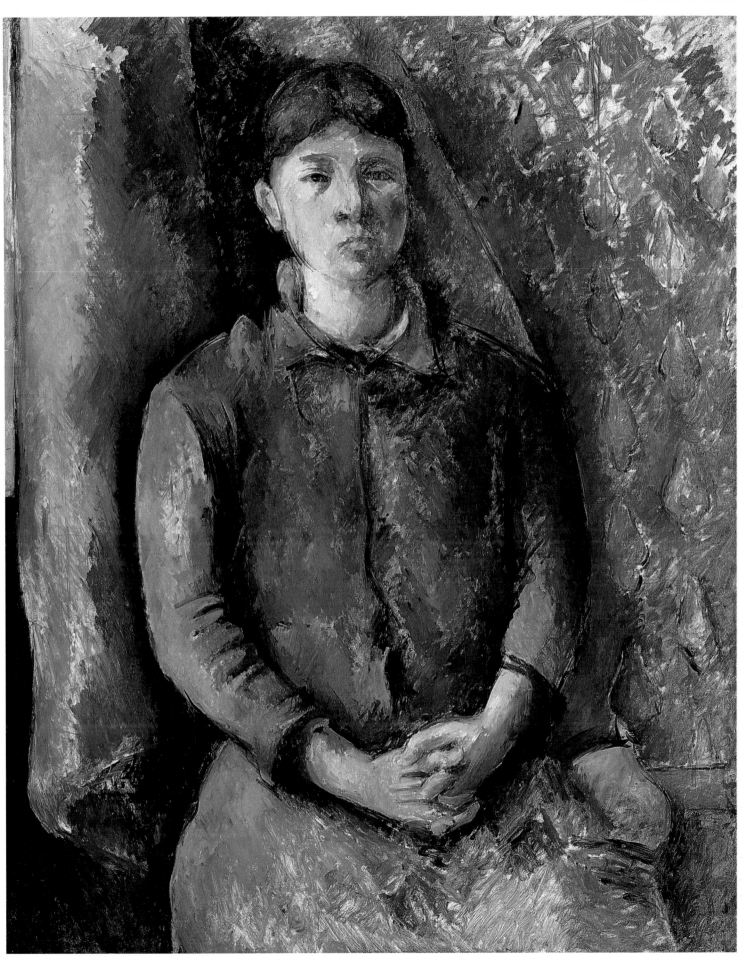

STILL LIFE

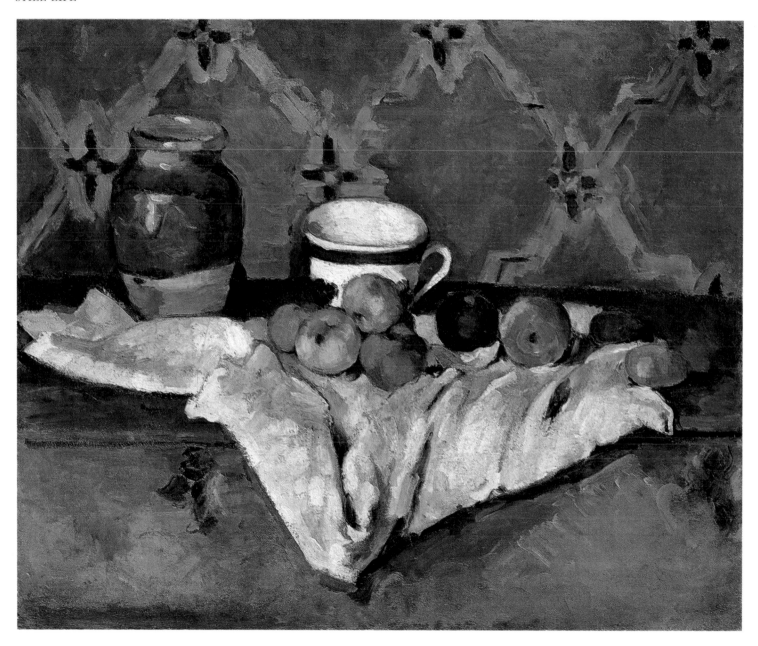

THE BUFFET

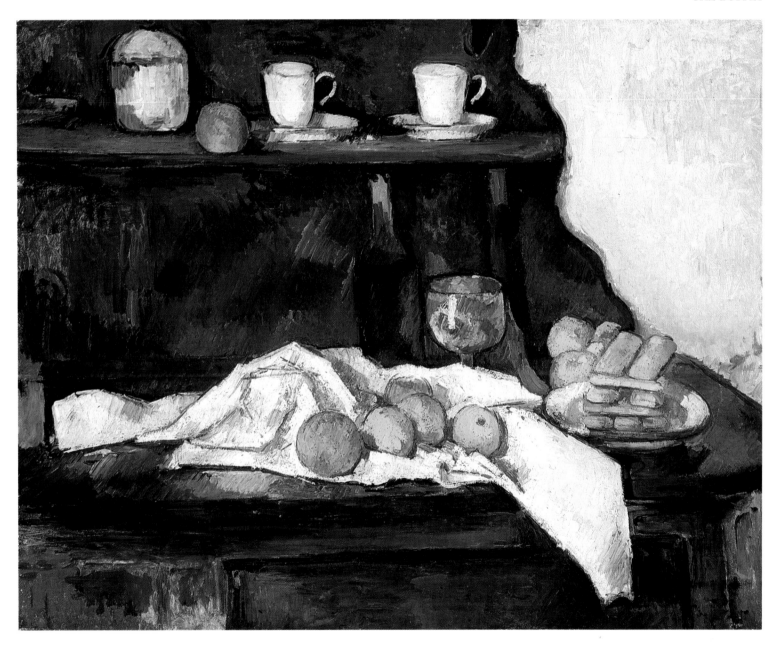

STILL LIFE (BOWL AND MILK JUG)

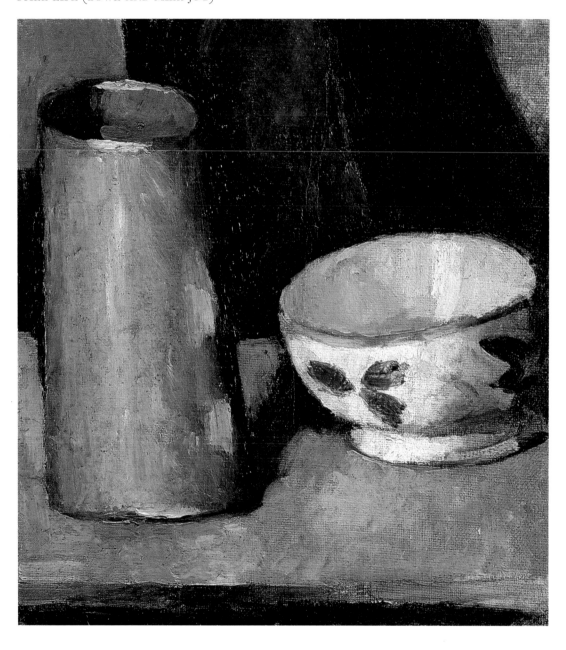

STILL LIFE WITH APPLES

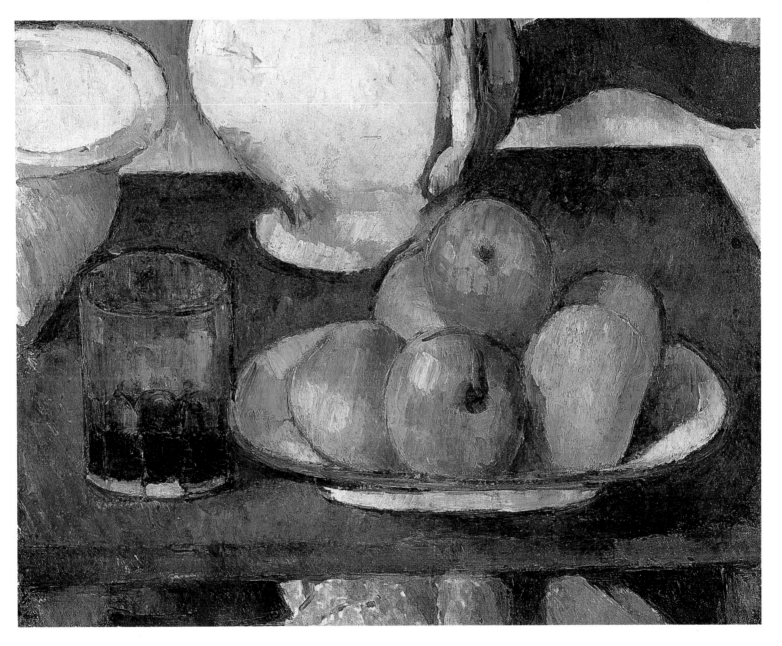

STILL LIFE: APPLES AND PEARS

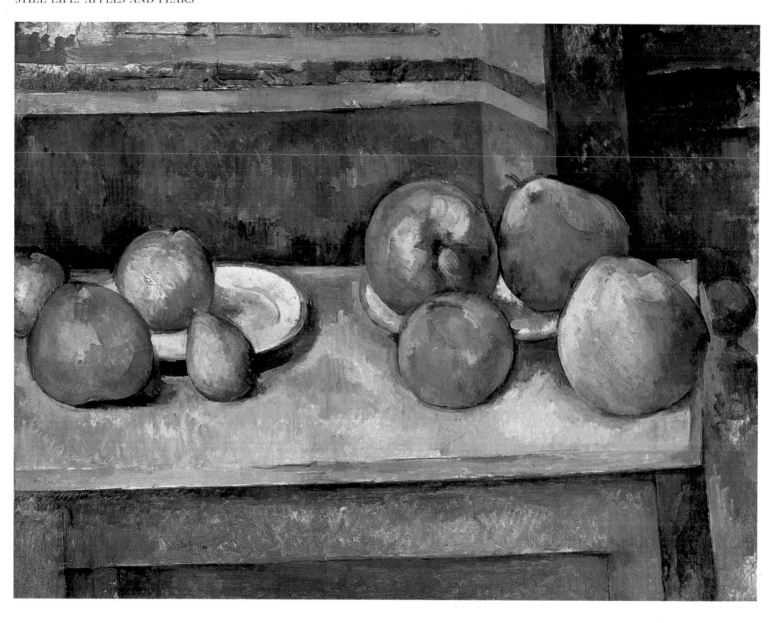

STILL LIFE WITH APPLES

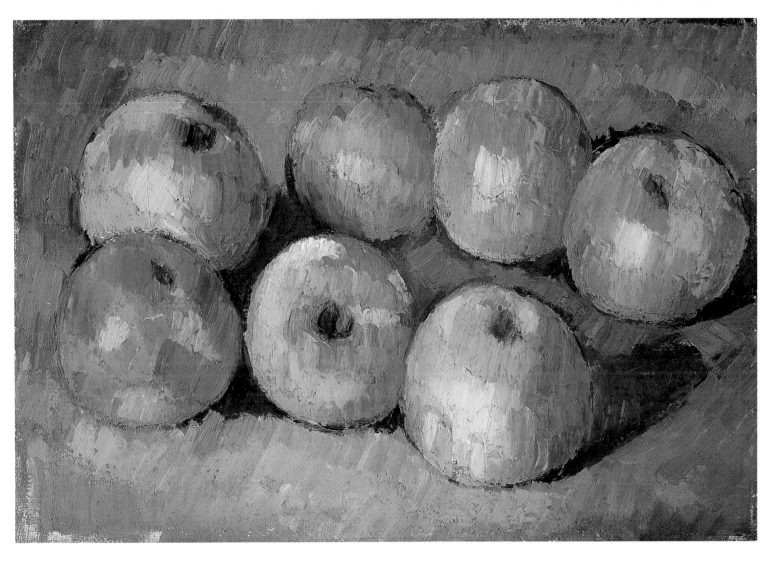

FLOWERS IN AN OLIVE JAR

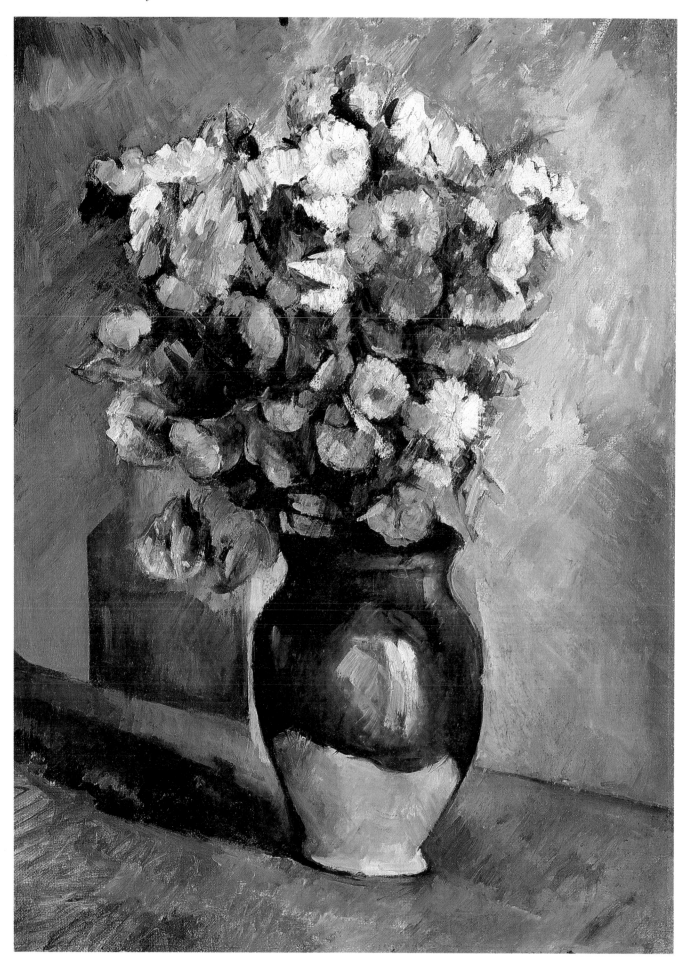

FLOWERS AND FRUIT

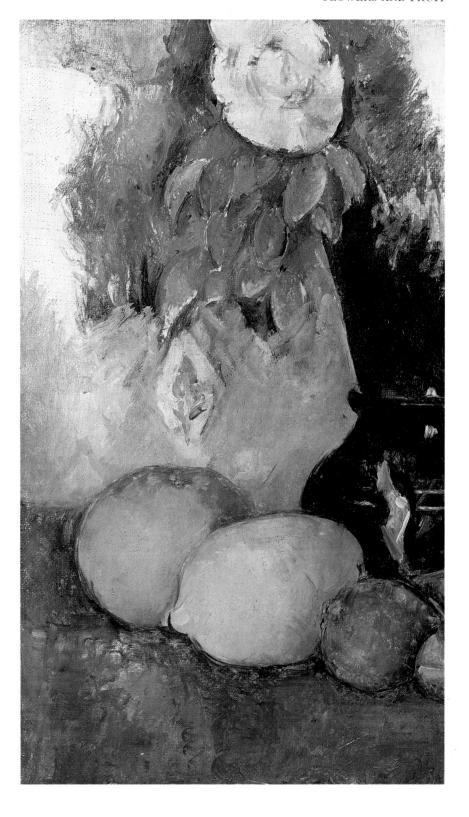

STILL LIFE WITH CHERRIES AND PEACHES

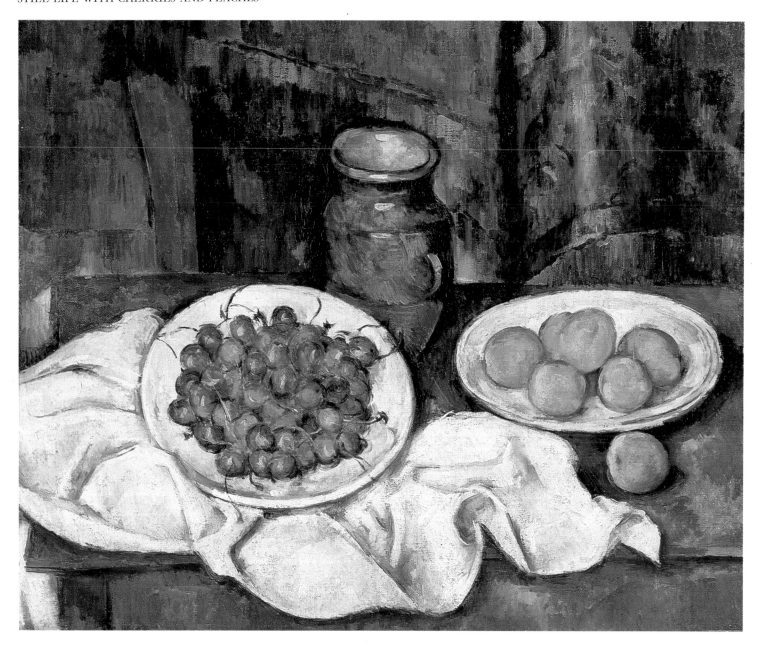

VESSELS, FRUIT AND CLOTH IN FRONT OF A CHEST

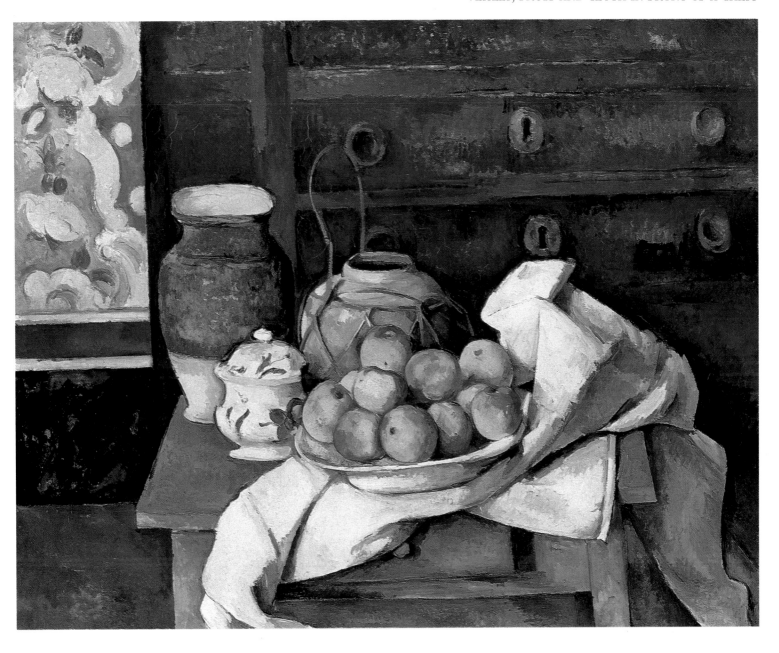

POTS OF GERANIUMS

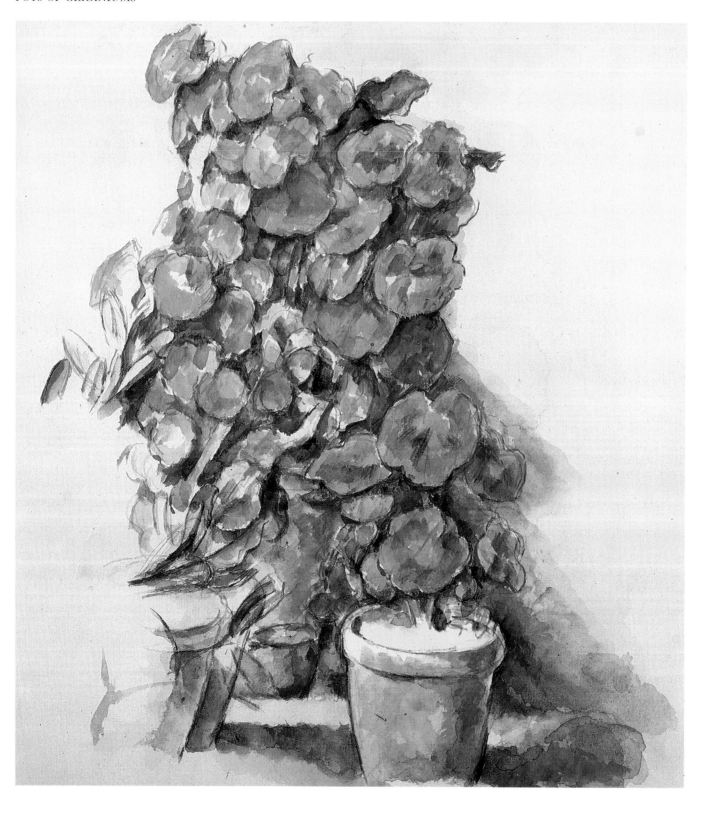

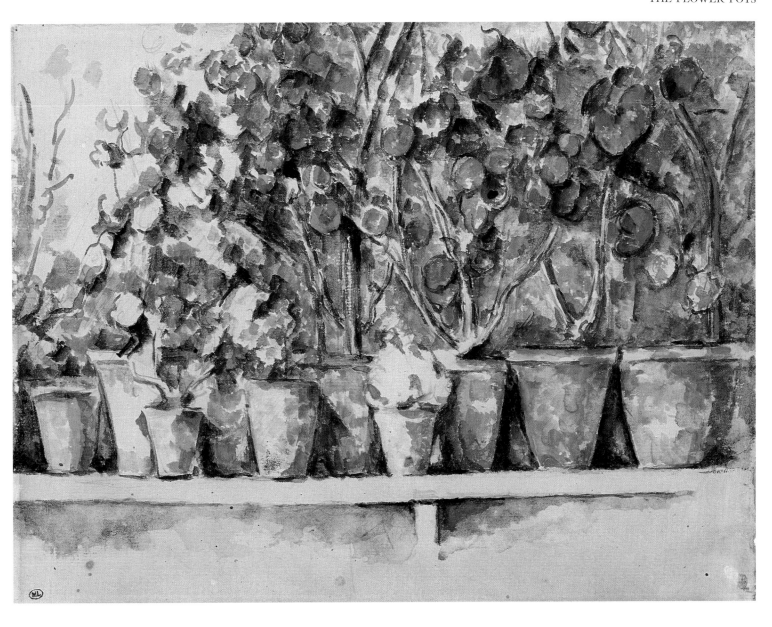

THE GREEN PITCHER

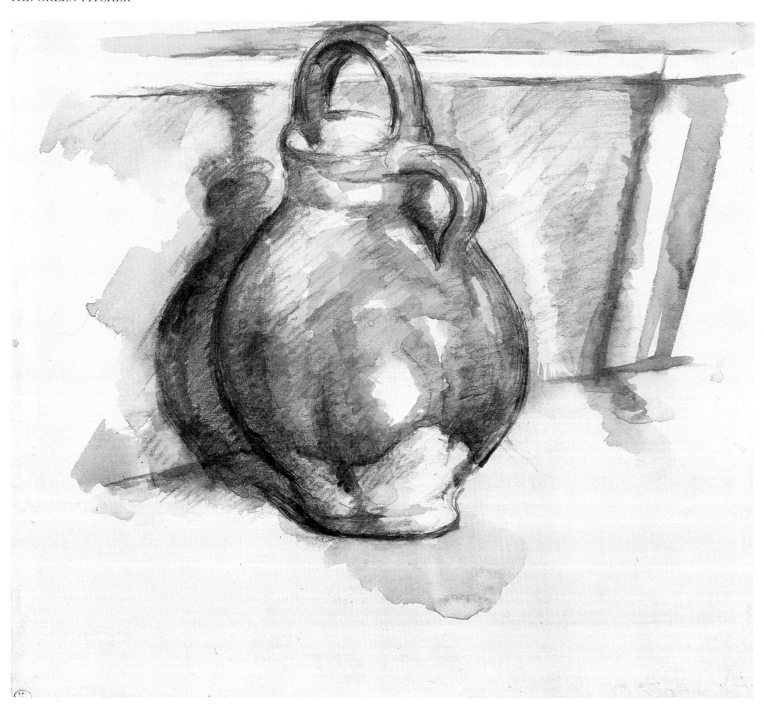

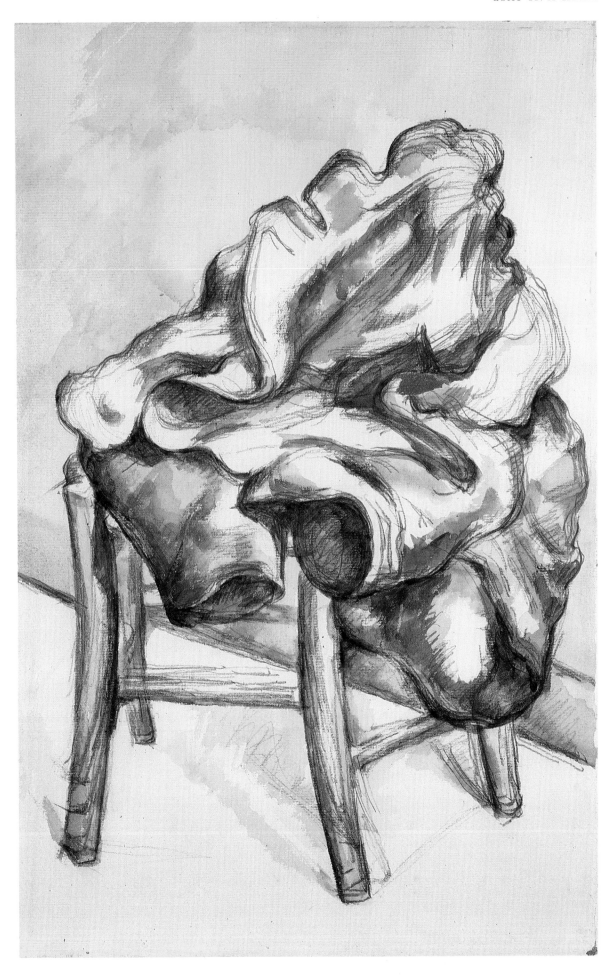

COUPLES RELAXING BY A POND

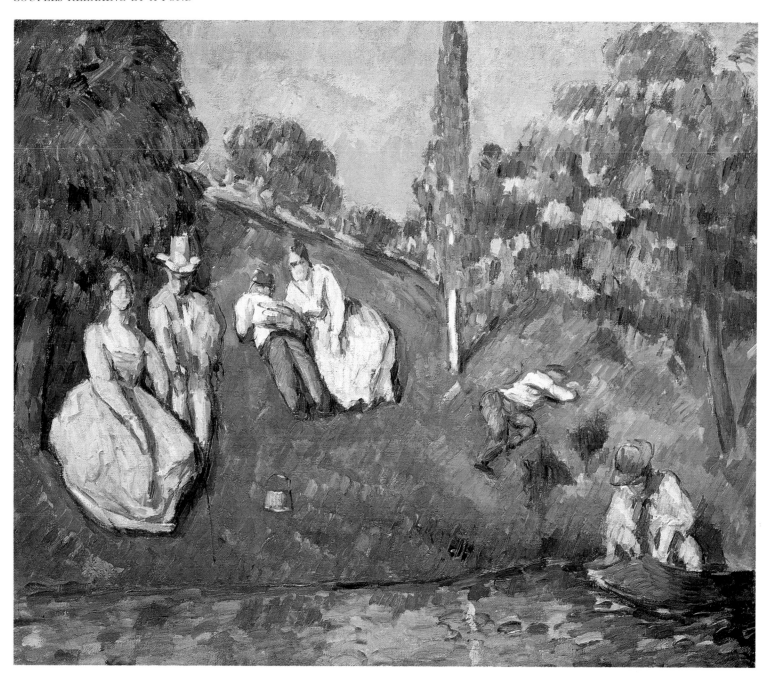

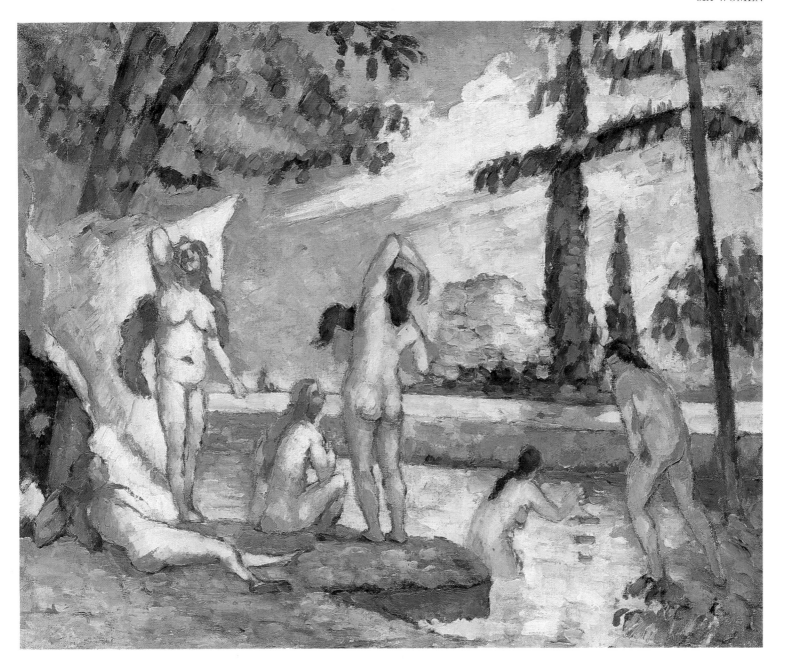

VENUS AND CUPID

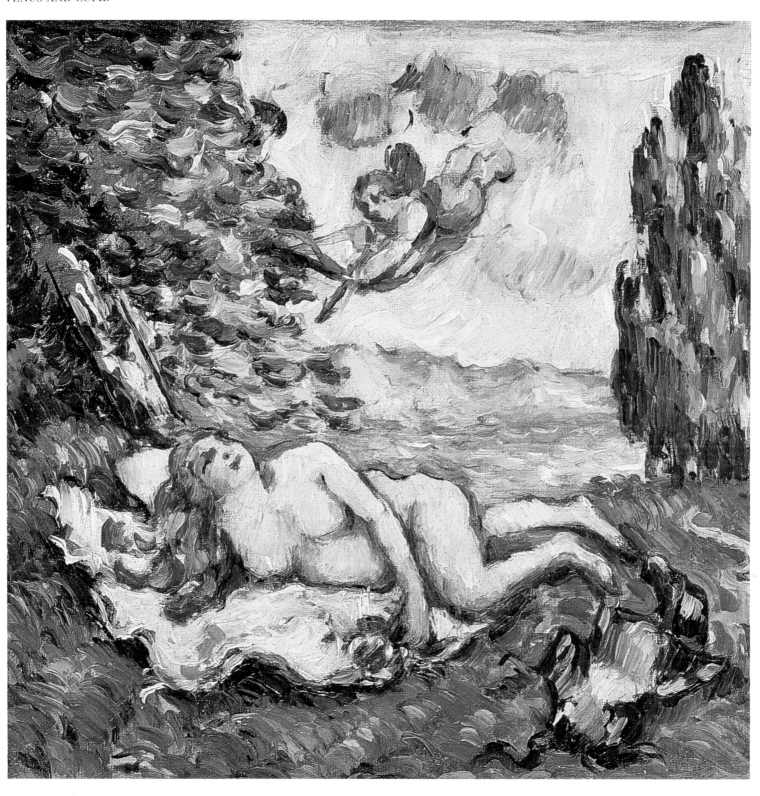

VENUS, OR RECLINING NUDE

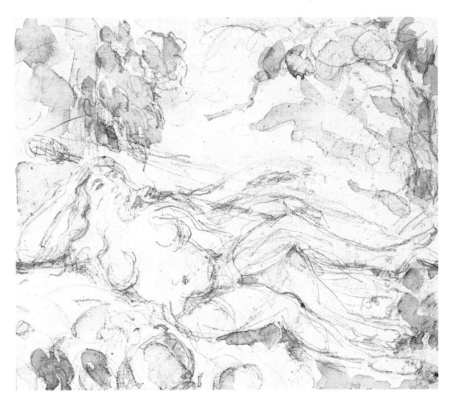

THREE BATHERS

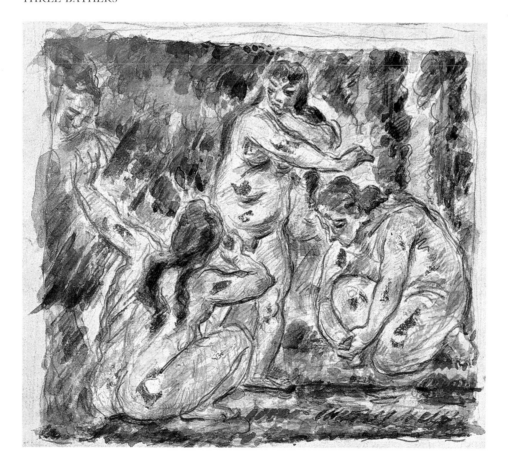

THREE BATHERS

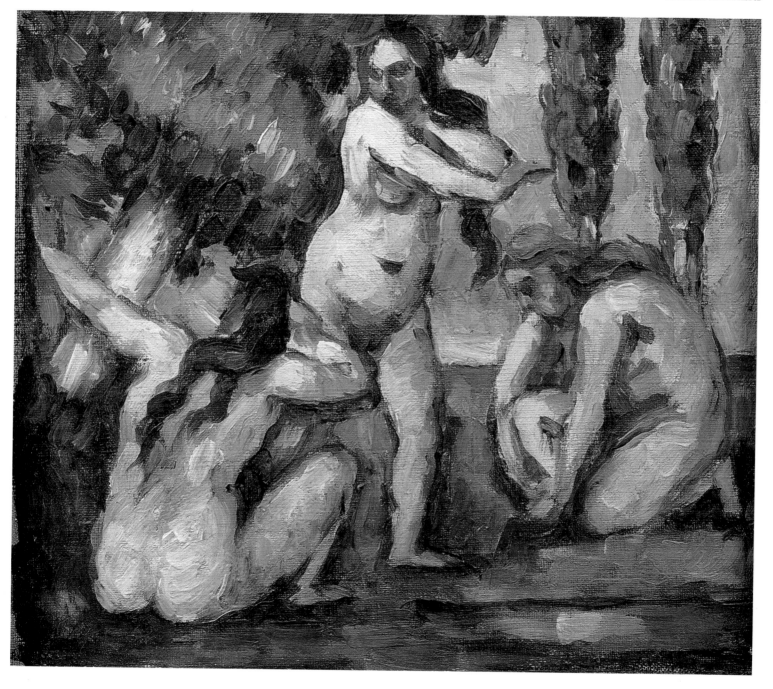

THE BATTLE OF LOVE

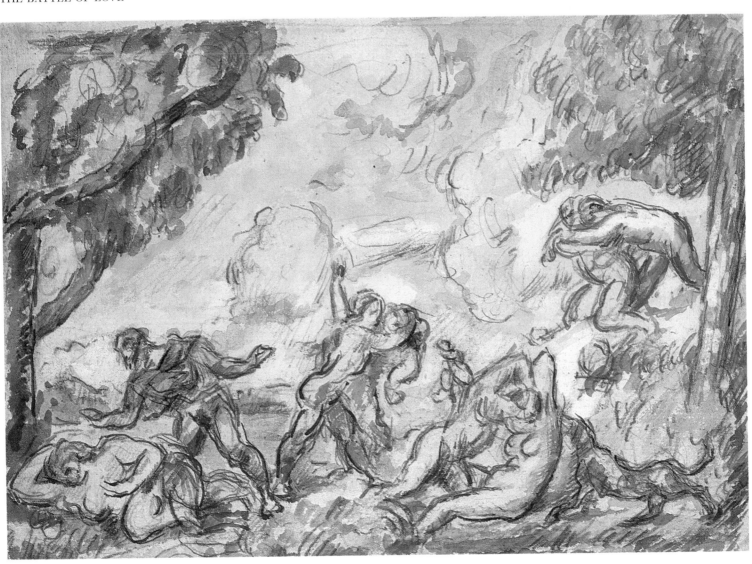

THE BATTLE OF LOVE

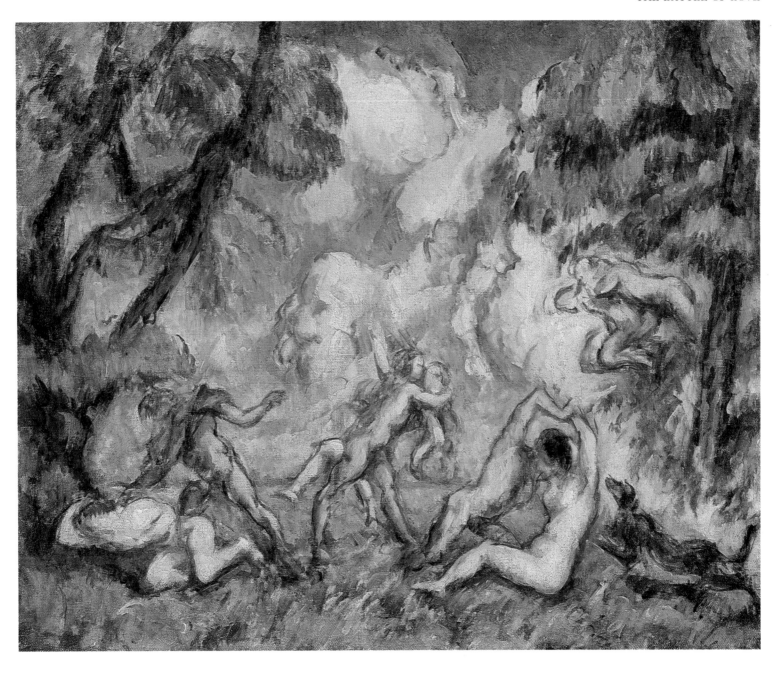

BATHERS

YOUNG MAN IN MOVEMENT, BESET BY RATS

SUGAR BOWL, STUDIES OF A BATHER

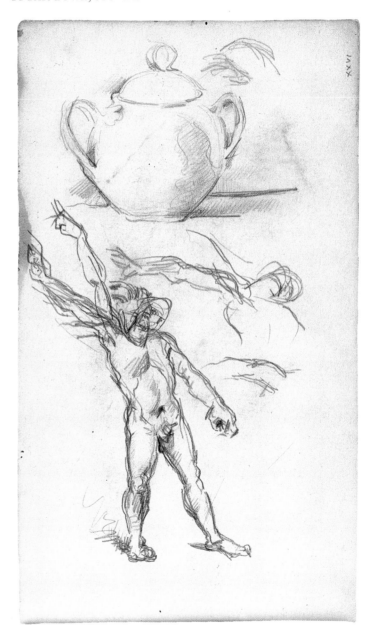

STUDIES AND PORTRAITS OF THE ARTIST'S SON

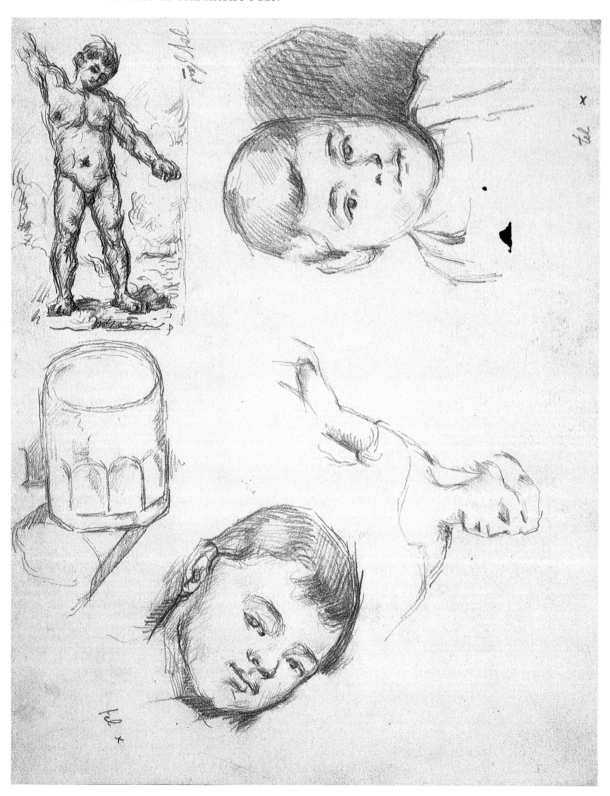

MAN STANDING, ARMS EXTENDED

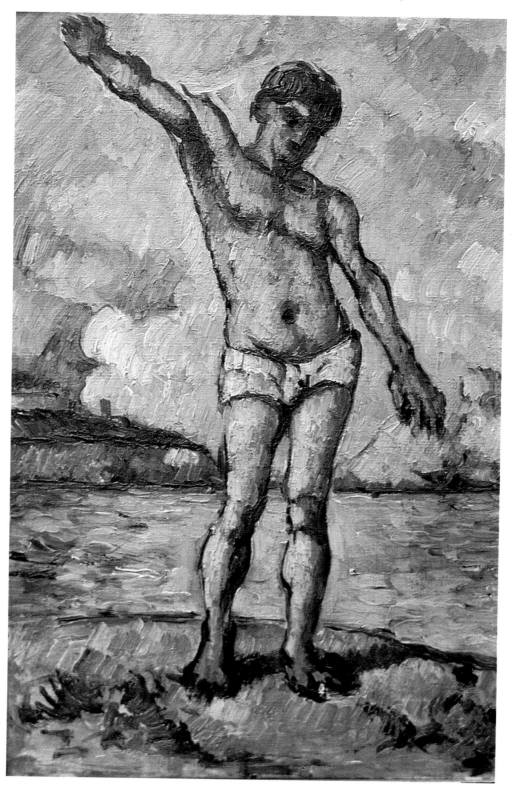

AFTER DELACROIX—ALLEGORICAL FIGURE OF A RIVER

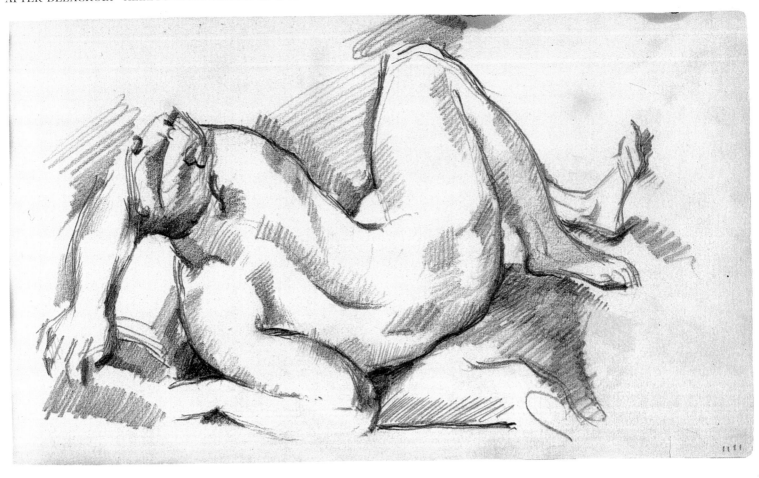

AFTER L'ÉCHORCHE

AFTER RUBENS—THREE NAIADS

FIVE BATHERS

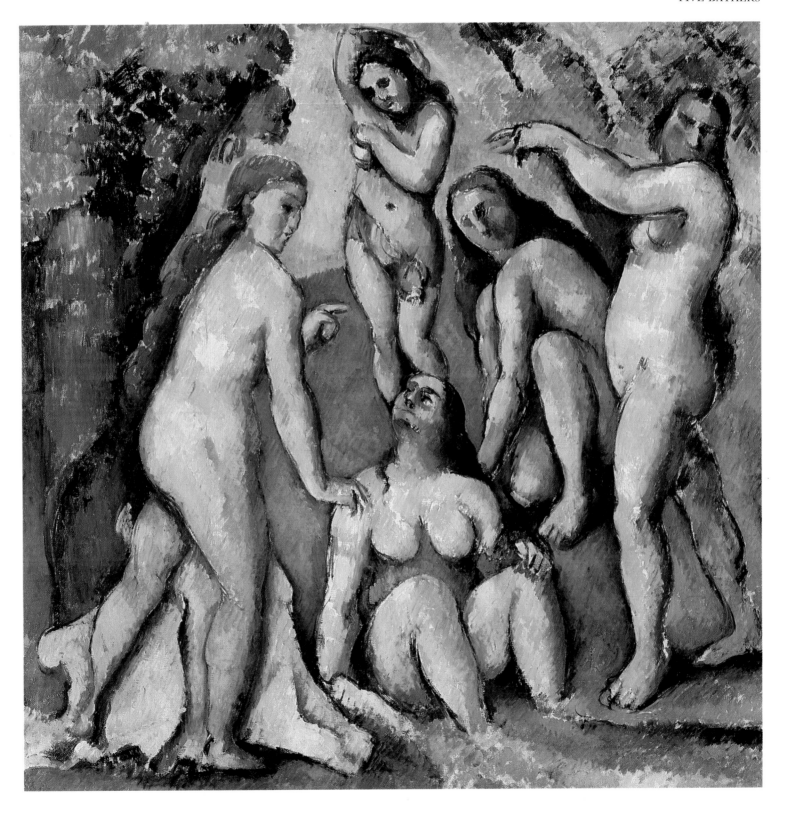

THE AVENUE AT THE JAS DE BOUFFAN

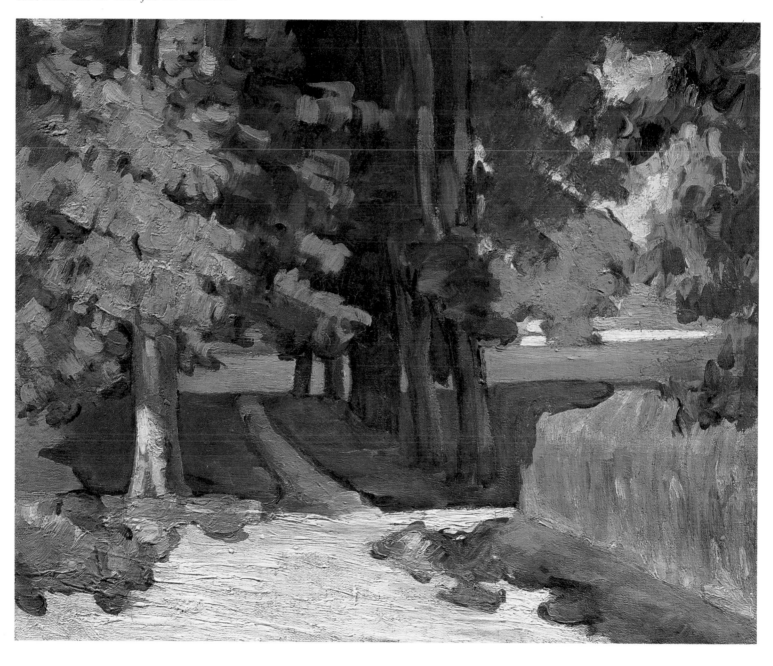

THE ÉTANG DES SOEURS AT OSNY

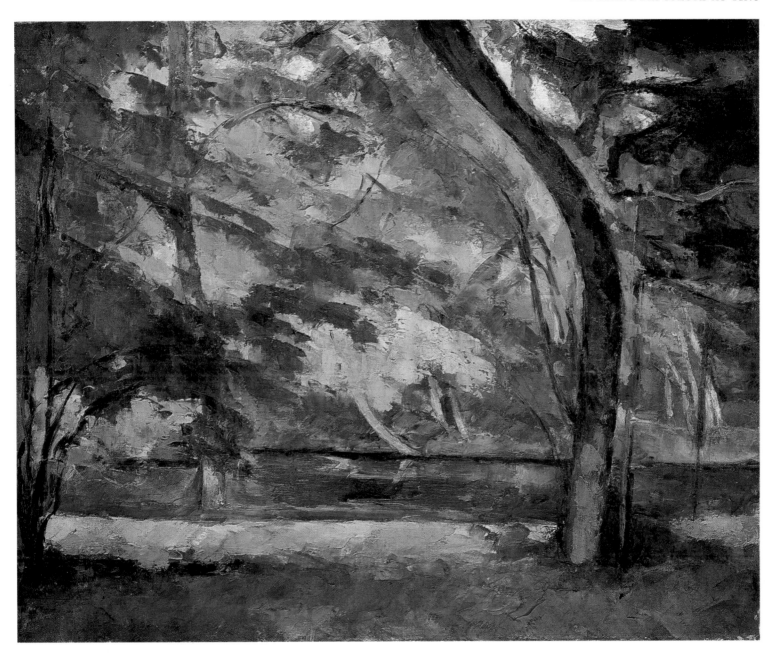

TURN IN THE ROAD

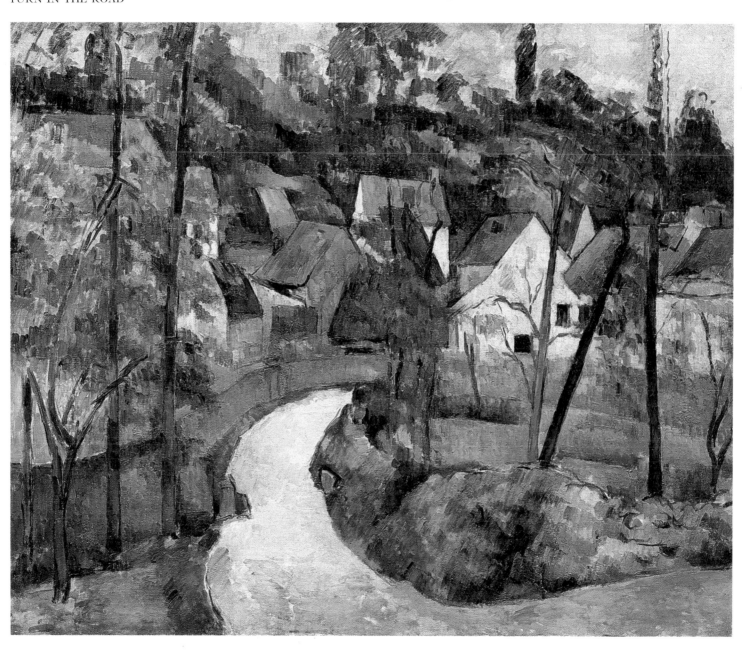

ROAD, TREES AND LAKE

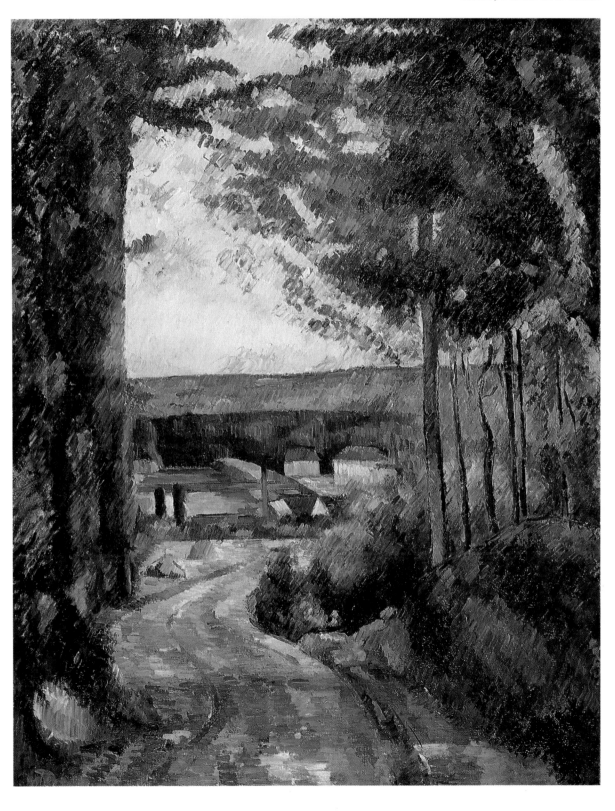

ROCKS AT L'ESTAQUE

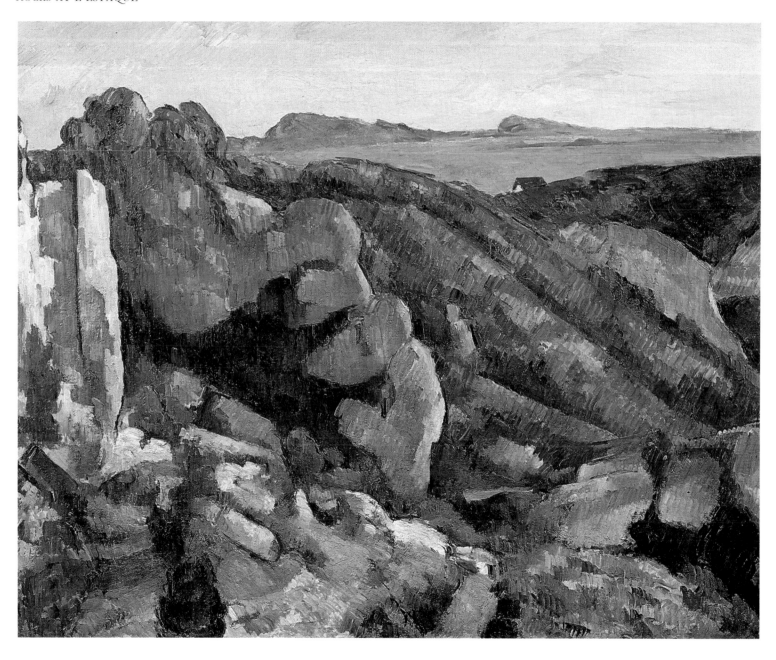

LANDSCAPE IN PROVENCE

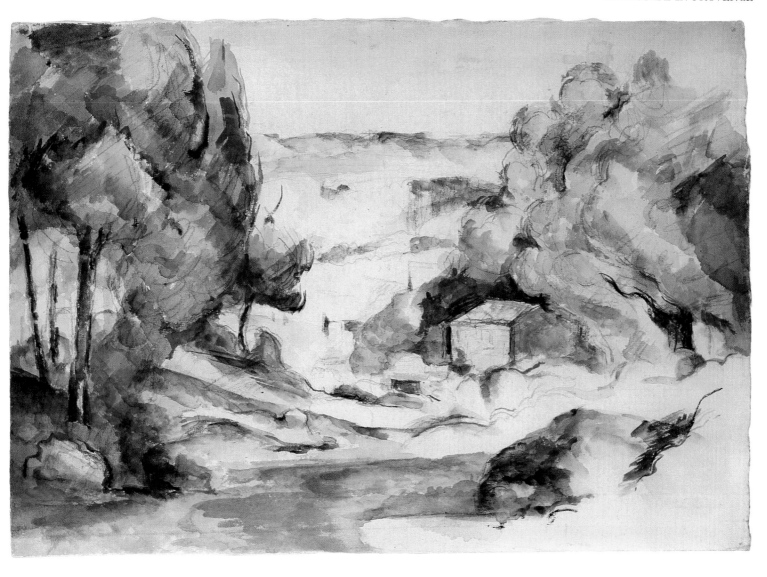

LANDSCAPE

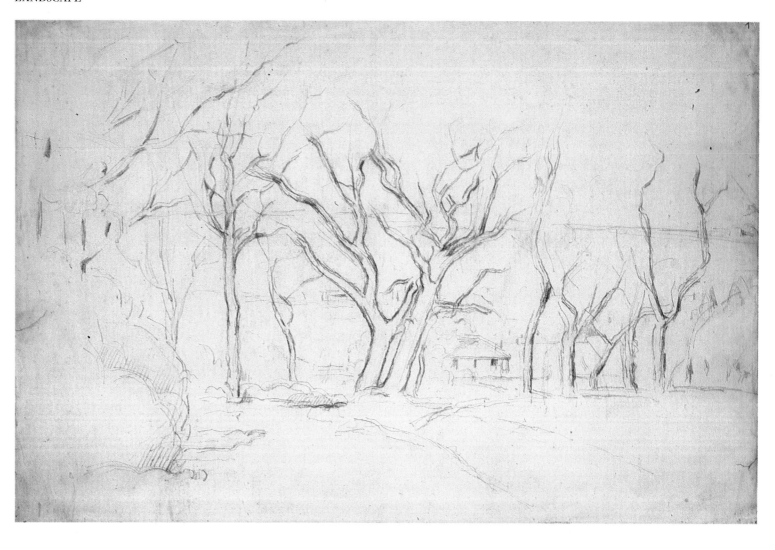

MELTING SNOW, FONTAINEBLEAU

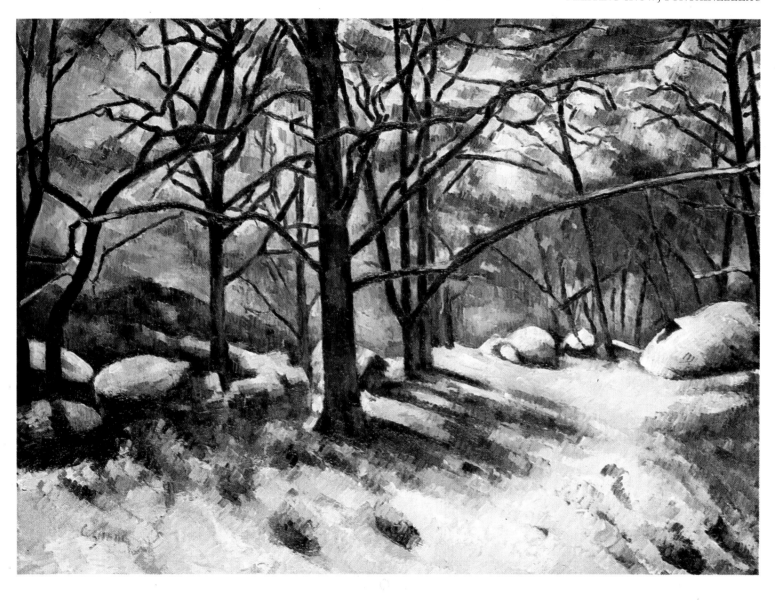

VIEW THROUGH TREES, L'ESTAQUE

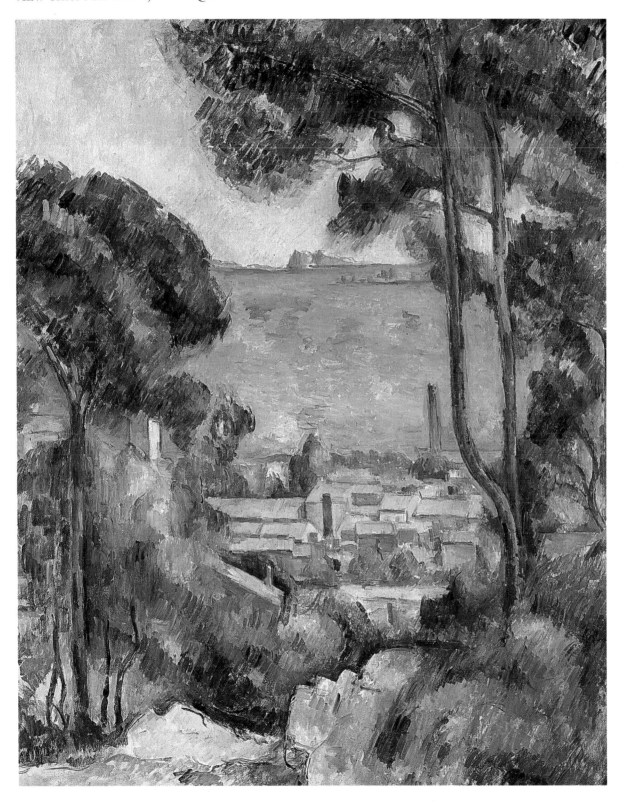

THE CHÂTEAU AT MEDAN

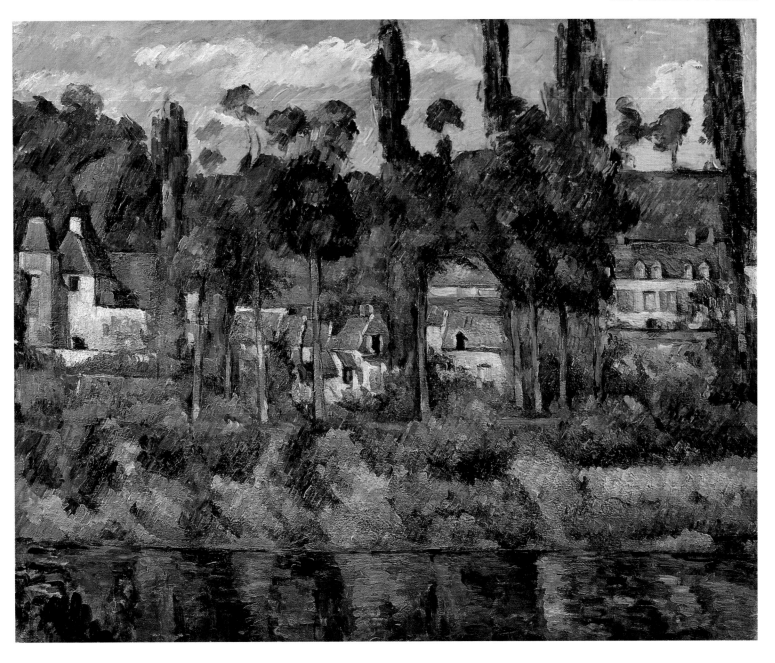

THE GULF OF MARSEILLES SEEN FROM L'ESTAQUE

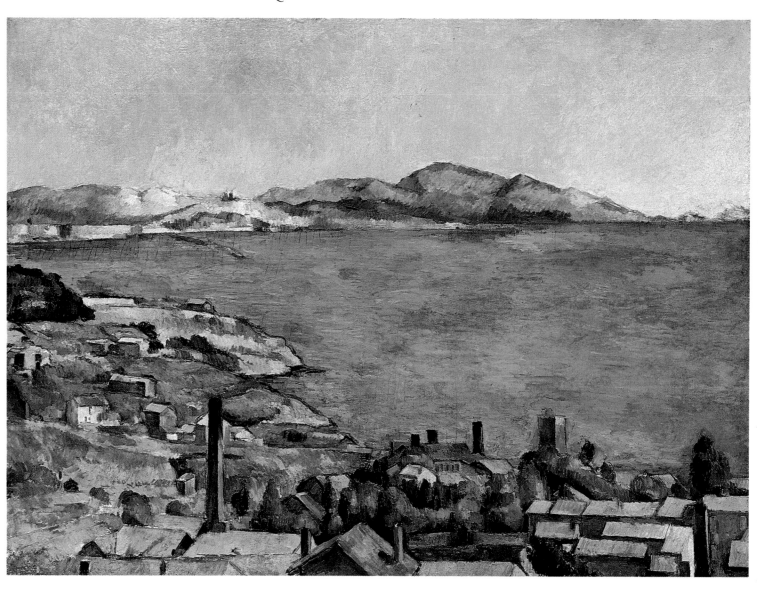

THE BAY OF MARSEILLES

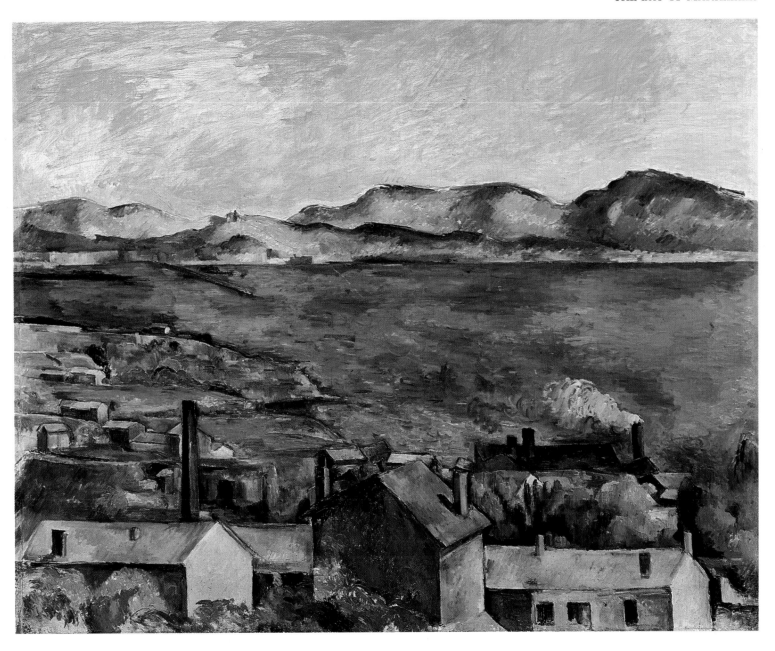

L'ESTAQUE AND THE GULF OF MARSEILLES

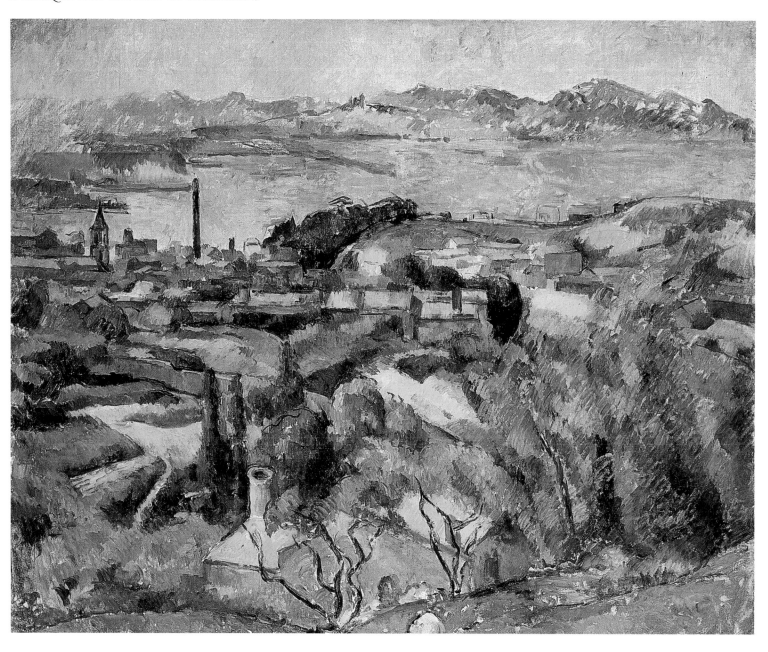

HOUSES IN PROVENCE

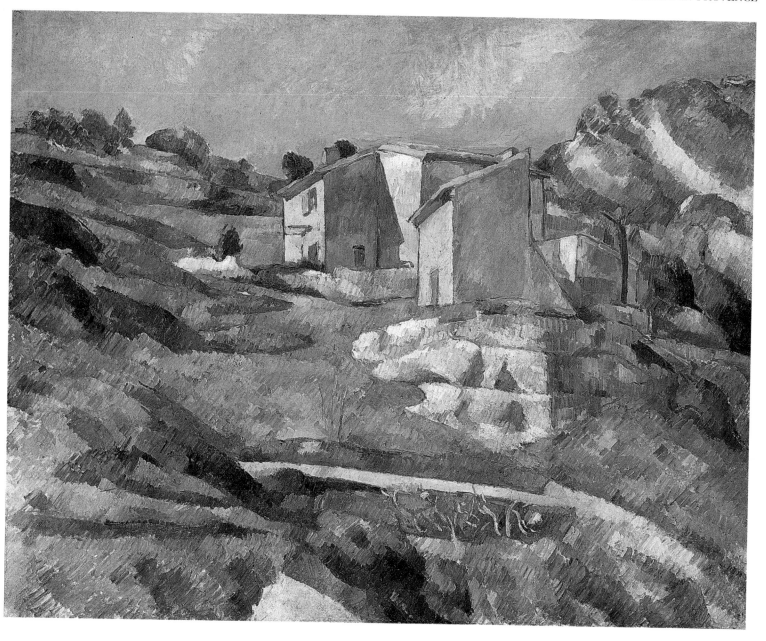

TREES

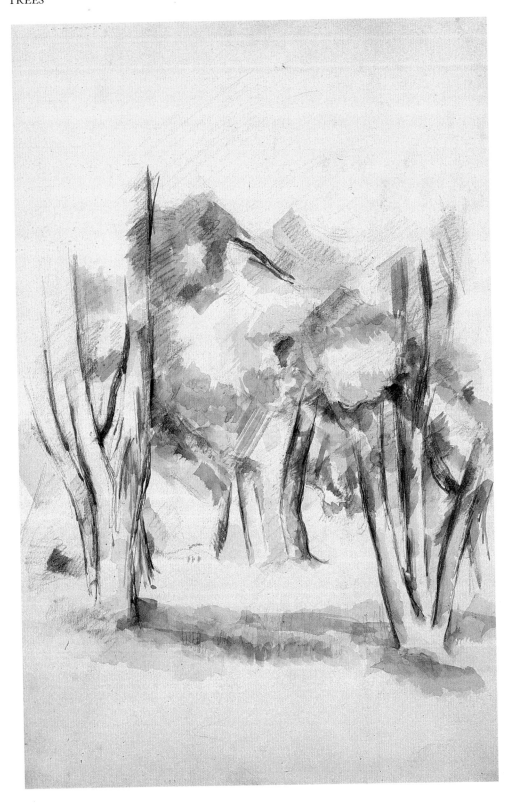

LANDSCAPE WITH TREES

ORCHARD

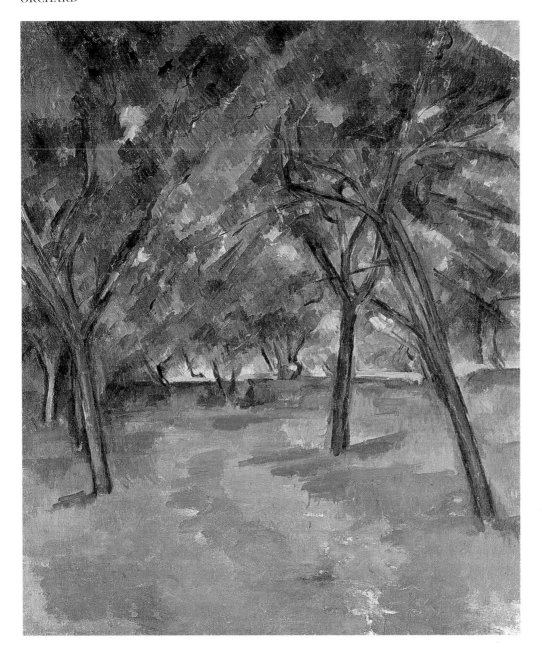

TALL TREES AT THE JAS DE BOUFFAN

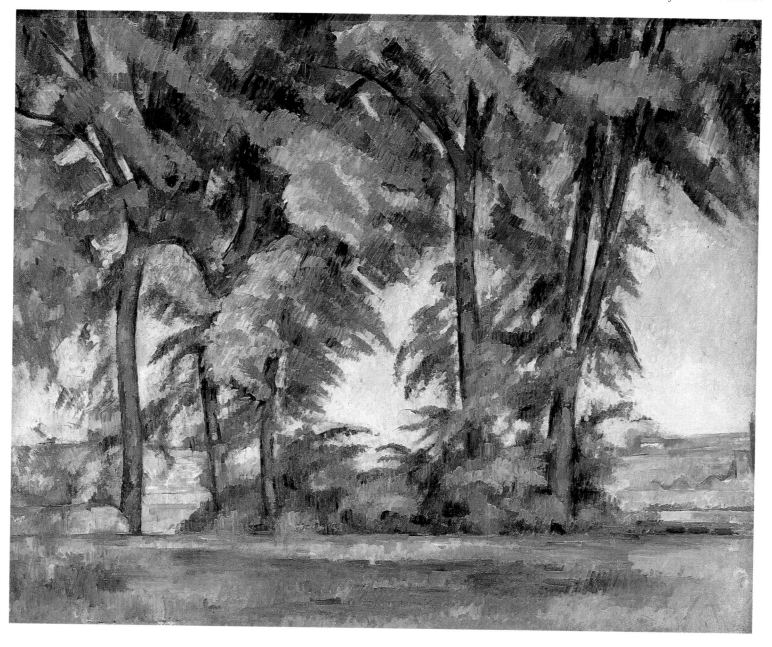

TREES AND HOUSES

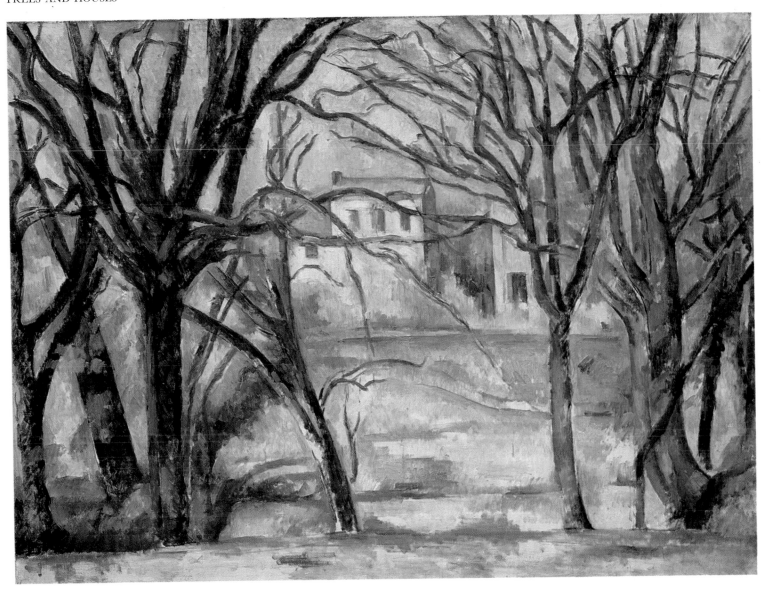

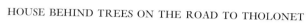

HOUSE BEHIND TREES ON THE ROAD TO THOLONET

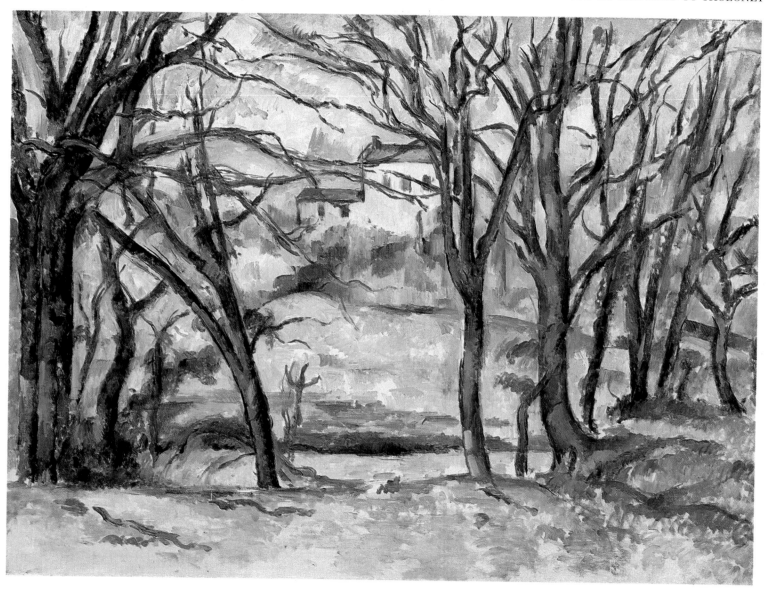

MONT SAINTE-VICTOIRE

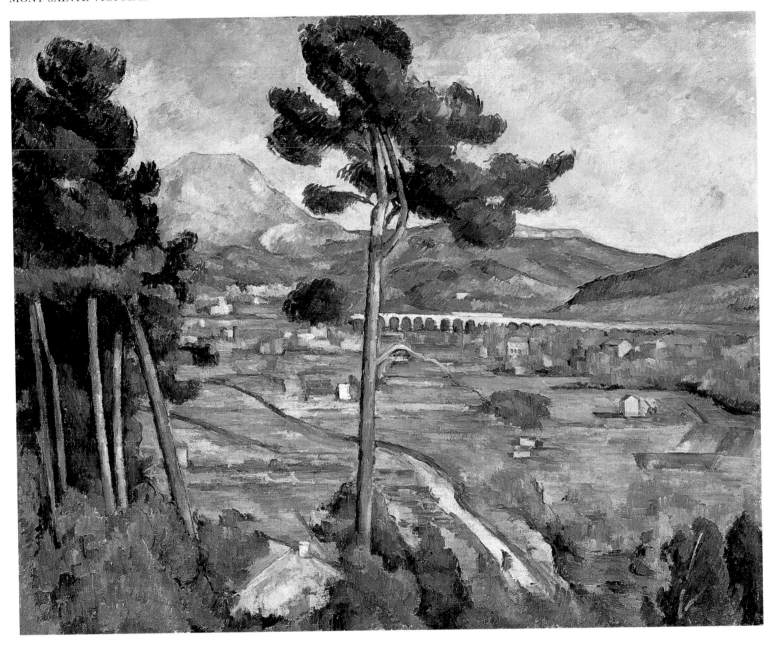

MONT SAINTE-VICTOIRE

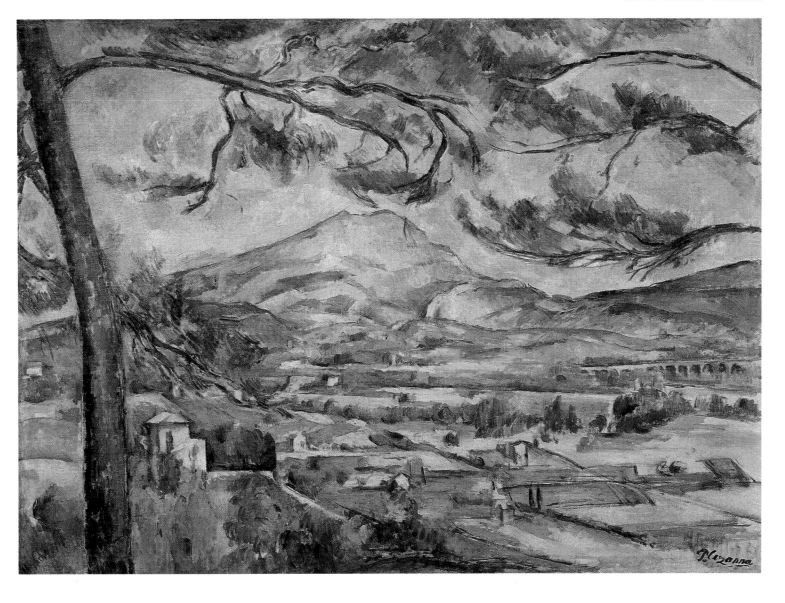

MOUNTAINS IN PROVENCE

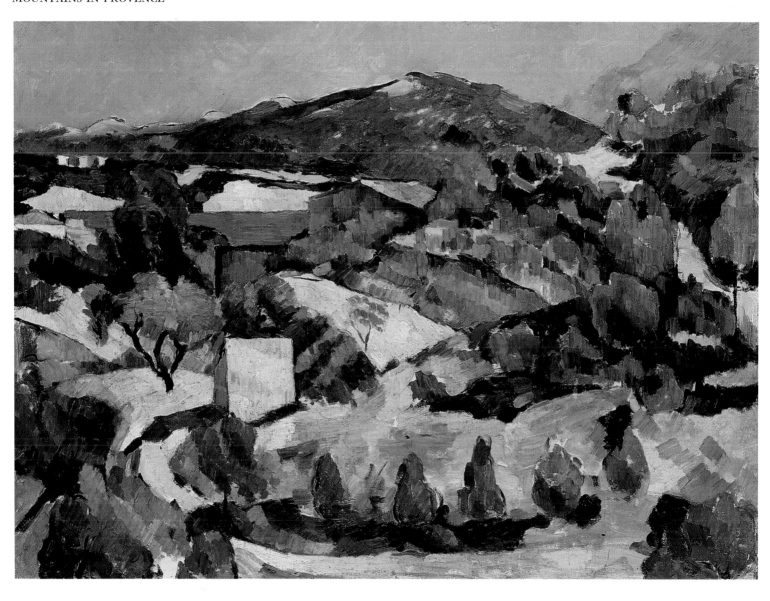

MOUNTAINS IN PROVENCE

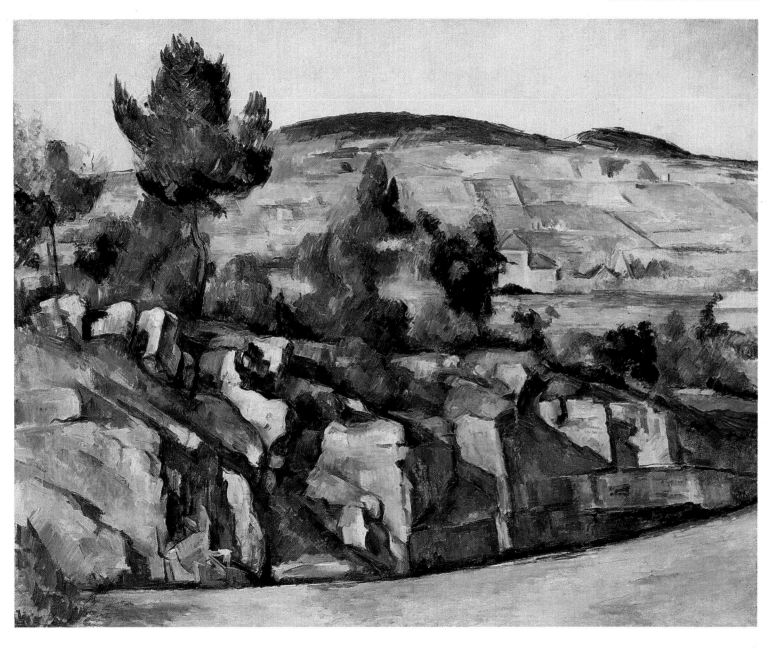

The Years of Maturity, 1886–1897

The death of his father in 1886 meant that Cézanne's financial troubles were at an end. His substantial inheritance allowed him to look after his family, travel freely and pursue his commitment to painting without outside interference. The journeys away from Aix continued, with long spells in rented studios in Paris and sporadic residences with his wife and son in Provence. In the summer of 1890, Cézanne took Hortense and Paul on an extended visit to Switzerland, spending enough time in the lakes and mountains to make the artist write longingly in his letters of the sunshine and the earth of Provence. Such excursions were exceptional, however, and Cézanne preferred to spend his days in solitary pursuit of those ambitions in painting which were as vivid to him as they were obscure to others.

Cézanne's estrangement at this time from his childhood friend Zola was to haunt him for a number of years, and it is said that he wept and locked himself away for a whole day when he heard of Zola's death in 1902. The termination of this friendship also meant the end of an important source of information about their lives, the exchange of letters between them; and it was not until the last decade of Cézanne's life that he was to find correspondents to whom he could write so frankly and so fulsomely. The surviving letters from this period are relatively scarce and brief, but in a number of ways they record Cézanne's changing circumstances and developing maturity as an artist. He writes to fellow artists and literary figures, to admirers and collectors; his growing celebrity is reflected in a correspondence with Gustave Geffroy, an influential critic; and there is a single tantalizing reference to Ambroise Vollard, arguably the most instrumental figure in Cézanne's late career. Nothing survives of the crucial correspondence that must have taken place between Vollard and Cézanne around 1895, as the young Parisian picture-dealer prepared to present the first exhibition of Cézanne's paintings in his new gallery; but that event marks the long-awaited turn in the tide for Cézanne's reputation and the beginning of his acceptance by the artistic establishment and the public at large.

The same confidence that emerges from his letters also distinguishes the paintings, drawings and watercolours of the late 1880s and early 1890s. There is a robustness, an ambition and a clarity about these pictures that suggest an artist coming to terms with his own 'temperament' (to use one of Cézanne's favourite terms) and beginning to 'realize' (to use another) on canvas his powerful sensations of the world. Many of Cézanne's most distinctive subjects, like Mont Ste-Victoire and the Card-Players, made their definitive appearance at this time, and the well-established themes of the still life and the family portrait achieved a new amplitude and monumentality. Whether using watercolour or oil paint, Cézanne contrived to explore the subtle dialogue between colour and form, the tensions between deeply recessed space and the flat pattern of the canvas surface, the familiar textures and experiences of his modest surroundings.

The series of Card-Players, produced between about 1890 and 1892, are some of Cézanne's most resolved and majestic paintings, elevating a casual and universal pastime to epic status. Apparently artless, these compositions revolve around a dense pattern of symmetries and contrasts: a large, bulky figure sets off an angular one; the tones of a silhouetted face are reversed in its mirror-image; an off-centre bystander is balanced against a pipe-rack, a curtain and a patch of sunlight. In each of the pictures a table lies parallel to the containing wall and the canvas surface, and every other object must strongly assert its volume against this grid. A rich interplay of colours, gestures and a massiveness subtly conjured up remind us of the hard-won mastery that Cézanne had achieved in his thirty years as a painter.

A still life of the same date, such as Basket with Apples, Bottle, Biscuits and Fruit *(Art Institute of Chicago) has a comparable clarity and a sense of elaborate pictorial relationships firmly resolved. His* Pot of Flowers and Pears *(c.1890, Courtauld Collection) emphasizes how delicate an artist Cézanne could be, relishing minute shifts of tone and colour within the dullest of neutral greys, and finely circumscribing the edge of a leaf or a piece of fruit. These still lifes also show how demanding Cézanne's relationship with nature and with perception had become, and the extent to which he would manipulate his subject in order to convey that relationship. A close examination of the Courtauld picture reveals two pieces of fruit with improbably geometric contours, a number of imperfect ellipses in the plate and flower-pot and a horizontal table-top, the shape of which is adapted wilfully according to the surrounding forms. Paradoxically, Cézanne has found it necessary to depart from reality in order to be truthful to it, to accentuate, to suppress, to break down and to reassemble the complex experience of three-dimensional vision on a two-dimensional canvas.*

Something of the originality and complexity of Cézanne's artistic enterprise had gradually communicated itself to his contemporaries, and his letters reflect the beginnings of a serious interest in his work. Octave Maus, organizing an exhibition of avant-garde French painting in Brussels in 1890, persuaded Cézanne to exhibit three paintings, while two young writers, Phillippe Solari and Joachim Gasquet, made his acquaintance and began a correspondence with him. Even more significantly, the critic Gustave Geffroy and the dealer Ambroise Vollard joined the ranks of his admirers, and Cézanne repaid the compliment to both men by embarking on their portraits. The letters to Geffroy and Monet record Cézanne's first approaches to the critic and his subsequent abandonment of his portrait, characteristically chastising himself for his lack of resolution and the 'meagre results' obtained. Vollard's autobiographical account, one of the fullest records of Cézanne at work on a painting, emphasizes the unpredictable and occasionally violent nature of Cézanne, endlessly frustrated by the complexity of his own ambition and by his awareness that 'Perception of the model and its realization are sometimes very long in coming. . . '.

Paris, 20 June, 1889

To Count Armand Doria

You were so kind as to promise M. Chocquet that the *Maison du Pendu* [*The House of the Hanged Man*], could be exhibited; this is the title which has been given to a landscape I painted in Auvers. Just now I learn that Monsieur Antonin Proust has admitted the painting for exhibition. Please be good enough to send the little picture to the Palais des Beaux-Arts for the World Exhibition.

Thanking you sincerely, I remain,

Yours respectfully, PAUL CÉZANNE

*

Paris, 27 November, 1889

To Octave Maus

Having learnt the contents of your flattering letter, I should like to thank you in the first place and to accept with pleasure your kind invitation.

May I, however, be permitted to refute the accusation of disdain which you attribute to me with reference to my refusal to take part in the exhibitions of painting?

I must tell you with regard to this matter, that as the many studies to which I have dedicated myself have given me only negative results, and as I am afraid of only too justified criticism, I had resolved to work in silence until the day when I should feel myself able to defend theoretically the result of my attempts.

However, in view of the pleasure in finding myself in such good company, I do not hesitate to modify my resolve and I beg you, Monsieur, to accept my thanks and friendly greetings.

PAUL CÉZANNE

*

Paris, 18 December, 1889

To Victor Chocquet

I am going to ask a favour of you, always provided that the idea which I have had seems acceptable to you. Asked by the Association des Vingts of Brussels to take part in their exhibition, and finding myself caught unprepared, I am venturing to ask you for the *Maison du Pendu* to be sent to them. I allow myself to enclose with these lines the first letter received from Brussels, which will make clear to you my position with regard to this association, when I add that I have consented to their friendly request.

Please accept, Monsieur Chocquet, my warmest greetings, and give Madame Chocquet my respects.

The mother and the little one join me in this.

Your grateful PAUL CÉZANNE

*

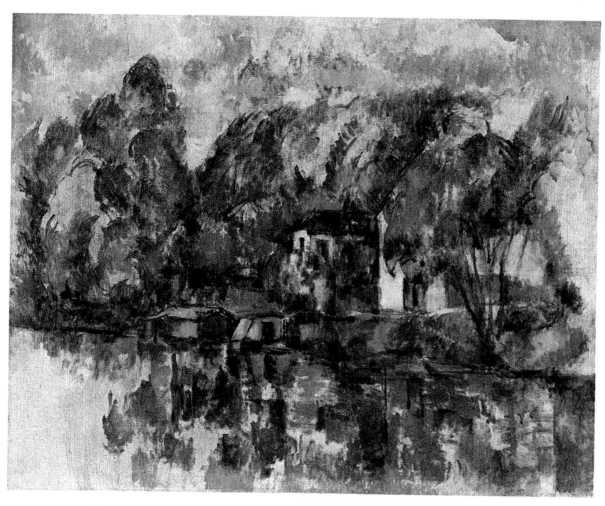

AT THE WATER'S EDGE

<div align="right">Paris, 21 December, 1889</div>

To Octave Maus

I have written to Tanguy to find out which of my studies it was that he had sold to M. de Bonnières. He was unable to give me any details. I am therefore asking you to catalogue this picture as: *Etude de Paysage*. Further, taken unawares, I turned to M. Chocquet who is at the moment out of Paris, and he immediately placed at my disposal: *Une Chaumière à Auvers-sur-Oise*. But this picture is without a frame, as the one ordered by M. Chocquet (carved wood) is not yet ready. If you have in your possession some old frame to put on it, you would be doing me a great favour. It is a canvas of usual measurements, size 15. Finally, I am sending you a picture: *Esquisse de Baigneuse* the frame of which I have sent to M. Petit.

Please accept, Monsieur, my warmest greetings.

<div align="right">P. Cézanne</div>

<div align="center">*</div>

Paris, 15 February, 1890

To Octave Maus I should like to thank you for sending me the catalogue of
the exhibition of the 'Vingts'; I do so all the more warmly because I had made up my mind to
ask you to be kind enough to send me a copy.

Permit me to express my heartiest congratulations for the *aspect pittoresque* [sic] and most
successfully planned design that you gave this charming little booklet.

Please accept, Monsieur, my sincerest thanks and my most cordial greetings.

PAUL CÉZANNE

*

Alfort, 26 March, 1894

To Gustave Geffroy I read yesterday the long study that you devoted to
throwing light on the efforts I have made in painting. I wish to express my gratitude for the
understanding that I find in you.

PAUL CÉZANNE

*

[*Draft, in one of Cézanne's sketchbooks*]
21 September, 1894

To a Merchant of Colours and Artists' Materials at Melun

Yesterday, the 20th inst., I bought four canvases from you
of which three are size 20 and one size 25. – The first three cost 2 fr. 50, the one of 25 costs 2
fr. 80. The total therefore should be 10 fr. 30, and not 11 fr. 50 which I paid by mistake.

I take it you will refund me this on my next journey to Melun.

*

Paris, 31 January, 1895

To Gustave Geffroy I have continued to read the essays which make up your
book *Le Coeur et l'Esprit* in which you were kind enough to write a dedication with so much
sympathy towards me. Now in continuing my reading, I have learnt to understand the honour
that you have shown me. I am asking you to preserve for me in the future this sympathy
which is precious to me.

PAUL CÉZANNE

*

Paris, 4 April, 1895

To Gustave Geffroy The days are lengthening, the temperature is growing
milder. I am unoccupied every morning until the hour when civilized man sits down to lunch.
I intend coming up to Belleville to shake your hand and to submit to you a plan which I have
now embraced, now abandoned and to which I sometimes return . . .

Very cordially yours, PAUL CÉZANNE, painter from inclination.

*

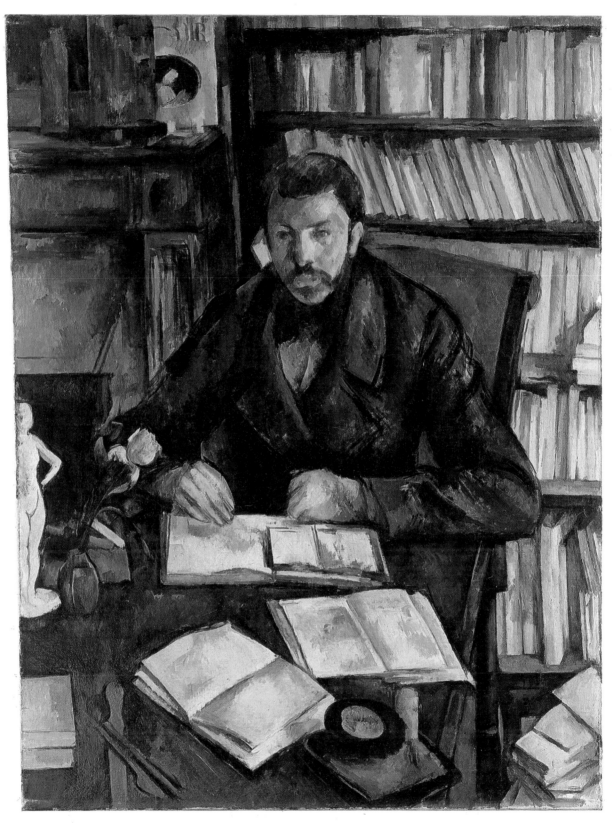

PORTRAIT OF GUSTAVE GEFFROY

Paris, 12 June, 1895

TO GUSTAVE GEFFROY As I am about to depart and cannot bring to a satisfactory
conclusion the work which surpasses my strength and which I was wrong to undertake, I
would like to ask you to excuse me and to hand over to the messenger whom I shall send to
you, the things which I have left in your library.

Please accept the expression of my regret and of my esteem.

P. CÉZANNE

*

[*Aix*] Jas de Bouffan, 5 July, 1895

TO FRANCISCO OLLER The high-handed manner you have adopted towards me
recently and the rather brusque tone you permitted yourself to use at the moment of your
departure are not calculated to please me.

I am determined not to receive you in my father's house.

The lessons that you take the liberty of giving me will thus have borne their fruit.
Good-bye.

P. CÉZANNE

*

Aix, 6 July, 1895

TO CLAUDE MONET I had to leave Paris, as the date fixed for my journey to Aix
had arrived. I am with my mother, who is far on in years and I find her frail and alone.

I was forced to abandon for the time being the study that I had started at the house of
Geffroy, who had placed himself so generously at my disposal, and I am a little upset at the
meagre result I obtained, especially after so many sittings and successive bursts of enthusiasm
and despair. So here I am then, landed again in the South, from which I should, perhaps, never
have separated in order to fling myself into the chimerical pursuit of art.

To end, may I tell you how happy I was about the moral support received from you, which
served as a stimulus for my painting. So long then, until my return to Paris, where I must go
to continue my task, as I promised to Geffroy.

Greatly regretting that I had to leave without seeing you again, I remain, cordially yours,

PAUL CÉZANNE

*

Aix, 30 April, 1896

TO JOACHIM GASQUET
I met you this evening at the bottom of the *cours*, you were accompanied by Mme Gasquet. If I am not mistaken, you appeared to be very angry with me.

Could you see inside me, the man within, you would be so no longer. You don't see then to what a sad state I am reduced. Not master of myself, a man who does not exist – and it is you, who claim to be a philosopher, who would cause my final downfall? But I curse the Geffroys and the few characters who, for the sake of writing an article for 50 francs, have drawn the attention of the public to me. All my life I have worked to be able to earn my living, but I thought that one could do good painting without attracting attention to one's private life. Certainly, an artist wishes to raise himself intellectually as much as possible, but the man must remain obscure. The pleasure must be found in the work. If it had been given me to realize my aim, I should have remained in my corner with the few studio companions, with whom we used to go out for a drink. I still have a good friend from that time, well, he has not been successful, which does not prevent him from being a bloody sight better painter than all the daubers, with their medals and decorations which bring one out in a sweat, and you want me at my age to believe in anything? Anyway, I am as good as dead. You are young, and I can understand that you wish to succeed. But for me, what is there left for me to do in my situation; only to sing small; and were it not that I am deeply in love with the landscape of my country, I should not be here.

But I have bored you enough as it is, and now that I have explained my position to you, I hope you will no longer look at me as if I had made an attempt upon your personal security.

Please accept, dear sir, also in consideration of my great age, the expression of my warmest feelings and best wishes.

PAUL CÉZANNE

*

Talloires, 21 July, 1896

TO JOACHIM GASQUET
Here I am, away from our Provence for some time. After quite a lot of toing-and-froing, my family, in whose hands I find myself at the moment, has made up my mind for me to settle down for the time being where I am. It's a temperate zone. The height of the surrounding mountains is quite considerable, the lake which is here narrowed by two tongues of land seems to lend itself to the linear exercises of the young English miss. It is still nature, of course, but a little bit as we have learned to see it in the travel sketchbooks of young ladies.

Always energetic, you, with your magnificent mental capacity, work incessantly and without too much fatigue. I am too remote from you, through my age and the knowledge which you acquire every day; nevertheless, I commend myself to you and your kind remembrance so that the links which bind me to this old native soil, so vibrant, so austere, reflecting the light so as to make one screw up one's eyes and filling with magic the receptacle of our sensations, do not snap and detach me, so to speak, from the earth whence I have imbibed so much even without knowing it. It would therefore be a real act of kindness and a comfort to me if you would be good enough to continue to send me your *Revue*, which would remind me of my distant land and of your lovable youth, in which I was allowed to take part. When I was last in Aix, I was sorry not to see you. But I have learnt with pleasure that Mme

Gasquet and you yourself have presided over a number of regional and meridional festivities.

In finishing, I shall ask you to give my respects to the Queen of Provence, to remember me to your father and the other members of your family and to permit me to remain cordially yours,

PAUL CÉZANNE

Address: Hotel de l'Abbaye,

Talloires par Annecy (Haute-Savoie).

It would require the pen of Château [briand], to give you an idea of the old monastery where I am staying.

*

Talloires, 23 July, 1896

TO PHILIPPE SOLARI When I was at Aix it seemed to me that I should be better elsewhere, now that I am here, I think with regret of Aix. Life for me is beginning to be of a sepulchral monotony. – I went to Aix three weeks ago, I saw Père Gasquet there, his son was at Nîmes. In June I spent a month at Vichy, one eats well there. Here, one doesn't eat badly either. – I am staying at the Hotel de l'Abbaye. – What a superb remnant of ancient times: – an open staircase 5 metres wide, a magnificent door, an interior courtyard with columns forming a gallery all round; a wide staircase leading up, the rooms look out on to an immense corridor, and the whole thing is monastic. – Your son will no doubt soon be in Aix. Tell him about my memories, of what we recall of our walks to Peirières, to Ste-Victoire and if you see Gasquet, who must be revelling in the joys of regained fatherhood, give him my love.

Remember me to your father and give him my respects.

To relieve my boredom, I paint; it is not much fun, but the lake is very good with the big hills all round, 2000 metres so they say, not as good as our home country, although without exaggeration it really is fine. – But when one was born down there, it's all lost – nothing else means a thing. One should have a good stomach and get roaring drunk; 'the vine is the mother of the wine' thus Pierre, do you remember? And to think that I'm going to Paris at the end of August. When shall I see you again? If your son should pass Annecy on his way back let me know.

A good strong handshake.

Your old, PAUL CÉZANNE

*

Paris, 29 September, 1896

TO JOACHIM GASQUET Here I am, rather late, confirming receipt of the friendly missive in which you have had the kindness to send me the last two numbers of the *Mois Dorés*. But on returning to Paris from Talloires, I have sacrificed quite some days in order to find a studio in which to spend the winter. Circumstances, I greatly fear, will keep me for some time in Montmartre, where my place of work is situated. I am a gunshot away from Sacré-Coeur, whose campaniles and clock-towers rise into the sky.

At the moment I am re-reading Flaubert, interrupting him while I leaf through the *Revue*. I am in danger of repeating myself frequently; it is fragrant with Provence. Reading you, I see

you again and when my head becomes calmer I think of the brotherly sympathy which you have shown me. I could not say that I envy you your youth, that is impossible, but your vigour, your inexhaustible vitality.

I thank you warmly, therefore, that you do not forget me now that I am far away.

Please remember me to your father, my old schoolmate, and give my respects to the Queen who presides so magnificently over the renewal of Art which awakens in Provence.

For yourself, accept the expression of my warmest sentiments and good wishes for your continued success.

Always yours, PAUL CÉZANNE

P.S. Unfortunately I have to tell you that Vollard has been unsuccessful in placing the drawings of M. Heiriès. He maintains that he has made several fruitless attempts because of the difficulty of finding an outlet, so small is the demand for book illustrations. I shall ask for the drawings to be returned to me and forward them to you with great regret.

PAUL CÉZANNE

*

[*Fragment*]
[*Date unknown*]

TO A YOUNG ARTIST (friend of Joachim Gasquet) . . . I have perhaps come too early. I was the painter of your generation more than of my own . . . You are young, you have vitality; you will impart to your art an impetus which only those who have emotion can give. I, I feel I am getting old. I shall not have the time to express myself . . . Let's work! . . .

Perception of the model and its realization are sometimes very long in coming . . .

*

Paris, 13 January, 1897

TO ANTOINE GUILLEMET Confined to my room for a fortnight by a persistent attack of influenza, I didn't receive until the day before yesterday the letter in which you gave me a rendezvous and the card which confirmed your good visit. So I want to tell you how very sorry I am that I was unable to be in my studio when you came to see me, and to say how very annoyed I am at the bad luck which prevented me from letting you know the condition I was in and that I should be unable to go to the studio.

Please accept my apologies for this, and believe me most cordially yours,

PAUL CÉZANNE

*

AFTER THE ANTIQUE

Paris, 30 January, 1897

TO JOACHIM GASQUET

Just now Solari has told me about your project. May I ask you to use all possible roundabout ways demanded by the circumstances to make M. Dumesnil accept the two pictures in question. I would be very happy if the Professor for Philosophy at the faculty of Aix would deign to accept my homage. I can rightly use the argument that in my country I am rather a friend of the arts than a fabricator of pictures and that, on the other hand, it would be an honour for me to know that two of my studies have been accepted in such a respected place, etc. etc. Please develop this argument further using your discretion: I know that you will do it magnificently.

So, that's agreed. And I thank you for the honour which comes to me through your mediation.

Please give all my respects to Mme Gasquet – the Queen, I mean – my best greetings to your father and, believe me, yours gratefully,

PAUL CÉZANNE

P.S. Thank you for the big last number of the *Revue*. And long live Provence.

*

AFTER THE ANTIQUE —
THE BORGHESE MARS

Tholonet, 2 September, 1897

TO EMILE SOLARI

I received your letter of 28 August last. I didn't answer at once. You did in fact announce that you were sending me a review which promised the enticing prospect of some of your poems. I waited several days, but no review . . .

On the other hand it is really very kind of you to remember, in the midst of your Parisian occupations and preoccupations, the all-too-short hours that you spent in Provence; it is true that the great magician, I mean the sun, was of the party. But your youth, your hopes must have contributed not a little to making you see our country in a favourable light. – Last Sunday your father came to spend the day with me – unfortunate man, I saturated him with theories about painting. He must have a good temperament to have withstood it. – But I see that I am going on a bit too long so I send you a cordial handshake, wishing you good luck and au revoir.

PAUL CÉZANNE

*

The Years of Maturity, 1886–1897

<div align="right">Tholonet, 8 September, 1897</div>

To Emile Solari I have just received *L'Avenir Artistique et Littéraire* which you were kind enough to send me. Thank you very much.

Your father is coming to eat a duck with me next Sunday. To be done with olives (the duck I mean). – What a pity that you can't be one of us! Remember me kindly in future ages and allow me to call myself yours very cordially,

<div align="right">P. CÉZANNE</div>

<div align="center">*</div>

<div align="right">Tholonet, 26 September, 1897</div>

To Joachim Gasquet To my great regret I cannot avail myself of your excellent invitation. But as I left Aix this morning at 5 o'clock, I could not return before the end of the day. I have had supper with my mother and the state of lassitude in which I find myself at the end of the day does not allow me to present myself in suitable shape before other people. Therefore, please excuse me.

Art is a harmony which runs parallel with nature – what is one to think of those imbeciles who say that the artist is always inferior to nature?

Most cordially yours, and I promise you to come soon and shake your hand.

<div align="right">P. CÉZANNE</div>

<div align="center">*</div>

From *Cézanne* by Ambroise Vollard

My visit to Cézanne, 1896

At dinner, to which I had been invited, Cézanne was in high spirits. What impressed me especially was his extreme politeness and courtesy when asking the slightest favour. His favourite words seemed to be 'Excuse me!' but, notwithstanding his spirit of courtesy, I guarded my every word with the utmost care, for I was apprehensive lest I should call forth Cézanne's anger, which was always ready to burst out at the slightest provocation. All my precautions, however, did not prevent me from making the much dreaded 'break'. We were talking of Gustave Moreau. I said, 'It seems that he is an excellent teacher.' When I began to speak, Cézanne was in the act of lifting his wine to his lips; he stopped, holding it in mid-air, and cupped the other hand behind his ear, being a little hard of hearing. He got the full force of the word 'teacher'. Its effect was like an electric shock.

'Teacher!' he shouted, setting down his glass so hard that it broke; 'they're all god-damned old women, asses, all of them! They have no guts!'

I was floored. Cézanne himself was speechless for a time after the ruinous outburst he had been guilty of. Then he broke into a nervous laugh and, returning to the subject of Gustave Moreau, went on: 'If that distinguished aesthete paints nothing but rubbish, it is because his dreams of art are suggested not by the inspiration of nature, but by what he has seen in the museums, and still more by a philosophical cast of mind derived from too close an acquaintance with the masters whom he admires. I should like to have that good man under my wing, to point out to him the doctrine of a development of art by contact with nature. It's so sane, so comforting, the only just conception of art. The main thing, Monsieur Vollard, is to get away from the école – from all the schools. Pissarro had the right idea; but he went a little too far when he said that they ought to burn all the necropolises of Art.'

When he had finished, I brought back the name of Verlaine into the conversation . . . Cézanne interrupted me: 'Baudelaire – there's a writer for you. His *Art Romantique* is amazing and he makes no mistakes in the artists that he appreciates.'

Cézanne could not endure either Van Gogh or Gauguin. Emile Bernard relates that, when Van Gogh showed Cézanne one of his canvases and asked him what he thought of it, Cézanne replied, 'You positively paint like a madman.'

And as for Gauguin, he accused him of having tried to 'rob him of his thunder'. So I took occasion to tell Cézanne in this connection how much respect and admiration Gauguin had for him; but Cézanne had already forgotten about the painter of Tahiti. 'You understand, Monsieur Vollard', he said, seeking to enlist my sympathies in his own cause, 'I have a little thunder, but I can't seem to express it. I'm like a man who has a piece of gold, and can't make use of it.'

To divert the master's train of thought, I informed him that a collector had just acquired three of his pictures in one purchase at my gallery.

'Was he a Frenchman?' inquired Cézanne.

'A foreigner, a Dutchman.'

'They have some fine museums there!' he mused.

Anxious to display my enthusiasms in art, I began to praise the *Night Watch*. Cézanne interrupted me.

'I know of nothing more ridiculous than all those people who crowd about the *Night Watch* and sigh with ecstasy. They would be the very first to vomit on it if Rembrandts should begin to go down in price . . . Why, with that mob around it, if I only had to blow my nose, I'd have to leave the room. You know, Monsieur Vollard, the grandiose (I don't say it in bad part) grows tiresome after a while. There are mountains like that; when you stand before them you shout, "*Nom de Dieu* . . ." But for every day a simple little hill does well enough. Listen, Monsieur Vollard, if the *Raft of the Medusa* hung in my bedroom, it would make me sick.' Then suddenly: 'Ah! when will I see a picture of mine in a museum? . . .'

We talked of Corot. Cézanne, his voice choked with laughter, said: 'Emile used to say that he might have enjoyed Corot to the utmost if he had peopled his forests with peasants instead of nymphs.' Then, rising, he brandished his fist at an imaginary Zola: 'The god-damned idiot.' His anger suddenly subsided, but with the traces of emotion still in his voice, he said, 'Excuse me, I love Zola so much!'

PORTRAIT OF AMBROISE VOLLARD

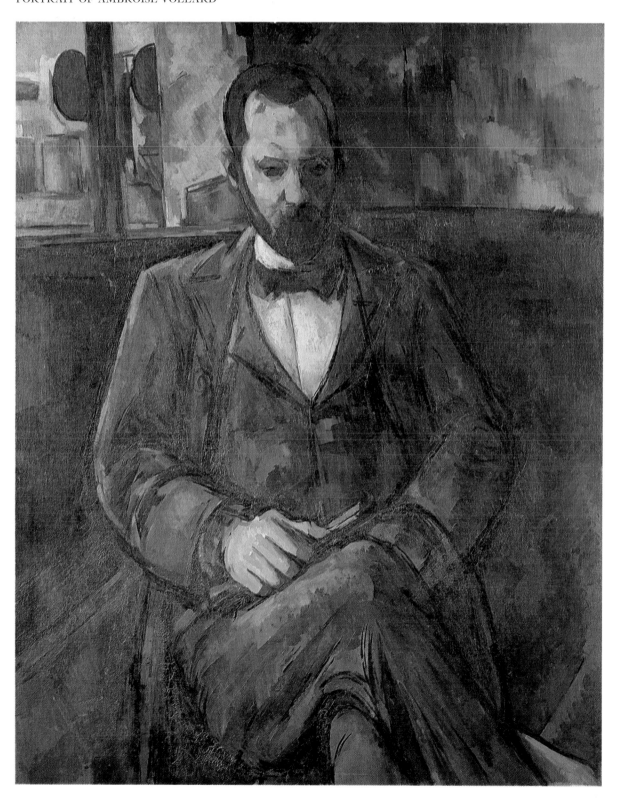

Cézanne paints my portrait

My relations with Cézanne were not confined to the visit I made to Aix. I saw him again on each of his trips to Paris, and his goodwill was such that one day I ventured to ask him to paint my portrait. He consented at once, and arranged a sitting at his studio in rue Hégésippe-Moreau for the following day.

Upon arriving, I saw a chair in the middle of the studio, arranged on a packing case, which was in turn supported by four rickety legs. I surveyed this platform with misgiving. Cézanne divined my apprehension. 'I prepared the model stand with my own hands. Oh, you won't run the least risk of falling, Monsieur Vollard, if you just keep your balance. Anyway, you mustn't budge an inch when you pose!'

Seated at last – and with such care! – I watched myself carefully in order not to make a single false move; in fact I sat absolutely motionless; but my very immobility brought on in the end a drowsiness against which I successfully struggled a long time. At last, however, my head dropped over on my shoulder, the balance was destroyed, and the chair, the packing-case and I all crushed to the floor together! Cézanne pounced upon me. 'You wretch! You've spoiled the pose. Do I have to tell you again you must sit like an apple? Does an apple move?' From that day on, I adopted the plan of drinking a cup of black coffee before going for a sitting; as an added precaution, Cézanne would watch me attentively, and, if he thought he saw signs of fatigue or symptoms of sleep, he had a way of looking at me so significantly that I returned immediately to the pose like an angel – I mean like an apple. An apple never moves!

The sittings began at 8 o'clock in the morning and lasted until 11.30. Upon my arrival, Cézanne would lay aside *Le Pelerin* or *La Croix*, his favourite journals. 'They're sensible papers', he would say. 'They lean on Rome.' It was the time of the war between the English and the Boers; and as Cézanne was always in favour of justice, he usually added: 'Do you think the Boers will win?'

The studio in rue Hégésippe-Moreau was even more simply decorated than the one at Aix. A few copies of Forain's drawings, clipped from the newspapers, formed the basis of the master's Paris collection. Cézanne had left what he called his Veroneses, his Rubens, his Lucas Signorellis, his Delacroix – that is to say the penny reproductions of which I have already spoken – at Aix. One day I told the painter that he could get very fine reproductions at Braun's. His answer was: 'Braun sells to the museums.' He looked upon a purchase from a purveyor to the museums as regal extravagance.

I can never forgive myself for having insisted on Cézanne's putting some of his own work on the walls of his studio. He pinned up about ten watercolours; but one day when the work was going badly, and after he had fretted and fumed and consigned both himself and the Almighty to the devil, he suddenly opened the stove, and tearing the watercolours from the walls, flung them into the fire. I saw a flicker of flame. The painter took up his palette again, his anger appeased.

When a sitting began, he would look at me his eyes intent and a little hard, his brush poised in the air. Sometimes he seemed restless. Once I heard him mutter fiercely between his teeth, 'That fellow Dominique is damnably good;' then, putting down a stroke, and leaning back to judge the effect, 'but he gives me a pain!'

Every afternoon Cézanne would be off to copy in the Louvre or the Trocadéro. Not infrequently he would stop in to see me for a moment about 5 o'clock, his face radiant, and

would say, 'Monsieur Vollard, I have good news for you. I'm pretty well satisfied with my work so far; if the weather is "clear grey" tomorrow, I think the sitting will be a good one!' That was his principal concern when the day was done: what kind of weather would we have tomorrow? Inasmuch as he was in the habit of going to bed very early, he usually woke up in the middle of the night. Haunted by his obsession, he would open the window. When he was satisfied about the weather, he would go and look over the work he had done, candle in hand, before getting back into bed. If he were pleased with his examination, he would wake up his wife so that she might share his satisfaction. And to make amends for disturbing her, he would invite her to play a game of draughts.

But for the sitting to be a real success, it was not enough for Cézanne to be satisfied with his study at the Louvre and for the weather to be 'clear grey'; there were other conditions necessary, above all that silence should reign in the 'pile driver factory'. That was the nickname Cézanne had given to an elevator in the neighbourhood. I took care not to tell him that when the noise stopped, it probably meant that the lift was undergoing repairs; I left him to his hope that the owners would fail in business some day. In fact the noise stopped very often, and he reflected hopefully that the pile drivers stopped when business was not good.

Another noise that he could not endure was the barking of dogs. There was a dog in the neighbourhood which made itself known occasionally – not very loud to be sure. But Cézanne had developed an extremely sharp ear for sounds which were disagreeable to him. One morning when I arrived he greeted me all smiles: 'Lépine is a good fellow! He has given an order for all dogs to be put in the pound; it's in *La Croix*.' Thanks to this we had several good sittings: the weather continued to be 'clear grey', and, by a piece of good fortune, the dog and the pile-driver factory never made a sound. But one day, when Cézanne had remarked to me for the thousandth time, 'Lépine is a good fellow', a faint 'bow-ow-ow' came to our ears. With a start he let his palette fall and cried in a discouraged voice: 'The wretch has got loose again!'

Very few people ever had the opportunity to see Cézanne at work, because he could not endure being watched while at his easel. For one who has not seen him paint, it is difficult to imagine how slow and painful his progress was on certain days. In my portrait there are two little spots of canvas on the hand which are not covered. I called Cézanne's attention to them. 'If the copy I'm making at the Louvre turns out well', he replied, 'perhaps I will be able tomorrow to find the exact tone to cover up those spots. Don't you see, Monsieur Vollard, that if I put something there by guesswork, I might have to paint the whole canvas over starting from that point?' The prospect made me tremble.

During the period that Cézanne was working on my portrait, he was also occupied with a large composition of nudes, begun about 1895, on which he laboured almost to the end of his life.

For his groups of nudes, the painter made use of sketches from life that he had made some years before in the Académie Suisse; beyond that, he resorted to his memories of the museums.

His ambition was to pose nude models out of doors; but that was not feasible for many reasons, the most important being that women, even when clothed, frightened him. The only exception to this rule was an old servant whom he used to employ at the Jas de Bouffan, an odd creature with a craggy countenance about which he used to say admiringly to Zola: 'Look, isn't it handsome? You might almost say it was a man!'

Imagine my surprise, then, when one day he announced that he wanted to pose a nude female model. I could not help exclaiming, 'What, Monsieur Cézanne, a nude model?'

'Oh Monsieur Vollard, don't worry, I'll get some old crow!'

He found just the one he wanted, and after doing a study of the nude, he painted two portraits of the same model clothed; they remind one of the poor relations that people Balzac's stories.

Cézanne assured me that he found this 'camel' much less satisfactory as a model than me. 'It is becoming very difficult to work from a female model', he explained. 'And besides, I have to pay very high; the price has gone up to 4 francs, 20 sous more than before the war. Oh! if I can only realize your portrait!' The goal of his ambition was always the Salon of Bouguereau, until the Louvre should be open to him. He considered the Louvre the only sanctuary worthy of his art . . .

Though Cézanne did not permit me to utter a single word during the sittings, he would talk willingly enough while I was getting ready, and also during the all-too-short rests that he allowed me. Upon entering one morning I found him grinning from ear to ear. He had discovered in *Le Pelerin* that some shares in the Sosnowice (which he pronounced *Sauce novice*) were being offered to the public. 'They'll go bankrupt', he said. 'The public isn't fool enough to buy anything with a name like that.' Some days later I found him sobered; the stock had gone up. 'Too bad, Monsieur Vollard', he said, 'they've found some easy marks. Life's frightful, isn't it!' Then, with the sort of self-satisfaction that we feel when others are being made sport of while we ourselves are out of harm's way, he added: 'I'm not used to the ways of the world, so I lean on my sister, she leans on her confessor, a Jesuit (they're mighty wise, those people), and he leans on Rome.' . . .

I had been told that Cézanne made a slave of his models. I proved it to my own satisfaction from sad experience. From the moment that he put down the first brushstroke until the end of the sitting, he treated the model like a simple still life. He loved to paint portraits. 'The goal of all art', he would say, 'is the human face.' If he did not paint it more often, the reason lay in the difficulty of procuring models who were as tractable as I. Consequently, after painting himself and his wife many times, and also a few obliging friends (at the time that Zola still had faith in Cézanne, the future novelist consented to pose for the nude), he resorted to painting apples, and even more frequently flowers – flowers did not decay: he used paper ones. But 'even they, confound 'em! faded in the long run.' . . .

After 115 sittings, Cézanne abandoned my portrait to return to Aix. 'The front of the shirt is not bad' – such were his last words on parting. He made me leave the clothes in which I posed at the studio, expecting, when he returned to Paris, to paint in the two white spots on the hands, and then, of course, to work over certain parts. 'I hope to have made some progress by that time. You understand, Monsieur Vollard, the contour keeps slipping away from me!' But he had not counted on the moths, 'the little wretches!' which devoured my clothes in short order. . . .

One day Cézanne was showing me a little portrait of Zola painted in the period of his youth, about the year 1860. I seized the opportunity to ask him at what period Zola and he had broken with each other. 'No harsh words ever passed between us', he replied. 'It was I who stopped going to see Zola. I was not at my ease there any longer, with the fine rugs on the floor, the servants, and Emile enthroned behind a carved wooden desk. It all gave me the feeling that I was paying a visit to a minister of the state. He had become (excuse me, Monsieur Vollard – I don't say it in bad part) a dirty bourgeois.'

Myself: I should think it must have been frightfully interesting to meet Edmond de

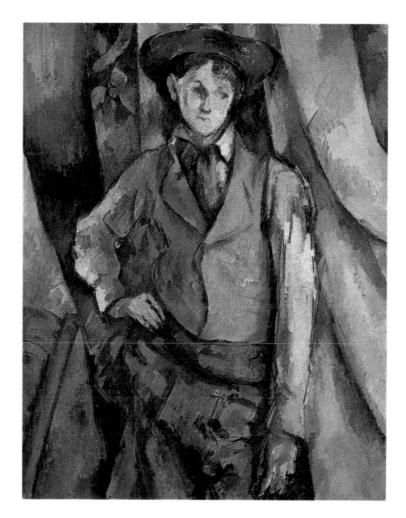

BOY IN A RED WAISTCOAT

Goncourt, the Daudets, Flaubert, Guy de Maupassant and all those people at Zola's house.

Cézanne: Oh, there were plenty of people there, but the things they talked about made me sick. I tried to arouse interest in Baudelaire once, but nobody cared anything about *him*.

Myself: Then what *did* they talk about?

Cézanne: Each one talked about the number of copies he had had printed of his last book, or how many he hoped to have printed of his next. Of course, they exaggerated a little. But you should have heard the women! Mme X would say proudly, casting a defiant look at Mme Z: 'My husband and I have figured that the last novel, with the illustrated editions and the "popular edition" has reached 35,000 copies.' 'And *we*', Madame Z would say, taking up the challenge, '*we* are promised by contract an edition of 50,000 copies for our next book, not counting the *edition de luxe*.'

Myself: Were they all authors of best-sellers or vain wives? Surely Edmond de Goncourt....

Cézanne: No, he was never vulgar about it; but just the same, he made a wry face whenever he heard a new record!

Myself: Do you like the Goncourts?

Cézanne: I used to like *Manette Salomon* very much, but I have never read any Goncourt since the 'widow', as Barbey d'Aurevilly called him, began to write alone.

At that time I went to see Zola only on rare occasions – it distressed me to watch him grow so stupid. Then one day a servant told me that his master was not at home – not to anybody. I don't know whether the instructions were meant for me in particular, but I went still less frequently . . . And then Zola wrote *l'Oeuvre*. . . .

Cézanne was silent for a moment, overwhelmed by the past. He continued: 'You can't ask a man to talk sensibly about the art of painting if he simply doesn't know anything about it. But by God!' – and here Cézanne began to tap on the table like a deaf man – 'how can he dare to say that a painter is done for because he has painted one bad picture? When a picture isn't realized, you pitch it in the fire and start another one!'

As he talked, Cézanne paced up and down the studio like a caged animal. Suddenly seizing a portrait of himself he tried to tear it to pieces; but his palette knife had been mislaid, and his hands were trembling violently. So he rolled the canvas up, broke it across his knee, and flung it in the fireplace.

Myself: But Zola talked to me about you at such length and in such affectionate terms. . . I don't understand. . . .

Cézanne looked at me with sorrowful eyes. The destruction of his canvas had calmed him. His anger had given way to pain.

'Listen, Monsieur Vollard, I must tell you. Although I stopped going to see Zola, I never got used to the idea that our friendship was a thing of the past. When I moved next door to him, in rue Ballu, it had been many moons since we had seen each other; but living so near to him I hoped that chance would bring us together often, – perhaps he would even come to see me . . . Later, when I was in Aix, I heard that Zola had arrived in town. I presumed that he would not dare to look me up of course; but why not bury the hatchet? Think of it, Monsieur Vollard, Zola was in Aix! I forgot everything – even that book of his, even that damned wench, the maid, who used to look daggers every time I scraped my shoes on the matting before entering Zola's drawing room. When I heard the good news, I was in the field, working on a fine *motif*; it wasn't going badly either; but I chucked the picture and everything else – Zola was in Aix! Without even taking time to pack up my traps, I rushed to the hotel where he was staying. But on the way, I ran into a friend. He informed me that someone had said to Zola on the previous day, 'Aren't you going to take a meal or two with Cézanne before you go?' and Zola had answered, 'What do I want to see that dead one again for?' So I went back to my work.'

Cézanne's eyes were full of tears. He blew his nose to hide his emotion.

'Zola was not spiteful, Monsieur Vollard, but his life was circumscribed by events.'

About the end of that year, I went to Aix. I found Cézanne reading *Athalie*. On the easel was a still life, begun several years before, of some skulls on an Oriental tapestry.

'A skull is a beautiful thing to paint!' he exclaimed. 'Look, Monsieur Vollard', and he pointed to the study.

He based great hopes on that canvas. 'I think I'm going to realize at last!' he said. After a pause: 'So Paris thinks my work is pretty good, eh? Ah! If Zola were only there, now that I'm bowling 'em over with masterpieces!'

I told Cézanne that Léon Dierx had asked to be remembered to him. 'I am very much touched that Léon Dierx should have kept such a warm place in his heart for me', he replied. 'Our acquaintanceship dates back many years. I met him for the first time in 1877 at Nina de Villard's in rue des Moines. Alas! the memories that are swallowed up in the abyss of the years! I'm all alone now; I would never be able to escape from the self-seeking of humankind anyway. Now it's theft, conceit, infatuation, and now it's rapine or seizure of one's production. But nature is very beautiful. They can't take that away from me!'

That was my last conversation with Cézanne. I never saw him again.

MADAME CÉZANNE

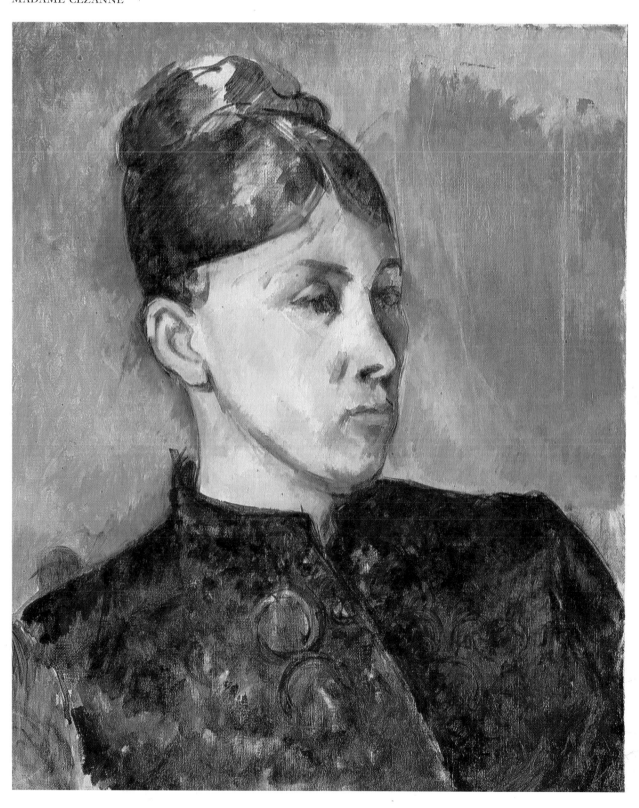

MADAME CÉZANNE WITH HER HAIR DOWN

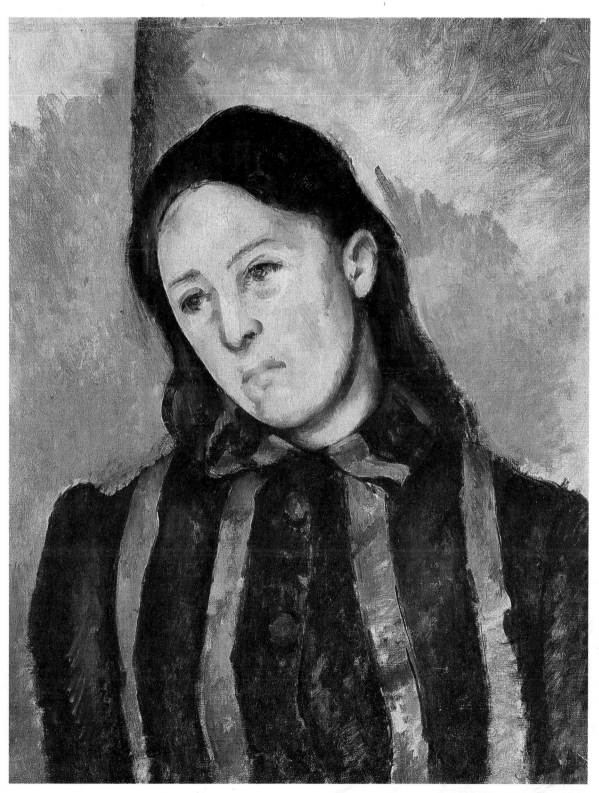

MADAME CÉZANNE IN A YELLOW ARMCHAIR

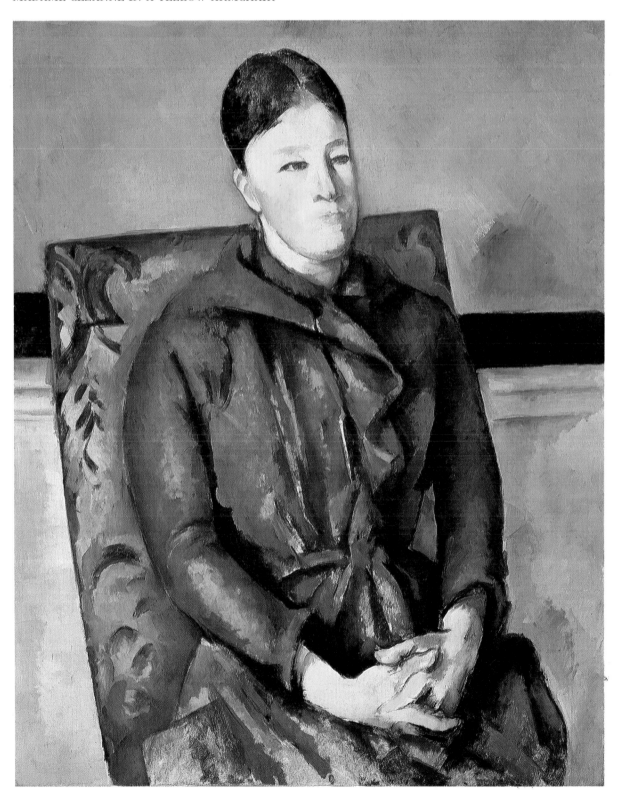

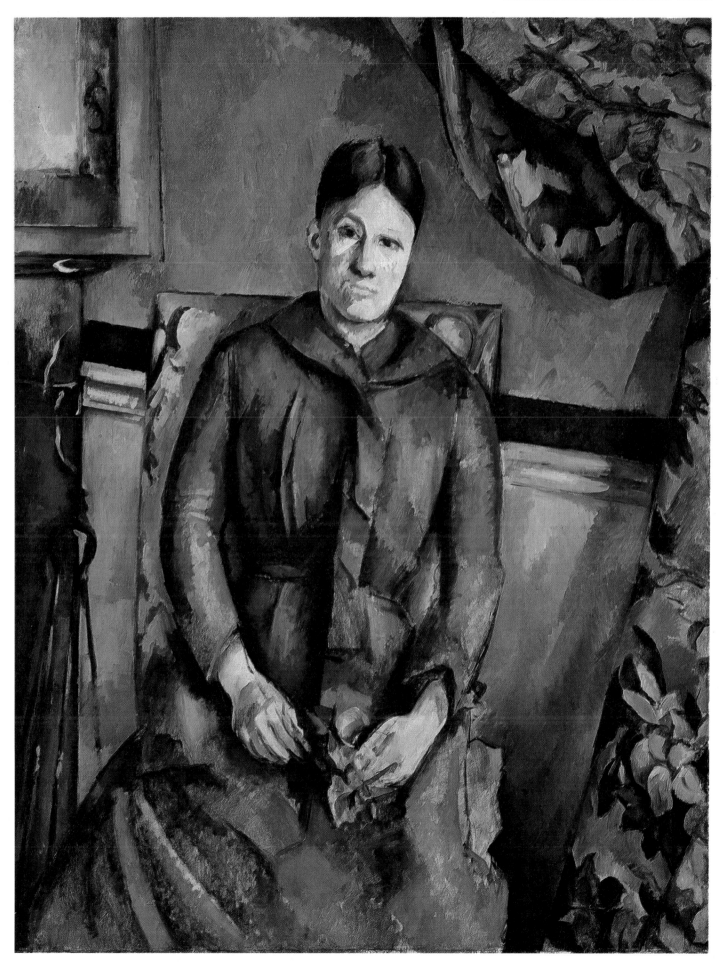

HARLEQUIN

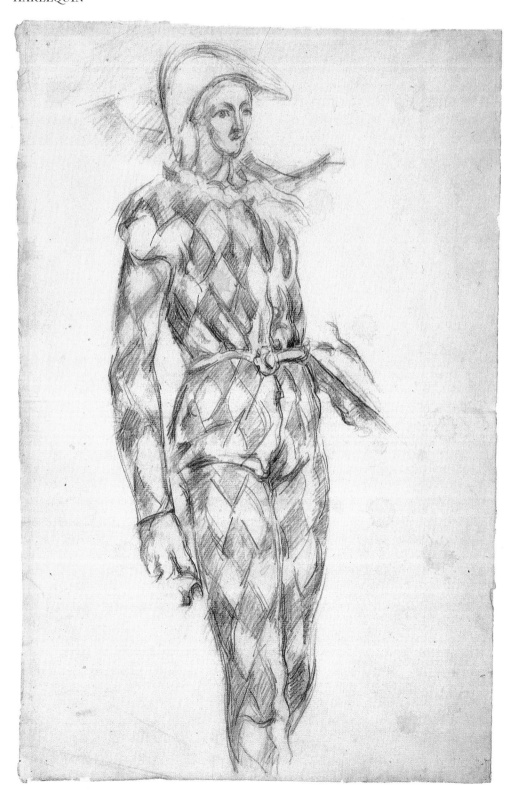

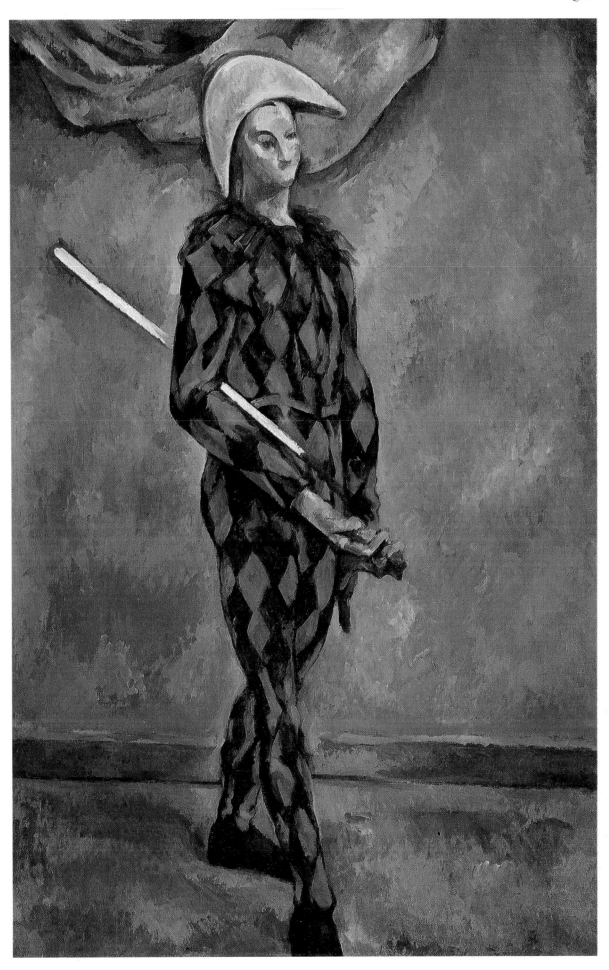

STUDIES FOR MARDI GRAS

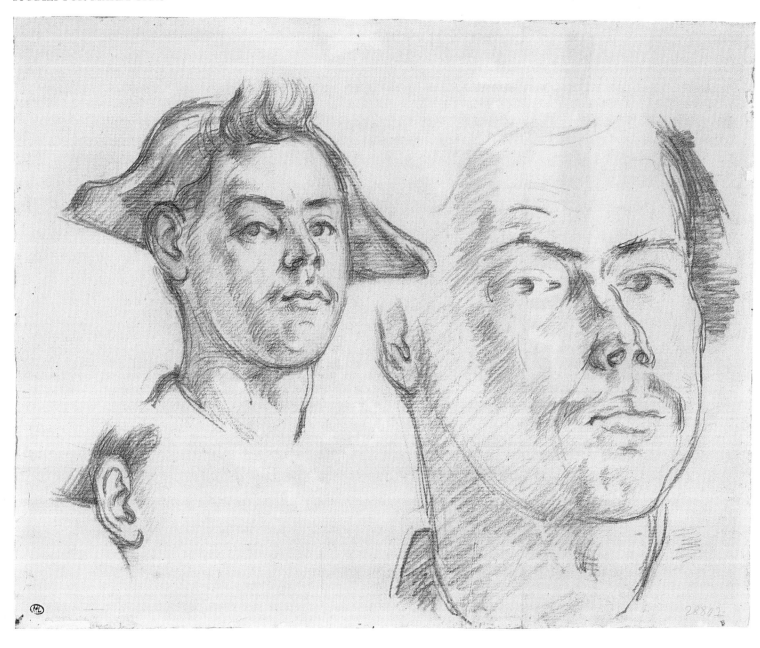

SELF-PORTRAIT

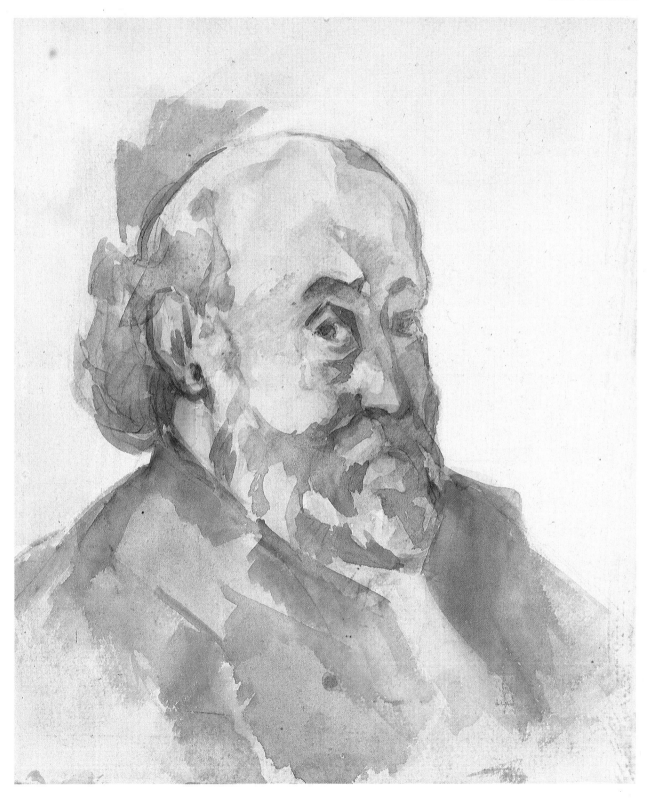

STUDY FOR THE CARD PLAYERS

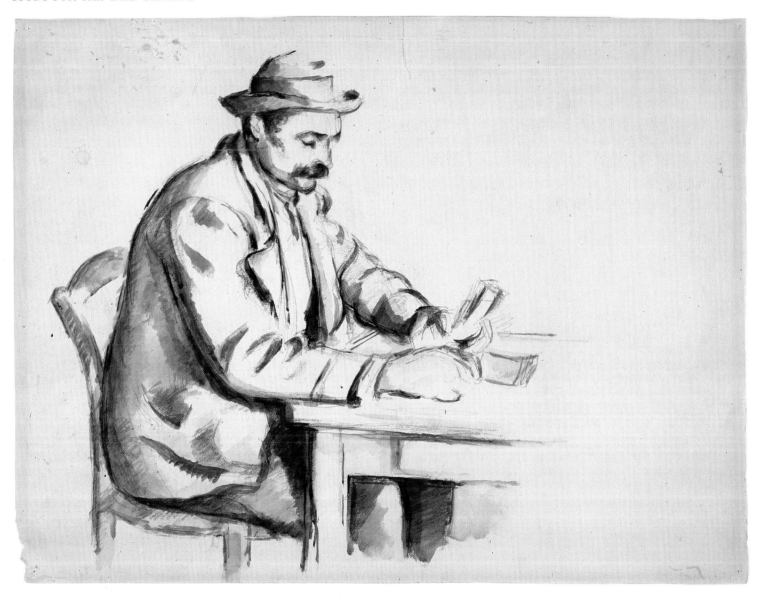

THE CARD PLAYERS

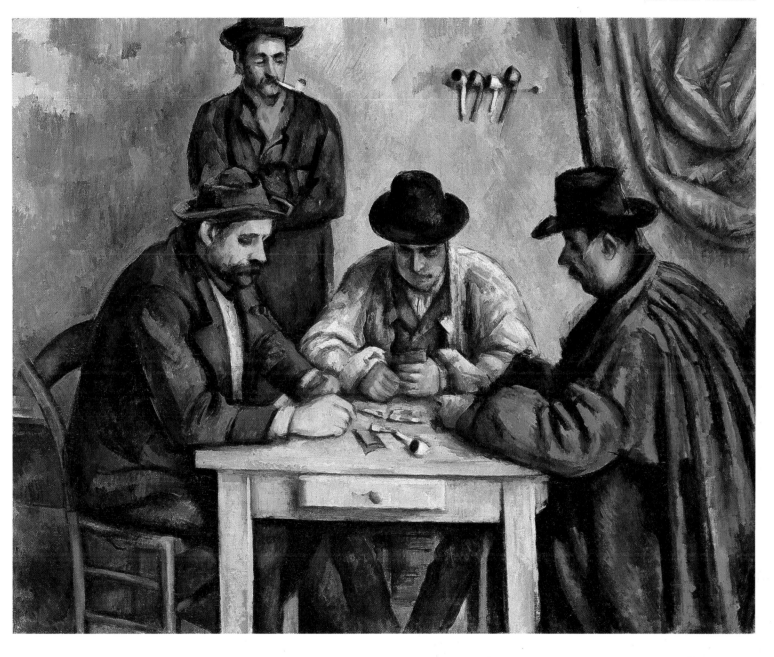

THE CARD PLAYERS

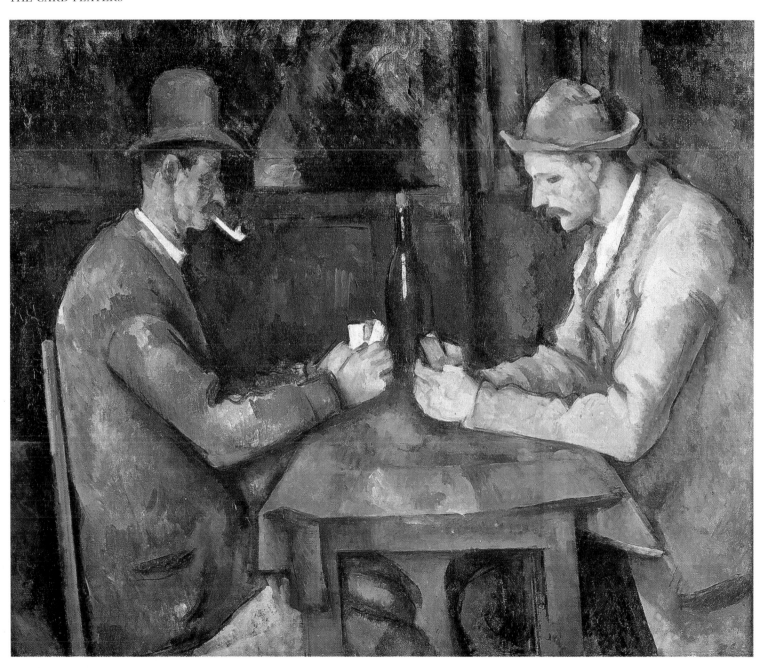

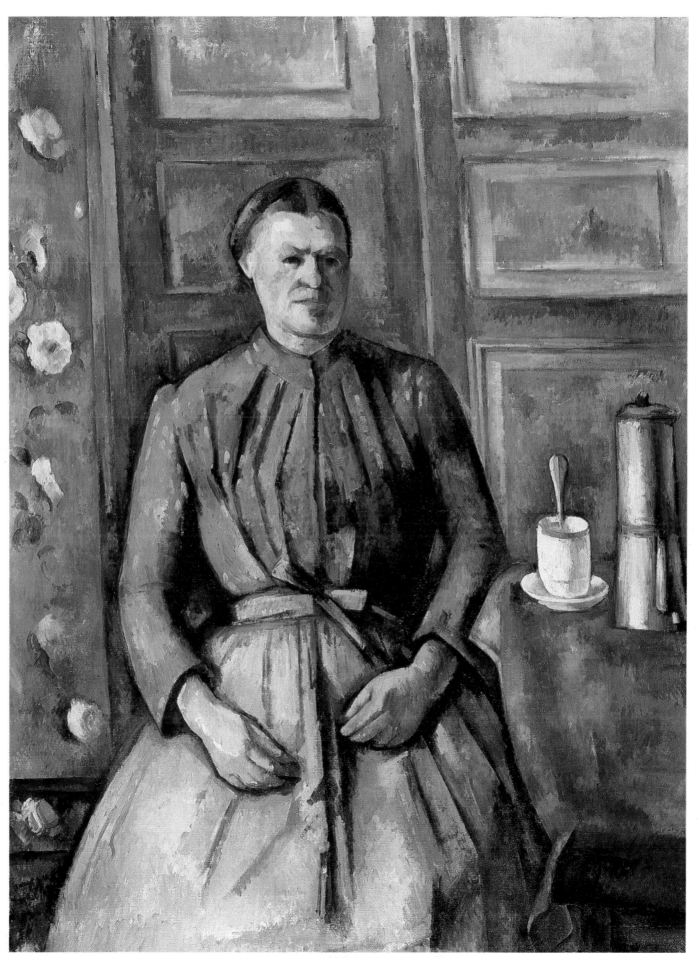

PORTRAIT OF A MAN

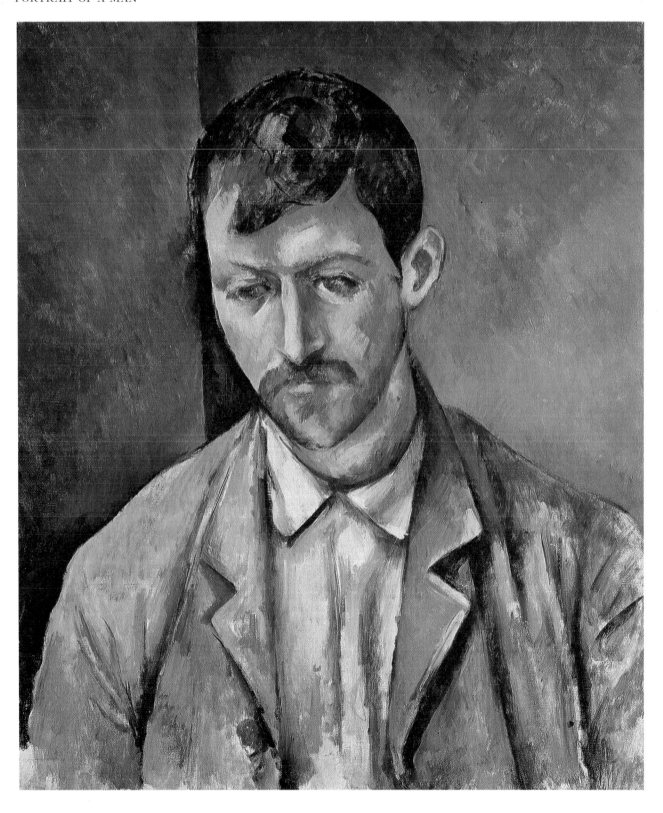

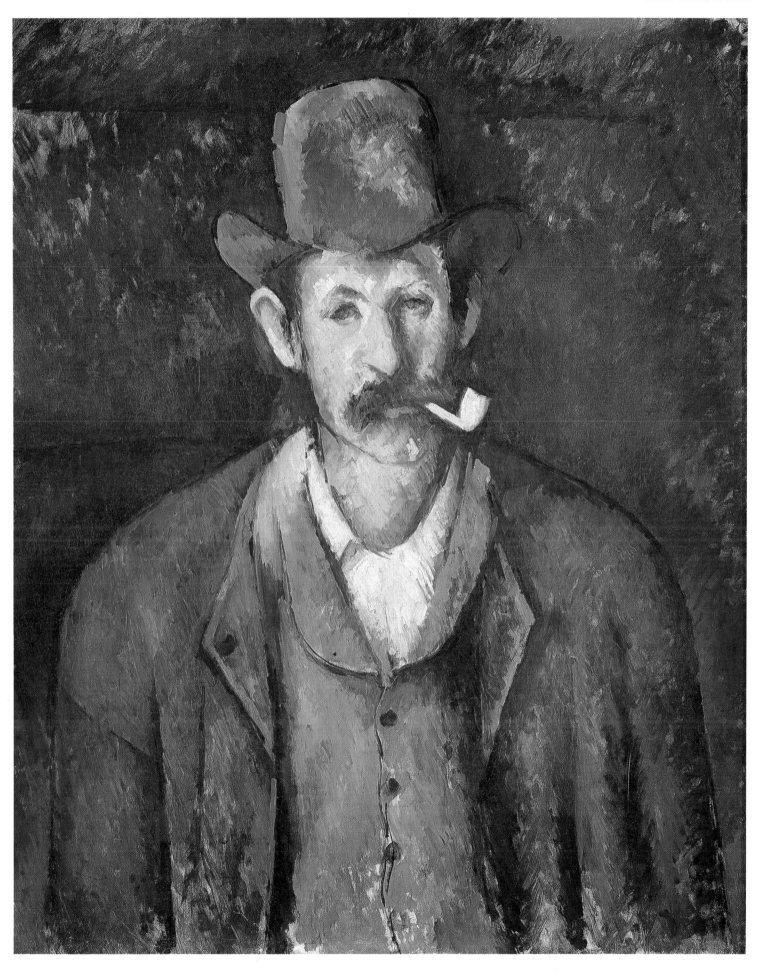

BOY IN A RED WAISTCOAT

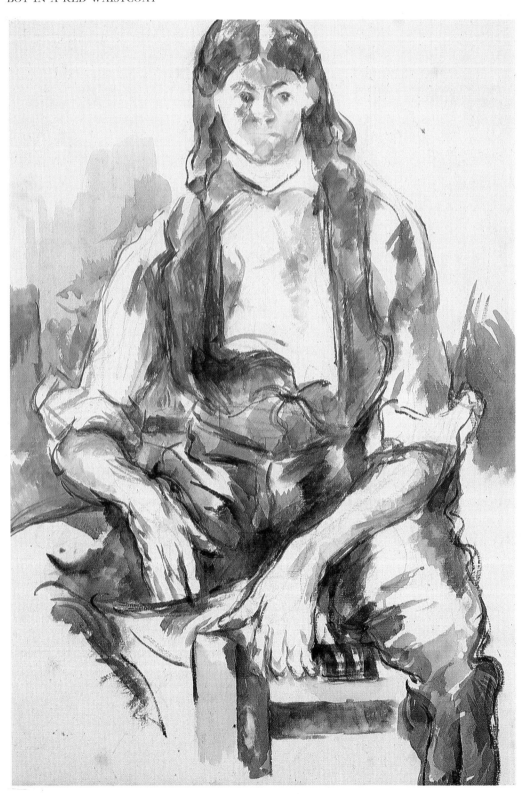

BOY IN A RED WAISTCOAT

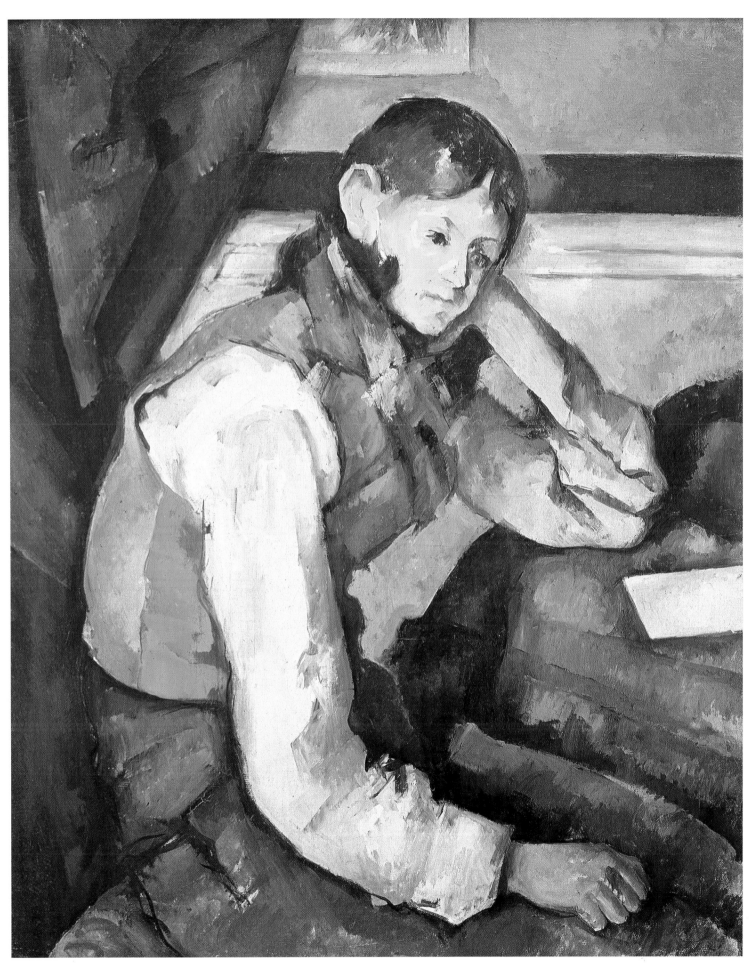

THE BLUE VASE

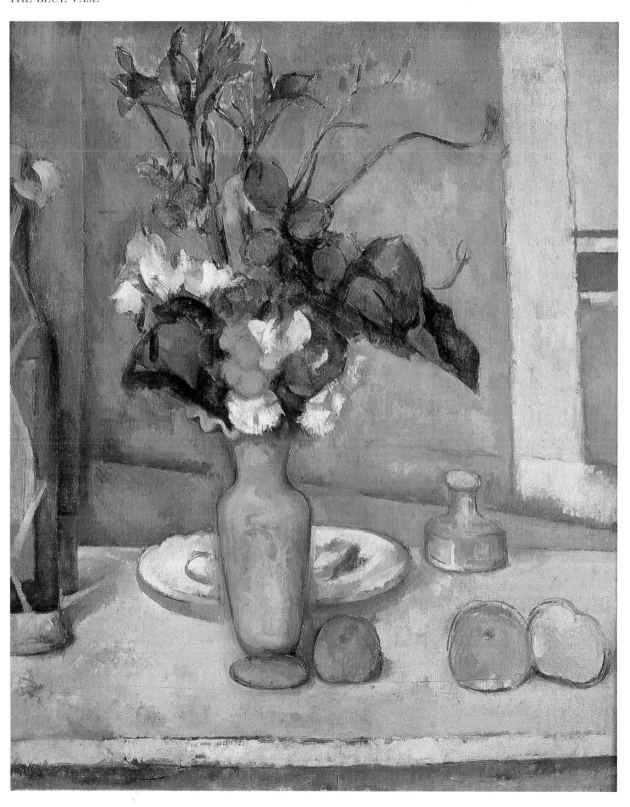

POT OF FLOWERS AND PEARS

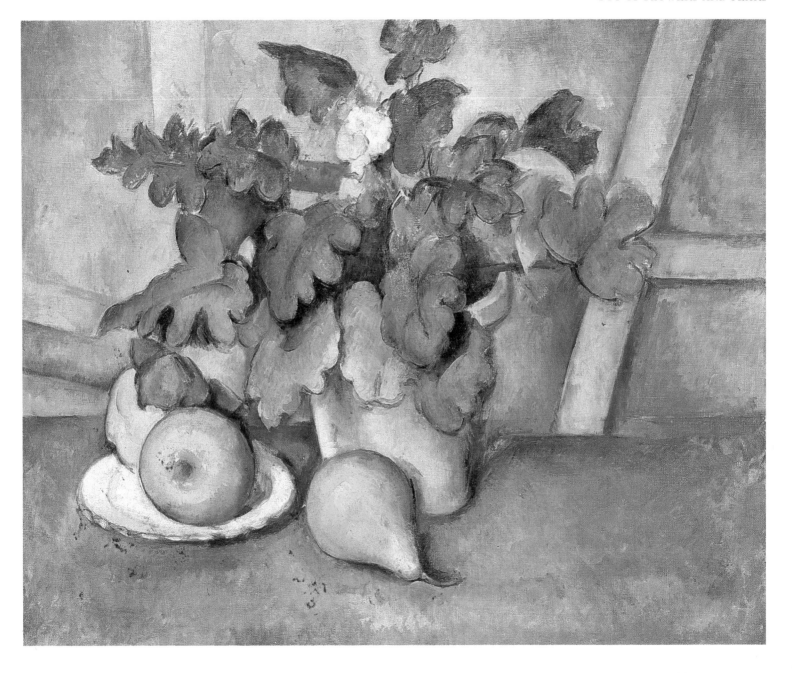

STILL LIFE WITH APPLES AND MELONS

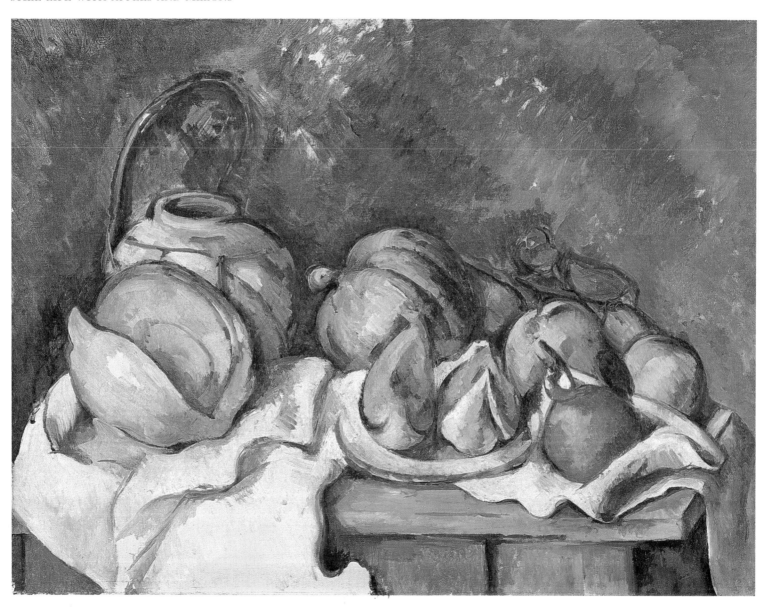

GINGER POT WITH POMEGRANATE AND PEARS

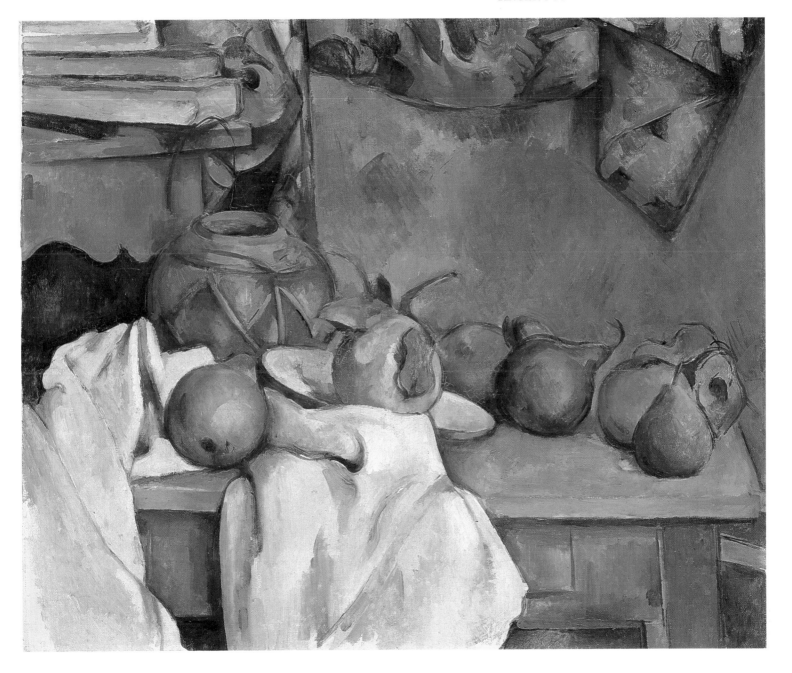

STILL LIFE WITH GINGER JAR AND EGGPLANTS

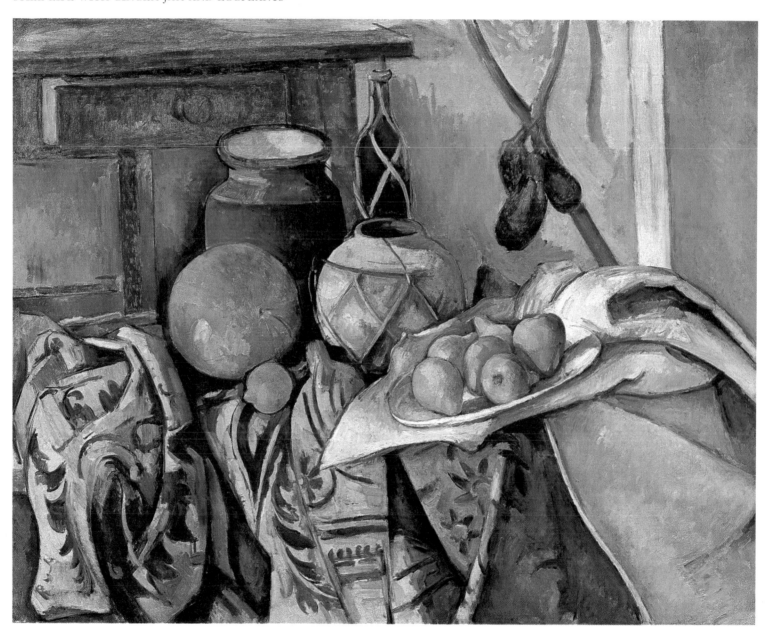

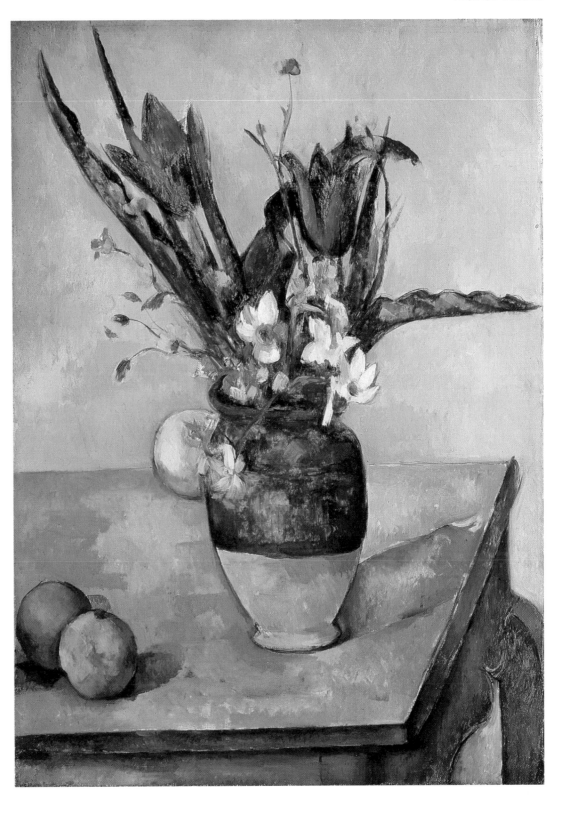

BASKET OF APPLES

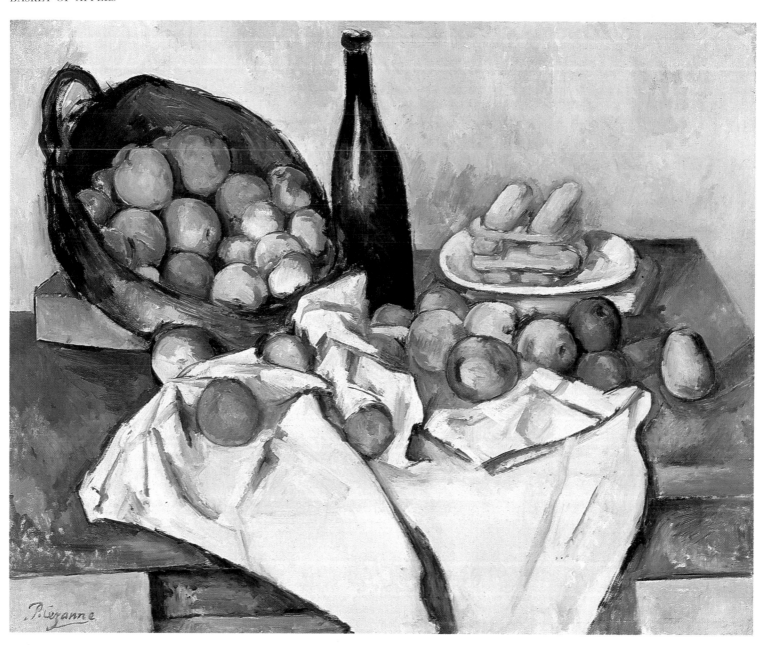

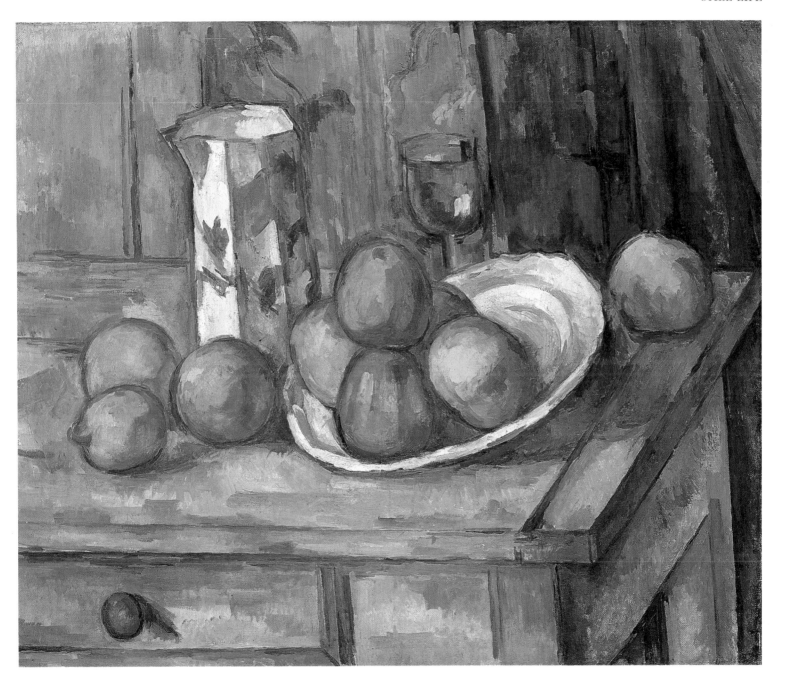

CARAFE AND KNIFE

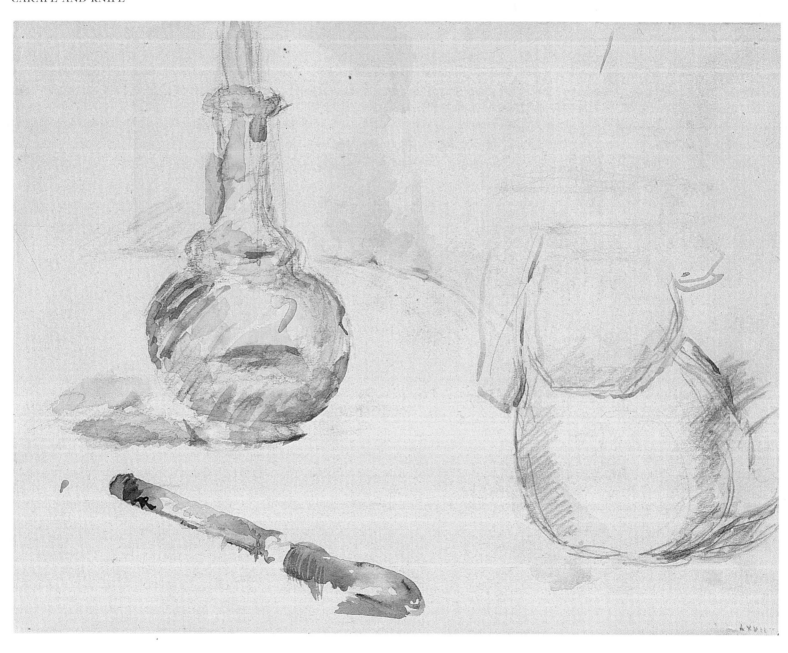

STILL LIFE WITH ONIONS

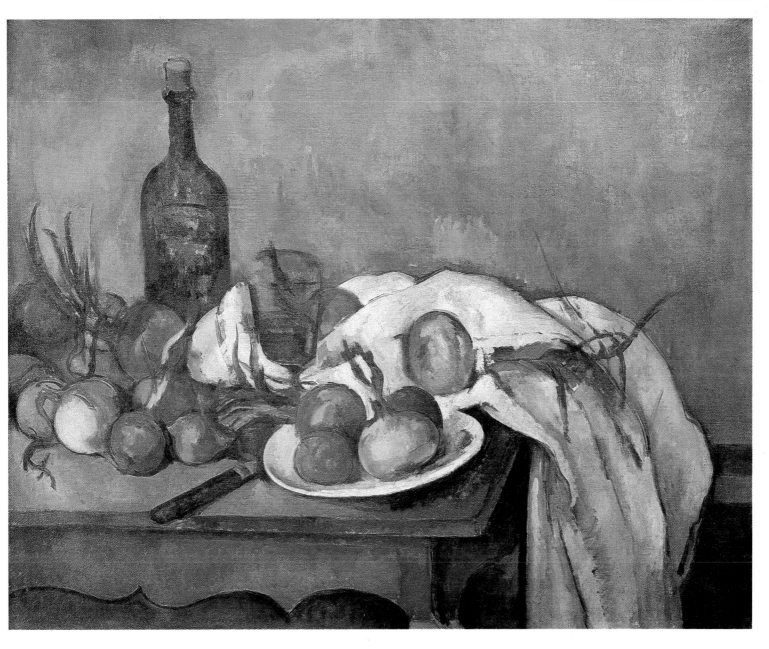

POT AND SOUP TUREEN

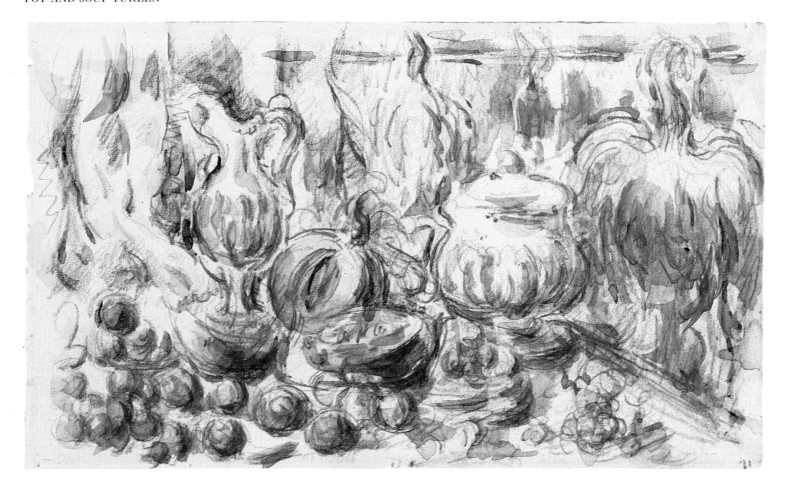

STUDY AFTER NICOLAS COUSTOU—STANDING CUPID

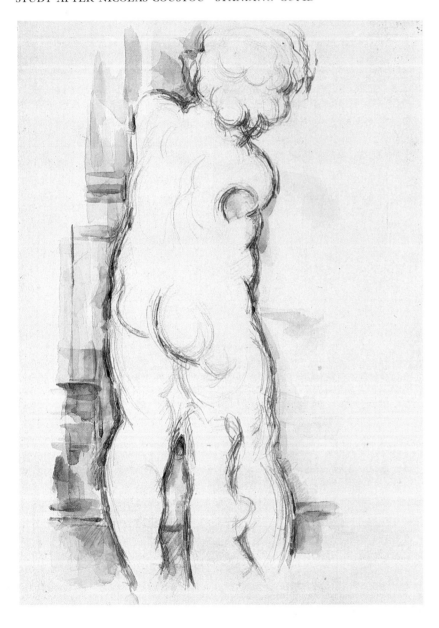

PLASTER CUPID

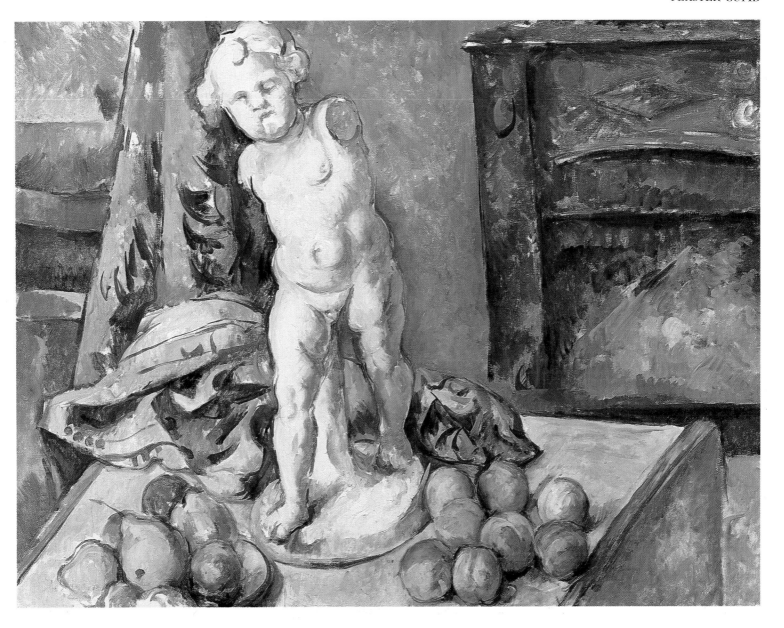

BOAT AND BATHERS

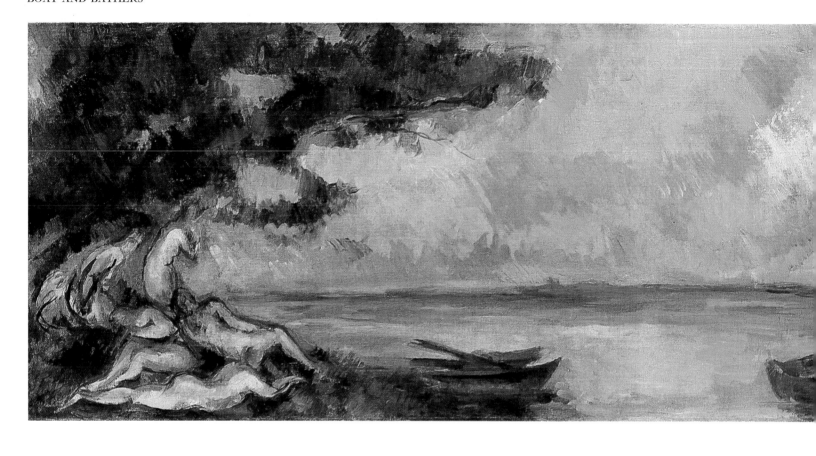

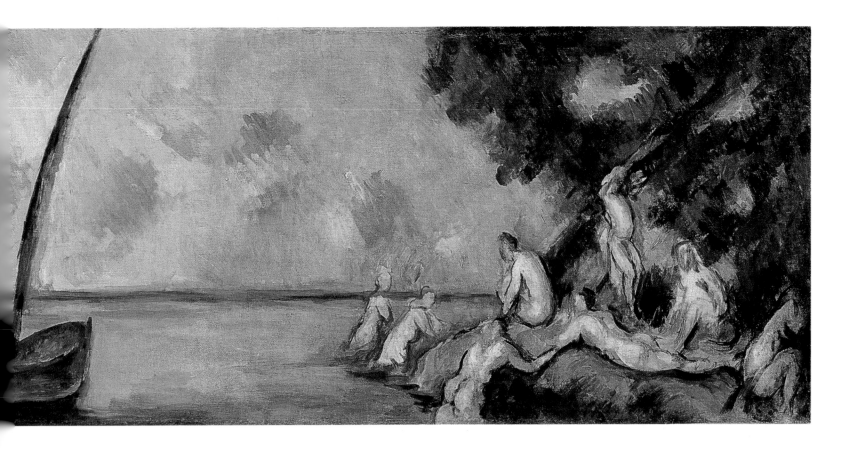

BATHERS

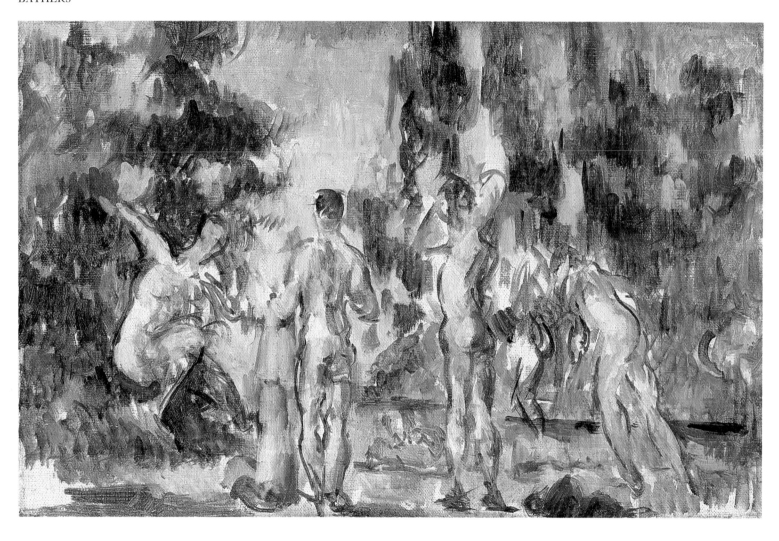

AFTER THE ANTIQUE—DANCING SATYR

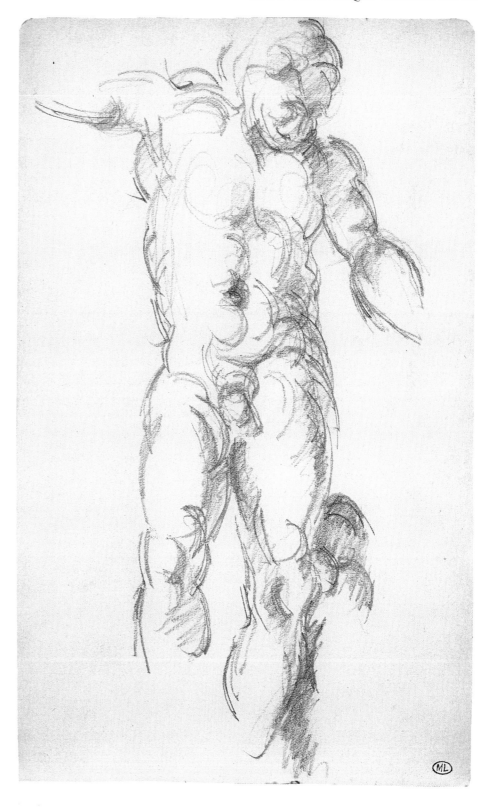

AFTER PIGALLE—LOVE AND FRIENDSHIP

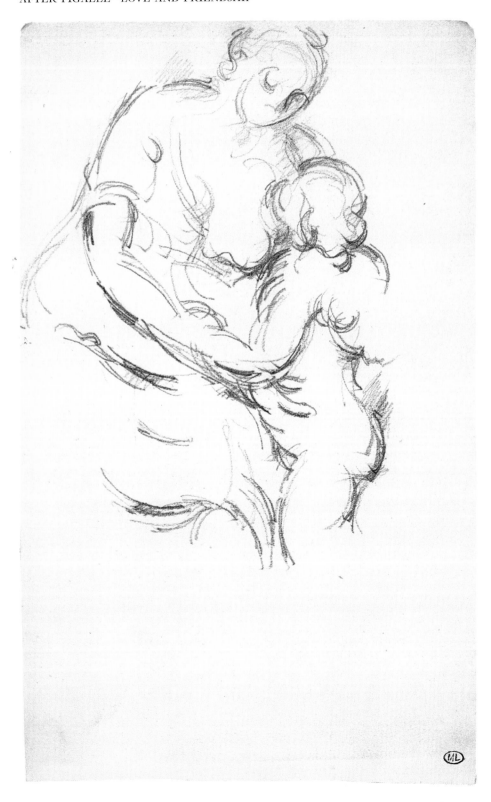

AFTER PIGALLE—MERCURY

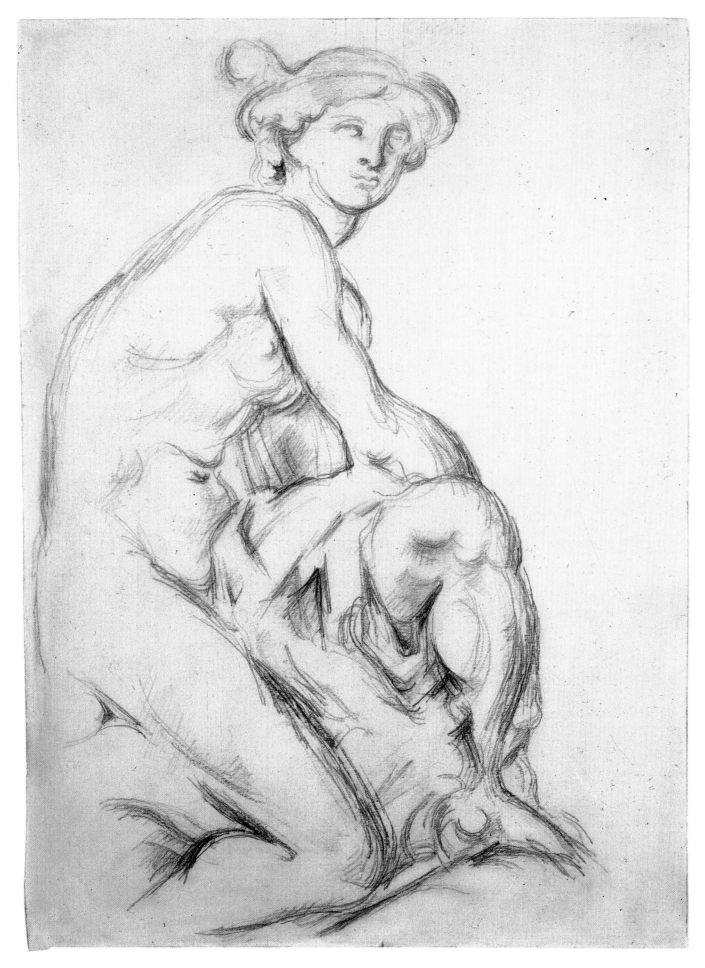

AFTER DESJARDINS—PIERRE MIGNARD

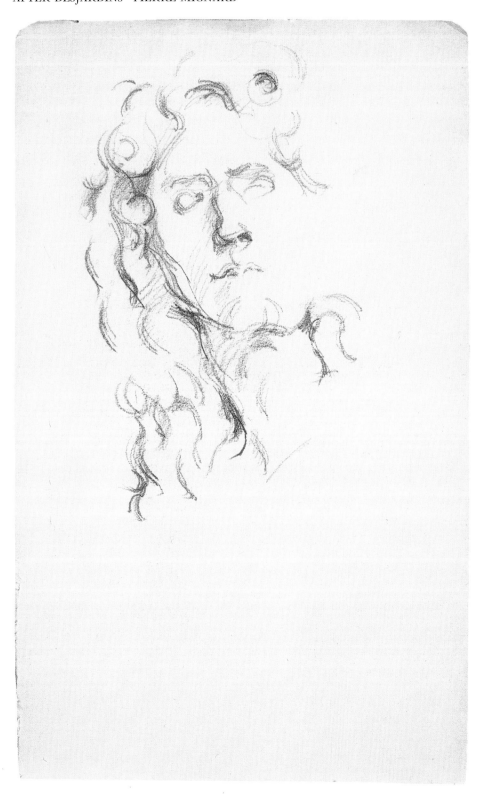

AFTER VAN CLEVE—LOIRE AND LORIET

MONT SAINTE-VICTOIRE

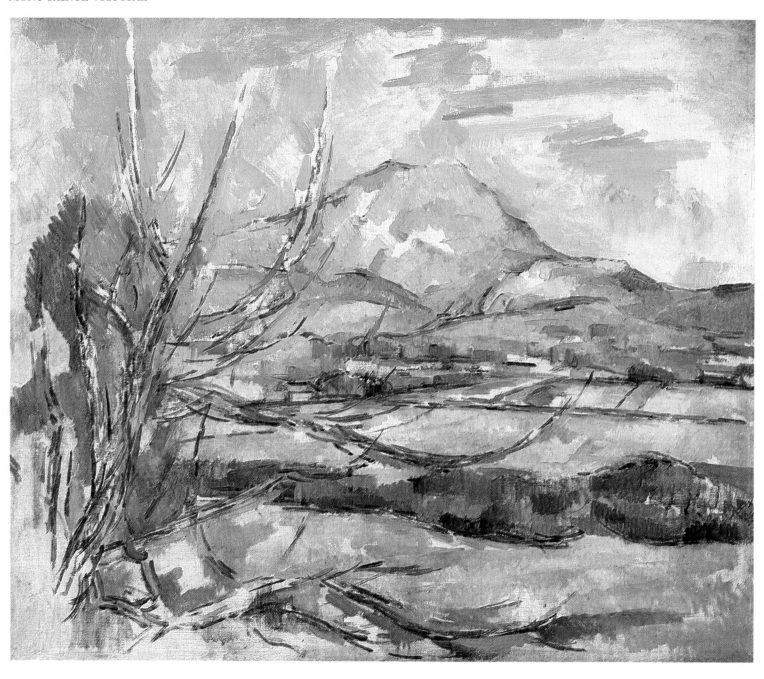

MONT SAINTE-VICTOIRE

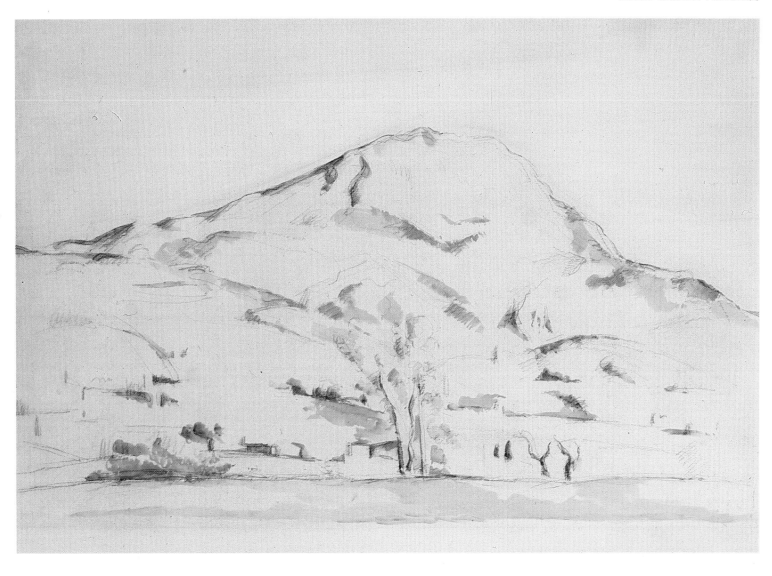

FARMHOUSES NEAR BELLEVUE

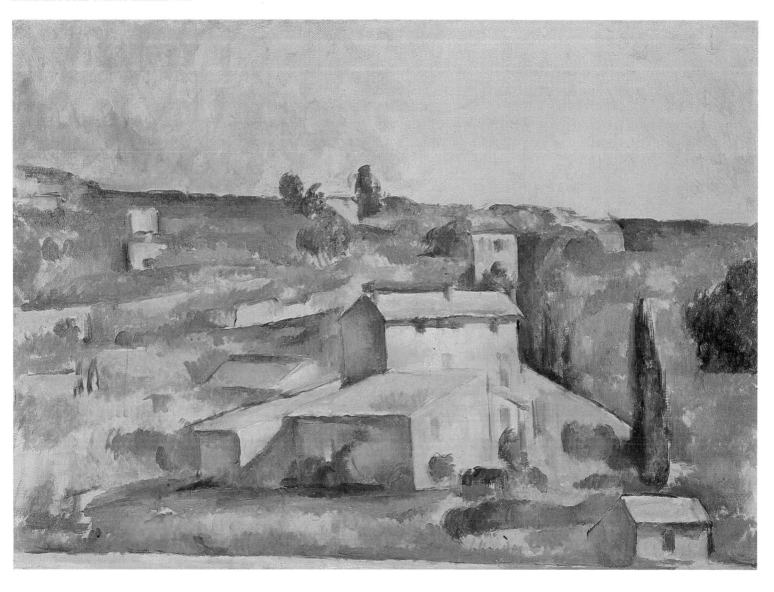

HOUSE AND FARM AT THE JAS DE BOUFFAN

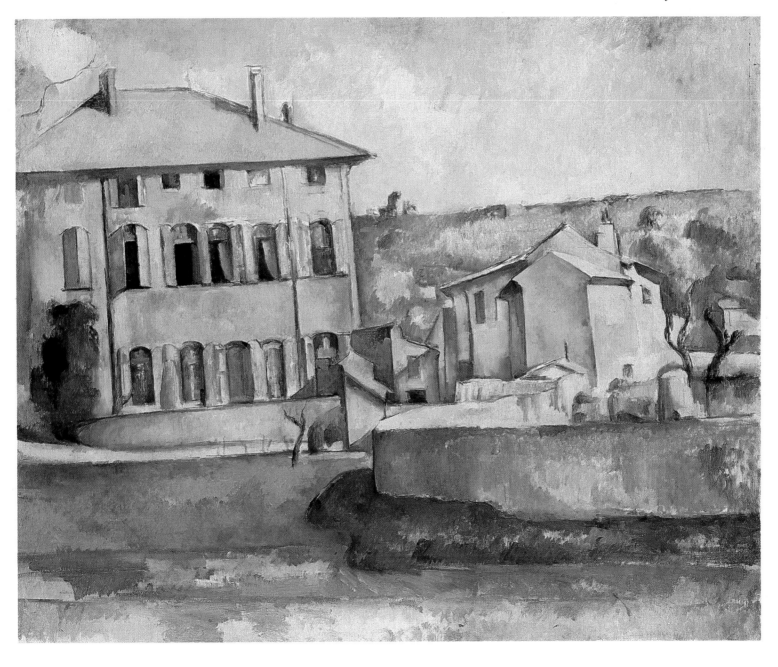

NEAR THE POOL AT THE JAS DE BOUFFAN

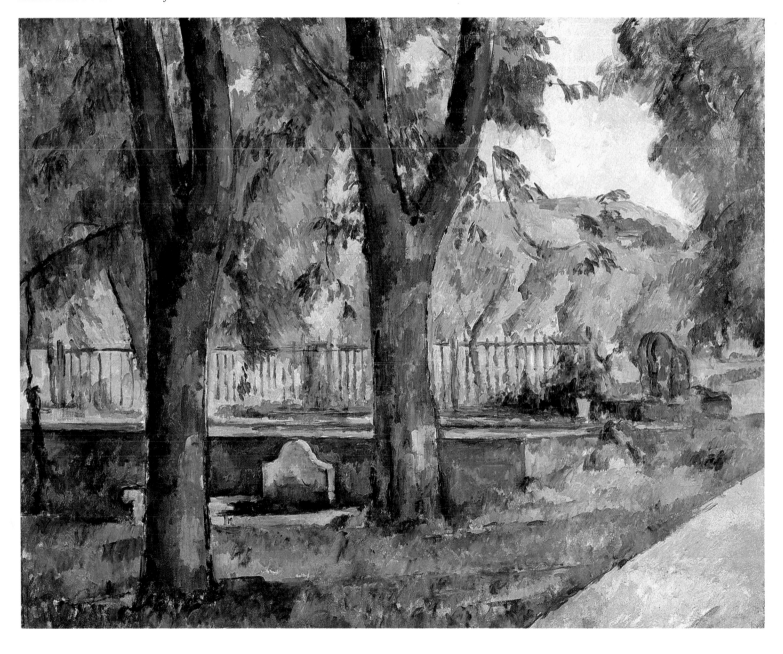

TREES LEANING OVER ROCKS

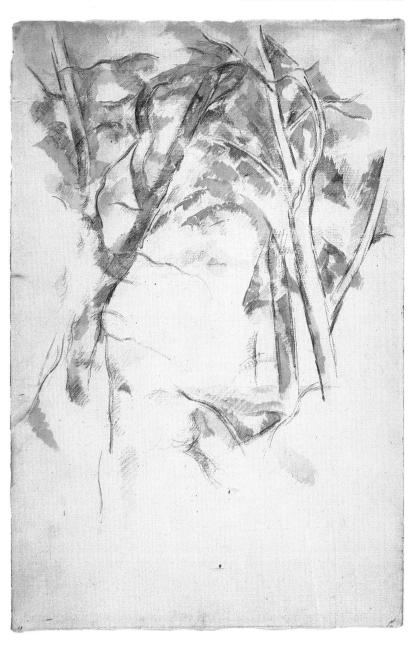

BRIDGE ON THE SEINE

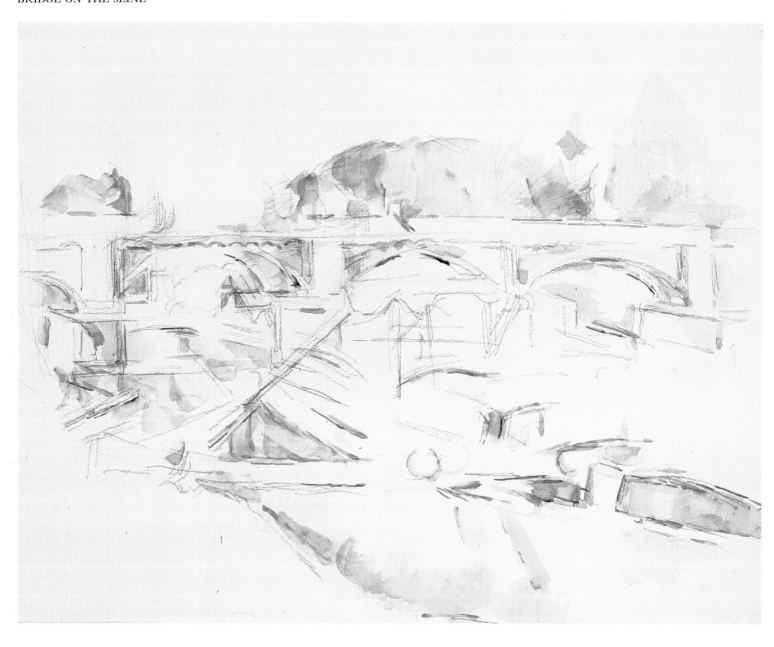

THE BALCONY

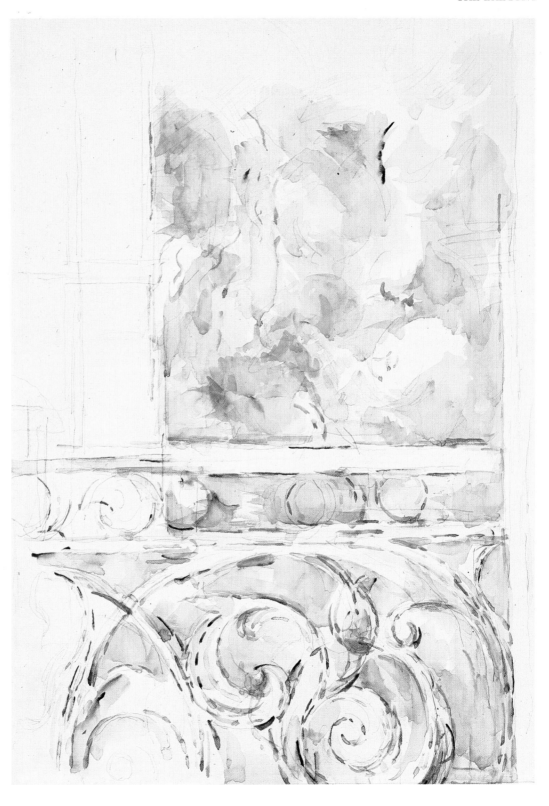

THE GREAT PINE

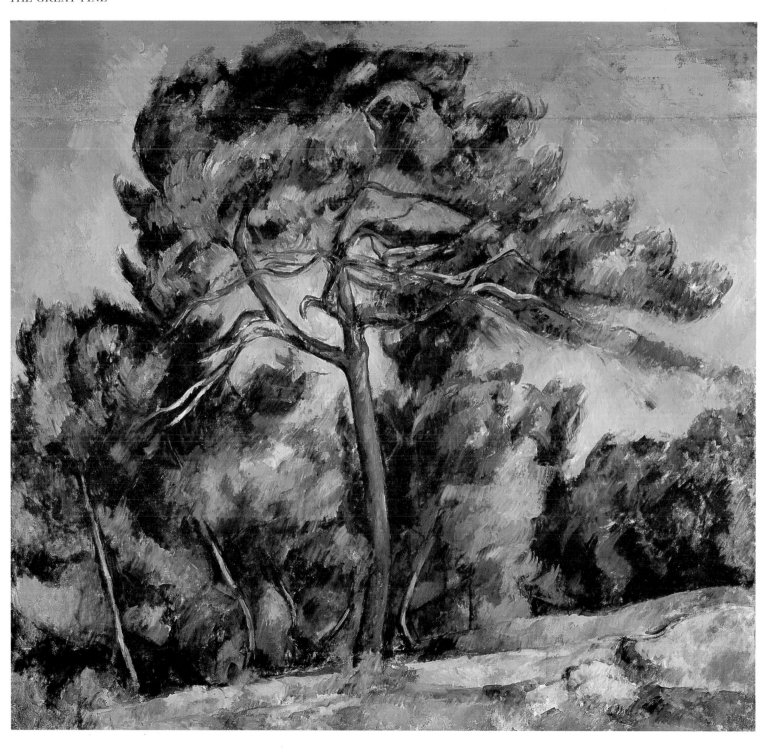

THE LARGE TREE

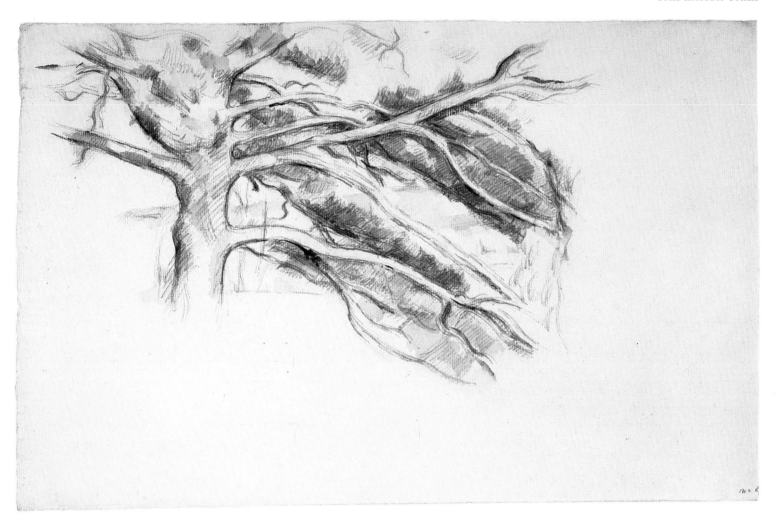

TREES AND ROCKS

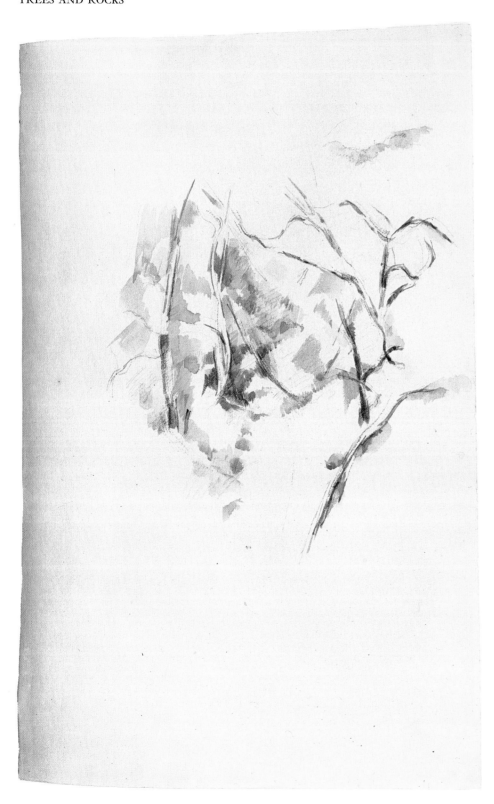

THE PISTACHIO TREE IN THE GROUNDS OF THE CHÂTEAU NOIR

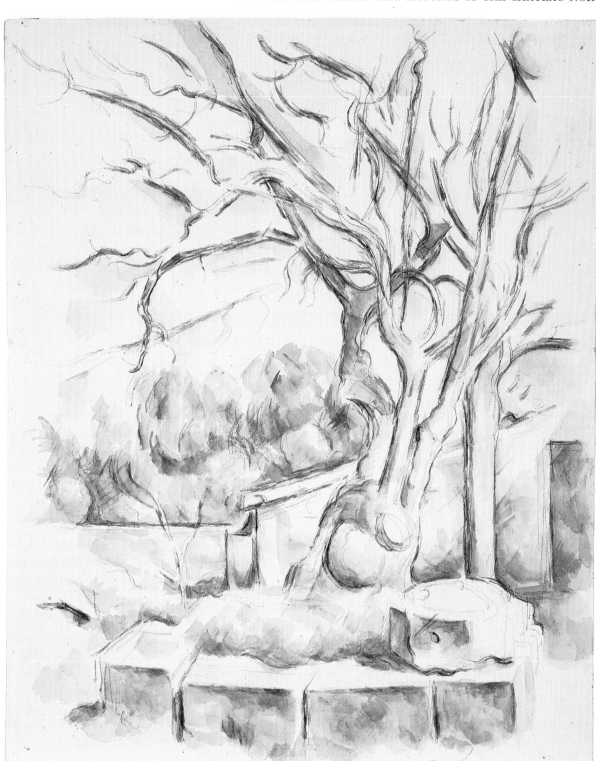

ROCKS IN THE FOREST

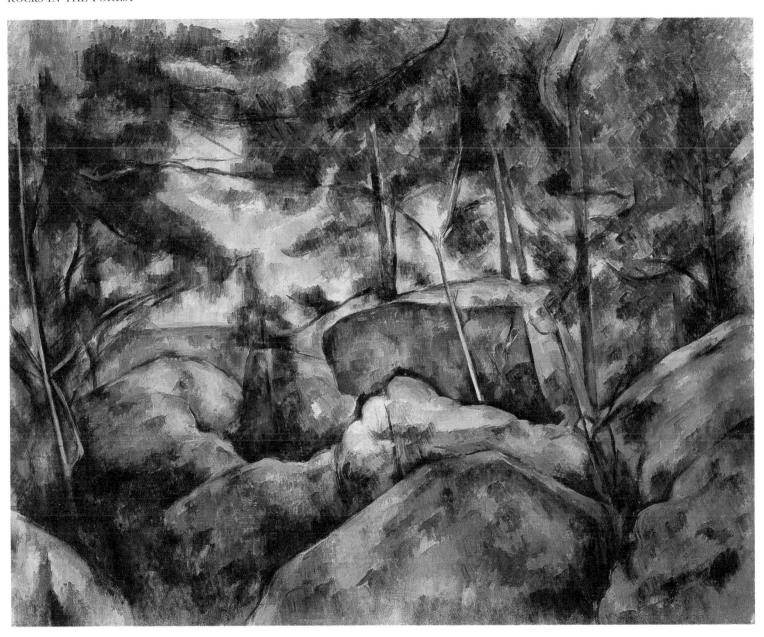

CHÂTEAU NOIR

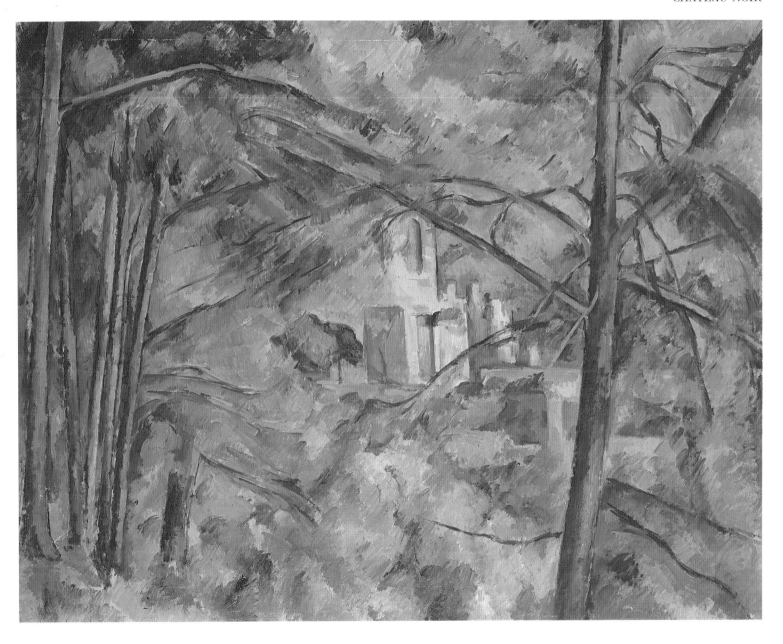

ROCKY RIDGE ABOVE CHÂTEAU NOIR

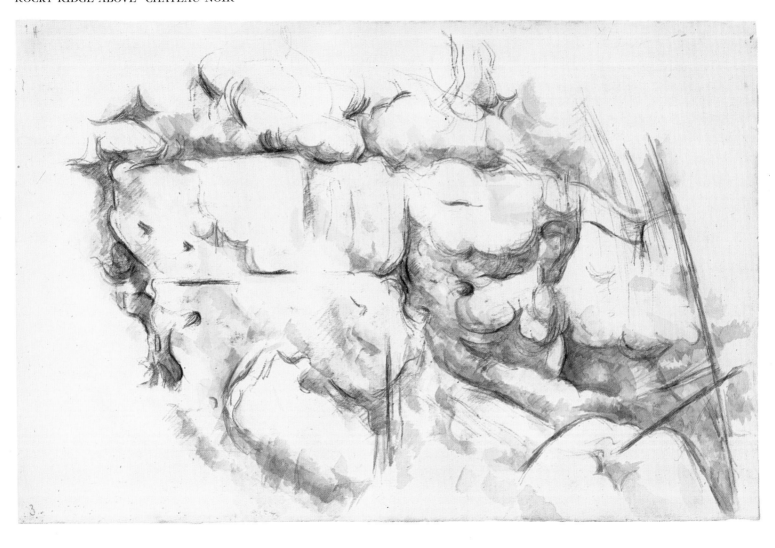

STUDY OF A TREE

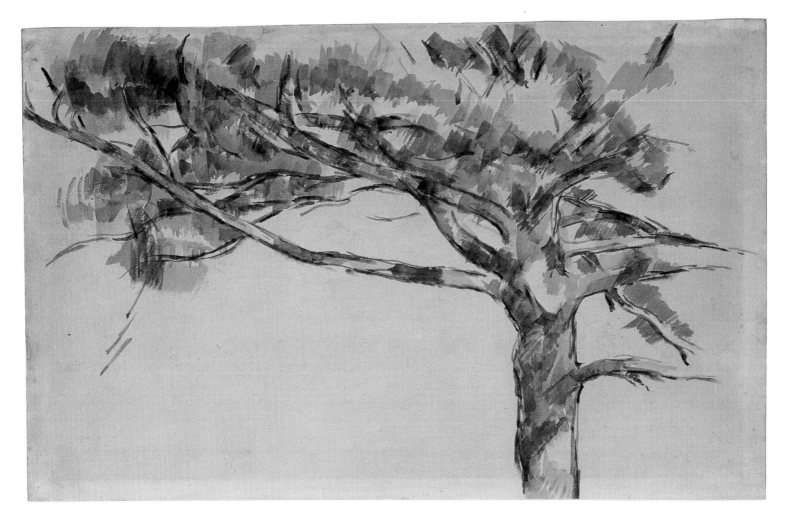

STUDY OF A TREE

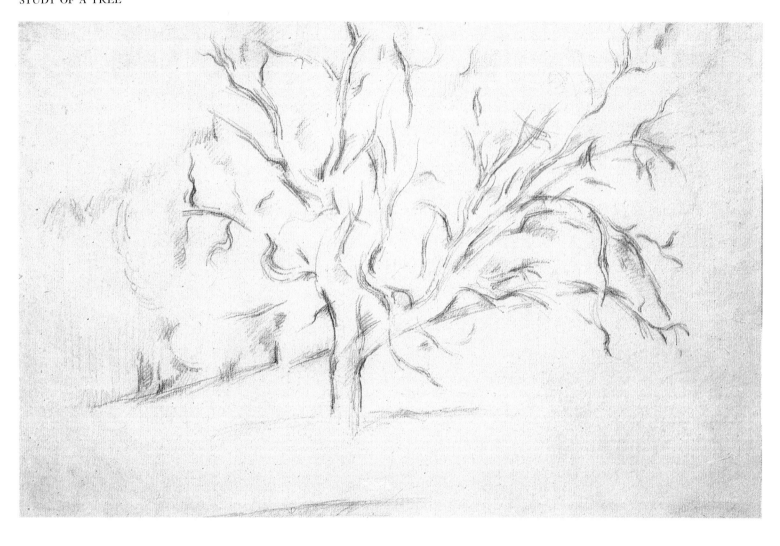

A LAKE AT THE EDGE OF A WOOD

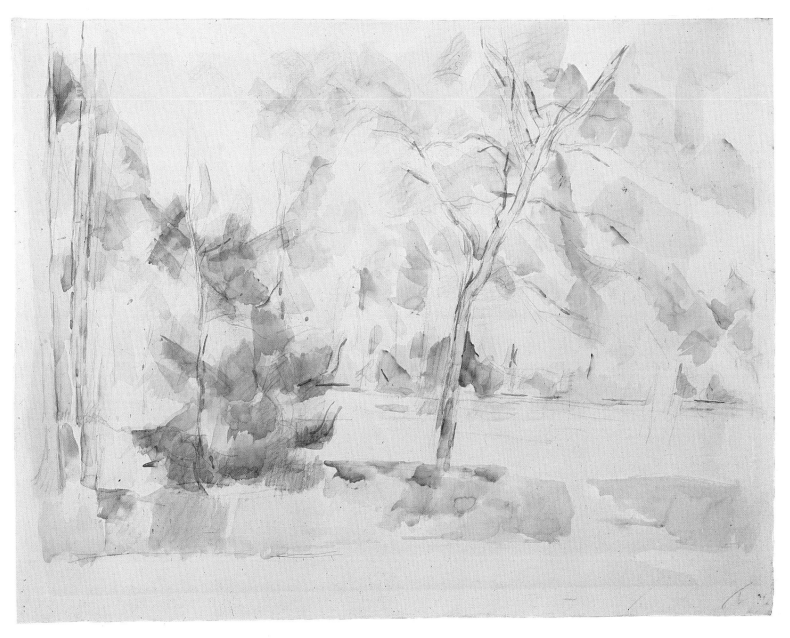

The Late Work, 1897–1906

The last decade of Cézanne's career is the most richly documented period of his life, both in the pages of his own long and informative letters and in the numerous memoirs by friends and admirers. His correspondence with younger painters such as Charles Camoin and Emile Bernard comes as close to an artistic testament as anything that Cézanne ever wrote, and the reminiscences of his colleagues offer us a remarkably complete picture of the ageing artist as seen by people of different sensibilities. After so many years of frustration, neglect and misunderstanding, Cézanne appears to have flourished in his late celebrity, only occasionally rebelling against an invasion of his privacy or the incomprehension of an admirer. Suspicious and volatile to the last, he remained largely insulated from the machinations of the art world by his financial independence, the geographical remoteness of his home in Aix and by the rôle of intermediary played by his son Paul, acting as agent between the artist and dealers like Vollard.

The paintings of Cézanne's final years have become some of the most discussed, celebrated and widely influential of his enormous output, despite frequently appearing incomplete or fragmentary. In the early years of the twentieth century, as the artist's letters show, major exhibitions in Paris and elsewhere included substantial numbers of his pictures, and an entire generation of younger painters (including Matisse, Picasso and Braque) was affected by his painting and his ideas. Cézanne himself sensed that his career might become part of a progression that would be finished by others, writing in 1903 that 'I see the promised land before me', but adding: 'Shall I be like the great Hebrew leader or shall I be able to enter?' In spite of declining energy and deteriorating health, and subject to loneliness and a sense of alienation amongst the conservative burghers of Aix, Cézanne continued to paint until his last days, as self-critical and uncompromising as ever.

In the final year or so of the nineteenth century, Cézanne produced what was probably his last self-portrait, now in the Museum of Fine Arts, Boston. There is a monumental simplicity about the classic three-quarter pose, the centrally positioned figure, the austere background and sparse furnishings; neither complacent nor sentimental, the artist appears to have reached some accommodation with his craft and with his temperament. It was presumably just such a figure that presented itself to the young Provençal and Parisian painters who visited Cézanne's studio at this time, bringing with them their own pictures for criticism, as Camoin did, or being allowed to paint in the master's studio, like Bernard. Cézanne's advice, as recorded in his letters, is encouraging but firm, and echoes the great themes of his own art. Camoin is urged to 'make some studies after the great decorative masters Veronese and Rubens . . .', but 'above all to study from nature'. Bernard is advised that 'One must look at the model and feel very exactly; and also express oneself distinctly and with force.' More elaborate ideas are put into that dense, cryptic prose favoured by Cézanne in his later years, ideas that were to be debated and disseminated for decades to come: 'treat nature by means of the cylinder, the sphere, the cone'; 'nature for us men is more depth than surface, whence the need to introduce into our light, vibrations . . .'

Cézanne's own pictures are often as diverse, ambiguous and elusive as his recorded statements. The near-abstract delicacy of his watercolour Study of Foliage (Museum of Modern Art, New York) appears to celebrate the 'manifold picture of nature' so frequently mentioned in his letters, while the heavy tones and awesome symmetry of Château Noir (Museum of Modern Art, New York) create an almost spectral, hallucinatory quality. Cézanne's late oil paintings can be as laboured and intense as his very earliest pictures, the paint thickly worked and the pigments brilliant and clamorous. Some of his watercolours, on the other

hand, are among the most exquisite of their kind, shimmering mosaics of fragile colour on white paper that conjure up light, atmosphere and space with the simplest of means. It is this diversity and breadth of experience in his final pictures, as well as in his recorded ideas, that most clearly characterize Cézanne's achievement and ultimately invalidate any attempt to confine his influence narrowly to one subsequent artistic movement or system.

A photograph taken of Cézanne in 1906, only months before his death, shows him seated in his studio in front of a still-unfinished Bather picture, one of a series of large, ambitious and problematic paintings which occupied him intermittently throughout his last years and can be seen as the culmination of a theme which dates back to his early career. Although Cézanne does not refer to the pictures specifically in his letters, his younger visitors did follow their progress and reflect on their significance. Cézanne repeatedly urges his correspondents to look at Michelangelo, Raphael, Delacroix and others, and Emile Bernard records that Cézanne's aim to paint 'a Poussin done again entirely from nature' lay behind the Bather series. In the absence of living models, Cézanne constructed his compositions from remembered poses and studies from the masters, imaginatively structuring and regrouping the limbs, thighs, breasts and heads of his subjects into a radical and rhythmic contemporary frieze. Of all Cézanne's late creations, it was the abrupt truncation and inventive interplay of volumes in the Bathers that most strongly influenced Matisse, Derain, Picasso and others in the early years of the twentieth century.

Cézanne's last letters are at times both poignant and serene, reflecting the artist's sense of mortality as well as his modest acknowledgement of progress achieved. '... I am becoming more clear-sighted before nature, but with me the realization of my senses is always painful,' he wrote to his son Paul in 1906, in a letter which also complains of the great heat that oppressed him in the summer of his last year. His physical vigour failing, his turbulent mind now subject to 'cerebral disturbances' and even his eyesight threatened by a diabetic condition, Cézanne in his late sixties continued to return to the motifs which had sustained his long painting career. The fruit of local orchards, the rocks and pines of Provence, the faces of his few acquaintances and the prospect of Mont Ste-Victoire all recur in his last watercolours and oil paintings. He would work in the landscape almost daily, until finally a chill, caught in a rainstorm, brought about a collapse and led suddenly to his death, in October 1906.

Marines [*1898*]

To Louis le Bail
The manner, a little too cavalier, in which you take the liberty of entering my room is not to my liking. In future, you would be better to have yourself announced.

Would you hand over the glass and the canvas which were left in your studio to the person who will come for them.

Accept Monsieur, my respectful greetings.

PAUL CÉZANNE

*

Paris, 22 June, 1898

To Joachim Gasquet
Having read the superb lines in which you exalt the Provençal blood, I cannot get myself to keep silence, as though I found myself in the presence of an unfortunate, a vulgar Geffroy.

There is only one thing to say, which is that the achievement does not measure up to the eulogy which you have written about it. But you are accustomed to that, and you see things so colourfully, as if through a prism, that in thanking you every word becomes pale.

Would you be good enough to tell Paul [Cézanne's son], on which day I could see you again? Sending you my warmest thanks, I ask you to give my respects to Mme Gasquet.

PAUL CÉZANNE

*

Paris, 23 December, 1898

To Henri Gasquet
I have just received the friendly greetings which you have been good enough to address to me. I can only thank you with great warmth. For me, this is the evocation of more than forty years of our past. May I say that it was an act of providence that allowed me to meet you? If I were younger, I would say that, for me, this is a support and a comfort. Someone stable in his principles and his opinions, that's splendid. I ask you to thank also your son, whom heaven has allowed me to encounter and whose friendship is very precious to me.

I hope to see him again soon, either that I go down to the Midi or that his studies and his literary interests bring him here again. He, Madame Gasquet and his friends have the future on their side. I associate myself with all my heart with the movement in the arts which they represent and to which they give its character. You have no idea how enlivening it is to find oneself surrounded by a young generation which consents not to bury one immediately; so I can only express the most sincere wishes for their triumph.

I don't want to dwell on this any longer here; it is much better to talk directly – one always explains and understands one another better . . .

Your old comrade, PAUL CÉZANNE

*

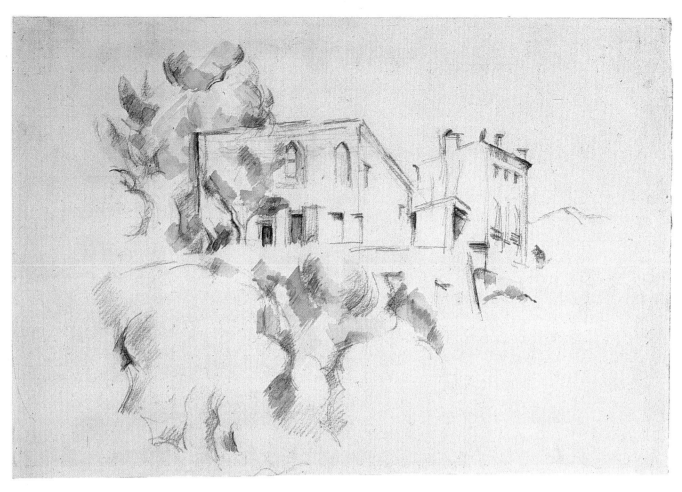

CHÂTEAU NOIR

Paris, 16 May, 1899

To Mademoiselle Marthe Conil My dear Niece, I received yesterday the letter in which you invite us to attend your first communion. Aunt Hortense, your cousin Paul and I are greatly touched by your kind invitation. But the great distance separating us from Marseille prevents us, to our great regret, from coming to you to be present at this beautiful ceremony.

At the moment I find myself tied to Paris by a rather lengthy piece of work, but I hope to come down south during the course of next month.

So I shall soon have the pleasure of embracing you. I ask you to pray for me, for once old age has caught up with us we find support and consolation in religion alone.

Thanking you for your kind thought, with love from aunt Hortense and your cousin Paul and a warm kiss from your old uncle,

Paul Cézanne

Give our love also to your sisters Paulette and Cécile.

*

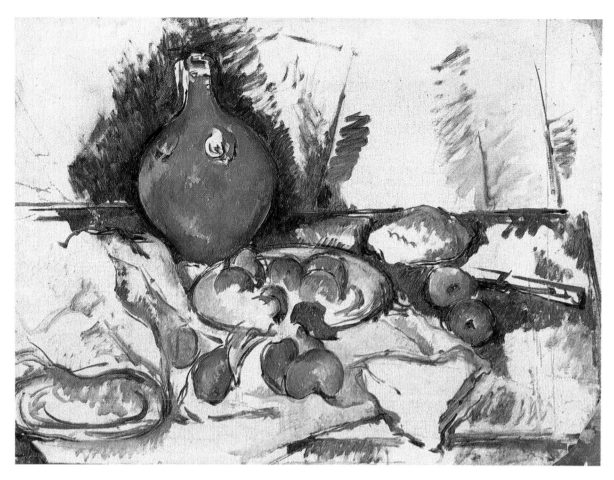

STILL LIFE WITH WATER JUG

Paris, 3 June, 1899

TO HENRI GASQUET Last month I received a number of the *Memorial d'Aix*, which published at the head of its column a splendid article of Joachim's about the age-old titles to fame of our country. I was touched by his thoughtfulness and I ask you to interpret to him the sentiments which he has reawakened in me, your old schoolfellow at the Pensionat St Joseph; for within us they have not gone to sleep for ever, the vibrating sensations reflected by this good soil of Provence, the old memories of our youth, of these horizons, of these landscapes, of these unbelievable lines which leave in us so many deep impressions.

As soon as I get down to Aix, I shall come and embrace you. For the time being I continue to seek the expression of the confused sensations which we bring with us when we are born. When I die everything will be finished, but never mind . . .

from your old comrade, PAUL CÉZANNE

*

Aix, Sunday, August, 1900

TO JOACHIM GASQUET I am returning the article which you lent me and which I have read with great pleasure. It illuminates admirably the verses which you have dedicated to the picture of rural life which you have represented in your beautiful poems. And now, as you are 'master of the expression of your sentiments', I too believe that with a work of this quality, you will achieve public recognition of your talent. . . .

PAUL CÉZANNE

*

Aix, 4 January, 1901

TO JOACHIM GASQUET I would like to thank you for the friendly letter you have written to me. It proves to me that you don't desert me. If isolation fortifies the strong, it is a stumbling block for the uncertain. I'll confess to you that it is always sad to renounce life while we are on earth. Feeling myself morally united with you, I shall resist to the end.

P. CÉZANNE

*

Aix, 5 June, 1901

TO MAURICE DENIS I learnt through the press of the manifestation of your artistic sympathy for me exhibited at the Salon de la Société Nationale des Beaux-Arts.

Please accept my warmest gratitude and be good enough to pass it on to the artists who have joined with you on this occasion.

PAUL CÉZANNE

*

[*Probably Aix, October, 1901*]

TO LOUIS AURENCHE Were I not under the powerful sway of the poet Larguier, I would deliver myself of some deeply felt phrases, but I am only a poor painter and without doubt it is rather the brush which heaven has put into my hands as a means of expression. So, it's not my affair to have ideas and to develop them. I shall be brief, – I wish that you may soon arrive at the end of your trials and your liberation will allow us to shake your hand vigorously and in friendship.

He, who precedes you on the road of life and wishes you the best of luck,

PAUL CÉZANNE

*

Aix, 23 January, 1902

TO AMBROISE VOLLARD It is now some days since we received the case of wine that you were kind enough to send us. In the meantime your last letter has reached me. I am still working at the bouquet of flowers which will doubtless take me until about 15 or 20 February. I shall have it very carefully packed and shall send it to the rue Lafitte. When it arrives please have it framed and may I ask you to have it entered?

The weather is very unsettled; sometimes beautiful sunshine is followed unexpectedly by dull, grey, leaden weather, which prevents the painting of landscape.

Paul and my wife join me in thanking you and I send you my warmest thanks for the magnificent present you made me of the work of the great Master [Delacroix].

Please accept my warmest greetings,

PAUL CÉZANNE

*

<div align="right">Aix, 28 January, 1902</div>

TO CHARLES CAMOIN Several days have now passed since I had the pleasure of reading your letter. I have little to tell you; indeed one says more and perhaps better things about painting when facing the motif than when discussing purely speculative theories – in which as often as not one loses oneself. I have more than once, in my long hours of solitude, thought of you. Monsieur Aurenche has been appointed tax collector at Pierrelatte in La Dauphinée. M. Larguier, whom I see fairly often, especially on Sundays, gave me your letter. He is pining for the moment of his release, which will take place in six or seven months. My son, who is here, has made his acquaintance and they often go out and spend the evening together; they talk a little about literature, about the future of art. When his military training is over M. Larguier will probably go back to Paris to continue his studies (moral philosophy and politics) at the rue Saint-Guillaume [Ecole des Sciences Politiques] where among others M. Hanoteaux is teaching, without, however, giving up poetry. My son will go back too, so he will have the pleasure of making your acquaintance when you return to the capital. Vollard passed through Aix about a fortnight ago. I had news of Monet, and Louis Leydet, son of the senator for the district of Aix, left his card. The latter is a painter, he is in Paris at the moment and has the same ideas as you and I. You see that an era of a new art is opening, you feel it coming; continue to study without weakening. God will do the rest. I conclude by wishing you good courage and good work and the success which cannot fail to crown your efforts.

Believe me to be very sincerely your friend and long live our country, our common mother, the land of hope, and please accept my warmest thanks for your kind thoughts.

<div align="right">Your devoted PAUL CÉZANNE</div>

<div align="center">*</div>

<div align="right">Aix, 3 February, 1902</div>

TO CHARLES CAMOIN I received your last letter only on Saturday, I have addressed my reply to Avignon. Today, the 3rd, I found your letter of the 2nd in my box, coming from Paris. Larguier was ill last week and kept in hospital, which explains the delay in sending me your letter.

Since you are now in Paris and the masters of the Louvre attract you, if it appeals to you, make some studies after the great decorative masters Veronese and Rubens, but as you would do from nature – a thing I myself was only able to do inadequately. – But you do well above all to study from nature. From what I have been able to see of you, you will advance rapidly. I am happy to hear that you appreciate Vollard, who is a sincere man and serious at the same time. I congratulate you on being with Madame, your mother, who in moments of sadness and discouragement will for you be the surest point of moral support and the most vital source from which you can draw fresh courage to work at your art; for this is what you must strive to do, not spineless and soft, but with quiet persistence, which will not fail to lead you into a state of clear insight, very useful to guide you firmly in life. – Thank you for the very brotherly way in which you regard my efforts to express myself lucidly in painting.

Hoping that one day I shall have the pleasure of seeing you again, I clasp your hand cordially and affectionately.

<div align="right">Your old colleague, PAUL CÉZANNE</div>

<div align="center">*</div>

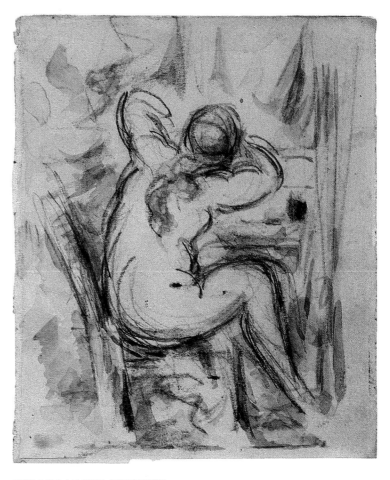

WOMAN AT HER TOILETTE

Aix, 3 February, 1902

To Louis Aurenche I received several days ago your kind letter and I am happy
with it. All the pleasant memories which you evoke come back into my head. I have vividly
regretted your departure but life is only a constant voyage and I liked being with you; that
was egoistic, because I found myself with new friends in the steppes of the good town of Aix.
I have not managed to become intimate with anyone here. Today, when the sky is overhung
with grey clouds, I see things even more in black. . . .

. . . Larguier, with his perfect equilibrium, gives me the pleasure of dining here in my house on
Sunday evenings with my wife and Paul. We miss you.

Larguier has been promoted Corporal. I have received a long letter from Camoin and have
answered him in a paternal manner, as befits my age.

My painting goes *cahin-caha*. Sometimes I have fabulous bursts of enthusiasm, and still more
often painful disappointments. Such is life. . . .

My best wishes and a firm handshake. In moments of sadness, think of your old friends and
do not entirely give up art; it is the most intimate manifestation of ourselves.

Thank you for remembering me and very cordially yours,

PAUL CÉZANNE

*

Aix, 10 March, 1902

To Louis Aurenche

I am very late in answering your last letter. The cause of it are the mental troubles from which I suffer and which allow me only to be guided by the model in my painting.

Here then is what I want to explain. Could you delay your arrival in Aix until May, because otherwise I could not offer you hospitality at my house, as my son occupies his room until that time. In May he departs to Paris with his mother, who is not too well. . . .

As for me, I painfully continue my painting studies. If I had been young, some dough would have come out of it. But old age is a great enemy of man. . . .

Believe me very cordially yours, PAUL CÉZANNE

—obliged to admit that he is not one of the most miserable on earth. – A little bit of confidence in yourself and work. Don't ever forget your art, *sic itur ad astra.*

*

Aix, 11 March, 1902

To Charles Camoin

Since your departure, the Bernheims and another dealer have been to see me; my son did a little business with them. But I remain true to Vollard and am only sorry that my son has now given them the impression that I would ever give my pictures to anyone else.

I am having a studio built on a piece of land that I bought for this purpose. Vollard, I have no doubt, will continue to be my intermediary with the public. He is a man with a great flair, of good bearing and knowing how to behave.

Your devoted PAUL CÉZANNE

*

Aix, 17 March, 1902

To Maurice Denis

In answer to your letter of the 15th, which touched me very deeply, I am writing immediately to Vollard asking him to place at your disposal the pictures which you consider suitable for exhibition at the 'Indépendants'.

Believe me yours most sincerely, PAUL CÉZANNE

*

Aix, 17 March, 1902

To Ambroise Vollard

I have received from Maurice Denis a letter which describes as a desertion my not taking part in the exhibition of the 'Indépendants'. I am replying to Monsieur Denis telling him that I am asking you to place at his disposal the pictures that you are able to lend him and to choose what will do least harm.

Believe me very sincerely yours, PAUL CÉZANNE

PORTRAIT OF AMBROISE VOLLARD

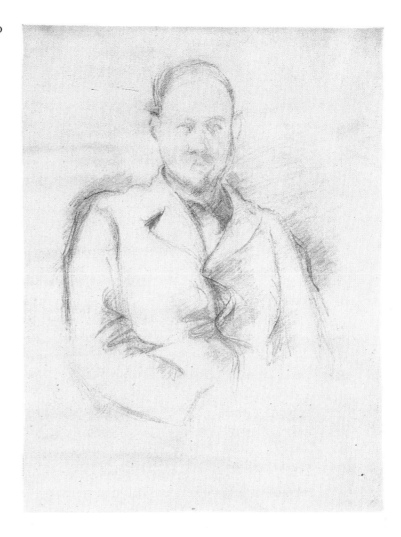

It seems to me that it is difficult for me to dissociate myself from the young people who have shown themselves to be so much in sympathy with me, and I do not think that I shall in any way harm the course of my studies by exhibiting.

P. CÉZANNE

If this causes you any inconvenience please let me know.

*

Aix, 2 April, 1902

TO AMBROISE VOLLARD I find myself obliged to postpone to a later date sending you the picture of your roses. Although I should greatly have liked to send something to the Salon of 1902, I am again this year putting off the execution of this plan. I am not satisfied with the result I have obtained. On the other hand I am not giving up work on my 'study' which, I like to believe, has obliged me to make efforts that will not be sterile. I have had a studio built on a small plot of land that I bought for that purpose. As you see, I am going on with my search and shall inform you of the results achieved as soon as I have obtained some satisfaction from my efforts.

Believe me very sincerely yours, PAUL CÉZANNE

*

<div align="right">Aix, 10 May, 1902

[*Draft*]</div>

To Ambroise Vollard De Montigny, distinguished member of the Society of Friends of the Arts in Aix, chevalier of the Légion d'honneur, has just invited me to exhibit something with his group.

I would, therefore, like to ask you to send me something which wouldn't look too bad, to have it framed at whatever cost, at my expense obviously, and to send it post haste to the Society of Friends of the Arts, Aix-en-Provence, Bouche-du-Rhône, 2, avenue Victor-Hugo.

<div align="center">*</div>

<div align="right">Aix, 8 July, 1902</div>

To Joachim Gasquet Yesterday Solari came to my house. I was out. According to the report of my housekeeper, I believe that you do not understand why I don't keep my word with regard to my intention to come to Font Laure.

I try to succeed by work. I despise all living painters, except Monet and Renoir, and I want to succeed by work.

As soon as I have a favourable moment, I shall come to shake your hand.

One must have something in the belly, then there is nothing but work.

<div align="right">Most cordially yours. PAUL CÉZANNE</div>

I had a study, started two years ago; I thought I had better get on with it. The weather has at last become beautiful.

<div align="center">*</div>

<div align="right">Aix, 1 September, 1902</div>

To Mademoiselle Paule Conil My dear Godchild, I received your nice letter on Thursday, 28th August. Thank you very much for having thought of your old uncle; this thought touches me and reminds me at the same time that I am still of this world, which might not have been the case.

I remember perfectly well the Establon and the once so picturesque banks of l'Estaque. Unfortunately what we call progress is nothing but the invasion of bipeds who do not rest until they have transformed everything into hideous *quais* with gas lamps – and, what is still worse – with electric illumination. What times we live in!

The sky, which has clouded over stormily, has refreshed the air a little and I am afraid that the sea is no longer warm enough to permit you to bathe with pleasure, if it permits you this hygienic diversion at all.

On Thursday I went to see Aunt Marie where I stayed to dinner in the evening. I met there Thérèse Valentin, to whom I showed your letter, as also to my sister.

Here everything is as usual. Little Marie cleaned my studio which is now ready and where I slowly settle in. I think with pleasure of your honouring me with a visit when you return.

Give my love to your sisters and also to little Louis. I kiss you warmly,

<div align="right">Your uncle, PAUL CÉZANNE</div>

<div align="center">*</div>

Aix, 9 January, 1903

TO AMBROISE VOLLARD

I am working doggedly, for I see the promised land before me. Shall I be like the great Hebrew leader or shall I be able to enter?

If I am ready by the end of February I shall send you my picture for framing and dispatch to some hospitable port.

I had to give up your flowers with which I am not very happy. I have a large studio in the country. I work there, I am better off than in town.

I have made some progress. Why so late and with such difficulty? Is art really a priesthood that demands the pure in heart who must belong to it entirely? I am sorry about the distance which separates us, for more than once I should have turned to you to give me a little moral support . . . If I am still alive we will talk about all this again. Thank you for thinking of me.

PAUL CÉZANNE

*

Aix, 13 September, 1903

TO CHARLES CAMOIN

I was delighted to get your news and congratulate you on being free to devote yourself entirely to your studies.

I thought I had mentioned to you that Monet lived at Giverny; I wish that the artistic influence which this master cannot fail to have on his more or less immediate circle, may make itself felt to the strictly necessary degree, which it can and ought to have on a young artist willing to work. Couture used to say to his pupils: 'Keep good company, that is: go to the Louvre. But after having seen the great masters who repose there, we must hasten out and by contact with nature revive within ourselves the instincts, the artistic sensations which live in us.' I am sorry not to be able to be with you. Age would be no obstacle were it not for the other considerations which prevent me from leaving Aix. Nevertheless I hope that I shall have the pleasure of seeing you again. Larguier is in Paris. My son is at Fontainebleau with his mother.

What shall I wish you: good studies made after nature, that is the best thing.

If you meet the master whom we both admire, remember me to him. He does not, I believe, much like being bothered, but in view of the sincerity he may relax a little.

Believe me very sincerely yours, PAUL CÉZANNE

*

Aix, 25 January, 1904

TO LOUIS AURENCHE

Thank you very much for the good wishes you and your family sent me for the New Year.

Please accept mine in turn for you and all at home.

In your letter you speak of my realization in art. I believe that I attain it more every day, although a bit laboriously. Because, if the strong feeling for nature – and certainly I have that vividly – is the necessary basis for all artistic conception on which rests the grandeur and beauty of all future work, the knowledge of the means of expressing our emotion is no less essential, and is only to be acquired through very long experience.

The approbation of others is a stimulus of which one must sometimes be wary. The feeling of one's own strength makes one modest.

I am happy at the success of our friend Larguier. Gasquet, who lives completely in the country, I have not seen for a long time.

I send you, dear Monsieur Aurenche, my very warmest greetings.

PAUL CÉZANNE

*

Aix-en-Provence, 15 April, 1904

TO EMILE BERNARD

When you get this letter you will very probably already have received a letter, from Belgium I believe, and addressed to you at the rue Boulegon. I am happy with the expression of warm artistic sympathy which you kindly address to me in your letter.

May I repeat what I told you here: treat nature by means of the cylinder, the sphere, the cone, everything brought into proper perspective so that each side of an object or a plane is directed towards a central point. Lines parallel to the horizon give breadth, whether it is a section of nature or, if you prefer, of the show which the *Pater Omnipotens Aeterne Deus* spreads out before our eyes. Lines perpendicular to this horizon give depth. But nature for us men is more depth than surface, whence the need to introduce into our light vibrations, represented by the reds and yellows, a sufficient amount of blueness to give the feel of air.

I must tell you that I had another look at the study you made from the lower floor of the studio, it is good. You only have to continue in this way, I think. You have the understanding of what must be done and you will soon turn your back on the Gauguins and [Van] Goghs!

Please thank Mme Bernard for the kind thoughts that she has reserved for the undersigned, a kiss from Père Goriot for the children, all my best regards to your dear family.

P. CÉZANNE

*

Aix, 12 May, 1904

TO EMILE BERNARD

My absorption in work and my advanced age will sufficiently explain the delay in answering your letter.

You entertain me, moreover, in your last letter with such a variety of topics, though all are connected with art, that I cannot follow it in all its developments.

I have already told you that I like Redon's talent enormously, and from my heart I agree with his feeling for and admiration of Delacroix. I do not know if my indifferent health will allow me ever to realize my dream of painting his apotheosis.

I progress very slowly, for nature reveals herself to me in very complex ways; and the progress needed is endless. One must look at the model and feel very exactly; and also express oneself distinctly and with force.

Taste is the best judge. It is rare. Art addresses itself only to an excessively limited number of individuals.

The artist must scorn all judgment that is not based on an intelligent observation of character.

He must beware of the literary spirit which so often causes the painter to deviate from his

true path – the concrete study of nature – to lose himself too long in intangible speculation.

The Louvre is a good book to consult but it must be only an intermediary. The real and immense study to be undertaken is the manifold picture of nature.

Thank you for sending me your book; I am waiting until I can read it with a clear head . . .

Sincerely yours, P. CÉZANNE

*

Aix, 26 May, 1904

TO EMILE BERNARD

On the whole I approve of the ideas you are going to expound in your next article for *Occident*. But I must always come back to this: painters must devote themselves entirely to the study of nature and try to produce pictures which will be an education. Talking about art is almost useless. The work which brings about some progress in one's own craft is sufficient compensation for not being understood by the imbeciles.

The man of letters expresses himself in abstractions whereas a painter, by means of drawing and colour, gives concrete form to his sensations and perceptions. One is neither too scrupulous nor too sincere nor too submissive to nature; but one is more or less master of one's model, and above all, of the means of expression. Get to the heart of what is before you and continue to express yourself as logically as possible.

Please give my kindest regards to Mme Bernard, a good squeeze of the hand for you, love to the children.

PICTOR P. CÉZANNE

*

Aix, 27 June, 1904

TO EMILE BERNARD

I have received your esteemed letter of . . . which I have left in the country. If I have delayed answering it, this was because I find myself in the grip of cerebral disturbances which hinder me from developing my thoughts freely. I remain in the grip of sense-perceptions and, in spite of my age, riveted to painting.

The weather is fine and I am taking advantage of it to work, I ought to make ten good studies and sell them at a high price, as amateur collectors are speculating on them . . .

It seems that Vollard, a few days ago, gave a *soirée dansante* where there was much feasting. – All the young school was there it appears, Maurice Denis, Vuillard, etc. Paul and Joachim Gasquet met again there. I think the best thing to do is to work hard. You are young, produce and sell.

You remember the fine pastel by Chardin, equipped with a pair of spectacles and a visor providing a shade. He's an artful fellow, this painter. Haven't you noticed that by letting a light plane ride across the bridge of the nose the tone values present themselves better to the eye? Verify this fact and tell me if I am wrong.

Very sincerely yours and with kind regards to Mme Bernard and love to Antoine and Irène.

P. CÉZANNE

. . . I must tell you that in view of the great heat I have my lunch brought out into the country.

*

Aix, 25 July, 1904

TO EMILE BERNARD

I have received the *Revue Occidentale*. I can only thank you for what you wrote about me.

I am sorry that we cannot be side by side, for I don't want to be right in theory, but in front of nature. Ingres, in spite of his *'estyle'* (Aixian pronunciation) and his admirers, is only a very small painter. The greatest, you know them better than I; the Venetians and the Spaniards.

In order to make progress, there is only nature, and the eye is trained through contact with her. It becomes concentric through looking and working. I mean to say that in an orange, an apple, a ball, a head, there is a culminating point; and this point is always – in spite of the tremendous effect; light and shade, colour sensations – the closest to our eye; the edges of the objects flee towards a centre on our horizon. With a small temperament one can be very much of a painter. One can do good things without being very much of a harmonist or a colourist. It is sufficient to have a sense of art – and this is without doubt the horror of the bourgeois, this sense. Therefore institutions, pensions, honours can only be made for cretins, humbugs and rascals. Don't be an art critic, but paint, there lies salvation.

A warm handclasp from your old comrade

P. CÉZANNE

*

Aix, 9 December, 1904

TO CHARLES CAMOIN

I received your kind letter dated from Martigues. Come whenever you like, you will always find me at work; you can accompany me to the *motif* if you like. Tell me the date of your arrival for if you come to the studio on the Lauves I can have lunch brought up for us both. I have lunch at 11 o'clock, and after that I set off for the *motif* unless it rains. I have a baggage depot 20 minutes away from my house.

The understanding of the model and its realization, is sometimes very slow in coming for the artist. Whoever the master may be whom you prefer, this must be only guidance for you. Otherwise you will never be anything but a *pasticheur*. With any feeling for nature and some fortunate talents – and you have some – you should be able to dissociate yourself; advice, someone else's methods must not make you change your own way of feeling. Should you momentarily be under the influence of someone older than you, believe me, as soon as you begin to feel vividly, your own emotion will always emerge and win its place in the sun, – gain the upper hand, confidence, – what you must strive to achieve is a good method of construction. Drawing is merely the outline of what you see.

Michelangelo is a constructor, and Raphael an artist who, great as he may be, is always tied to the model. – When he tries to become a thinker he sinks below his great rival.

Very sincerely yours, P. CÉZANNE

*

238

THE GROUNDS OF CHÂTEAU NOIR

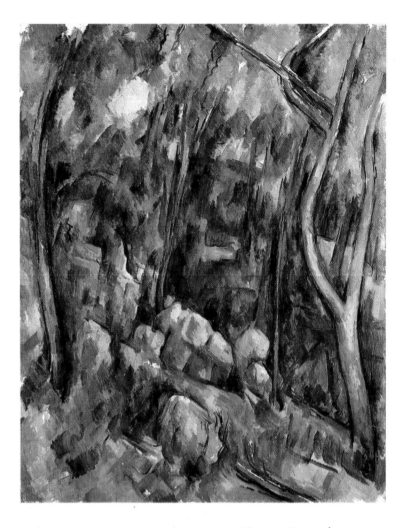

Aix, 23 December, 1904

TO EMILE BERNARD I received your kind letter dated from Naples. I shall not enter with you into aesthetic considerations. Yes, I approve of your admiration for the strongest of the Venetians; we praise Tintoretto. Your need to find a moral, an intellectual point of support in works, which assuredly will never be surpassed, keeps you constantly on the *qui vive*, incessantly on the search for the means, only dimly perceived, which will surely lead you, in front of nature, to sense your own means of expression; and on the day you find them, be convinced you will rediscover without effort, in front of nature, the means employed by the four or five great ones of Venice.

This is true, without any possible doubt – I am quite positive: – an optical sensation is produced in our visual organs which allows us to classify the planes represented by colour sensations as light, half tone or quarter tone. Light, therefore, does not exist for the painter. As long as we are forced to proceed from black to white, with the first of these abstractions providing something like a point of support for the eye as much as for the brain, we flounder, we do not succeed in becoming masters of ourselves, in being in possession of ourselves. During this period (I am necessarily repeating myself a little) we turn towards the admirable works that have been handed down to us through the ages, where we find comfort, support, such as a plank provides for the bather. – Everything you tell me in your letter is very true.

. . . My wife and son are in Paris at the moment. We shall be together again soon I hope. . . .

P. CÉZANNE

*

<div align="right">Aix, 23 January, 1905</div>

To Roger Marx

Monsieur le Rédacteur, I read with interest the lines that you were kind enough to dedicate to me in your two articles in the *Gazette des Beaux-Arts*. Thank you for the favourable opinion that you express about me.

My age and health will never allow me to realize my dream of art that I have been pursuing all my life. But I shall always be grateful to the public of intelligent amateurs who – in spite of my hesitations – have intuitively understood what I wanted to try in order to renew my art. To my mind one does not put oneself in place of the past, one only adds a new link. With a painter's temperament and an artistic ideal, that is to say a conception of nature, sufficient powers of expression would have been necessary to be intelligible to the general public and to occupy a fitting position in the history of art.

Please accept, Monsieur le Rédacteur, the expression of my warmest sympathy as an artist.

<div align="right">P. Cézanne</div>

*

<div align="right">Aix, 1905, Friday</div>

To Emile Bernard

I am replying briefly to some of the paragraphs in your last letter. As you say, I believe I have in fact made some more progress, rather slow, in the last studies which you have seen at my house. It is, however, very painful to have to state that the improvement produced in the comprehension of nature from the point of view of the picture and the development of the means of expression is accompanied by old age and a weakening of the body.

If the official salons remain so inferior, the reason is that they encourage only more or less widely accepted methods. It would be better to bring in more personal emotion, observation and character.

The Louvre is the book in which we learn to read. We must not, however, be satisfied with retaining the beautiful formulas of our illustrious predecessors. Let us go forth to study beautiful nature, let us try to free our minds from them, let us strive to express ourselves according to our personal temperament. Time and reflection, moreover, modify little by little our vision, and at last comprehension comes to us.

It is impossible in this rainy weather to practise out of doors these theories which, however, are so right. But perseverance leads us to understand interiors like everything else. Only the old dregs clog our intelligence, which needs to be whipped on.

Very sincerely yours and my regards to Madame Bernard and love to the children.

<div align="right">P. Cézanne</div>

You will understand me better when we see each other again; study modifies our vision to such a degree that the humble and colossal Pissarro finds himself justified in his anarchistic theories.

Draw; but it is the reflection which envelops; light, through the general reflection, is the envelope.

<div align="right">P.C.</div>

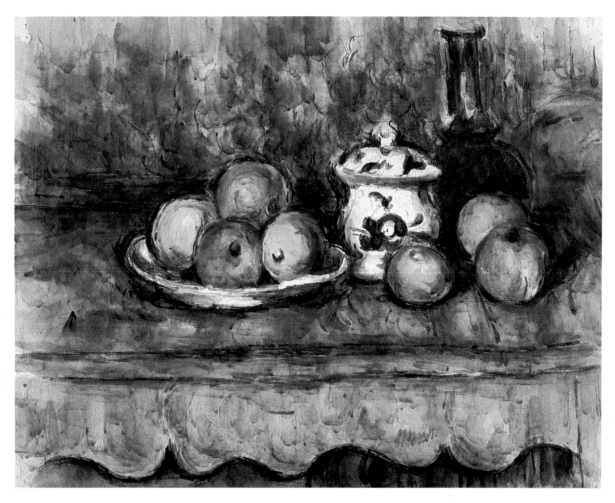

STILL LIFE WITH CARAFE AND SUGAR BOWL

Aix, 23 October, 1905

TO EMILE BERNARD

Your letters are precious to me for a double reason: the first being purely egoistic, because their arrival lifts me out of the monotony caused by the incessant pursuit of the sole and unique aim, which leads in moments of physical fatigue to a kind of intellectual exhaustion; and the second allows me to reassess for you, undoubtedly rather too much, the obstinacy with which I pursue the realization of that part of nature, which, coming into our line of vision, gives us the picture. Now the theme to develop is that – whatever our temperament or form of strength face to face with nature may be – we must render the image of what we see, forgetting everything that existed before us. Which, I believe, must permit the artist to give his entire personality, whether great or small.

Now, being old, nearly 70 years, the sensations of colour, which give the light, are for me the reason for the abstractions which do not allow me to cover my canvas entirely nor to pursue the delimitation of the objects where their points of contact are fine and delicate; from which it results that my image or picture is incomplete. On the other hand the planes fall one on top of the other, from whence neo-impressionism emerged, which circumscribes the contours with a black line, a fault which must be fought at all costs. But nature, if consulted, gives us the means of attaining this end.

I remembered quite well that you were at Tonnerre but the difficulties of settling down in my house make me place myself entirely at the disposal of my family, who make use of this to seek their own comfort and neglect me a little. That's life; at my age I should have more experience and use it for the general good. I owe you the truth about painting and shall tell it to you.

Please give my kind regards to Madame Bernard; the children I must love, seeing that St Vincent de Paul is the one to whom I must recommend myself most.

Your old, PAUL CÉZANNE

A strong handshake and good courage.
Optics, which are developed in us by study, teach us to see.

*

[*Aix*] Friday [*18*] July, 1906

TO HIS SON PAUL This morning, as my head feels fairly clear, I am answering your two letters, which always give me the greatest pleasure. Four-thirty in the morning – by 8 o'clock the temperature will be unbearable – I am continuing my studies. One ought to be young and do many of them. The atmosphere is sometimes full of dust and the colours are deplorable – it is only beautiful at certain times.

Thank you for the news you give me, I pursue my good old way.

My love to Mamma and to all the people who still remember me. Give my regards to Madame Pissarro, – how distant everything already is and yet how close.

Your father who embraces you both.

PAUL CÉZANNE

I have not yet seen your aunt. I sent her your first letter.
Do you know where the little sketch of the *Bathers* is?

*

Aix, 3 August, 1906

TO HIS SON PAUL I received your affectionate letters of various dates all fairly close together. If I have not answered at once, the oppressive heat which reigns is the reason. It depresses my brain considerably and prevents me from thinking. I get up in the early morning, and live my ordinary life only between 5 and 8 o'clock. By that time the heat becomes stupefying and exerts such a strong cerebral depression that I can't even think of painting. I was forced to call in Doctor Guillaumont for I had an attack of bronchitis, and I gave up homeopathy in favour of mixed syrups of the old school. – I didn't half cough, mother Brémond applied some cotton-wool soaked in iodine, and it did me a lot of good. I regret my advanced age, because of my colour sensations. – I am glad that you see Monsieur and Madame Legoupil who have their feet on the ground and must ease your existence considerably. I am happy to hear of the good relations you have with the intermediaries between art and the public, whom I wish to see continue in their favourable attitudes towards me. . . .

I embrace you and Mamma with all my heart.

Your old father, PAUL CÉZANNE

*

Aix, 12 August, 1906

To His Son Paul

The days have been terribly hot; today, particularly this morning, it was pleasant from 5 o'clock in the morning, the time at which I got up, until about 8 o'clock. The sensations of pain exasperate me to the point where I can no longer overcome them and force me to live a retired life, that is what is best for me. At St Sauveur, the old choirmaster Poncet has been succeeded by an idiot of an abbé, who works the organ and plays wrong. In such a manner that I can no longer go to Mass, his way of playing music makes me positively ill.

I think that to be a Catholic one must be devoid of all sense of justice, but have a good eye for one's interests.

Two days ago the *sieur* Rolland came to see me, he made me talk about painting. He offered to pose for me as a bather on the shores of the Arc. – That would please me, but I am afraid that the gentleman simply wants to lay hands on my sketch; in spite of that I almost feel inclined to try something with him. . . .

A poor tramp from Lyon came to borrow a few sous from me, he seemed to me to be in a frightful mess.

I embrace you and Mamma with all my heart.

Your old father, PAUL CÉZANNE

*

Aix, 14 August, 1906

To His Son Paul

It is 2 o'clock in the afternoon. I am in my room, the heat has started again, it is appalling. – I am waiting for 4 o'clock, the carriage will come and fetch me and will take me to the river by the bridge of the Trois Sautets. It is a little fresher there; I felt very well there yesterday, I started a watercolour in the style of those I did at Fontainebleau, it seems more harmonious to me, it is all a question of putting in as much interrelation as possible. . . .

By the river a poor little child, very lively, came up to me, in rags, asked me if I was rich; another, older, told him that one didn't ask that. When I got back into my carriage to return to town he followed me; at the bridge I threw him two sous, if you could have seen how he thanked me.

My dear Paul, I have nothing to do but paint. I embrace you with all my heart, you and Mamma, your old father,

PAUL CÉZANNE

*

Aix, Sunday, 26 August, 1906

To His Son Paul

If I forget to write to you it is because I lose a little the awareness of time. It has been terribly hot and on the other hand my nervous system must be very much enfeebled. I live a little as if in a void. Painting is what means most to me. I am very irritated about the cheek of my compatriots who try to put themselves on an equal footing with me as an artist and to lay their hands on my work. – You should see the dirty tricks they play. I go every day to the river by carriage. It is quite nice there, but my

weakened state is very bad for me. Yesterday I met the priest Roux, he repels me.

I am going up to the studio, I got up late this morning, after 5 o'clock. I am still working with much pleasure, but sometimes the light is so horrible that nature seems ugly to me. Some selection is therefore necessary. My pen hardly works. I embrace you both with all my heart and remember me to all the friends who still think of me, across time and space. A kiss for you and Mamma. Greetings to Monsieur and Madame Legoupil, your old father,

<div align="right">PAUL CÉZANNE</div>

<div align="center">*</div>

<div align="right">Aix, 8 September, 1906</div>

TO HIS SON PAUL Today (it is nearly 11 o'clock) a startling return of the heat. The air is overheated, not a breath of air. This temperature can be good for nothing but the expansion of metals, it must help the sale of drinks and bring joy to the beer merchants, an industry which seems to be assuming a fair size in Aix, and it expands the pretensions of the intellectuals in my country, a pack of ignoramuses, cretins and rascals.

The exceptions, there may be some, do not make themselves known. Modesty is always unaware of itself. – Finally I must tell you that as a painter I am becoming more clear-sighted before nature, but that with me the realization of my sensations is always painful. I cannot attain the intensity that is unfolded before my senses. I have not the magnificent richness of colouring that animates nature. Here on the bank of the river the *motifs* multiply, the same subject seen from a different angle offers subject for study of the most powerful interest and so varied that I think I could occupy myself for months without changing place, by turning now more to the right, now more to the left.

My dear Paul, in conclusion I must tell you that I have the greatest faith in your feelings, which impress on your mind the necessary measures to guard our interests, that is to say that I have the greatest faith in your direction of our affairs. . . .

Your father, who sends a kiss for you and Mamma,

<div align="right">PAUL CÉZANNE</div>

<div align="center">*</div>

<div align="right">Aix, 21 September, 1906</div>

TO EMILE BERNARD I am in such a state of mental disturbance, I fear at moments that my frail reason may give way. After the terrible heatwave that we have just had, a milder temperature has brought some calm to our minds, and it was not too soon; now it seems to me that I see better and that I think more correctly about the direction of my studies. Will I ever attain the end for which I have striven so much and so long? I hope so, but as long as it is not attained a vague state of uneasiness persists which will not disappear until I have reached port, that is until I have realized something which develops better than in the past, and thereby can prove the theories – which in themselves are always easy; it is only giving proof of what one thinks that raises serious obstacles. So I continue to study.

But I have just reread your letter and I see that I always answer off the mark. Be good enough to forgive me; it is, as I told you, this constant preoccupation with the aim I want to reach, which is the cause of it.

I am always studying after nature and it seems to me that I make slow progress. I should have liked you near me, for solitude always weighs me down a bit. But I am old, ill, and I have

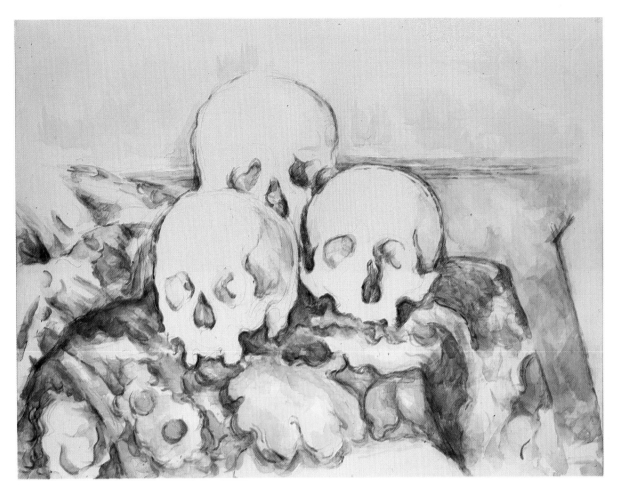

THE THREE SKULLS

sworn to myself to die painting, rather than go under in the debasing paralysis which threatens old men who allow themselves to be dominated by passions which coarsen their senses.

If I have the pleasure of being with you one day, we shall be better able to discuss all this in person. You must forgive me for continually coming back to the same thing; but I believe in the logical development of everything we see and feel through the study of nature and turn my attention to technical questions later; for technical questions are for us only the simple means of making the public feel what we feel ourselves and of making ourselves understood. The great masters whom we admire must have done just that.

A warm greeting from the obstinate macrobite who sends you a cordial handshake.

PAUL CÉZANNE

*

Aix, 22 September, 1906

TO HIS SON PAUL I sent a long letter to Emile Bernard, a letter which reflects my preoccupations, I described them to him, but as I see a little further than he does and as the manner in which I told him of my reflections cannot offend him in any way, even though I have not the same temperament nor his way of feeling, at last and finally I have come to believe that one cannot help others at all. With Bernard it is true one can develop theories indefinitely because he has a rational temperament. I go into the country every day, the motifs are beautiful and in this way I spend my days more agreeably than anywhere else.

I embrace you and Mamma with all my heart, your devoted father,

PAUL CÉZANNE

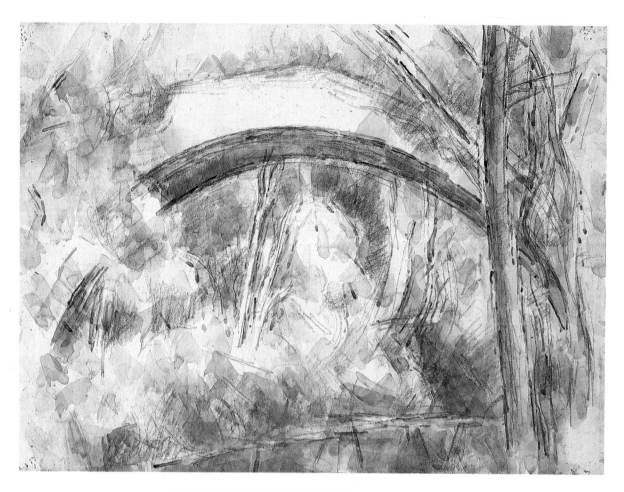

THE BRIDGE AT TROIS SAUTETS

My dear Paul, I have already told you that I am oppressed by cerebral disturbances, my letter reflects them. Moreover, I see the dark side of things and so feel myself more and more compelled to rely on you and to look to you for guidance.

*

Aix, 26 September, 1906

TO HIS SON PAUL
I received a notification from the Salon d'Automne, signed by Lapigie, who is doubtless one of the big organizers and . . . of the exhibition; from it I see that eight of my pictures are on view. Yesterday I saw that valiant Marseillean Carlos Camoin, who came to show me a pile of paintings and to seek my approval; what he does is good, if anything he seems to be making progress, he is coming to spend a few days at Aix and is going to work on the *petit chemin du Tholonet*. He showed me a photograph of a figure by the unfortunate Emile Bernard; we are agreed on this point, that he is an intellectual constipated by recollections of museums, but who does not look enough at nature, and that is the great thing, to make himself free from the school and indeed from all schools. – So that Pissarro was not mistaken, though he went a little too far, when he said that all the necropoles of art should be burned down. . . .

I embrace you and Mamma with all my heart, your father,

PAUL CÉZANNE

*

Aix, 13 October, 1906

TO HIS SON PAUL Today, after a terrific thunderstorm in the night and as it was still raining this morning, I remained at home. It is true, as you remind me, that I forgot to mention the wine. Madame Brémond tells me that we must have some sent. When, on the same occasion, you see Bergot, you should order some white wine for yourself and your mother. It has rained a lot and I think that this time the heat is over. As the banks of the river are now a bit cool I have left them and climb up to the quartier de Beauregard where the path is steep, very picturesque but rather exposed to the mistral. At the moment I go up on foot with only my bag of water colours, postponing oil painting until I have found a place to put my baggage; in former times one could get that for 30 francs a year. I can feel exploitation everywhere. – I am waiting for you to make a decision. The weather is stormy and changeable. My nervous system is very weak, only oil painting can keep me up. I must carry on. I simply must produce after nature. – Sketches, pictures, if I were to do any, would be merely constructions after nature, based on method, sensations, and developments suggested by the model, but I always say the same thing. – Could you get me marzipan in a small quantity?

I embrace you and Mamma with all my heart, your father,

PAUL CÉZANNE

*

Aix, 15 October, 1906

TO HIS SON PAUL It rained on Saturday and Sunday and there was a thunderstorm, the weather is much cooler – in fact it is not hot at all. You are quite right in saying that here we are deep in the provinces. I continue to work with difficulty, but in the end there is something. That is the important thing, I believe. As sensations form the basis of everything for me, I am, I believe, impervious. I shall, by the way, let the poor devil, you know who, imitate me as much as he likes, it is scarcely dangerous. . . .

I should like to ask you to order me two dozen marten-hair brushes, like the ones we ordered last year.

My dear Paul, in order to give you news as satisfactory as you would like, I would need to be twenty years younger. – I repeat, I eat well, and a little moral satisfaction – but work alone can give me that – would do me a lot of good. – All my compatriots are arseholes beside me.

I should have told you that I received the cocoa.

I embrace you and Mamma, your old father,

PAUL CÉZANNE

I think the young painters are much more intelligent than the others, the old ones see in me only a disastrous rival. Ever your father,

P. CÉZANNE

I must say it again, Emile Bernard seems to me worthy of deep compassion for he has to look after his family.

*

STILL LIFE WITH FAIENCE POT

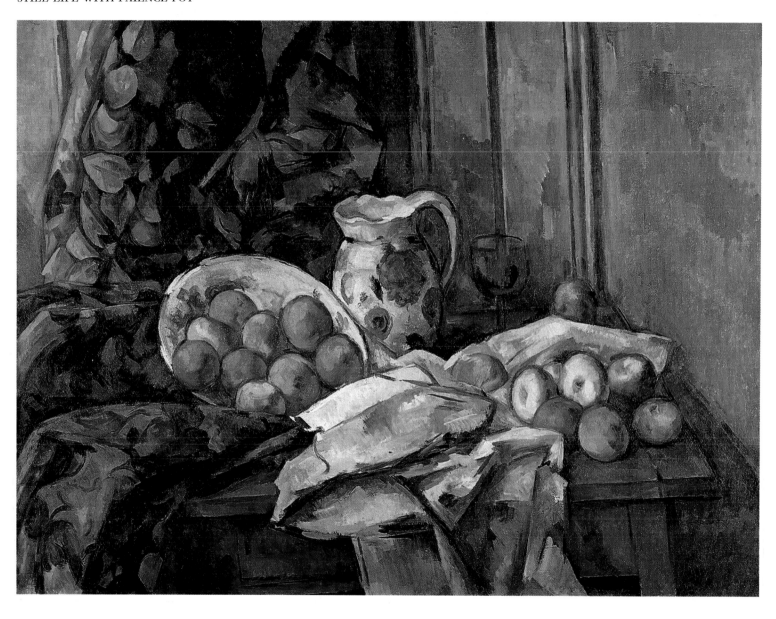

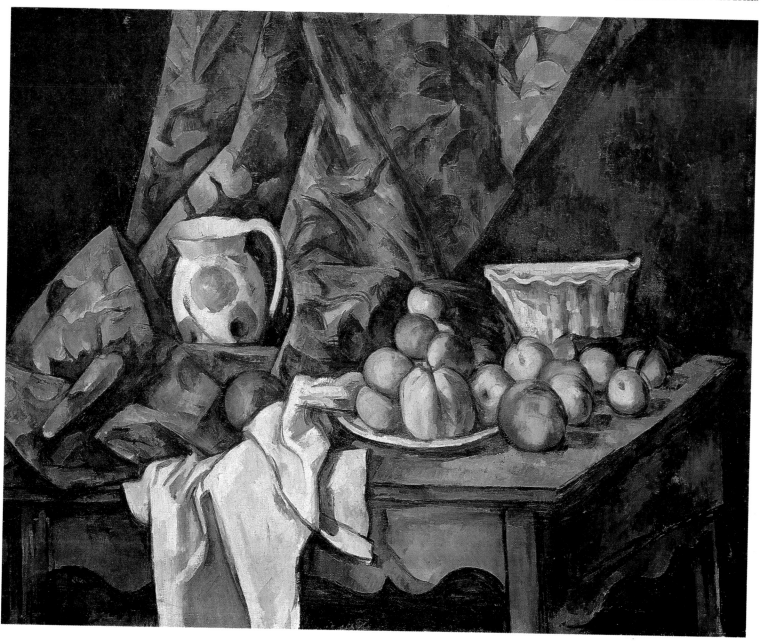

THE THREE SKULLS

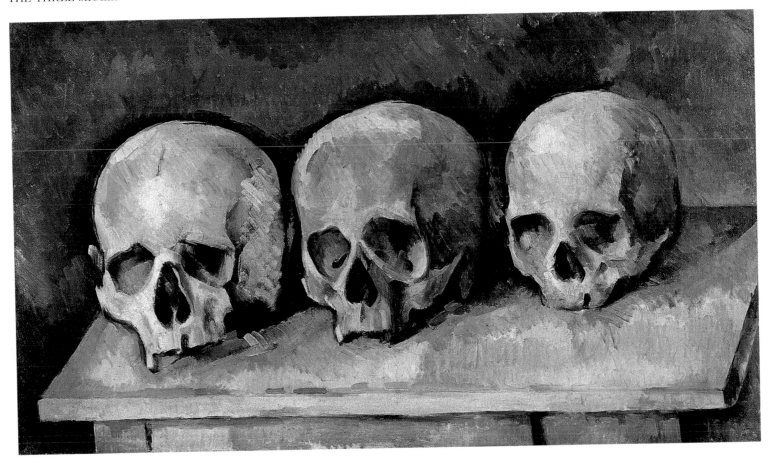

PYRAMID OF SKULLS

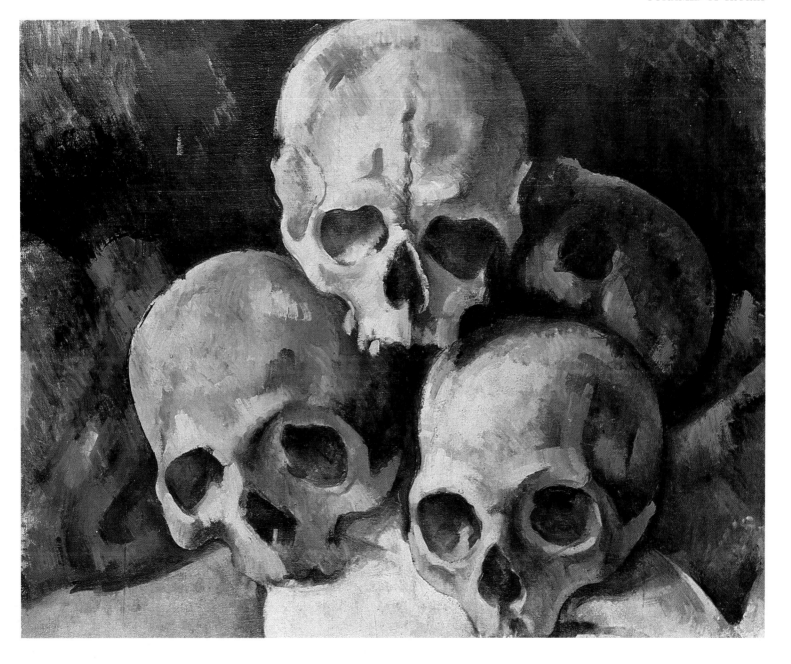

BOTTLE, CARAFE, JUG AND LEMONS

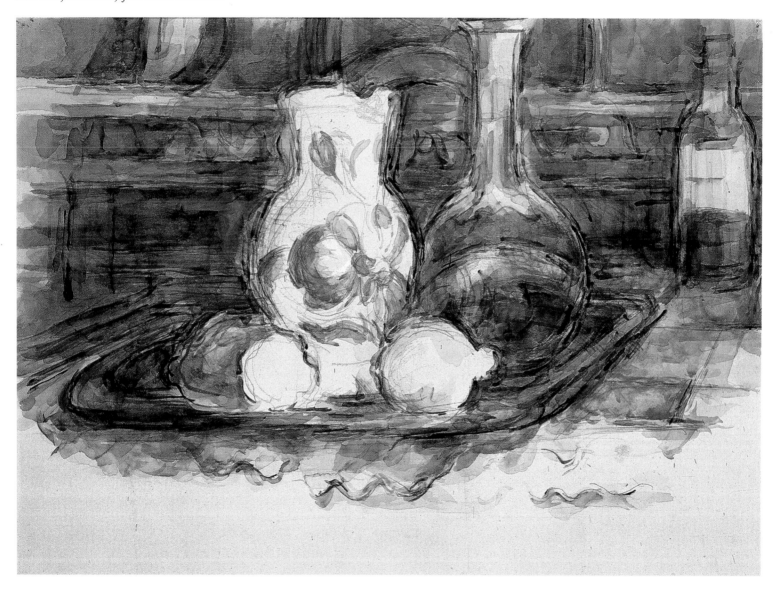

BOTTLES, POT, ALCOHOL STOVE, APPLES

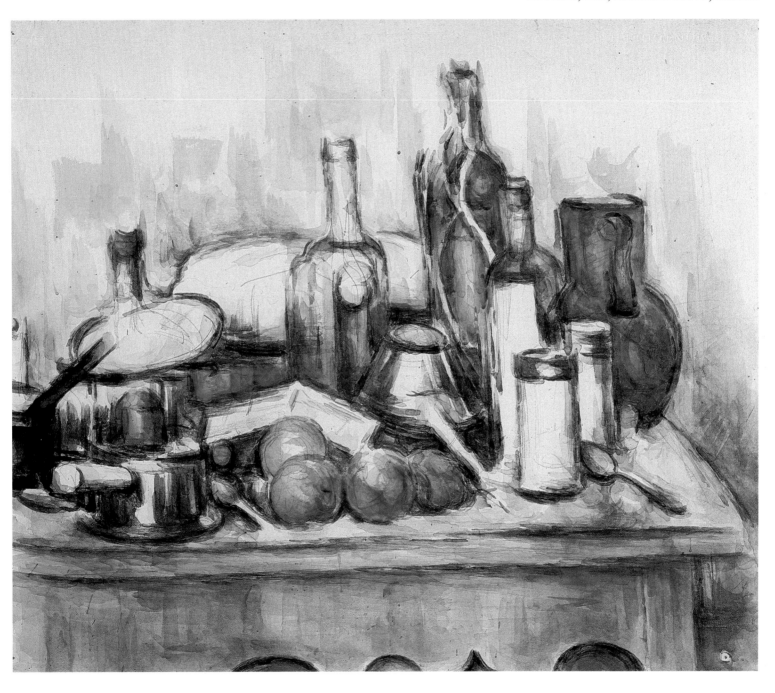

STILL LIFE WITH POMEGRANATES, CARAFE, SUGAR-BOWL, BOTTLE AND WATERMELON

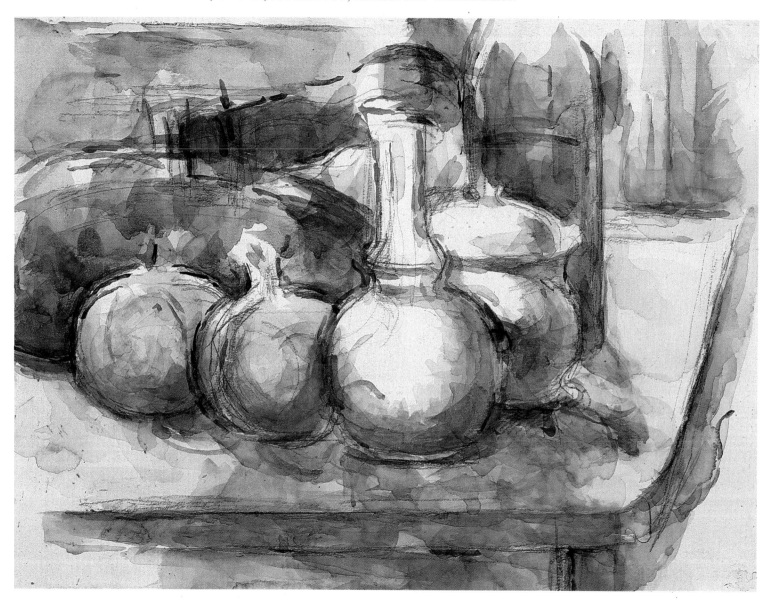

STILL LIFE WITH APPLES, BOTTLE AND CHAIR BACK

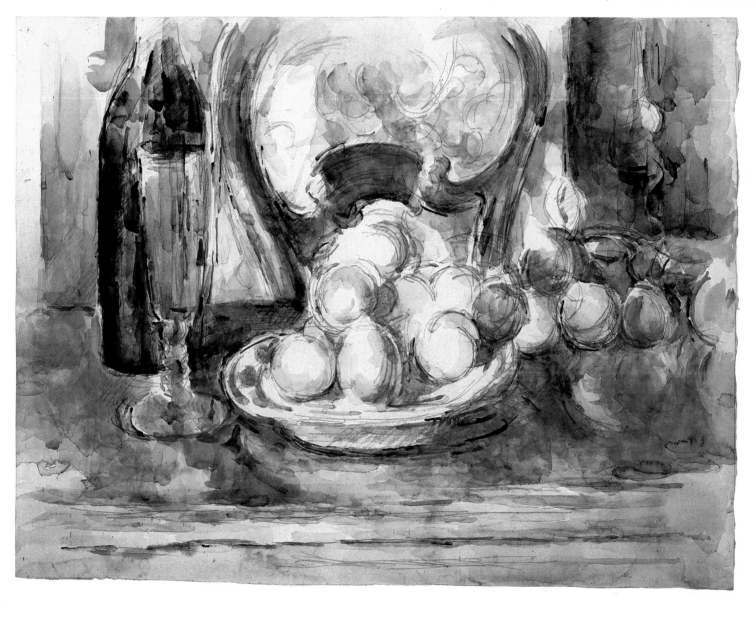

STILL LIFE WITH WATERMELON

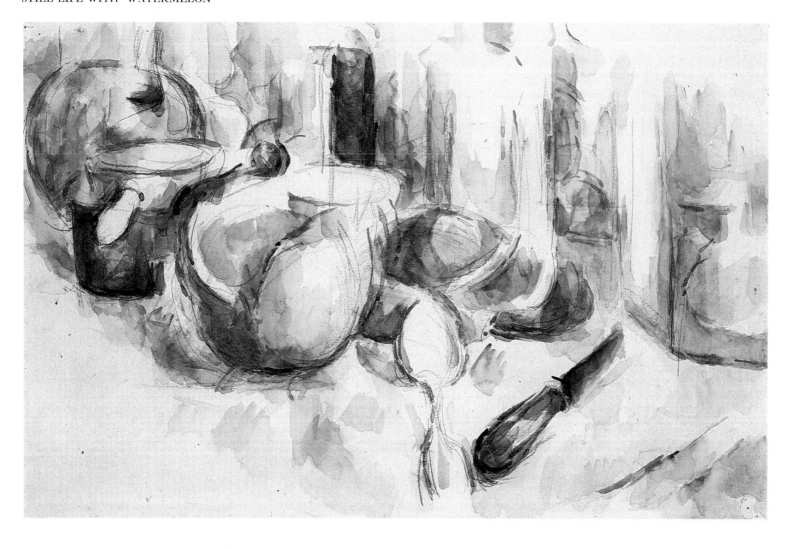

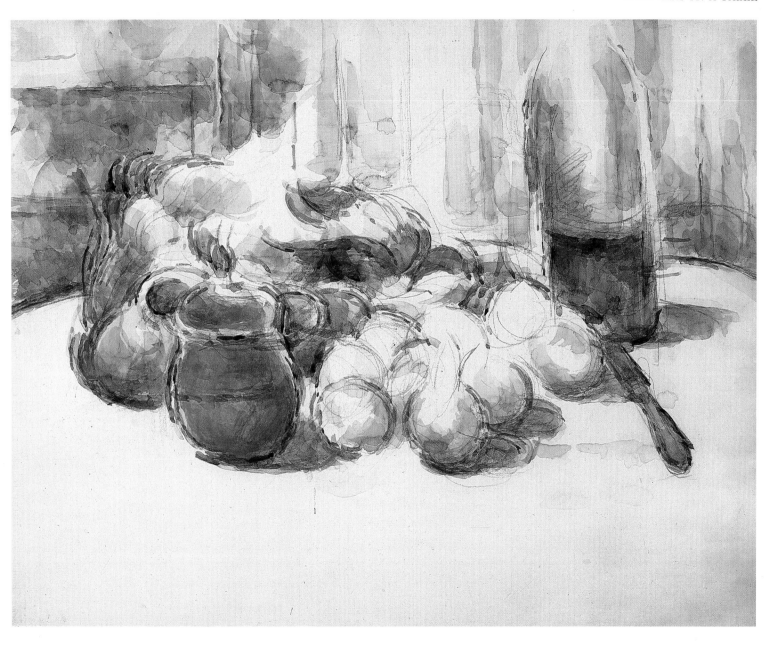

PORTRAIT OF THE GARDENER VALLIER

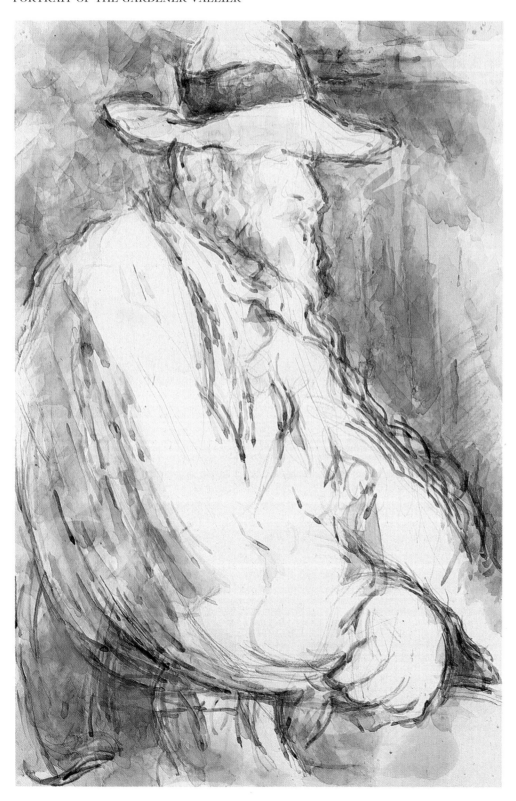

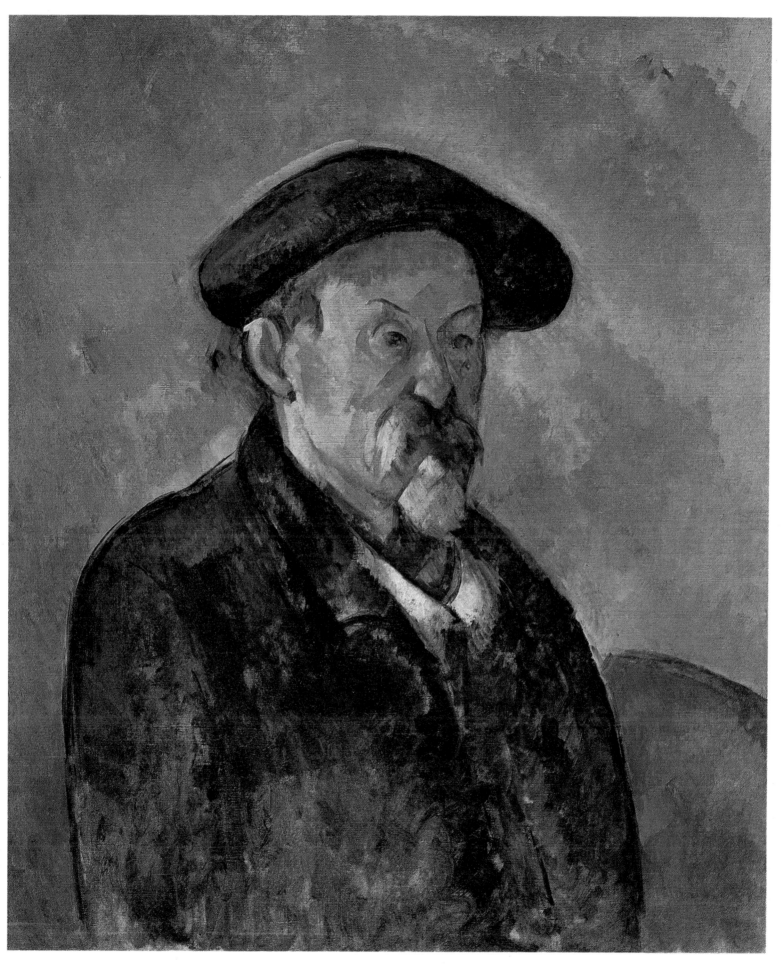

THE SAILOR

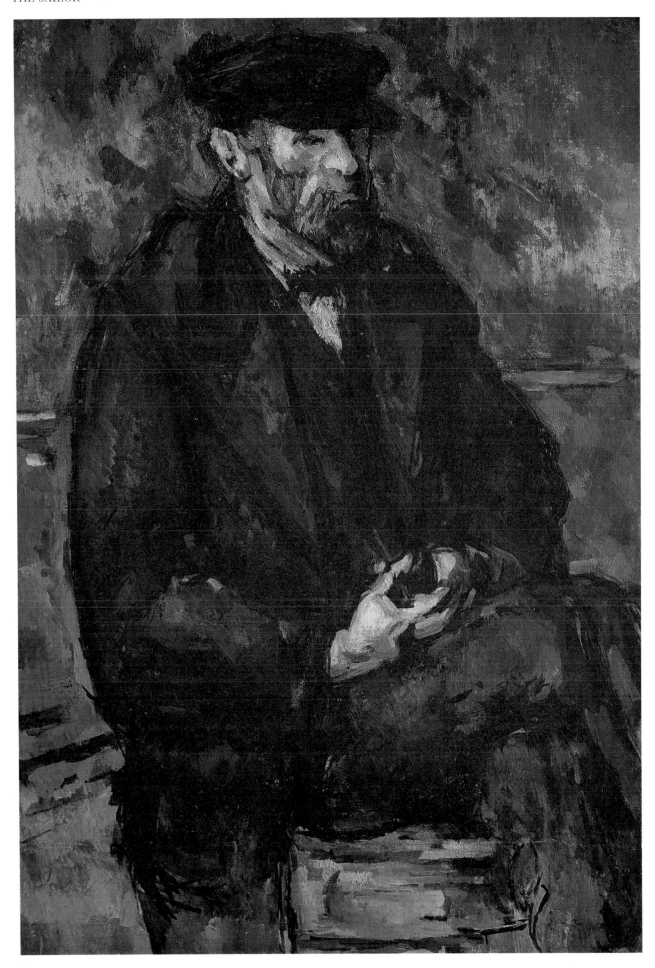

AN OLD WOMAN WITH A ROSARY

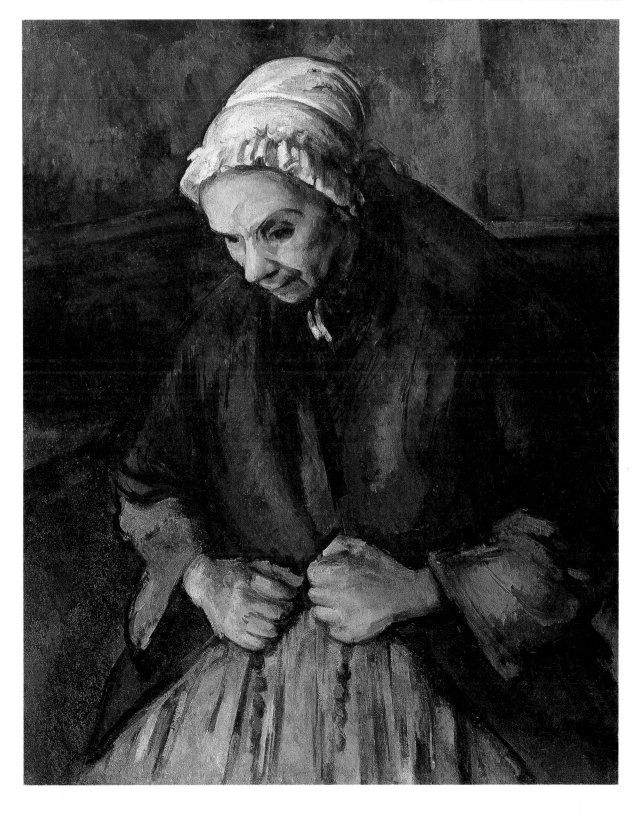

BATHERS

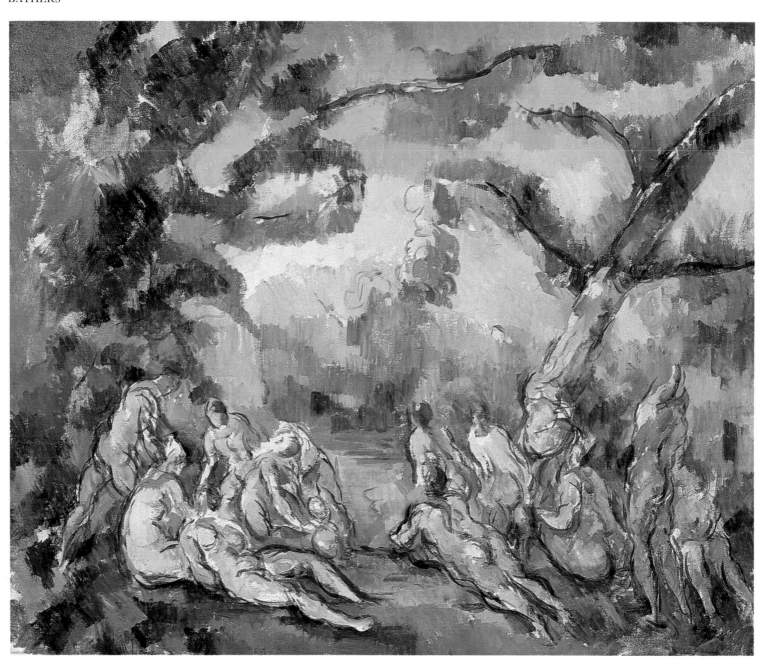

SEVEN BATHERS

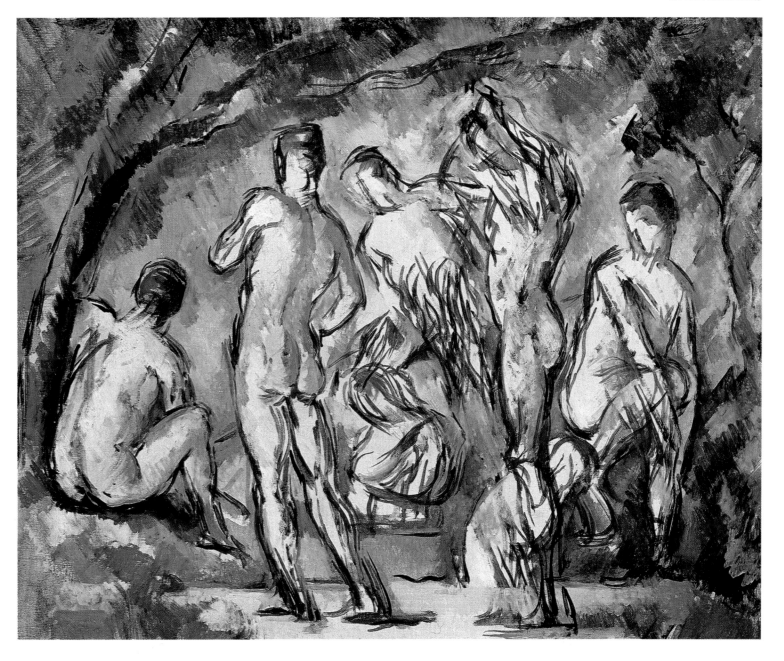

BATHERS

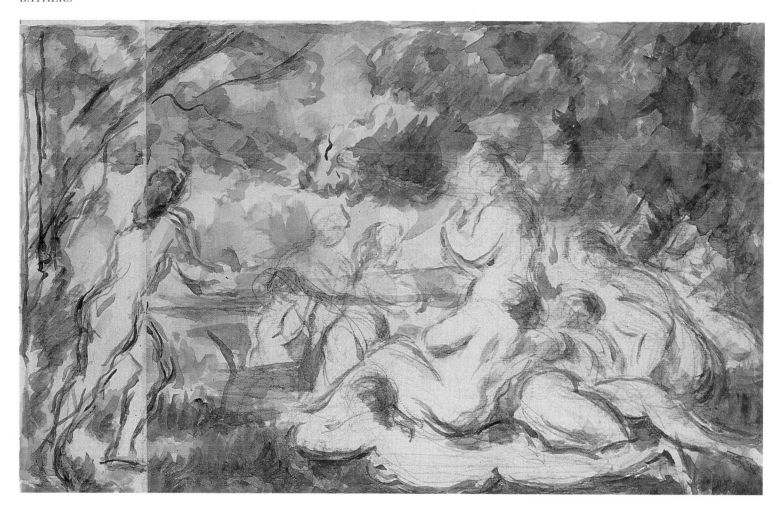

STUDY FOR BATHERS

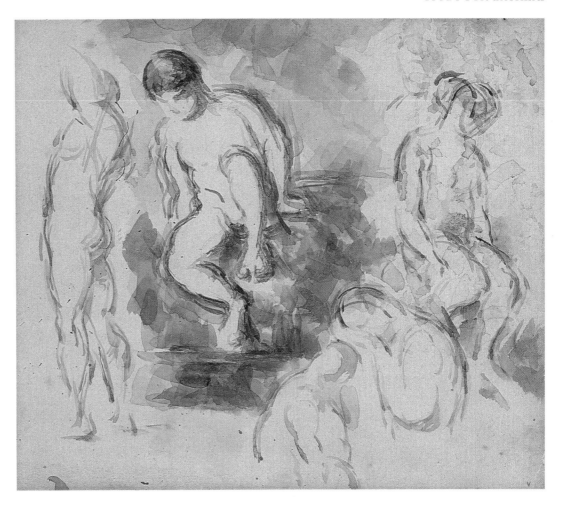

GROUP OF WOMEN

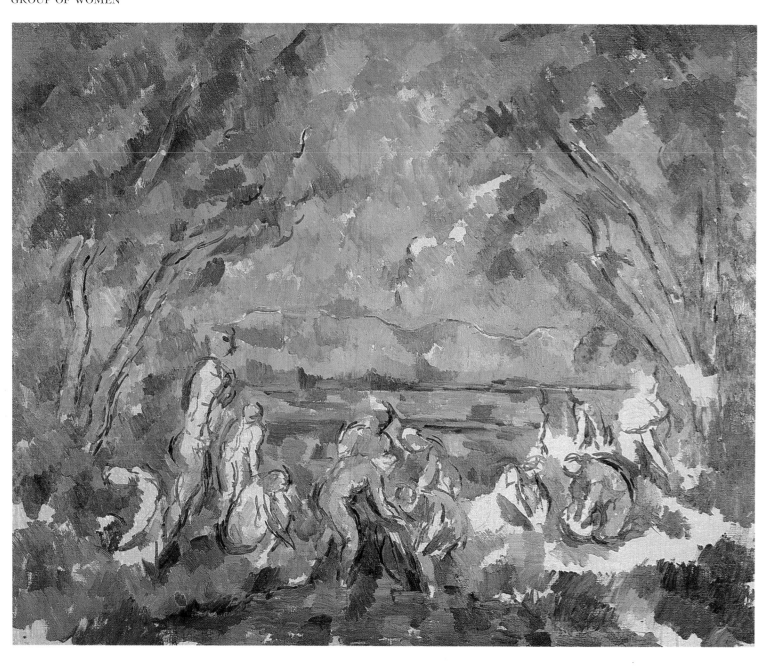

THE BOAT (FISHING)

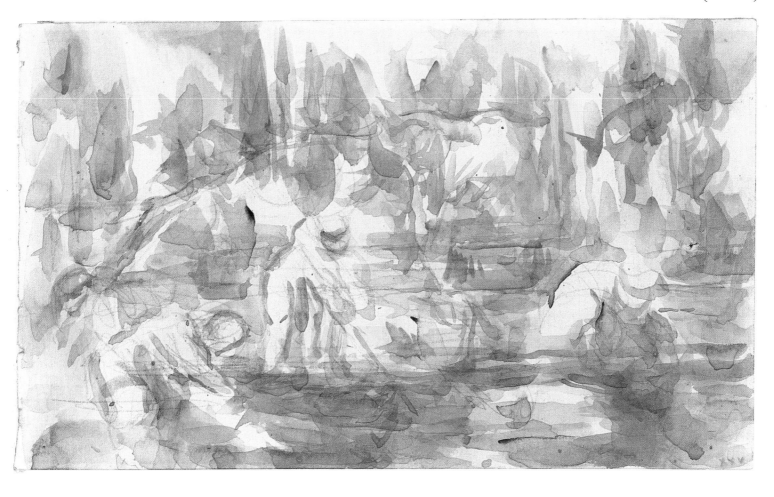

THE LARGE BATHERS

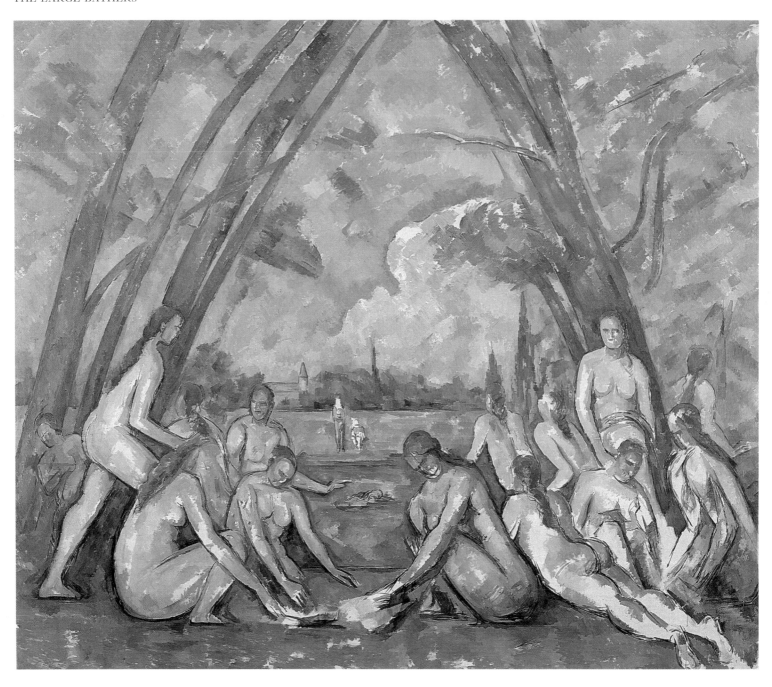

BATHERS

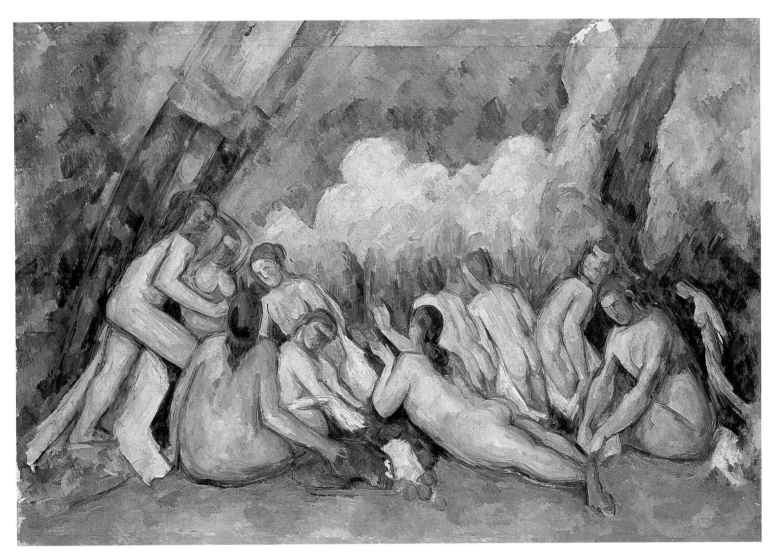

MILLSTONE IN THE PARK OF CHÂTEAU NOIR

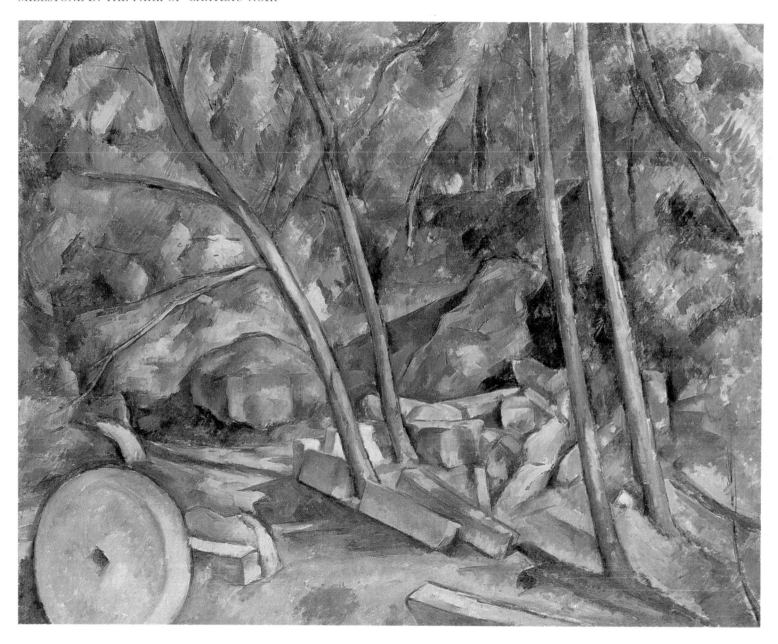

CISTERN AT CHÂTEAU NOIR

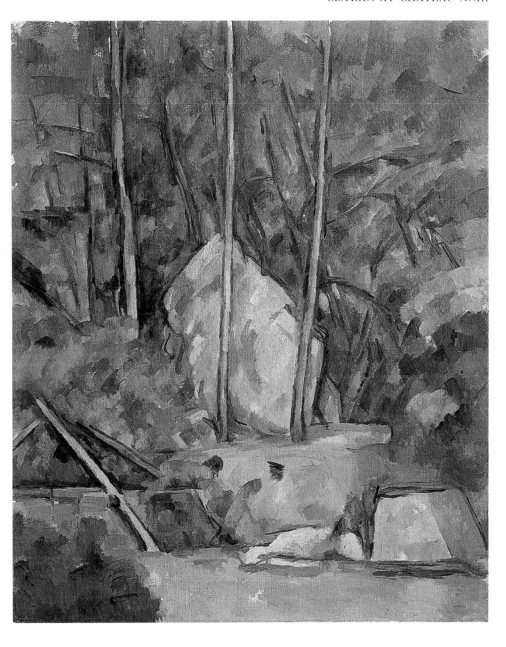

PINES AND ROCKS AT CHÂTEAU NOIR

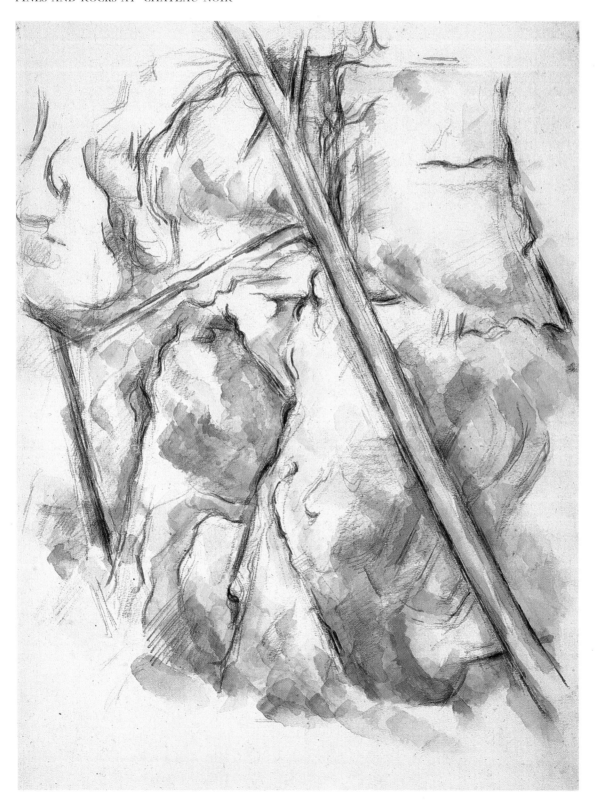

UNDER THE TREES

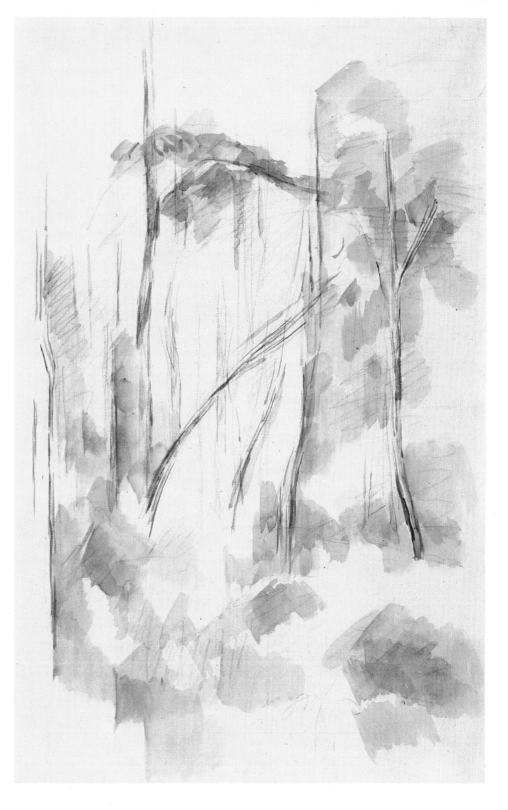

THE RED ROCK

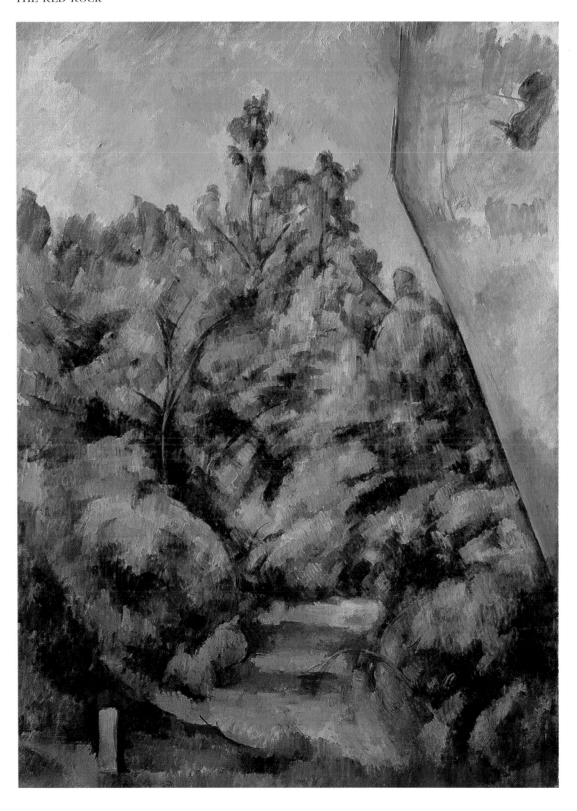

MONT SAINTE-VICTOIRE SEEN FROM THE BIBÉMUS QUARRY

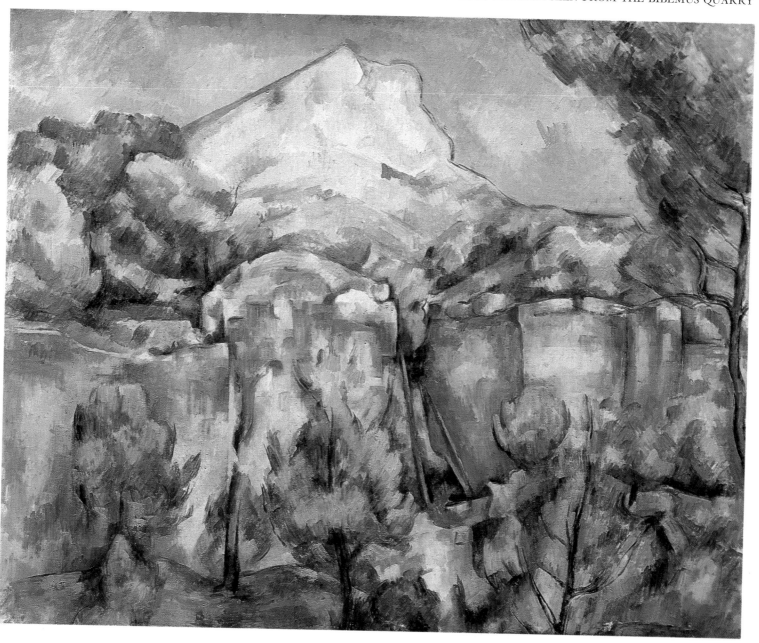

MONT SAINTE-VICTOIRE SEEN FROM LES LAUVES

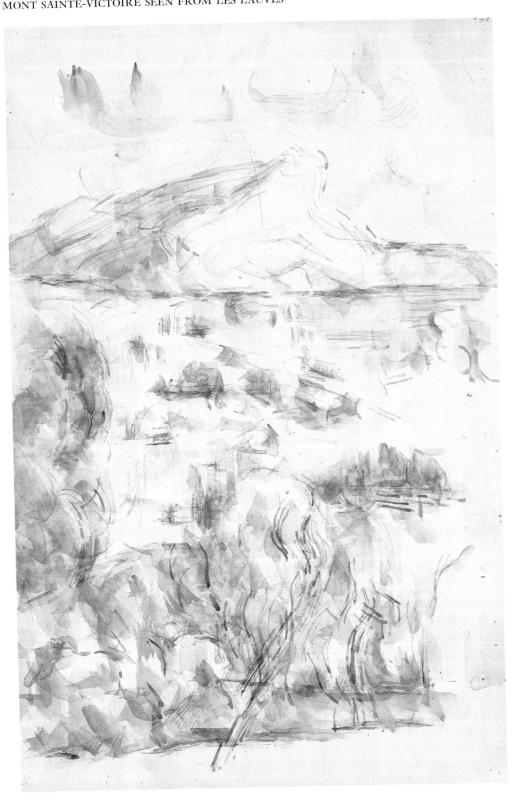

MONT SAINTE VICTOIRE

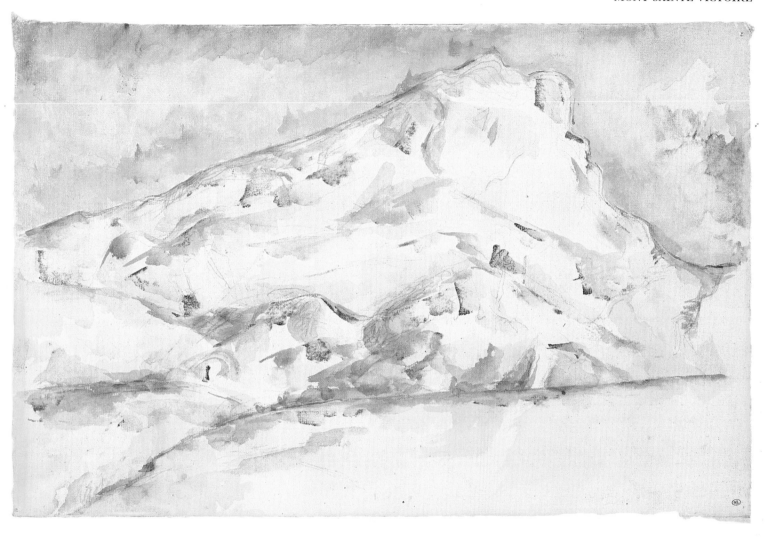

MONT SAINTE-VICTOIRE

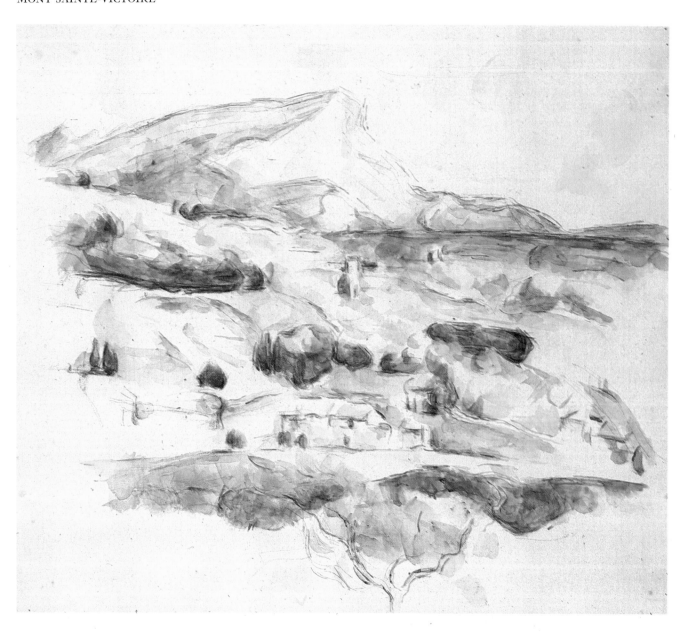

MONT SAINTE-VICTOIRE

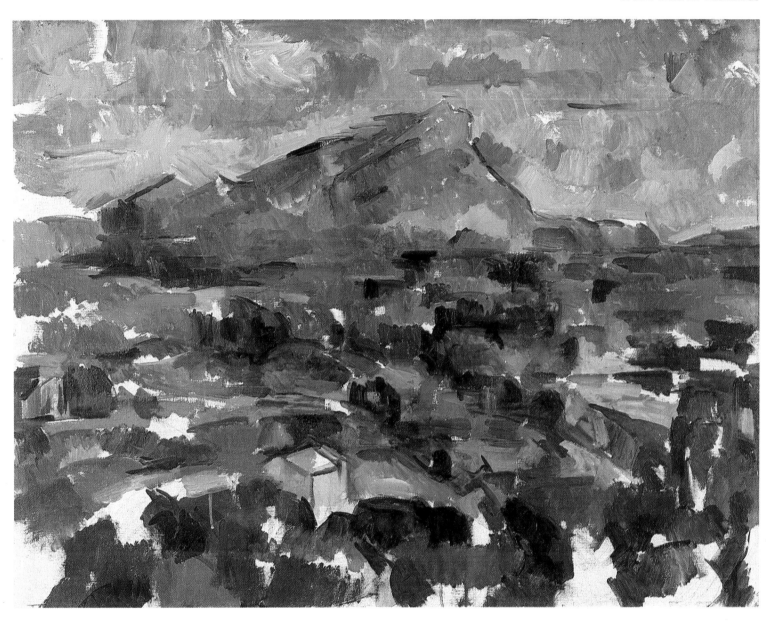

PROVENÇAL LANDSCAPE

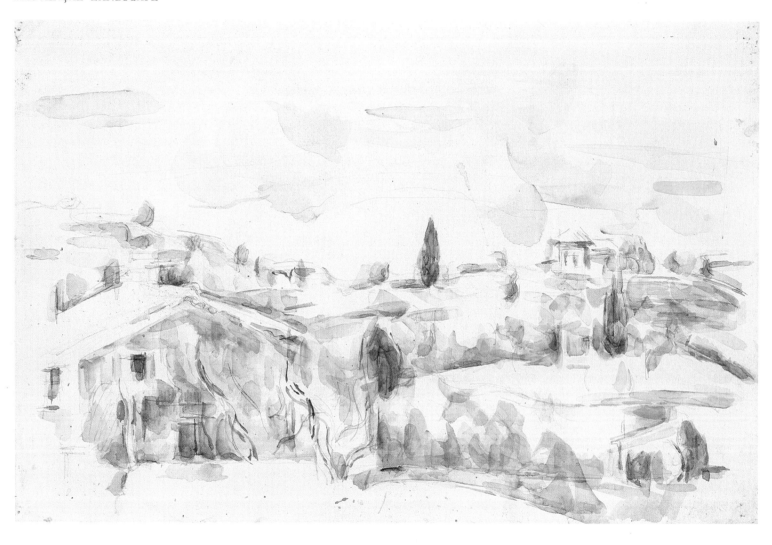

281

VIEW OF THE CATHEDRAL AT AIX

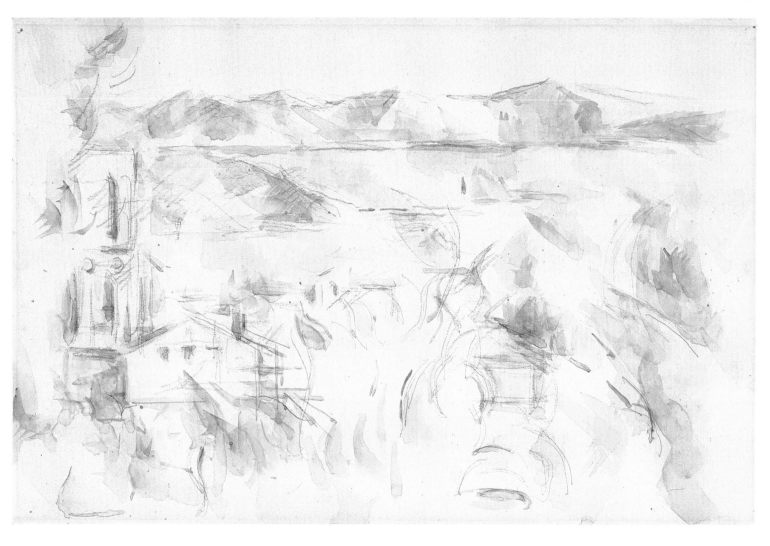

CHÂTEAU NOIR

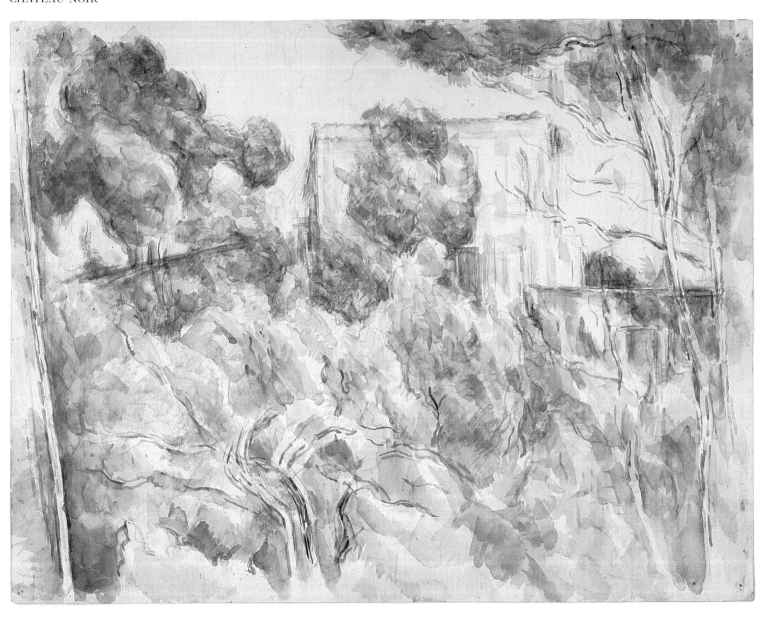

PISTACHIO TREE AT CHÂTEAU NOIR

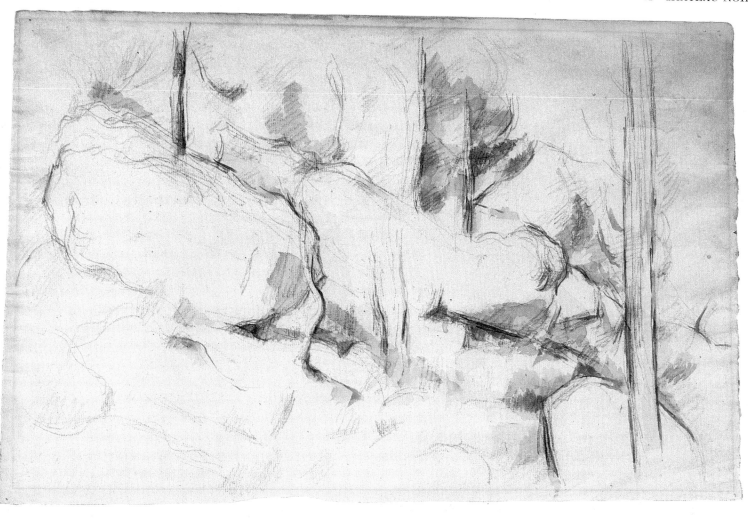

BEND IN THE ROAD

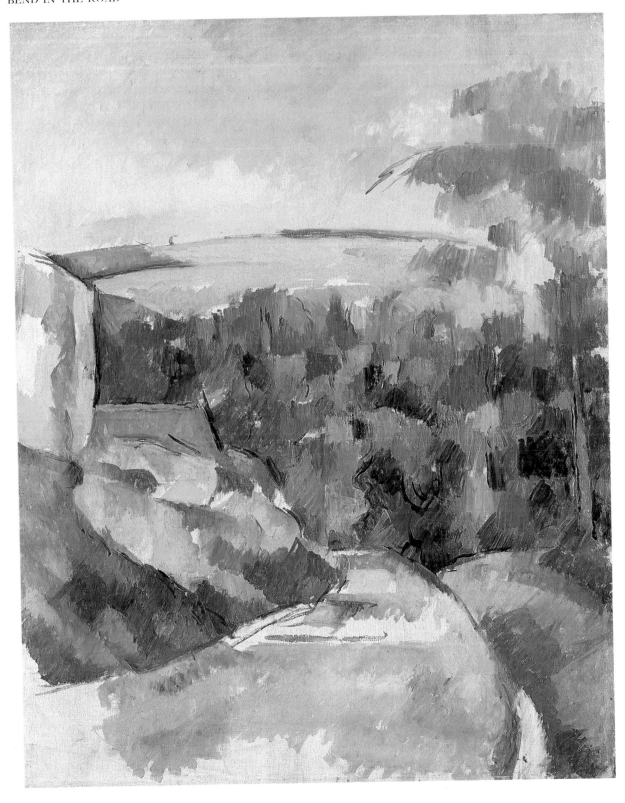

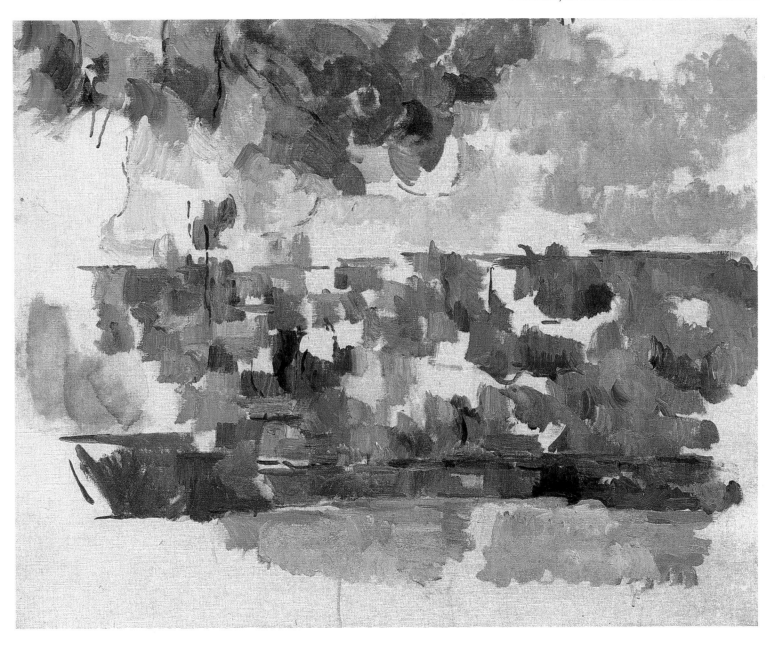

CHÂTEAU NOIR

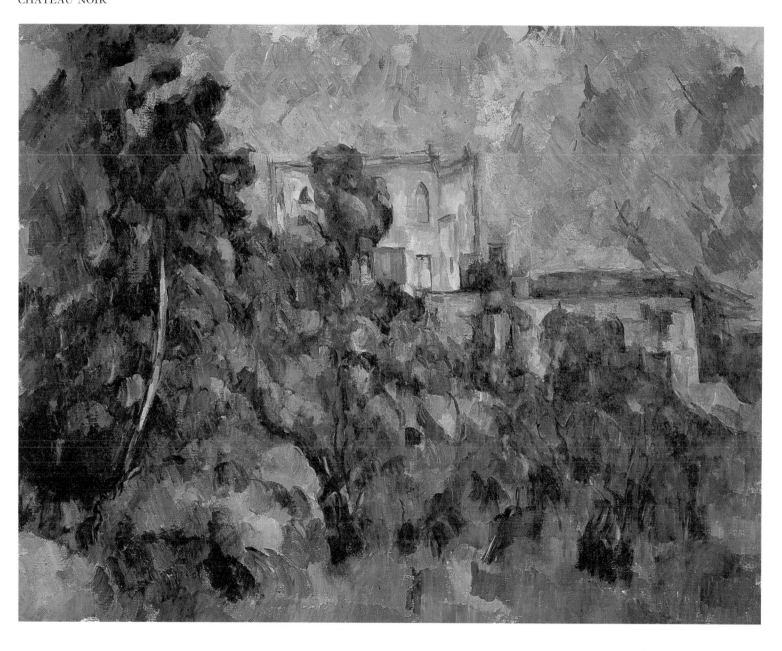

HOUSE ON A HILL

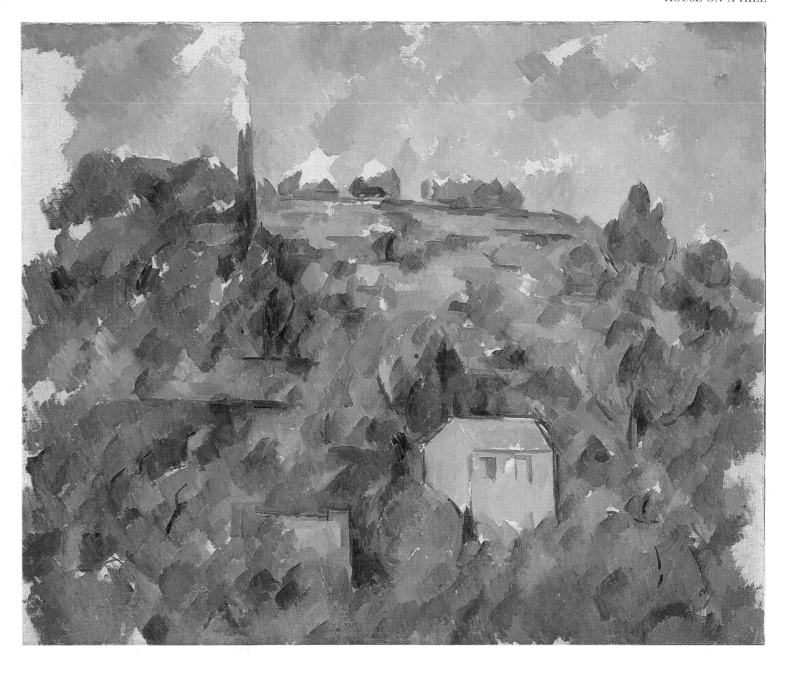

Cézanne Recorded by his Contemporaries

In the late 1890s, after more than three decades of neglect and incomprehension, Cézanne's work began to attract the interest and admiration of a new generation of painters, writers and critics. His reputation as a semi-mythical, ill-tempered recluse was gradually eroded through their visits to Aix and by the subsequent published accounts of his way of life and opinions. More than a dozen individuals recorded their reminiscences, and Cézanne appeared in newspaper articles, critical studies, monographs and even in the pages of a contemporary novel. Inevitably, each author saw a slightly different Cézanne, stressing those aspects of his work or thinking that corresponded most closely with their own. Their accounts range from the authoritative to the crudely fictitious, but together they make a compelling and largely plausible record.

Emile Bernard was born in 1868 and in his twenties made the acquaintance of both Van Gogh and Gauguin. A painter as well as a writer, he acted as an important channel for new ideas and as an intermediary between other individuals and artistic groups throughout the 1890s. By the time he first met Cézanne in 1904, Bernard had become a devout Catholic and had begun to turn from the movements of his own day to the sacred art of the Renaissance. His Conversation with Cézanne, which was first published in 1921, is a retrospective elaboration of earlier writings, and Bernard's own views come through clearly. With due allowance for Bernard's theoretical turn of mind, the Conversation and the earlier Opinions appear to offer a reliable guide to some of Cézanne's ideas.

The two briefer accounts by Jules Borély and Léo Larguier were both compiled in the early years of this century and each was based on limited but sympathetic encounters with the Master of Aix. Borély was an archaeologist with perhaps fewer preconceptions to impose on his view of Cézanne, and his account of the painter's enthusiasms for Rubens, Delacroix, Monet and Baudelaire has a ring of authenticity about it. Larguier's text is more problematic, since it claims to represent the authentic words of Cézanne, as communicated to the writer by Paul, the artist's son. Many of the notions and the phrases reported by Larguier are again familiar from other sources, but it is difficult as with Bernard, to resist the belief that Larguier (a poet himself) has superimposed on some of these aphorisms his own language and thoughts.

Finally, the most controversial collection of memoirs of the artist comes from the Provençal poet and former friend of Cézanne, Joachim Gasquet. As Cézanne's letters to Gasquet in the late 1890s show, an intimate relationship was established between painter and writer. Cézanne painted portraits of both Joachim and his father Henri Gasquet, whom Cézanne had known as a schoolboy in Aix, but their friendship cooled in mysterious circumstances soon after 1900. Joachim Gasquet's book, Cézanne, was first published in 1921 and contains extended accounts of visits to the artist's studio, conversations in the countryside and even excursions to the Louvre in the artist's company. Gasquet's style is colourful and extravagant, and it has been shown that he cannibalized other already published sources, such as those by Bernard and Vollard, in his own text. For these reasons, Gasquet has been treated with great caution as an authentic source of information about Cézanne, though it should be said in his defence that Cézanne himself admired Gasquet's writing. In a letter of 1898, Cézanne thanked Gasquet for his 'superb lines' and apologized for his own letter: '. . . you see things so colourfully, as if through a prism, that in thanking you every word becomes pale.' Despite the author's tendency towards improvisation, something of the Cézanne who once said of one of his visitors that 'I saturated him with theories about painting' comes through in Gasquet's prismatic, loquacious prose.

From *A Conversation with Cézanne* by Emile Bernard

In 1904, in the course of one of our walks around Aix, I said to Cézanne: 'What do you think of the Masters?'

'They are good. I used to go to the Louvre every morning when I was in Paris; but in the end I sided with nature rather than them. You have to create your own vision.'

'What do you mean by that?'

'You have to create a perspective of your own, to see nature as though no one had ever seen it before.'

'You are another Descartes, you want to forget your predecessors and rebuild the world within yourself.'

'I don't know who I am! As a painter I must see with an original eye.'

'Won't that result in a vision which is too personal and therefore beyond the comprehension of others? For after all, isn't painting like speech? When I speak, I use the same language as you; would you understand me if I had made up a new, unknown one for myself? New ideas must be expressed in everyday terms. Perhaps that is the only way of presenting them and having them accepted.'

'By a perspective I mean a logical vision; in other words one which has nothing absurd about it.'

'But what will you base your perspective on, Master?'

'On nature.'

'What do you mean by that word? Our human nature or nature herself?'

'Both.'

'So you understand art to be a union of the world and the individual?'

'I understand it as personal apperception. This apperception I locate in sensation and I require of the intellect that it should organize these sensations into a work of art.'

'But what sensations are you referring to? Those of your feelings or of your retina?'

'I don't think you can distinguish between the two; however, as a painter, I believe in the visual sensation above all else.'

'So then, you belong to the naturalist school, like Zola?'

'I want to be a painter and I rely on my eye to create a picture which will appeal to the eye.'

'All right, but what is it that you reproach the Masters for which made you part company from them? Aren't art and nature two different things?'

'I would like to unite them. It is my opinion that by taking nature as your starting point you attain art. Where the teachings of the museums go wrong is in their insistence in using methods which take you completely away from the observation of nature, which must remain your guide.'

'That's true, but I think you are confusing routine and tradition, teachers and masters. The study of nature formed the basis of the art of the Ancients. Leonardo da Vinci, Michelangelo and others exhausted themselves in their efforts to wrench their masterpieces from her. You know how much time they spent in their extraordinary inquiries to which they gave the name of theory, since for them art only began at the moment when the painter, becoming an artist, could devote himself to the creation of works which proceeded from his own thought.'

'That is true; but it's a dangerous path to follow, and all those theories drawn from nature were not nature as such. They studied the sciences which emerged from it, but paid it scant, if any, attention in its own right. In this way a ready-made vision was arrived at which was

modified only according to the aptitude of the pupil.'

'Here we have come up against the central problem. Should we paint what we see as we think we see it, adding nothing, or should we receive an education in theory, just as poets receive one in metrics, which enables us to create works drawn from within ourselves, that is to say by combining nature with our own ideas?'

'I favour the first method. The real vision of the world has yet to be written; man has spent too long seeking himself in all that he has done.'

'But isn't he the intelligence behind it?'

'I consider the intelligence of the Pater Omnipotens and I say: what can I do better than He? Then I strive to forget our illustrious predecessors and I ask of Creation that she alone may become known to me.'

'I see; you seek art in nature and nature outside yourself in the sights which present themselves to your eyes. It is an act of submission, of humility through which you will achieve virtue.'

'I am not used to so much reasoning.'

'For the masters we were speaking of, the external, the incidental spectacle of nature was nothing other than a call to their own genius. The truth of the world, a vision of the Universe – these things they sought within themselves. It was in the depths of their own feelings, in thoughts and ideas, that they tried to perceive the models for their works; and in this way each of them created new paintings, new images, using the laws of art which they took from the laws of nature.'

'Quite so; but in place of reality they put imagination, along with its companion, abstraction. I have told you before and I tell you again now: you must arrive at that concrete vision which makes a painter ... You must have a vision.'

'Didn't the masters whom you venerate create one for themselves – drawn not from the methods of art, but from the expression of ideas by means of thought? If you compare Leonardo da Vinci with any of the others, isn't everything different: colour, form, composition, style? Isn't the true personality to be found in the conscious man rather than in the sensual man?

We must turn our attention to the image of nature; until now we have only considered the image of man.'

'Is it possible for there to be a true image of nature? And how would we know that it is the true one? Doesn't every painter formulate a different one from his fellow artists? Goya said that "nature has neither colour nor line." Are we not taken in by our illusions, even in the realm of the senses? And are our senses themselves sound enough or perfect enough to allow us to enter into contact with what you call nature without making one single mistake?'

'I know, there have been philosophers, German philosophers, who have denied the existence of reality, for whom all is illusion, dream, phenomenon. They are *littérateurs*.'

'So you deny philosophy, then?'

'I deny that which is absurd and which you wrongly call philosophy; the painter's only task is to realize an image.'

*

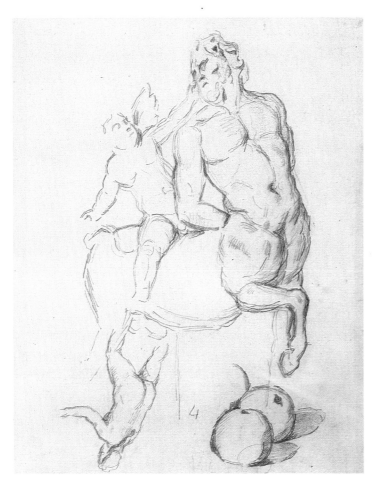

PAGE OF STUDIES

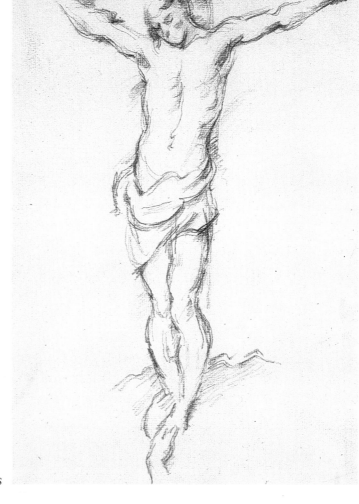

AFTER RUBENS — CHRIST ON THE CROSS

'As for me, I want to be a child, and I delight in seeing, hearing, breathing, in being an ecstatic sensibility which seeks to express itself on canvas.'

'So you forbid yourself to create anything?'

'To copy creation is enough for me. Those who believed that they had devised something new were deluding themselves.'

'But what of the *Last Judgement*, the *Stanze* of the Vatican, the *Wedding at Cana*, the *Allegories* of Rubens?'

'Ah well, yes; a Delacroix can allow himself that, but as for us, we must restrict ourselves to the study of the tableau of nature.

'Doesn't that amount to creating something inferior – a failure to recognize the aim of painting?'

'Painting is its own end. The painter paints; whether it be an apple or a face, for him it is a pretext for a play of lines and colours, nothing more.'

'I return to the opinion of Pascal: why recreate what God has created so well?'

'Can we do better than He?'

*

Cézanne seemed tired, so I suggested the shade of a tree whose dark mantle spread across the sloping road.

We sat down.

'My diabetes is making me feel ill,' he told me. 'I am hardly able to discuss anything. I feel as though I am possessed by an illness which will carry me away.'

He mopped his brow and went on. 'Be a painter, not a writer or a philosopher! I too wanted to taste the fruits of imagination. I was swept along by Delacroix, impelled by the masters in the Louvre. My youth was filled with impassioned canvases on which, one after the other, I reproduced in my own way works by Veronese, Ribera, Caravaggio, Calabrese, Courbet and Delacroix himself. When I met Monet and Pissarro, who had rid themselves of all these encumbrances, I realized that all one should ask of the past is that it provide an education in painting. Like me, they were full of enthusiasm for the great romantics; but instead of allowing themselves to be overawed by their vast paintings, they looked only at their innovations in colouring, which lead to a new development of the palette. Pissarro represented nature like no one before him, and as for Monet, I have never met anyone with such compositional sense, such a prodigious facility for seizing upon what is true . . . Imagination is a very beautiful thing; but one must also have a firm base. As for myself, when I came into contact with the Impressionists, I realized that I had to become a student of the world again, to make myself a student once more. I no more imitated Pissarro and Monet than I did the masters in the Louvre. I tried to produce work which was my own, work which was sincere, naïve, in accordance with my abilities and my vision.'

'You wanted to give art a new beginning, just as Descartes provided one for philosophy. You made a clear break with everything that had been discovered before you.'

'Yes. I am the primitive of a new art. I shall have my successors; I can sense it.'

<p style="text-align:center">*</p>

'Of course we mustn't confine ourselves to what is strictly real, to *trompe-l'oeil*. The transposition made by the painter, from a perspective of his own, gives a new interest to that part of nature which he has reproduced; he renders as a painter that which has not yet been painted; he makes it into painting in an absolute sense – that is to say something other than reality. This is no longer straightforward imitation.'

'No. Rather, it is a translation expressed in a particular language, which allows the qualities of art to be brought into play.'

'And whose agent is temperament, talent.'

'Your friend Zola said that art was nature seen through a temperament. No doubt you agree with that opinion?'

'The definition seems a good one to me; but I would add – by a temperament which is disciplined, which can organize its sensations.'

'A temperament which has its own appropriate methods.'

'And which treats all others with suspicion.'

'So with each painter art has a new beginning?'

'Not so. Doubtless there are things in nature which have not yet been seen. If an artist discovers them, he opens the way for his successors. If I have left something unsaid, they will say it.'

<p style="text-align:center">*</p>

'It would take too long to tell you what I think of the critics; they have treated me very badly so far; one day perhaps they will shower me with praise as foolish as the absurd malice with which they vilify me now. I bear them no grudge. I no longer read them. The painter must enclose himself within his work; he must respond not with words, but with paintings.'

'Just wait until one of your canvases sells at a good price. That will be the ultimate argument for a society which no longer knows what art is.'

'It would be amusing if one day I received the kind of sums commanded by a Bouguereau or a Meissonier!'

'That's by no means impossible. You will make your dealer rich. It will be legitimate revenge on those who have slighted you, and your compatriots will raise a statue to you if you are dead, or salute you, hat in hand, if you are alive.'

'My compatriots are clods beside me. I despise them all.'

At this point a look of indescribable contempt came over Cézanne's face and he shook his fist at the town of Aix.

'You must forgive them! Isn't it the critics in Paris who are mostly at fault?' I said to him.

*

'As you know, I have often done studies of bathers, both male and female, which I would have liked to make into a full-scale work done from nature; the lack of models forced me to limit myself to these sketches. Various obstacles stood in my way, such as finding the right place to use as the setting, a place which would not be very different from the one which I had fixed upon in my mind, or assembling a lot of people together, or finding men and women who would be willing to undress and remain still in the poses I had decided upon. And then I also came up against the problem of transporting a canvas of that size, and the endless difficulties raised by suitable or unsuitable weather, where I should position myself, and the equipment needed for the execution of a large-scale work. So I found myself obliged to postpone my plan for a Poussin done again entirely from nature and not constructed from notes, drawings and fragments of studies. At last a real Poussin, done in the open air, made of colour and light, rather than one of those works thought out in the studio, where everything has that brown hue resulting from a lack of daylight and the absence of reflections of sky and sun.'

*

'How can one look at nature without thinking of its author? The artist must look upon the world as his catechism; he must submit to it without question. The proof of it is there for his eyes to see, his senses to perceive. And I presume he thinks that he was not given these faculties in order to be deceived.'

Cézanne Recorded by his Contemporaries

From *Cézanne in Aix* by Jules Borély, 1902

Last July I went to Aix to see the painter Cézanne. I arrived without any introduction, got his address at a bookseller's shop in the town and set off at about 2 o'clock along a path which led up to his house through some fields.

Having found the door closed, I was strolling along under the blue sky between two drystone walls when suddenly, at the turning in the road, I caught sight of the man I was looking for, Cézanne.

Here was Cézanne, looking like a craftsman returning from some country house with all his equipment; a glazier's smock, a conical-shaped hat, a game-bag with a green bottle-neck protruding from it; and in his hands his enormous box of paints, his canvas and easel.

*

'Monsieur Cézanne, I was looking for you, wishing very much to see your paintings again.'

'Sir,' he said to me, 'you are too generous!... you want me to show you something of what I have attempted? Alas, although I am already old, I am still a novice. And yet I am beginning to understand; if I may say so, I think I do understand. Ah, you like painting! I would like to be able to show you some Monets. I haven't got any; they are very expensive these days. I have got a Delacroix. Are you a painter, sir? Ah, you are!... Would you believe it, I am close to having some principles and a method for my vocation. I spent a long time looking: indeed, I am still looking; that's the stage I've reached at my age! Don't be surprised at my disjointed way of talking,' he added, 'I have my blank moments. You want to see my painting?'

'I've heard about your painting,' I said to him, 'in such terms that I am consumed with a desire to see it.'

Cézanne stopped short at this. He said to me quite simply:

'Sir, we are alone out here in the fields; be honest with me, man to man; don't sing my praises! Yes, I think I am a painter. Moreover, people seem to recognize that, since they buy my impressions. Nevertheless, they remain imperfect. Oh yes, yes! I say it myself, I don't capture subjects properly. Ah! Monet! You know him. Monet? Monet, as I see it, is the most gifted painter of our age.'

We reached the little farmhouse. He pushed the door open and invited me to take a seat on one of the white wooden chairs left out on the terrace at the foot of some pale acacias. He deposited his bag, his box of paints and his canvas, and came and sat beside me; the countryside lay before us. Beyond a tangle of olive branches and some withered trees, the town of Aix, in the sunlight, mauve-coloured, nestled among the surrounding hills which rose up cerulean and airy... Cézanne reached out his arm to measure the steeple of the cathedral between his thumb and index finger.

'How easily things like this can be distorted... I make great efforts and have much difficulty. Monet has the ability to look at something and to draw it instantly in proportion. He takes something from here and puts it there; that's a touch of Rubens.'

*

We sat down to talk some more about Monet, Renoir, Sisley.

'Unlike Monet,' Cézanne said, 'Renoir does not adhere to a consistent aesthetic; his genius makes him forever dissatisfied with his means. Monet keeps to one vision of things; he is quite content to remain at the point he reaches. Yes, a man like Monet is fortunate indeed; he

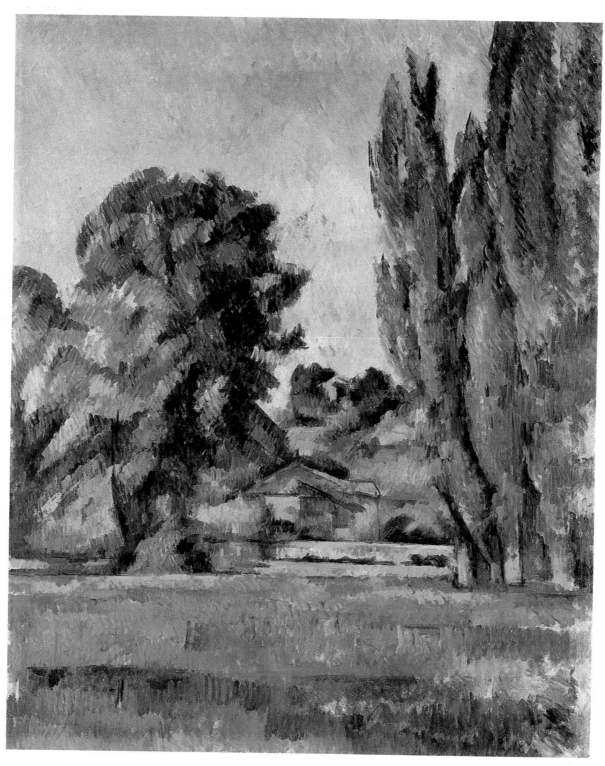

LANDSCAPE WITH POPLARS

achieves his glorious destiny. Woe betide the painter who wrestles too much with his talent: he, perhaps, who wrote verse in his youth . . .'

On saying this he sighed, began to laugh as he looked towards the valley and completed my confusion by adding:

'Painting is a funny thing.' Then he turned away as he stood up, saying slowly: 'I become absorbed in some strange reflections.'

*

'Isn't painting a matter of producing a harmonious impression? And what if I want to celebrate light like this?'

'I know what you mean; there is a languid glow which I will not be able to emulate on canvas; but what if I could create this impression by means of another, corresponding one, even if it meant using bitumen!'

We went out. Cézanne had taken off his smock and had his rustic sack slung across an old frock-coat. As he locked the door, he began laughing again and said to me:

'I am the unhappiest of men.'

I noticed that locks of his fine white hair were standing up on his head, as they do in paintings of old men by Greuze in his depictions of family scenes.

We were on our way down into town.

'Look: isn't there something classical about this countryside?'

*

'Do you like Baudelaire?'

'Yes.'

'I didn't know him, but I did know Manet. As for old Pissarro, he was a father to me; someone to turn to for advice, not unlike the good Lord Himself.'

'Was he a Jew?'

'Yes, he was. Above all else, make sure you receive a good education in art. Do you like Degas?'

'Most certainly! But it's still *peinture de cabinet*, if I may say so.'

'I agree with you; at the same time, as soon as we disagree over a trifle, another trifle makes me want to make it up again.'

*

The sun cast the wavering shadow of the plane trees across the sand.

'How difficult it is to paint well! How can one approach nature directly? Look, between that tree and ourselves there is a space, an atmosphere, that I grant you; but there is also this trunk, this entity, tangible and resistant . . . If only we could see with the eyes of a newborn child!'

'Today our sight is a little weary, burdened by the memory of a thousand images. And these museums, and the paintings in them! . . . And the exhibitions! . . . We no longer see nature; we see pictures over and over again. To see the works of God! That is what I am striving for. But am I what is called a realist or an idealist, or again a painter, a draughtsman? I am afraid of being compromised, mine is a very serious situation; nonetheless I am a painter, am I not, people do recognize that?'

I took my leave of Cézanne after spending another half-hour with him in his cold house. On a narrow table in the middle of his bedroom I caught a glimpse of three human skulls facing one another, three finely polished ivories. He spoke to me of a very fine study which he had painted and which was somewhere in his attic. I wanted to see it. He looked for the key to this garret, but to no avail; the maid had mislaid it.

My train leaves this evening. I take my leave of this man who is so marvellous to watch and listen to. It is enough to have succumbed to the charm of his roving spirit, his spirit which is at once so simple and so complex.

*

Cézanne speaks

When critics write their appreciations of works of art, they formulate them less on the basis of aesthetic criteria than on that of literary convention.

The artist must avoid all things literary in art.

Art is the revelation of an exquisite sensibility.

Sensibility characterizes the individual; at the height of perfection it distinguishes the artist. A high degree of sensibility is the best possible disposition for any beautiful conception of art. The most seductive thing about art is the personality of the artist himself.

The artist objectifies his sensibility, his inborn distinction.

The nobility of the conception reveals the spirit of the artist.

The artist makes things concrete and gives them individuality.

The artist experiences a sense of joy in being able to communicate to others the enthusiasm he feels in front of the masterpiece of nature, whose mystery he believes he understands.

Genius is the ability to renew one's emotions in daily experience.

For the artist, to see is to conceive and to conceive is to compose.

For the artist does not note his emotions as the bird modulates its sounds: he composes.

The significance of art is not to be seen in the universality of its immediate results.

Art is a religion. Its aim is the elevation of thought.

Whoever lacks a taste for the absolute (that is, perfection) contents himself with placid mediocrity.

One judges the excellence of a mind by the originality with which it develops its ideas.

An intellect with a powerful ability to organize represents the most precious collaboration which a sensibility can have in its efforts to realize a work of art.

Art is an adaptation of things to our needs and tastes.

The technique of art comprises a language and a logic.

An artistic formula is perfect when it is adequate for the character and grandeur of the subject being interpreted.

Style is not created through servile imitation of the masters; it proceeds from the artist's own particular way of feeling and expressing himself.

We can judge the artist's elevation of spirit and conscience by the manner in which an artistic idea is rendered.

The search for novelty and originality is an artificial need which barely conceals banality and absence of temperament.

Line and relief do not exist. Drawing is a relation of contrasts, or simply the relation of two tones, black and white.

Light and shade are a relation of colours; the two principal accidentals differ not by dint of their general intensity but rather their own specific sonority.

The form and contour of objects are given to us by those oppositions and contrasts which result from their particular colourations.

Pure drawing is an abstraction. Drawing and colour are not distinct, everything in nature is coloured.

Insofar as one paints, one draws. Accuracy of tone establishes both light and modelling for an object at the same time. The greater the harmony of colour, the greater the precision of the drawing.

Contrasts and relations of tone – there lies the whole secret of drawing and relief.

Nature exists in depth. Between the painter and his model is interposed a plane – atmosphere. Bodies perceived in space are all convex.

Atmosphere forms the unchanging background, a screen on which all oppositions of colour, all accidentals of light dissolve. It constitutes the atmosphere of the painting by contributing to its synthesis and general harmony.

One can say therefore that to paint is to *contrast*.

There is neither light nor dark painting, only relations of tones. When these are applied with precision, harmony is immediately established. The more numerous and varied they are, the greater their effect and the more pleasing they are to the eye.

Painting, like any art, comprises a technique, a workmanlike handling of material, but the accuracy of a tone and the felicitous combination of effects depend entirely on the choice made by the artist.

The artist does not perceive every relation directly: he senses them.
Style comes from precise sensation and full realization.

Painting is the art of combining effects, that is to say establishing relations among colours, contours and planes.

Method is clarified through contact with nature. It develops through circumstances. It consists in the search for a way of expressing what one feels, in the organization of these feelings into a personal aesthetic.

A priori, the schools do not exist.
The overriding question concerns art in itself. Painting is therefore either good or bad.

To look upon nature is to discern the character of one's model. Painting does not mean slavishly copying the object: it means perceiving harmony amongst numerous relationships and transposing them into a system of one's own by developing them according to a new, original logic.

To make a picture is to compose . . .

From *Some of Cézanne's Opinions*, by Emile Bernard

Ingres is a pernicious classicist, and so in general are all those who deny nature or copy it with their minds made up and look for style in the imitation of the Greeks and Romans.

Gothic art is deeply inspiring; it belongs to the same family as we do.

Let us read nature; let us realize our sensations in an aesthetic that is at once personal and traditional. The strongest will be he who sees most deeply and realizes fully like the great Venetians.

Painting from nature is not copying the object, it is realizing one's sensations.

There are two things in the painter, the eye and the mind; each of them should aid the other. It is necessary to work at their mutual development, in the eye by looking at nature, in the mind by the logic of organized sensations which provides the means of expression.

To read nature is to see it, as if through a veil, in terms of an interpretation in patches of colour following one another according to a law of harmony. These major hues are thus analysed through modulations. Painting is classifying one's sensations of colour.

There is no such thing as line or modelling; there are only contrasts. These are not contrasts of light and dark, but the contrasts given by the sensation of colour. Modelling is the outcome of the exact relationship of tones. When they are harmoniously juxtaposed and complete, the picture develops modelling of its own accord.

One should not say model, one should say modulate.

Shadow is a colour as light is, but less brilliant; light and shadow are only the relation of two tones.

Everything in nature is modelled on the sphere, the cone and the cylinder. One must learn to paint from these simple forms; it will then be possible to do whatever one wishes. Drawing and colour are not separate at all; in so far as you paint, you draw. The more the colour harmonizes, the more exact the drawing becomes. When the colour achieves richness, the form attains its fullness also. The contrasts and connections of tones – there you have the secret of drawing and modelling.

The effect is what constitutes a picture. It unifies the picture and concentrates it. The effect must be based on the existence of a dominating patch.

It is necessary to be workmanlike in art. To get to know one's way of realization early. To paint in accordance with the qualities of painting itself. To use materials crude and pure.

It is necessary to become classical by way of nature, that is to say through sensation.

It is all summed up in this: to possess sensations and to read nature.

Cézanne Recorded by his Contemporaries

From *Cézanne* by Joachim Gasquet

From the time he made the first sketch, inspired entirely by Rubens, right up until his death, he worked on an enormous canvas; a canvas repeatedly abandoned only to be taken up again, torn to pieces, burnt, destroyed, begun anew and which, in its final form, is now part of the Pellerin collection. A long time ago I saw a splendid version, almost completed, at the top of the staircase in Jas de Bouffan. There it remained for three months, after which Cézanne turned it round to face the wall. Subsequently it disappeared. He didn't want anyone to talk to him about it, even during the time it stood resplendent in the sunshine, and you had to walk past it to get to his studio beneath the roof. What became of it? The subject which so haunted him was of women bathing beneath the trees in a meadow. He made thirty or so little studies, including two or three very fine canvases, well developed, a multitude of drawings, watercolours and albums of sketches which never left the chest of drawers in his bedroom or the drawer of his table in the studio.

'That will be my painting,' he used to say sometimes, 'that's what I will leave behind . . . But what about the centre? I can't find the centre . . . What am I going to group them round, tell me? Ah, Poussin's arabesque! He knew what he was doing all right. In the *Bacchanalia* in London, the *Flora* in the Louvre, where do the lines of the figures end and those of the landscape begin? . . . It is all one. There is no centre. What I want is something like a gap, a gaze of light, an invisible sun keeping close watch on all my figures, bathing, caressing, intensifying them . . . in the middle.' At this point he tore up a sketch.

'That's not it . . . And anyway, to get people to pose for that in the open air . . . When the soldiers were bathing I did try to go along the river Arc to see the contrasts, the flesh tones against the greens . . . But it's not the same, it's of no use to me; it can't be of any use to me for these women of mine . . . Confound it! See how mannish this one looks . . . I can't stop picturing those soldier boys.'

'And, shaking his fist at the tender, bluish flesh of his study and, beyond their charms perhaps at every woman in the world, he cried out:

'Oh, the damned bitches! Damned bitches!

*

'Ah! We are living under the thumb of the borough surveyor. This is the age of the engineer, the republic of straight lines . . . Tell me, is there one single straight line in nature? Absolutely everything is subjected to the surveyor's line, town and countryside alike . . . Where is Aix, the Aix I knew in the old days when Zola and Baille were here? Where are the fine streets of the old suburb, the grass which grows between the paving stones, the oil lamps? . . . Yes, lamplight rather than your garish electricity which violates the mystery of the place; whereas our old oil lamps tinged it with gold, gave it fire, permeated it like a Rembrandt painting . . . We used to serenade the local girls . . . I would play the corinet, you know, while Zola, being more distinguished, played the clarinet . . . What a noise! . . . But the acacias wept above the walls, the moon turned the portal of St-Jean blue and we were fifteen years old . . . In those days we thought we ruled the world! . . . Just imagine, at school Zola and I were looked upon as oddities. I would trot out a hundred lines of Latin verse in the twinkling of an eye . . . for next to nothing . . . Good heavens, I was a businessman when I was young! . . . As for Zola, he never lifted a finger . . . He was a daydreamer, a stubborn brute, . . .

a sickly dreamer!... You know, the sort that little ruffians can't abide... They would ostracize him at the slightest excuse... Even our friendship stems from that... from a trouncing I got from everyone in the playground, big and small, because I ignored the ban, carried on regardless. I simply couldn't help myself talking to him... A decent sort... The next day he brought me a basketful of apples. 'Look, Cézanne's apples!', he said cheekily. 'They come from a long way back...'

*

JOACHIM GASQUET

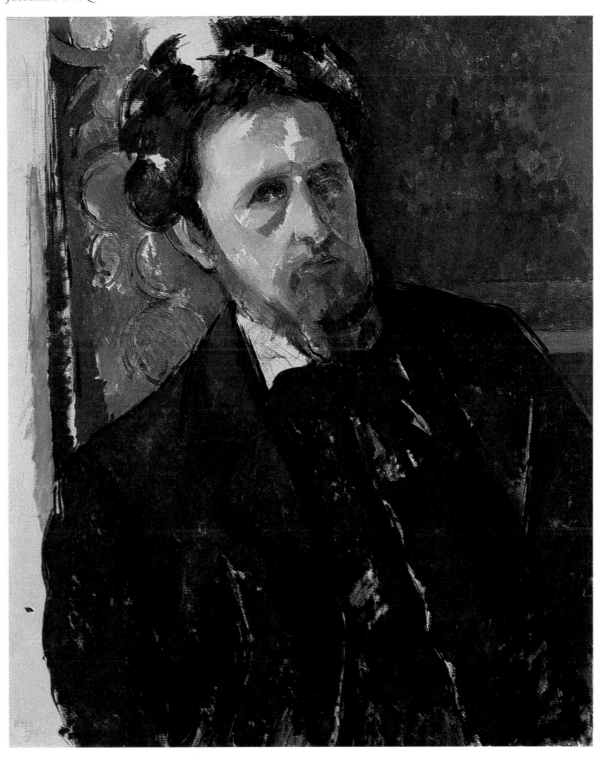

The *Motif*

That day in the Blaques district, not far from Les Milles and three quarters of an hour away from Aix and Jas de Bouffan, beneath a large pine tree and at the edge of a red and green hill, we looked down over the valley of the Arc. It was a fresh, sky-blue day, an early autumn morning at the end of summer. The town, concealed by a fold in the hillside, could be distinguished by the smoke rising from it. We turned our backs to the pools. To the right, views over Luyne and the Pilon du Roi, a hint of the sea. Before us and beneath the Virgilian sun stood Ste-Victoire, immense, tender and bluish, the undulations of Montaiguet, the viaduct of the Pont de l'Arc, the houses, the quivering trees, the square fields – the countryside of Aix.

Such is the landscape which Cézanne painted. He was staying with his brother-in-law. He had set up his easel in the shade of a group of pines. He had been at work there for two months, one canvas in the morning and another in the afternoon. His work was 'coming along well'. He was in high spirits. The session was nearly at an end.

*

CÉZANNE: I have my *motif* . . . (he clasps his hands). That's what a *motif* is, you see . . .

GASQUET: What do you mean?

CÉZANNE: Ah yes . . . (he makes the same gesture as before, separates his hands, all ten fingers spread, very slowly brings them together again, then joins, clasps, clenches, intertwines them). That's what has to be achieved . . . If I pass too high or too low, everything is ruined. There mustn't be one single stitch which is too loosely woven, not one gap through which emotion, light, truth might escape. You see, I develop my whole canvas at once, as a unity. Everything disparate I bring together in one outburst, one act of faith . . . All that we see dissipates, moves on. Nature is always the same, but nothing of her remains, nothing of what appears before us. Our art must provide some fleeting sense of her permanence, with the essence, the appearance of her changeability.

It must give us an awareness of her eternal qualities. What lies below her? Nothing, perhaps. Perhaps everything. Everything, do you see? And so I join her roaming hands . . . From right and left, here, there, everywhere, I capture her tones, colours, nuances, I fix them, bring them together . . . They create lines. They become objects, rocks, trees, without my thinking about it. They acquire a volume. They have a tonal value. If these volumes, these values correspond on my canvas – in my sensibility – to the planes, the marks which I have established, which are there in front of my eyes, well then, my canvas clasps its hands. It doesn't waver. It passes neither too high nor too low. It is true, compact, full . . . But if the slightest thing distracts me, if I falter for a moment, especially if one day I interpret more than I should, if today I am carried away by a theory which opposes that of the day before, if I think as I paint, if I intervene – bang! Everything's gone.

GASQUET: What do you mean, if you intervene?

CÉZANNE: The artist is only a receiver of sensations, a brain, a registering machine . . . A good machine, of course, fragile and complex, especially in relation to others . . . But if he intervenes, if, paltry as he is, he dares to interfere deliberately with what he has to convey, then his own mediocrity filters through. The work produced is inferior.

*

CÉZANNE: This canvas smells of nothing. Tell me, what scent emanates from it? What odour does it give off? Let's see . . .

GASQUET: The smell of pines.

CÉZANNE: You say that because two large pine trees are waving their branches in the foreground. But that's a visual sensation . . . Moreover, the strong blue scent of the pines, which is sharp in the sunlight, must combine with the green scent of the meadows which, every morning, freshens the fragrance of the stones and of the marble of the distant Ste-Victoire. I haven't conveyed that. It must be conveyed. And through colours, without literary means.

*

You know that when Flaubert was writing *Salammbô* he said that he saw everything in purple. Well, when I was painting my *Old Woman with a Rosary* I kept seeing a Flaubert tone, an atmosphere, something indefinable, a bluish russet colour which seemed to emanate from *Madame Bovary*. I read Apuleius to rid myself of this obsession, which for a while I considered dangerous, overly literary. It was no use. This wonderful russet-blue took me over, it sang in my soul. I was completely immersed in it.

GASQUET: It came between you and reality, between your eyes and the model?

CÉZANNE: Not at all. It floated, as if it were elsewhere. I observed every detail of dress, of headgear, of folds in the apron; I deciphered the cunning face. Only much later did I realize that the face was russet-hued, the apron bluish, just as it was only when the painting was finished that I recalled the description of the old serving woman at the agricultural show. What I am trying to convey to you is more mysterious; it is bound up with the very roots of being, the intangible source of sensation. Yet it is precisely that, I believe, of which temperament is made.

*

CÉZANNE: Look at Ste-Victoire. What *élan*, what an imperious thirsting after the sun, and what melancholy, of an evening, when all this weightiness falls back to earth . . . These masses were made of fire. Fire is in them still. Both darkness and daylight seem to recoil from them in fear, to shudder before them. There above us is Plato's cave: see how, as large clouds pass by, the shadow which they cast trembles on the rocks, as if burned, suddenly devoured by a mouth of fire. For a long time I was unable, unaware of how to paint Ste-Victoire because I imagined the shadow to be concave, like everyone else who fails to look; but look, it is convex, it flees from its centre.

*

CÉZANNE: Clichés are the leprosy of art. You can follow the path of mythology through painting, it is the story of an intrusive tradition. When you have painted goddesses you have ceased to paint women. Go round the salons. If some devil can't convey the reflections of water beneath the leaves he throws in a naiad. Look at *La Source* by Ingres. What has that to do with water . . . ? And in literature you prattle on, you cry out: Venus, Zeus, Apollo, when you can no longer say with deep feeling: foam of the sea, clouds of the sky, strength of the sun. Do you believe in this old Olympian claptrap? Well?

GASQUET: But what of Veronese, Rubens, Velasquez, Tintoretto? What of all those whom you love? . . .

CÉZANNE: Them! They had such vitality that they made the sap flow again in all those dead trees – their own sap, their prodigious vitality. The flesh they paint has the feel of a caress, the warmth of blood. When Cellini threw that bleeding head into Perseus' hand, he had really killed someone, really felt a warm spurt of blood stick to his fingers... One murder a year, that was his average... They had no other truth than that. Such was the nature of these figures of gods and goddesses. Through them they glorified man rather than the madonnas and saints whom they no longer believed in. See how cold their religious painting is. Tintoretto always goes beyond his subjects; his interest is in himself. Titian's *St Jerome in Milan*, with all its beasts, its snail, its pullulating rocks – is he an ascetic, a stoic, a philosopher, a saint? We don't know. He is a man. An old white-haired man with his stone in his hand, ready to strike at the enigma, the flint of mystery, to make a spark of truth fly. This truth speaks out from the russet colour of such a fierce painting. It does not come from the arms of the cross which you don't see to begin with – which is there because the painting has been commissioned by some religious order or church. What a painter...! They are true pagans. In the Renaissance there is an explosion of extraordinary veracity, a love of painting and form which has never been seen again... Along come the Jesuits. Everything becomes stilted. Everything is learnt and taught. A revolution is needed for nature to be rediscovered, for Delacroix to paint his beach at Etretat, Corot his tumbledown houses in Rome, Courbet his undergrowth and his waves. And how painfully slowly, through how many stages! Things are put into place... Rousseau, Daubigny, Millet. A landscape is constructed, like a scene from history... From the outside, I mean. The rhetoric of landscape is created, a language, effects which are passed on. The machinations on canvas which, said Rousseau, Dupré had taught him. Corot himself. I prefer a more firmly based kind of painting. People have not yet discovered that nature is more depth than surface. Because, you see, you can modify, embellish, dress up the surface, but you can't touch its depth without touching truth. A healthy need for truth takes hold of you. You would rather throw your canvas away than invent or imagine some detail.

*

CÉZANNE: You either see a painting straight away or you never see it. Explanations have no value. What is the point of a commentary? All such things are approximations. One should simply chatter, as we do, because it's enjoyable, just as we would have a good drink of wine... I dislike literary painting. To spell out beneath a figure what he is thinking and doing is to admit that his thoughts or his gestures have not been expressed by drawings and colour. And to want to force an expression upon nature, to twist trees, to distort rocks as Gustave Doré does, or even to refine it, like de Vinci, that too is still literary. There is a logic of colour, by God! The painter owes loyalty to her alone. Never to the logic of the brain; if he abandons himself to that he is lost. Always the logic of the eye. If he senses things precisely, he will think precisely. Painting is a point of view before all else. The subject matter of our art is there, in the thoughts of our eyes... Nature always makes her meaning clear, as long as we respect her.

GASQUET: So she has meaning for you? Don't you give her that meaning?

CÉZANNE: Perhaps... Indeed, essentially you are right, I wanted to copy nature, but I could not. I searched in vain, turned around, approached her from every side. Irreducible. On all sides. But I was pleased with myself when I discovered, for example, that the sun could not be reproduced, that it had to be represented by something else... by colour. Everything else, theory, drawing, which is a form of logic in its own way, a hybrid logic somewhere between

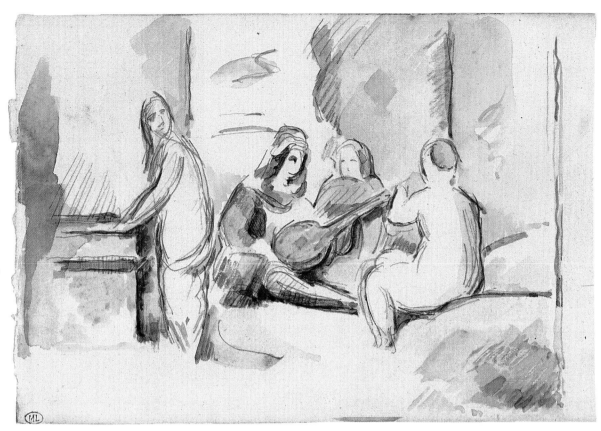

COPY OF GIORGIONE'S CONCERT CHAMPÊTRE

arithmetic, geometry, and colour, drawing which is a still life, ideas, sensations themselves: all these are just subterfuges. Sometimes they think they are short cuts, when in fact they are deviations. There is only one way that everything can be conveyed, expressed: colour. Colour is organic, if I may put it that way. Colour is alive, it alone can convey living things.

*

CÉZANNE: Tradition! I am more traditional than people think. It's like Rodin. People have no grasp at all of his real character. He is a man from the Middle Ages who makes admirable fragments, but fails to see the whole. His work should be arranged in the porch of a cathedral, just like the sculptors of the past.

Rodin is a prodigious stonecutter, with a very modern touch, who will make a success of as many statues as you like, but he is devoid of ideas. He lacks a religion, a system, a faith. His *Gates of Hell*, his *Monument to Work* – someone else prompted him to do them, and they will never be built, you'll see . . .

*

. . . I didn't intend to belittle Rodin by what I said, you know. I like him, I admire him a lot, but he is very much of his time, as we all are. We are makers of fragments. We no longer know how to compose.

*

CÉZANNE: This may surprise you. I hardly ever go into the little room where the Primitives are. That isn't painting as far as I am concerned. I'm wrong, perhaps I'm wrong, I admit. But what do you expect when I have spent an hour contemplating *le Concert Champêtre* or Titian's *Jupiter and Antiope*, when I still have *The Wedding at Cana* in front of me? What effect do you expect the ineptitudes of Cimabue to have on me, or the naïveties of Angelico, or even the perspectives of Uccello? These are ideas without flesh. All that I leave to Puvis. I like muscle, beautiful tones, blood. I'm like Taine and, moreover, I'm a painter. I'm a sensualist.

Just look at that . . . *The Victory of Samothrace*. It's an idea, a whole people, a heroic moment in the life of a people, and yet the fabrics cling, the wings beat, the breasts swell. I don't need to see the head to imagine the expression, because all the blood which surges up and circulates and sings in the legs, the haunches, the whole body, has rushed up to the brain, risen to the heart. It moves, it's the movement of the whole woman, the whole statue, the whole of Greece.

*

CÉZANNE: Ingres has no blood in his veins either, by God! He makes drawings. The Primitives made drawings. They coloured in, produced coloured drawings like missals on a grand scale. Painting, what is called painting, only came into being with the Venetians. Taine tells us that in Florence, at first, all the painters were goldsmiths. They made drawings. Like Ingres . . . Oh, Ingres, Raphael and the rest of them were very fine. I'm no more of a fool than the next man; I can take pleasure in line when I want to. But there is a stumbling block. Holbein, Clouet, Ingres – they have nothing but line. Well, that's not enough! It's very beautiful, but it isn't enough.

*

CÉZANNE: David killed painting. The conventional stereotype was introduced. They wanted to paint the ideal foot, the ideal hand, the perfect face and belly – the supreme being. They banished character. What makes a great painter is the character he gives to everything he touches – salience, movement, passion; for passionate serenity does exist. The others are afraid of that, or rather they haven't thought about it; perhaps as a reaction to all the passion, turbulence and brutality of their own society.

GASQUET: But David was deeply involved in such things.

CÉZANNE: Yes, but I know nothing colder than his *Marat*! What a puny hero! A man who had been his friend, who had just been murdered, whose praises he was to sing before all Paris, all France, all posterity. Did he patch him up enough in his sheet, water him down enough in his bath? He was thinking of what would be said of the painter and not of what would be thought of Marat. A bad painter. And he had seen the corpse before his very eyes . . .

*

(We went into the Salon Carré. He positioned himself before *The Wedding at Cana*. His bowler was tilted back on his head and his coat trailed under his arm. He looked in ecstasy.)

CÉZANNE: That's what painting is. The details, the whole; volumes, values, composition, excitement, – it's all there . . . It's amazing, isn't it! . . . What are we? . . . Close your eyes, wait for a moment; don't think about anything. Open them . . . Do you see? . . . You see nothing but a great wave of colour, yes? An iridescence, colours, an extravagance of colours. That's what a painting must give us before all else. Know how to see, to feel . . . especially in front of some great composition like those created by Veronese. Now there was a happy man. And he brings

PORTRAIT OF EUGENE DELACROIX

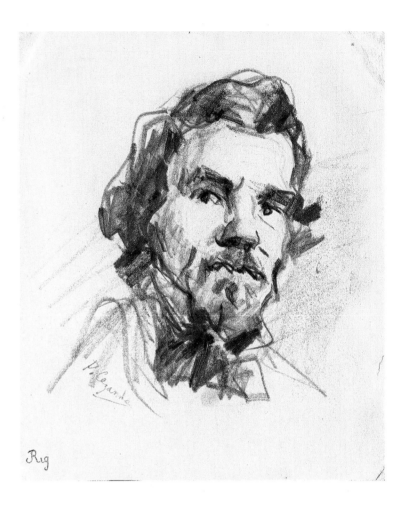

happiness to all who understand him. He is a unique phenomenon. He painted in the same way as we look at things; and with no more effort. He just danced. All those subtleties just flowed from his mind, just as everything I'm saying to you flows from my mouth. He spoke in colours. It's extraordinary, I scarcely know anything about his life!

*

CÉZANNE: Yes, Tintoretto; Rubens – that's what a painter is, just as Beethoven is the musician and Plato is the philosopher.

GASQUET: You know what Ruskin said, that as far as painting is concerned his *Adam and Eve* is the finest in the world?

CÉZANNE: I've only seen a photograph of it... I've leafed through all I could find about his work. It's gargantuan. Everything is in it, from still life to God. It's the sacred ark. Every form of existence is there, conveyed with extraordinary pathos, passion and imagination. Had I ever gone to Venice it would have been for him. It seems that it's the only place to get to know him. I recall that, in a *Temptation of Christ*, which I think is in San Rocco, there is an angel with swelling breasts, wearing bangles; also a pederastic demon holding out stones to Jesus with, yes, with lesbian concupiscence. Nothing more perverse has ever been painted. I don't know, but when you showed me the photograph at your house it made me think of a Verlaine writ large, an Aretino with the genius of Rabelais. Chaste and sensual, brutish and cerebral, wilful as well as inspired – without sentimentality; I think this Tintoretto knew everything, what makes for joy and torment... I can't speak of it without trembling. Those fearsome portraits brought me close to him.

*

CÉZANNE: Ah! What it would be to have pupils! To be able to pass on my experience to someone else. I am nothing; I have accomplished nothing, but I have learnt. To be able to pass that on. To link up with all those great figures from the past two centuries. That fixed point rediscovered in the midst of all this modern chaos . . . In vain. Perhaps in vain . . .

(He clenches his fists. He rolls his eyes in fury.)

CÉZANNE: And all these idiots! . . . A tradition. A tradition could be started again from me, even though I am nothing. To work with pupils, but with pupils whom you teach, mark you, and who don't try to teach you. That has happened to me . . .

(He walks over to a window and looks out at the sunlit row of buildings.) That isn't stupid at all . . . In fact, whoever could convey that, in all its simplicity – the Seine, Paris, a Paris day – could come in here with his head held high . . . You have to be a good workman. Nothing but a painter. Have a system. Realize.

<p style="text-align:center">*</p>

(He goes up to *The Women of Algiers*.)

We are all in this Delacroix. When I talk to you about the joy of colour for its own sake, that's what I'm trying to say . . . Those pale roses, these surly looking cushions, this Turkish slipper, all this clarity – it seems to pour into your eye, just as a glass of wine flows down your throat, and you are intoxicated straight away. Without knowing how, you feel lighter. These subtleties relieve and purify. If I had done something wrong, I think I would come and stand here to put myself right again . . . And it's full to bursting. The tones merge into one another, like silk. Everything is woven together, worked into a whole. That's why it moves. It's the first time that anyone has painted a volume since the great masters. And with Delacroix, it goes without saying that there is a certain something, a feverish excitement not to be found in the Old Masters.

<p style="text-align:center">*</p>

GASQUET: What about Courbet?

CÉZANNE: A builder. A crude plasterer. A grinder of colours. He built like a Roman. And yet he too is a true painter. There isn't another this century to better him. In vain he can roll up his sleeves, pull his felt hat down over his ears, knock down the Column – his technique, beneath his grand, sweeping airs, is classical . . . He is profound, serene, mellow. He has painted nudes as golden as the harvest which I am very fond of. His palette smells of wheat . . . Yes, yes, Proudhon turned his head with his realism, but, when it comes down to it, this great realism of his, it's like Delacroix's romanticism, he only forced it into a few pictures, with bold sweeps of the brush, and they were the most gaudy and least beautiful ones. And anyway, he was more involved in his subject – his realism – than in technique. He always sees things composed. His vision remained that of the Old Masters.

<p style="text-align:center">*</p>

The Studio

Cézanne was finishing off my father's portrait. I was present at the sittings. The studio was empty. The only things in it were the easel, the little painting table, the chair my father sat on and the stove. Cézanne worked standing up... Canvases were piled up in a corner against the wall. There was a soft, even bluish light reflected from the walls. On a white wooden bookcase there were two or three plaster casts and some books. When I arrived, Cézanne would fetch an old armchair with half its straw seat missing from the bedroom next door. My father would smoke his pipe and we would chat together.

Although he had his palette and brushes in his hands, Cézanne spent most of his time watching, scrutinizing my father's face. He didn't paint. Every once in a while he would apply a nervous brushstroke here, a light touch there, a vivid blue stroke which fixed an expression, brought out and defined some fleeting facet of character... The next day I would find on the canvas the results of the previous day's analysis.

*

CÉZANNE: Listen, Henri. What you have is certainty. That is my main aim – certainty! Every time I attack a canvas I feel sure, I really believe that this will be it... But I remember at once that I have always failed in the past. And so I fret and fume... You know what is right and what is wrong in life, and you go your own way... I, on the other hand, never know where I'm going, where I would like to go with this damned vocation of mine. Every theory lands you in trouble... Is it because I'm shy? Basically, if you have character you have talent... I'm not saying that character is enough in itself, that it's enough to be a good man to be a good painter... That would be too simple... But I don't believe that a scoundrel can be a man of genius.

*

GASQUET'S FATHER: But my son tells me that you haven't got the position you should have.

CÉZANNE: Let him talk... I must stay at home, see no one, work. My position, my position... That would mean being pleased with myself, which I'm not. I never will be. I can't be. Up until the war my life was full of damned problems, as you know; I wasted my life. When I think about it, it was only at l'Estaque that I came to fully understand Pissarro – a painter like myself. Your son knows him... a determined man. An obsessive love of work took hold of me. Not that I didn't work before that; I always did. But what I have never had is a friend like you, someone I would never have talked to about painting, with whom I had an unspoken understanding . . .

*

GASQUET: But what do you really mean by classical?

CÉZANNE: I don't know... Everything and nothing.

GASQUET: I've heard you say that you were, wanted to be, classical.

(He thought for a moment.)

CÉZANNE: Imagine Poussin redone entirely from nature; that's the classsicism I mean.

(He begins to paint again. The portrait is well advanced; two white squares remain on the cheek and forehead. The eyes are alive. Two fine blue strokes extend the drawing of the hat almost to the edge of the canvas.)

I would like to see them here, that crowd who write about us, here in front of this face of yours and with me clutching my paint tubes and brushes... they're miles away... They don't even suspect how, by blending a finely shaded green into a red, you can make a mouth

look sad or make a cheek smile. You yourself are aware that in every one of my brushstrokes there is something of my blood mixed with a little of your father's – in the sun, the light, the colours; and that there is a mysterious exchange between his soul, which he is unaware of, and my eye which recreates it and through which he will recognize himself . . . if I were a painter, a great painter! . . . There, on my canvas, every stroke must correspond to a breath taken by the world, to the brightness there on his whiskers, on his cheeks. We must live in harmony together, my model, my colours and I, blending together with every passing moment.

*

CÉZANNE: An art which isn't based on feeling isn't an art at all . . . Feeling is the principle, the beginning and end; craft, objective, technique – all these are in the middle . . . Between you and me, Henri, between what makes up your particular character and mine there is the world, the sun . . . that which is transient . . . that which we both see . . . Our dress, our flesh, reflections . . . That's what I have to concentrate on. That's where the slightest error with the brush can send everything off course . . . If I am moved by emotion alone, then your eye goes askew . . . If I weave around your expression the infinite network of little blues and browns which are there, which marry together, I will make you look out from my canvas as you do in life . . . One stroke after another, one after another . . . And if I am just cold, if I draw or paint as they do in the schools . . . then I will cease to see anything. A conventional mouth and nose, always the same; no soul, no mystery, no passion . . .

*

GASQUET: What about Velasquez?

 CÉZANNE: Ah, Velasquez! That's another story. He had his revenge . . . You see, this man just got on with his painting, preparing to pass down to us the forges of Vulcan and the triumphs of Bacchus which cover the walls of every palace in Spain . . . Then some fool, thinking he's doing him a favour, talks about all this, drags him along to see the king . . . Photography hadn't been invented then . . . Paint a portrait of me on foot, on horseback, of my wife, my daughter, this madman, that beggar, this one, that one . . . Velasquez became the king's photographer . . . this lunatic's plaything . . . And so he turned everything in upon himself, his work, his great spirit . . . He was imprisoned . . . Escape was impossible . . . He took a terrible revenge. He painted them with all their flaws, their vices, their decadence . . . His hatred and his objectivity became one . . .

*

CÉZANNE: And painting . . . It's so fine and yet so terrible to stand in front of a blank canvas. Take that one – months of work have gone into it. Tears, laughter, gnashing of teeth. We were talking about portraits. People think that a sugar basin has no face, no soul. But even that changes day by day. You have to know how to catch and cajole those fellows . . . These glasses and plates talk among themselves. Endless confidences . . . As for flowers, I've given them up. They wither away so quickly.

*

Fruits are more faithful. They like having their portraits painted. They seem to sit there and ask your forgiveness for fading. Their thought is given off with their perfumes. They come with all their scents, they speak of the fields they have left, the rain which has nourished them, the daybreaks they have seen.

*

CÉZANNE: Painting is damned difficult, Henri... You always think you've got it, but you haven't... Take your portrait – it's a fragment, and you know how hard you have to work on a face if you are to produce eyes which can see and a mouth which speaks... Well, that's nothing! To make paintings you almost need to be able to put down a fragment like that every day... Tintoretto did, and Rubens... And it isn't only faces... It's the same thing with these still lifes. They have the same density, the same complexity. Every object requires a different technique. You can never fully know your craft... I could paint for a hundred years, a thousand years without stopping and I would still feel as though I knew nothing...

God knows how the Old Masters got through those acres of work... As for me, I exhaust myself, work myself to death trying to cover fifty centimetres of canvas... No matter... that's life... I want to die painting...

*

CORNER OF A STUDIO

List of Plates

120 AFTER DELACROIX – ALLEGORICAL FIGURE OF A RIVER,
 *c.*1878–81
 Pencil, 12 × 21 cm
 Art Institute of Chicago; Arthur Heun Fund

121 AFTER L'ÉCHORCHE, *c.*1875–86
 Pencil, 22 × 12 cm
 Art Institute of Chicago

122 AFTER RUBENS – THREE NAIADS, 1876–9
 Pencil, 31 × 45 cm
 Feilchenfeldt Collection, Zürich

123 FIVE BATHERS, *c.*1885–7
 Oil on canvas, 66 × 66 cm
 Kuntsmuseum, Basle

124 THE AVENUE AT THE JAS DE BOUFFAN, *c.*1874–5
 Oil on canvas, 38 × 46 cm
 Tate Gallery, London

125 THE ÉTANG DES SOEURS AT OSNY, *c.*1877
 Oil on canvas, 65 × 81 cm
 Courtauld Institute Galleries, London (Courtauld Collection)

126 TURN IN THE ROAD, *c.*1879–82
 Oil on canvas, 60 × 73 cm
 Museum of Fine Arts, Boston; Bequest of John T. Spaulding

127 ROAD, TREES AND LAKE, *c.*1879–82
 Oil on canvas, 81 × 60 cm
 Rijksmuseum Kroller-Muller, Otterlo

128 ROCKS AT L'ESTAQUE, *c.*1882–5
 Oil on canvas, 73 × 91 cm
 Museu de Arte de Sao Paulo, Brazil

129 LANDSCAPE IN PROVENCE, *c.*1875
 Watercolour, 38 × 50 cm
 Kunsthaus, Zürich

130 LANDSCAPE, *c.*1884–7
 Pencil, 35 × 54 cm
 British Museum, London

131 MELTING SNOW, FONTAINEBLEAU, *c.*1879–80
 Oil on canvas, 73 × 100 cm
 Museum of Modern Art, New York; Gift of Andre Meyer

132 VIEW THROUGH TREES, L'ESTAQUE, *c.*1882–5
 Oil on canvas, 73 × 60 cm
 Private Collection

133 THE CHÂTEAU AT MEDAN, *c.*1879–81
 Oil on canvas, 59 × 72 cm
 Burrell Collection, Glasgow Museums and Art Galleries

134 THE GULF OF MARSEILLES SEEN FROM L'ESTAQUE, *c.*1883–5
 Oil on canvas, 73 × 100 cm
 Metropolitan Museum of Art, New York; Bequest of Mrs H. O. Havemeyer

135 THE BAY OF MARSEILLES, 1886–90
 Oil on canvas, 80 × 100 cm
 Art Institute of Chicago; Mr & Mrs Martin A. Ryerson Collection

136 L'ESTAQUE AND THE GULF OF MARSEILLES, 1882–5
 Oil on canvas, 65 × 81 cm
 Philadelphia Museum of Art; Mr & Mrs Carroll S. Tyson Collection

137 HOUSES IN PROVENCE, *c.*1880
 Oil on canvas, 65 × 81 cm
 National Gallery of Art, Washington; Collection of Mr & Mrs Paul Mellon

138 TREES, *c.*1882–4
 Watercolour, 47 × 31 cm
 Feilchenfeldt Collection, Zürich

139 LANDSCAPE WITH TREES, *c.*1885–7
 Pencil, 12 × 21 cm
 Art Institute of Chicago; Arthur Heun Fund

140 ORCHARD, *c.*1885–6
 Oil on canvas, 65 × 50 cm
 Academy of Fine Arts, Honolulu

141 TALL TREES AT THE JAS DE BOUFFAN, *c.*1885–7
 Oil on canvas, 65 × 81 cm
 Courtauld Institute Galleries, London (Courtauld Collection)

142 TREES AND HOUSES, *c.*1885–7
 Oil on canvas, 54 × 73 cm
 Musée de l'Orangerie, Paris; Collection Jean Walter and Paul Guillaume

143 HOUSE BEHIND TREES ON THE ROAD TO THOLONET,
 *c.*1885–7
 Oil on canvas, 68 × 92 cm
 Metropolitan Museum of Art, New York; Robert Lehman Collection

144 MONT SAINTE-VICTOIRE, *c.*1885–7
 Oil on canvas, 65 × 81 cm
 Metropolitan Museum of Art, New York; Bequest of Mrs H. O. Havemeyer

145 MONT SAINTE-VICTOIRE, *c.*1886–8
 Oil on canvas, 66 × 92 cm
 Courtauld Institute Galleries, London (Courtauld Collection)

146 MOUNTAINS IN PROVENCE, *c.*1878–80
 Oil on canvas, 53 × 72 cm
 The National Museum of Wales, Cardiff

147 MOUNTAINS IN PROVENCE, *c.*1886–90
 Oil on canvas, 64 × 79 cm
 National Gallery, London

151 AT THE WATER'S EDGE, *c.*1890
 Oil on canvas, 73 × 92 cm
 *National Gallery of Art, Washington; Gift of the W. Averell Harriman
 Foundation in Memory of Marie N. Harriman*

153 PORTRAIT OF GUSTAVE GEFFROY, *c.*1895
 Oil on canvas, 16 × 89 cm
 Private Collection

158 AFTER THE ANTIQUE, *c.*1894–7
 Pencil, 15 × 23 cm
 Cabinet des Dessins, Musée du Louvre, Paris

159 AFTER THE ANTIQUE – THE BORGHESE MARS, *c.*1892–5
 Pencil, 22 × 14 cm
 Cabinet des Dessins, Musée du Louvre, Paris

162 PORTRAIT OF AMBROISE VOLLARD, *c.*1899
 Oil on canvas, 100 × 81 cm
 Petit Palais, Paris

166 BOY IN A RED WAISTCOAT, *c.*1893–5
 Oil on canvas, 90 × 72 cm
 Collection of Mr & Mrs Paul Mellon, Virginia

168 MADAME CÉZANNE, *c.*1890–92
 Oil on canvas, 46 × 38 cm
 Philadelphia Museum of Art

169 MADAME CÉZANNE WITH HER HAIR DOWN, *c.*1883–7
 Oil on canvas, 62 × 51 cm
 Philadelphia Museum of Art

170 MADAME CÉZANNE IN A YELLOW ARMCHAIR, *c.*1893–5
 Oil on canvas, 81 × 65 cm
 Art Institute of Chicago

171 MADAME CÉZANNE IN A RED DRESS, *c.*1890–94
 Oil on canvas, 116 × 89 cm
 Metropolitan Museum of Art, New York; Mr & Mrs Henry Ittleson, Jnr., Fund

172 HARLEQUIN, c.1888
Pencil, 47 × 31 cm
Art Institute of Chicago; Gift of Tiffany & Margaret Blake

173 HARLEQUIN, c.1888–90
Oil on canvas, 101 × 65.7 cm
National Gallery of Art, Washington; Collection of Mr & Mrs Paul Mellon

174 STUDIES FOR MARDI GRAS, c.1888
Pencil, 245 × 306 cm
Cabinet des Dessins, Musée du Louvre, Paris

175 SELF-PORTRAIT, c.1895
Watercolour, 28 × 26 cm
Feilchenfeldt Collection, Zürich

176 STUDY FOR THE CARD PLAYERS, c.1890–92
Watercolour, 36 × 48 cm
Art Institute of Chicago; Anonymous Loan

177 THE CARD PLAYERS, c.1892
Oil on canvas, 65 × 82 cm
Metropolitan Museum of Art, New York; Bequest of Stephen C. Clark

178 THE CARD PLAYERS, c.1890–92
Oil on canvas, 45 × 57 cm
Musée d'Orsay, Paris

179 WOMAN WITH A COFFEE-POT, c.1890–95
Oil on canvas, 130 × 97 cm
Musée d'Orsay, Paris

180 PORTRAIT OF A MAN, c.1890–92
Oil on canvas, 55 × 46 cm
Private Collection

181 MAN WITH A PIPE, c.1892
Oil on canvas, 73 × 60 cm
Courtauld Institute Galleries, London (Courtauld Collection)

182 BOY IN A RED WAISTCOAT, c.1889–90
Watercolour, 46 × 31 cm
Feilchenfeldt Collection, Zürich

183 BOY IN A RED WAISTCOAT, c.1890–94
Oil on canvas, 79 × 64 cm
Private Collection, Switzerland

184 THE BLUE VASE, c.1883–7
Oil on canvas, 61 × 50 cm
Musée d'Orsay, Paris

185 POT OF FLOWERS AND PEARS, c.1888–90
Oil on canvas, 46 × 55 cm
Courtauld Institute Galleries, London (Courtauld Collection)

186 STILL LIFE WITH APPLES AND MELONS, c.1890–94
Oil on canvas, 65 × 81 cm
National Gallery, London; on Loan from Private Collection

187 GINGER POT WITH POMEGRANATE AND PEARS, c.1890–93
Oil on canvas, 46 × 55 cm
Philips Collection, Washington; Gift of Gifford Phillips

188 STILL LIFE WITH GINGER JAR AND EGGPLANTS, c.1890–94
Oil on canvas, 73 × 92 cm
Metropolitan Museum of Art, New York

189 VASE OF TULIPS, 1890–92
Oil on canvas, 59 × 42 cm
Art Institute of Chicago; Mr & Mrs Lewis Larned Coburn Memorial Collection

190 BASKET OF APPLES, c.1895
Oil on canvas, 60 × 80 cm
Art Institute of Chicago; Helen Birch Bartlett Memorial Collection

191 STILL LIFE, c.1900
Oil on canvas, 55 × 46 cm
National Gallery of Art, Washington; Gift of the W. Averell Harriman Foundation in Memory of Marie N. Harriman

192 CARAFE AND KNIFE, c.1882
Watercolour, 21 × 28 cm
Philadelphia Museum of Art

193 STILL LIFE WITH ONIONS, c.1895–1900
Oil on canvas, 66 × 82 cm
Musée de'Orsay, Paris

194 POT AND SOUP TUREEN, c.1890
Watercolour on paper, 12 × 21 cm
National Museum of Western Art, Tokyo; Matsukata Collection

195 FOLIAGE, c.1895–1900
Watercolour and pencil, 44 × 56 cm
Museum of Modern Art, New York; Lillie P. Bliss Collection

196 STUDY AFTER NICOLAS COUSTOU – STANDING CUPID, c.1900–04
Watercolour, 48 × 32 cm
Szepmuveszeti Muzeum, Budapest

197 PLASTER CUPID, c.1895
Oil on canvas, 63 × 81 cm
Nationalmuseum, Stockholm

198-9 BOAT AND BATHERS, c.1890–94
Oil on canvas, 30 × 125 cm
Musée de l'Orangerie, Paris; Collection Jean Walter and Paul Guillaume

200 BATHERS, c.1890–94
Oil on canvas, 22 × 33 cm
Musée d'Orsay, Paris

201 AFTER THE ANTIQUE – DANCING SATYR, c.1894–8
Pencil, 22 × 14 cm
Cabinet des Dessins, Musée du Louvre, Paris

202 AFTER PIGALLE – LOVE AND FRIENDSHIP, c.1895
Pencil, 22 × 14 cm
Cabinet des Dessins, Musée du Louvre, Paris

203 AFTER PIGALLE – MERCURY, c.1890
Pencil, 38 × 25 cm
Museum of Modern Art, New York; Joan & Lester Arnet Fund

204 AFTER DESJARDINS – PIERRE MIGNARD, c.1892–5
Pencil, 22 × 14 cm
Cabinet des Dessins, Musée du Louvre, Paris

205 AFTER VAN CLEVE – LOIRE AND LORIET, c.1894–8
Pencil, 22 × 14 cm
Cabinet des Dessins, Musée du Louvre, Paris

206 MONT SAINTE-VICTOIRE, c.1890–95
Oil on canvas, 55 × 65 cm
National Gallery of Scotland, Edinburgh

207 MONT SAINTE-VICTOIRE, c.1902–6
Watercolour, 48 × 31 cm
Philadelphia Museum of Art

208 FARMHOUSES NEAR BELLEVUE, c.1892–5
Oil on canvas, 36 × 50 cm
Phillips Collection, Washington

209 HOUSE AND FARM AT THE JAS DE BOUFFAN, c.1885
Oil on canvas, 61 × 74 cm
Narodni Galerie, Prague

210 NEAR THE POOL AT THE JAS DE BOUFFAN, c.1888–90
Oil on canvas, 64 × 80 cm
Metropolitan Museum of Art, New York; Bequest of Stephen C. Clark

211 TREES LEANING OVER ROCKS, c.1892
Watercolour, 42 × 30 cm
National Gallery of Art, Washington; Collection of Mr & Mrs Paul Mellon

212 BRIDGE ON THE SEINE, c.1885
Watercolour, 49 × 60 cm
Yale University Art Gallery; Philip L. Goodwin Collection

213 THE BALCONY, c.1895
Watercolour, 55 × 39 cm
Philadelphia Museum of Art; A. E. Gallatin Collection

214 THE GREAT PINE, c.1892–6
Oil on canvas, 84 × 92 cm
Museu de Arte de Sao Paulo, Brazil

215 THE LARGE TREE, date unknown
Pencil and watercolour on paper, 31 × 46 cm
Metropolitan Museum of Art, New York; Bequest of Theodore Rousseau. Jointly owned by the Metropolitan Museum and Fogg Art Museum, Harvard University

216 TREES AND ROCKS, c.1890
Watercolour, 49 × 31 cm
Von der Heydt-Museum, Wuppertal

217 THE PISTACHIO TREE IN THE COURTYARD OF THE CHÂTEAU NOIR, c.1900
Watercolour, 54 × 43 cm
Art Institute of Chicago

218 ROCKS IN THE FOREST, c.1894–8
Oil on canvas, 73 × 93 cm
Metropolitan Museum of Art, New York; Bequest of Mrs H. O. Havemeyer

219 CHÂTEAU NOIR, c.1904
Oil on canvas, 73 × 92 cm
Oskar Reinhart Collection, Winterthur

220 ROCKY RIDGE ABOVE CHÂTEAU NOIR, c.1895–1900
Watercolour and pencil, 32 × 48 cm
Museum of Modern Art, New York; Lillie P. Bliss Collection

221 STUDY OF A TREE, 1885–90
Watercolour, 28 × 44 cm
Kunsthaus, Zürich

222 STUDY OF A TREE, c.1895–1900
Pencil drawing, 48 × 31 cm
Narodni Galerie, Prague

223 A LAKE AT THE EDGE OF A WOOD, c.1900–04
Watercolour, 46 × 59 cm
St Louis Art Museum

227 CHÂTEAU NOIR, c.1887–90
Pencil and watercolour, 36 × 53 cm
Museum Boymans-van Beuningen, Rotterdam

228 STILL LIFE WITH WATER JUG, c.1895–1900
Oil on canvas, 53 × 71 cm
Tate Gallery, London

231 WOMAN AT HER TOILETTE, c.1883–6
Pencil and watercolour, 16 × 13 cm
Hood Museum of Art, Dartmouth College; Gift of Josephine & Ivan Albright

233 PORTRAIT OF AMBROISE VOLLARD, c.1899
Graphite, 45 × 39 cm
Fogg Art Museum, Harvard University, Cambridge, Mass.; Bequest of Mr & Mrs Frederick B. Deknatel

239 THE GROUNDS OF CHÂTEAU NOIR, c.1900
Oil on canvas, 91 × 71 cm
National Gallery, London

241 STILL LIFE WITH CARAFE AND SUGAR BOWL, c.1900–06
Watercolour, 48 × 63 cm
Kunsthistorisches Museum, Vienna

245 THREE SKULLS, c.1902–6
Watercolour over graphite, 48 × 63 cm
Art Institute of Chicago; Mr & Mrs Lewis Larned Coburn Memorial Collection

246 THE BRIDGE AT TROIS SAUTETS, c.1906
Watercolour, 41 × 54 cm
Cincinnati Art Museum; Gift of John Emery

248 STILL LIFE WITH FAIENCE POT, c.1900–05
Oil on canvas, 73 × 100 cm
Oskar Reinhart Collection, Winterthur

249 STILL LIFE WITH APPLES AND PEACHES, c.1905
Oil on canvas, 81 × 100 cm
National Gallery of Art, Washington; Gift of Eugene & Agnes Meyer

250 THE THREE SKULLS, c.1900
Oil on canvas, 35 × 61 cm
Detroit Institute of Arts; Bequest of Robert H. Tannahill

251 PYRAMID OF SKULLS, c.1900
Oil on canvas, 37 × 46 cm
Feilchenfeldt Collection, Zürich

252 BOTTLE, CARAFE, JUG AND LEMONS, c.1902–6
Pencil and watercolour, 44 × 58 cm
Thyssen-Bornemisza Foundation, Switzerland

253 BOTTLES, POT, ALCOHOL STOVE, APPLES, c.1900–06
Watercolour, 47 × 56 cm
Private Collection

254 STILL LIFE WITH POMEGRANATES, CARAFE, SUGAR-BOWL, BOTTLE AND WATERMELON, c.1900–06
Watercolour, 30 × 40 cm
Cabinet des Dessins, Musée du Louvre, Paris

255 STILL LIFE WITH APPLES, BOTTLE AND CHAIR BACK, c.1902–6
Pencil and watercolour, 46 × 60 cm
Courtauld Institute Galleries, London (Courtauld Collection)

256 STILL LIFE WITH WATERMELON, c.1900–06
Watercolour, 32 × 48 cm
Galerie Beyeler, Switzerland

257 STILL LIFE ON A TABLE, c.1902–6
Watercolour, 48 × 60 cm
F. V. Thaw & Co. Ltd., New York

258 PORTRAIT OF THE GARDENER VALLIER, c.1906
Watercolour, 48 × 39 cm
Private Collection

259 SELF-PORTRAIT WITH A BERET, c.1898–90
Oil on canvas, 64 × 54 cm
Museum of Fine Arts, Boston; Charles H. Bayley Picture and Painting Fund and Partial Gift of Elizabeth Paine Metcalf

260 THE SAILOR, c.1905
Oil on canvas, 107 × 75 cm
National Gallery of Art, Washington, Gift of Eugene & Agnes Meyer

261 AN OLD WOMAN WITH A ROSARY, c.1896
Oil on canvas, 81 × 66 cm
National Gallery, London

262 BATHERS, 1899–1904
Oil on canvas, 51 × 62 cm
Art Institute of Chicago; Amy McCormick Memorial Collection

263 SEVEN BATHERS, c.1900
Oil on canvas, 38 × 46 cm
Galerie Beyeler, Switzerland

264 BATHERS, c.1885–1900
Watercolour, 17 × 27 cm
Private Collection, Switzerland

Guide to the principal personalities mentioned in the text

ALEXIS, Paul
Alexis came from Aix and made the acquaintance of both Cézanne and Zola in his youth. His career as a poet was encouraged by Cézanne, who admired his early verses and painted a picture of Alexis reading to Zola. He remained close to Zola and tried to promote Cézanne's career in later life.

AURENCHE, Louis
The writer Louis Aurenche was one of the group of young artists who visited and befriended Cézanne in his last years. A brief but warm correspondence took place between them from 1901 to 1902, by which time Aurenche had moved to a civil service job at some distance from Aix.

BAILLE, Baptistin
Cézanne, Zola and Baille were the closest of school friends, and their exploits together in the countryside were a formative episode in the artist's early life. The three friends were united again in Paris in the 1860s as they pursued their different careers, but contact with Baille was lost when he took up law and eventually became a Professor at the Ecole Polytechnique.

BERNARD, Émile
Almost thirty years younger than Cézanne, Bernard established a close relationship with him in the early years of the twentieth century. Bernard, himself a painter, had been involved with many of the artistic movements of the 1880s and 1890s, and was important in promoting Cézanne's work to a wider audience. Cézanne's letters to Bernard contain some of his most famous thoughts about art, though other letters make it clear that Cézanne had a low opinion of Bernard's own painting.

BORÉLY, Jules
On the basis of a single visit to Cézanne at Aix in 1902, the archaeologist Jules Borély published a brief account of the painter in old age. Borély recorded little about Cézanne's paintings, but left a vivid and apparently factual memoir of the artist's conversations and opinions.

CAILLEBOTTE, Gustave
An important organizer of, and contributor to, several Impressionist exhibitions, Caillebotte was also a wealthy collector of contemporary art who bought a number of pictures by Cézanne. There is no evidence of a close relationship between the two men, but Cézanne sent Caillebotte a touching note on hearing of the death of his mother.

CAMOIN, Charles
Camoin forms an important link between Cézanne's late years and the young Parisian avant-garde of the early twentieth century. In 1901, Camoin made Cézanne's acquaintance while on military service at Aix, and Cézanne encouraged and instructed the younger artist in his painting. A sympathetic correspondence ensued, some of Cézanne's observations being presumably transmitted to Camoin's friends and contemporaries in Paris, such as Pierre Matisse and André Derain.

CÉZANNE, Anne-Elizabeth
Little is known about Cézanne's mother, but it is clear from the artist's letters that his relationship with her was a good deal closer than his relationship with his father. She appears to have taken Cézanne's side in a number of family disputes and to have helped conceal the existence of the artist's son Paul from Cézanne's father. Curiously, there are few pictures by Cézanne which can be seen as portraits of his mother.

CÉZANNE, Louis-Auguste
The father of the painter, Louis-Auguste set himself up in the hat trade at Aix and later became a prosperous banker. His relationship with his son appears to have been an oppressive one, though he continued to supply a modest allowance for the painter and thus to make his artistic career possible. He appears only rarely, as a curious figure with a hat or visor, in Cézanne's pictures, and these few portraits do not suggest any affection between father and son.

CÉZANNE, Marie
The oldest of Cézanne's two sisters, Marie was born in 1841. She never married and continued to live in Aix, maintaining contact with Cézanne and influencing him towards the end of his life in his move towards Catholicism.

CÉZANNE, Paul
The artist's only child, Paul, was born in 1872 and became the most intimate companion of his father in his old age. Cézanne's affection for Paul is evident in his numerous drawings and paintings of him, though the father's tendency to indulge his son is also clear in his letters. In his last years, Cézanne was happy to trust his affairs to Paul, who appears to have thrived on his dealings with galleries and collectors.

CÉZANNE, Rose
Rose was born in 1854, fifteen years after Cézanne, and was the youngest of the three children. She later married Maxim Conil, who owned some land near Aix where Cézanne would often paint. Cézanne's letters show considerable affection towards Rose's children, his only nephews and nieces.

CHOCQUET, Victor
One of the half-dozen most important patrons of early Impressionism, Victor Chocquet was an official in the customs service who spent much of his income on art. He befriended Cézanne and became an enthusiastic admirer of his work, acquiring probably the largest early collection of his pictures. Both Renoir and Cézanne painted portraits of Chocquet.

CONIL, Maxim
Husband of Cézanne's sister Rose, Maxim Conil appears to have been instrumental in the decision to sell the family house, the Jas de Bouffan, as part of the financial settlement after the deaths of Cézanne's parents. He also allowed the artist to paint on his property near Aix-en-Provence.

COSTE, Numa
Coste was one of the circle of Cézanne's boyhood friends who remained in sporadic contact with him throughout his life. Letters from Cézanne to Coste in the 1860s, some of which coincided with Coste's lengthy military service, suggest a close and active friendship. In later life, Coste became a man of letters but continued to paint as an amateur.

DEGAS, Edgar
The paths of Degas and Cézanne crossed several times during their careers and there is evidence that they respected each other's work, though there are stories that their personalities did clash. Both were the sons of bankers and enjoyed some financial independence; both had an almost exaggerated respect for the Old Masters, and pursued such traditional themes as the nude and the portrait; and both spent their last years in the obsessive re-examination of certain favourite motifs. Degas owned nine pictures by Cézanne.

DENIS, Maurice
Before he had met Cézanne, the young painter and writer Maurice Denis had exhibited in Paris his picture *Hommage à Cézanne* in 1900. His subsequent correspondence with Cézanne, and his published accounts of a visit to the artist at Aix in 1906, provide some useful insights into Cézanne's thinking, but Denis did not establish the close personal relationship that was achieved by Gasquet, Camoin or Bernard.

EMPERAIRE, Achille
Emperaire is a curiously shadowy figure in the story of Cézanne's life, but it is also clear that he had considerable importance for the artist. Ten years older than Cézanne, Emperaire studied with him at the Aix Academy, and a number of his dark and brooding figure studies have a close affinity with Cézanne's. Emperaire never had the means nor the recognition to advance his career, but Cézanne remained loyal to what he considered to be his genuine artistic abilities.

FIQUET, Hortense
In 1869, at the age of thirty, Cézanne met the nineteen-year-old model Hortense Fiquet and subsequently lived with her in Paris. Their ensuing relationship and the birth of their son, Paul, caused untold problems for Cézanne, who was determined that his father should not hear of his unofficial 'family'. Eventually the liaison was recognized and Cézanne married Hortense in 1886. Hortense appears to have had some influence over the artist, but they often lived apart. Cézanne painted a large number of portraits of her, many of surprising tenderness.

GACHET, Paul
Dr Gachet played a significant but peripheral role in the art of the late nineteenth century. He had met Cézanne's father as a young man and later became acquainted with Pissarro when they both settled near Pontoise. Gachet was an amateur artist and briefly persuaded Cézanne to take up etching, as well as interceding with Cézanne's father to increase the painter's allowance. Some years later, Dr Gachet treated Van Gogh during his illness, and was painted and drawn by him several times.

GASQUET, Henri
A friend from Cézanne's schooldays, Henri Gasquet appears to have renewed his acquaintance with the painter in later life. Cézanne described him as 'stable in his principles and opinions' and it appears that he enjoyed Cézanne's friendship for several years in the late 1890s. Joachim, his son, published an account of Cézanne painting the portrait of his father.

GASQUET, Joachim
Son of Henri Gasquet, Joachim was a young poet and journalist when he first befriended Cézanne in 1896. The Gasquet family was involved in an attempt to revive a specifically Provençal culture, and Joachim wrote a number of articles in which Cézanne was seen to express the spirit of Provence. For several years the relationship was a close one, and Cézanne said of Joachim in 1898 that 'his friendship is very precious to me'. After 1900 this friendship cooled, but some years later Joachim wrote an extended memoir of Cézanne in his highly distinctive, colourful prose.

GEFFROY, Gustave
Art critic, writer and champion of the new art, Geffroy was a personal friend of many of the leading painters of the day. From the 1880s onwards Geffroy promoted the criticism and the exhibition of the Impressionists and their circle, and in the mid-1890s offered his support to Cézanne. They met at Monet's house in 1894 and in the following year Cézanne began, but failed to complete, Geffroy's portrait. The personal connection between the two men was never warm and, in later years, Cézanne partly blamed Geffroy for his loss of privacy.

GUILLAUMIN, Jean-Baptiste Armand
Guillaumin was one of the first painters whom Cézanne met when he arrived in Paris from Aix and started to study at the Académie Suisse. Principally a landscapist, Guillaumin exhibited with Cézanne at the first Impressionist exhibition in 1874 and in a number of subsequent Impressionist exhibitions.

GUILLEMET, Antoine
During the 1860s Cézanne established a warm friendship with the landscape-painter Guillemet and his wife, and as late as 1897 they were still exchanging occasional letters. Guillemet was a follower of Daubigny and Corot, preferring to stay within the official Salon system rather than side with the Impressionists. In 1882 he was able to use his influence to get one of Cézanne's paintings exhibited at the Salon as the work of 'P. Cézanne, pupil of A. Guillemet'.

HUOT, Joseph
Huot was one of the circle of Cézanne's friends who studied at the Academy in Aix. When Cézanne left for Paris, he corresponded briefly with Huot, but an account of a meeting between the two men in 1878 (Huot had become an architect) shows that Cézanne had come to regard him as a virtual stranger.

LARGUIER, Léo
The poet Léo Larguier was part of the circle of the writer Joachim Gasquet and through him was introduced to Cézanne at Aix. In 1925 Larguier published 'Le Dimanche avec Paul Cézanne', a freely reconstructed account of his acquaintance with the artist, and a series of aphorisms supposedly pronounced by Cézanne. Larguier developed a close friendship with the artist's son, Paul, who is claimed as the authority for Cézanne's opinions.

MARION, Fortuné
In their early days, Marion was sometimes part of the 'inner circle' of friends, including Cézanne, Zola and Baille, who organized walking and painting expeditions around Aix. Marion's predilection for natural sciences was already apparent, however (one of Cézanne's letters mentions his geological excavations), and he later pursued a distinguished academic career. Cézanne used Marion as a model on several occasions.

MAUS, Octave
Maus wrote to Cézanne in his capacity as organizer of the exhibitions of *Les Vingts*, an Art Association in Brussels. Les Vingts acquired a reputation for showing unorthodox contemporary art and in 1889 Maus persuaded Cézanne to allow him to include three of his pictures in their 1890 exhibition.

MONET, Claude
Monet was in many ways the archetypal Impressionist, exhibiting at most of the Impressionist exhibitions and pursuing the idea of a freshly perceived and vividly painted landscape through much of his career. Cézanne met him in the 1860s and retained the highest respect for his work throughout his life. The association was not a close one in later years, but Monet did invite Cézanne to a distinguished gathering at Giverny in 1894, and bought some examples of Cézanne's paintings.

OLLER, Francisco
In the 1860s, the Puerto-Rican painter Francisco Oller associated with the circle of the Académie Suisse and became an acquaintance of Pissarro's and Cézanne's. Little is known about his subsequent association with Cézanne, but an attempt in the mid-1890s to revive their friendship ended in confusion and misunderstanding.

PISSARRO, Camille
Apart from his considerable achievements as a painter, Pissarro deserves a place in the history of Impressionism as an adviser, supporter and general catalyst within the contemporary avant-garde. At the beginning of Cézanne's career, Pissarro encouraged and assisted him, showing him by example the special vitality of nature studied on the spot. Pissarro's residence in and around Pontoise was the reason for several of Cézanne's visits to the area, and the two artists' letters show that they remained on friendly terms. Despite his own relative lack of success, Pissarro was partly responsible for persuading Vollard to hold the first Cézanne exhibition in 1895.

RENOIR, Pierre-Auguste
Renoir was originally a loyal member of the Impressionist movement, but his seductive style and decorative colour soon ensured his commercial success and ultimate abandonment of many Impressionist ideas. He remained personally popular with his contemporaries, however, visiting Cézanne in Aix and painting his own distinctive version of Mont Ste-Victoire. Cézanne claimed that Renoir and Monet were the only two living artists he did not despise.

SOLARI, Philippe
Alone amongst Cézanne's close acquaintances, Solari made his career as a sculptor. Originally part of the talented group of poets, writers and artists who studied together in Aix in the 1850s, Solari remained in contact with his contemporaries when many of them moved to Paris in the following decade. With some support from Zola, Solari achieved success at the Salon and produced portrait sculptures of Zola and, many years later, Cézanne. There is evidence that their friendship was rekindled in the 1890s, when Cézanne also befriended the sculptor's son, Emile Solari, himself an aspiring poet and playwright.

VALABRÈGUE, Antoine
One of several of the friends from Cézanne's early days in Aix who grew up to be a writer and poet. References in Cézanne's letters suggest that their early friendship was a close one, and the artist attempted a number of portraits of him. In the 1880s they encountered each other again in Aix and walked around the town, recalling the events of their youth.

VILLEVIEILLE, Joseph-François
Villevieille was a painter some ten years older than Cézanne. He also came from Aix and worked intermittently in Paris. He had been a pupil of Granet, an important Aixian artist who had some influence on Cézanne, and was able to offer practical advice and tuition to Cézanne in the early 1860s.

VOLLARD, Ambroise
Picture-dealer, maker of reputations, writer and friend to the famous, Vollard was a key figure in the art of the late nineteenth and early twentieth centuries. He opened his first gallery in the Rue Laffitte in 1893 and subsequently presented exhibitions by Manet, Van Gogh, Gauguin and many others, including Cézanne's first solo exhibition in 1895. Vollard had his portrait painted by Cézanne, visited the artist at Aix and later wrote down his typically random and discursive reminiscences of their relationship.

ZOLA, Émile
Zola's importance in Cézanne's early life can hardly be exaggerated. The two were intimate friends from boyhood onwards, sharing the highest artistic aspirations and a love for art, literature and nature. Zola began his career as a writer, journalist and critic in the 1860s, soon achieving financial success and international notoriety with his ambitious sequence of novels based on a quasi-scientific, realistic portrayal of modern French society. Zola's early support for Cézanne was gradually withdrawn as the writer lost faith in Cézanne's achievement, and the two friends parted company in 1886.

Further reading

L. Venturi, *Cézanne, Son Art, Son Oeuvre*, 2 volumes, Paris, 1936.

J. Rewald, *Paul Cézanne, A Biography*, New York, 1939.

J. Rewald (ed.), *Paul Cézanne Letters*, Oxford, 1941.

M. Schapiro, *Cézanne*, New York, 1952.

L. Gowing, *Watercolour and Pencil Drawings by Cézanne*, London, 1973.

A Chappuis, *The Drawings of Paul Cézanne*, 2 volumes, London, 1973.

W. Rubin (ed.), *Cézanne: The Late Work*, New York, 1977.

M. Doran (ed.), *Conversations avec Cézanne*, Paris, 1978.

J. Rewald, *Paul Cézanne; the Watercolours*, London, 1983.

G. Adriani, *Cézanne Watercolours*, New York, 1983.

R. Shiff, *Cézanne and the End of Impressionism*, Chicago, 1984.

J. Rewald, *Cézanne, a Biography*, London, 1986.

Text sources

The extracts from the letters of Cézanne are taken from J. Rewald (ed.), *Cézanne Letters*, Oxford, 1976. 'Mes Confidences' was first published in A. Chappuis, *The Drawings of Paul Cézanne*, 2 Volumes, London, 1973.

Other texts are taken from the following:

A. Vollard, *Cézanne*, New York, 1937.

E. Bernard, *Souvenirs sur Paul Cézanne*, Paris, 1926.

E. Bernard, 'Paul Cézanne', in *l'Occident*, Paris, July, 1904 (translation of 'Some of Cézanne's Opinions' taken from L. Gowing, *Watercolour and Pencil Drawings by Cézanne*, London, 1973).

J. Borély, 'Cézanne à Aix,' in *l'Art Vivant*, Paris, 1926.

L. Larguier, *Le Dimanche avec Paul Cézanne*; Souvenirs, Paris, 1925.

J. Gasquet, *Cézanne*, Paris, 1926.

Picture acknowledgements

The publishers would like to thank the following sources for supplying colour transparencies:
Artothek, Munich; Bridgeman Art Library, London; Giraudon, Paris; Réunion des musées nationaux, Paris; and Scala, Florence.

NOTE

Where the date of a letter is not known, a suggested date is given in brackets.